Sell Your Photographs

Sell Your Photographs

The Complete Marketing Strategy for the Freelancer

By NATALIE CANAVOR

MADRONA PUBLISHERS, INC. SEATTLE

Library of Congress Cataloging in Publication Data

Canavor, Natalie, 1942–
 Sell your photographs.

 Includes index.
 1. Selling—Photographs. 2. Photography,
Journalistic. 3. Self-employed. I. Title.
HF5439.P43C36 658.89′77 79-18958
ISBN 0-914842-40-4

Madrona Publishers, Inc.
2116 Western Avenue
Seattle, Washington 98121

For Fred and for Victoria

Contents

Introduction

MANY photographers, both amateur and professional, become frustrated with photography.

The amateur, fired at the beginning by an enthusiasm given to few other hobbies, may spend years buying expensive equipment, developing his craft and piling up boxes of slides and prints. But sooner or later the idea of taking more pictures that practically no one will see dampens his fervor.

The serious photographer wants to reach others with his images. It is natural to want results seen, appreciated and perhaps even sold. Not knowing how to accomplish this, some may give up photography altogether. Others continue but, lacking any incentive or means of measuring achievement, produce repetitious work and stop growing in photography.

The professional photographer envied by amateurs may find his work scarcely more rewarding. A staff photographer employed by a newspaper, business or industry can find himself in a deadend, spending his days on routine and unfulfilling assignments. He sees no way to improve the position he holds or obtain a better one. The freelancer *he* may envy can feel equally trapped. Some freelance photographers must hustle for uncongenial work to pay the rent; others are boxed into byways of the industry that provide no outlets for their financial and esthetic ambitions.

Still others establish footholds in the fields of their choice but fail to secure their positions, and they go out of business. It is not unusual for even a first-rate photographer to open and close a new studio every few years or reluctantly move on to something else.

Even pros who are unquestionably successful in their own specializations

feel the drive for new outlets and challenges, because without movement, creative thinking stagnates.

All of these photographers, despite their many differences and aims, have some things in common. They want recognition, they want incentive to maintain their enthusiasm and to produce ever-better work and, to varying degrees, they want money to support themselves and what tends to be a very expensive hobby.

It is this book's premise that intelligent marketing is the most direct and effective route toward achieving these goals. It was written for every photographer interested in the freelance selling of his pictures, from the serious amateur making the attempt for the first time to the professional who wants to improve his business or investigate new, unfamiliar channels.

You may be among the kinds of photographers already described. Or you may be a recently graduated student with technical grounding but no insight into commercial realities; a professional photographer who wants markets for his "personal work"; a part-time practitioner eager to make the transition to full-time photography; an apprentice without the marketing know-how to get out on his own; a retired person seeking extra income from a hobby. You may be a biologist, engineer or technician who takes photographs in the course of his work and wonders whether there is not a market for them.

Productive routes for all these photographers exist. This book's objective is to help you find and develop them yourself. Besides providing a framework of useful information and marketing guidelines, it will lead you to cultivate a new perspective on photography and on your role as a visual communicator, thus gearing you to formulate new directions in your thinking and create your own best markets.

This is not a formula book. There is no list of Ten Ways to Become Rich and Famous, any more than there is a set of rules which will produce The Great Photograph. Marketing photography is infinitely more interesting, challenging and exciting than trying to follow a blueprint.

It is intended that you select, adapt and imaginatively apply the information and ideas offered here on a strictly individual basis. Not all suggestions can be appropriate to all readers; just as every photographer is different, this will be a different book to each reader.

You will not find exhaustive coverage of markets. Happily, the market cannot be so simply delimited. Concentration is on the tools you need to think through any situation encountered, to help you recognize market potentials and explore them in relation to your own work.

Note too that this book is not intended to be a technical manual on picture-taking. You probably have more than enough techniques, equipment and advice on craft already; what you need are opportunities to exercise your skills. We will, however, discuss subjects like editorial criteria, graphic considerations, the photomechanical reproduction process and other technicalities that can give you a decided edge over the competition.

One more thing this book is not: a business procedure guide. Subjects like taxes, depreciation and accounting are best learned from good business manuals. Pricing and protecting your work, though, are intrinsic to the conduct of freelance photography, and these subjects are included.

You may discover that there is far more to the consistent marketing of photographs than you anticipated—or hoped for. Energy, initiative and imagination must be applied not only to making photographs but to selling them. You may find yourself asked to expand your horizons considerably. But unrelated to the camera as some sections may seem, all the subjects you are urged to think about will reflect upon the quality and direction of your photography.

Learning to edit enables you to set criteria and eliminate shortcomings. Analyzing markets will increase the range of subjects discerned for your camera. Practicing how to develop editorial concepts can give image-making a meaningful context and take you beyond a superficial apprehension of your world. Understanding the viewpoints of professionals in journalism, advertising, portraiture, industrial photography and other specializations will broaden your perspective on photography's possibilities.

The reader prepared to embark on new directions today can find opportunities wider than ever before in photography's brief history. A true appreciation for photography's contributions to our lives has just begun and holds implications in many endeavors. Where photographic imagery has traditionally been employed, innovative uses are being explored. In fields opened only recently to photography the prospects are enormous. In still other fields yet to be specified, emerging concepts of visual communication will open altogether new dimensions.

It is hard to think of any enterprise more open to a pioneering spirit. That results are limited only by the photographer's initiative and ingenuity is a basic tenet of this book.

Besides helping you to achieve your ambitions, *Sell Your Photographs* will, I hope, raise your aspirations higher than ever.

Sell Your Photographs

1

Getting Ready to Sell

Myths

Too many photographers who are ready to explore the photographic marketplace let themselves get hung up on myths and half-truths. It is important to separate fact from fancy at the outset, since making the wrong assumptions can permanently hinder your development as a successful freelancer. Here are twelve popular myths.

1. "You must practice photography full-time to have a chance."

Except for a few highly specialized areas, such as fashion photography, this is generally untrue. Giving up your job to strike out as a freelancer can be a great mistake. It is better to build up your sales experience, outlets and contacts first. Many photographers prefer to derive their basic income from some source other than photography so that their photographic time belongs to themselves rather than to a commercial buyer.

In many areas of photography great success can be enjoyed by the part-timer, and many clever photographers use the expertise gained in their other activities to good advantage.

2. "You must live in New York."

Although the major markets are in New York and a few other cities, most are easily reached by mail or telephone, backed up by an occasional visit. A base elsewhere can even be an advantage. National publications headquartered in New York are often highly receptive to material originated out of town, because they already have more than enough coverage from New York photographers. The competition in places like New York is so intense that native photographers sometimes move to smaller cities to make their reputations.

Moreover, small communities can provide you with excellent opportunities for selling photography, no matter how high your aspirations.

3. "You need special equipment and a lot of money to freelance photography."

Whatever your resources, you can work productively within their limits if you do not solicit assignments beyond your capability. It can be unwise to saddle yourself with the overhead of an expensive studio, if doing so means you have to dash madly about just to support the studio. Some famous photographers find themselves in that position from time to time. The equipment you need will depend on the kind of photography you want to produce and sell.

A specialist in food photography, for example, will probably require an 8-by-10 view camera and its accessory paraphernalia, as well as good studio space. But many kinds of photography are beautifully accomplished with small-format cameras. If you are satisfied with your present equipment, whatever its nature, you probably have enough for the moment.

With scarcely any cash outlay, you may be able to sell work from your files, especially if your files are large. In other cases, a little judicious spending can support a promising project or purchase some professional trappings to help your marketing effort. Equipment, studio space, and darkroom facilities can be rented.

4. "Photographic opportunities are limited to those of a certain age, sex or race."

This is true insofar as freelancing is a people-business; you will find yourself subjected to some prejudices or preferences, as in any human encounter. But the creative fields are more open than most. An enormous talent may come to light when someone picks up a camera for the first time in his life at the age of seventy, or twelve. Several of the best (and most successful) photographers I can think of turned to it after one or more full careers in something wholly unrelated.

Women have been at some disadvantage in situations where physical strength is thought necessary, as in apprentice jobs or jobs in dangerous places, but more than enough women photographers have achieved recognition to demonstrate women's full range of capabilities in photography. The problem has lain more in the area of those *non*photographic qualities that have traditionally been discouraged in women: ego, aggressiveness, persistence, and their like. These attributes have always seemed necessary to freelance effort. Many picture buyers wish more women would show up with their portfolios. (In this book, incidentally, photographers are usually referred to as "he" for convenience, certainly not because I assume most readers are male.)

As for racial discrimination, I personally have never been aware of an instance. But it must be acknowledged that some exceptional minority photographers have had great difficulty in obtaining the assignments and recognition they deserve, and that an unknown number of others have been too discouraged to even attempt joining the mainstream. There are signs that the situation is improving and that individual effort can more easily earn its reward.

5. *"Major markets are open only to professionals."*

Certain competitive areas, such as commercial photography in New York, are geared to full-time entrepreneurs. But most buyers do not make distinctions between amateurs and professionals, because no real distinction exists. In contests, for example, the usual rule is that a professional is a person earning more than fifty percent of his income from photography. But there is no way to denote skill, qualification or experience. Many of the heaviest picture buyers acknowledge that a lot of their best work comes from amateurs. Most buyers do not care where your regular income comes from if you are offering something they need. Unnecessarily pure distinctions between amateurs and pros only make life complicated. What if an industrial photographer decided to undertake portraiture—would he be a professional in the new field?

6. *"It is hard for newcomers to get into buyers' offices, or for a photographer to see buyers in a field new to him."*

Again with some notable exceptions such as commercial photography, getting your work reviewed is as simple as calling for an appointment or mailing photographs in. As a picture editor I recall one photographer who brought me his portfolio, and after I had accepted some of his pictures and we had become better acquainted, he confided how he had arranged the appointment. He had called a friend's brother, who knew someone who had once worked at the magazine, who could refer him to a current art director, so the photographer could finally call and say, "So-and-so asked me to call you for an appointment." I tried to tell him that all he had to do was call and ask, but I don't think he ever believed me. I have come to realize that his attitude is more common than it ought to be.

Picture buyers see photographers because they need to. No matter how many pictures they have, they rarely have enough. There are two reasons for this. First, many buyers have very specific needs, and they have no easy way to locate the photographs they need or the photographers qualified to take them. Second, most of the photographers who submit work do not know how to anticipate the buyer's needs, and they show the wrong material. A constant demand for more and better pictures keeps an editor's door open to all photog-

raphers. Although many media directors take pains to let this policy be known, it is hard to publicize. The photographer must take the initiative.

7. "The professional freelancer has secret markets and selling techniques unavailable to others."

No such secrets exist. The experienced freelancer's advantage lies in accumulated knowledge, derived from hard work, research and experience. He may have contacts in the field cultivated over many years, but nonetheless he must be as good as any newcomer in gauging needs and filling them. Successful freelancers do have a way of thinking about photography and markets that is readily learned when it is understood, as we shall see.

8. "Selling photography requires enormous aggressiveness and a hard sales pitch."

Many of the most successful photographers I have known are soft-spoken, understated people who rarely talk about themselves at all. In most cases their pictures must make the sale for them, and a tough self-sell is distinctly out of order. In cases where personality is considered, preference usually is given the quietly confident, cooperative person who can work well with others. It is true that persistence, initiative and ego are needed. Rejection is part of the game. How you react to it is what counts. When you understand the buyer's viewpoint and needs, have confidence in the pictures you are showing and your ability to perform the assignment you want, you can sell effectively.

9. "Marketing methods are completely different for various photographic specializations."

Every instance may be different and unique, but the principles involved are basically the same. Whether you are selling a medical picture or an airplane picture, you will probably use the same research methods and guidebooks. Whether your presentation is planned for an advertising campaign or a teenager's magazine, your market analysis must include similar factors. For this reason, you will get the most benefit from this book by reading all of it.

Photographers interested in selling "art" images will seek out the appropriate chapter, only to be referred to the commercial sales principles described elsewhere. Other subjects are covered in specific chapters but apply to many situations. For example, how to develop ideas is discussed in the context of editorial photography but is equally crucial to the photographer who wants an exhibit hung, a book published, or an agent to handle his work. Similarly, the section on following-up after journalistic assignments applies equally to ad agency work, weddings, and other kinds of work.

The last three myths relate less to personal requirements than to the nature of the photographic marketplace.

10. "Marketable images must meet a universal standard of quality."

It might be nice if this were true, but it isn't. This can easily be proved by looking through the books, magazines, advertising and other visual material that surrounds us. There are no absolute standards for photography. There is virtually no agreement about what a good photograph is. There is not even agreement on who might be authorized to make such a decision. Many buyers define a good photograph in terms that have nothing to do with technical or esthetic factors but have a great deal to do with the purpose for which they wish to use it. Certain markets prefer work that might be called unoriginal and uninteresting. If you can honestly evaluate your own photographs and potential markets, fine opportunities to get work seen and sold exist for nearly everyone.

11. "There are already too many photographers competing for freelance sales and assignments."

It is true that more photographers are assaulting the buyers' citadels than ever before. Something about photography has extraordinary appeal to the modern consciousness, and many people with creative leanings are studying it in courses and trying for career switches. But however great the pool of talent available, only a small percentage approach the market properly. Many do not have the technical range to execute other people's conceptions, even when they know how to solicit the assignments.

Many hopeful freelancers try for the same small group of obvious outlets while other markets which may pay equally well, and may be better suited to their talents, go begging for pictures. The photographer who applies himself to market research has a great competitive edge.

12. "The market for photography is declining."

The glory days of the great picture magazines are certainly gone. More important, though, other segments of the market have expanded. Special interest magazines, foreign periodicals, professional and trade publications, and the audio-visual industry are great picture markets today. The fields of teaching, corporate communications, civic improvement, scientific research, and criminology use photography in unprecedented quantities. The exhibition of photography in museums, galleries, offices and homes should not be overlooked.

These are times in which premiums go to innovative photographers who can envision new photographic applications and communicate them to others. Markets disappear and new markets spring up every day. No matter how the balance shifts there remains a wealth of possibilities. Never assume that the market for photography is finite; in fact, the opposite is more the case. The

real difficulty lies in recognizing opportunities and your own potential contributions.

Know thyself: the classification idea

Selling photographs is a matter of finding the meeting points between your photographic assets and the needs of the marketplace. While everyone readily acknowledges the need for marketing guidelines, too many photographers neglect to consider the other side of the equation—themselves.

As a photographer, your range of interests, the type of picture-taking situations you enjoy, your educational background, working experiences, hobbies, attitudes and personality are just as important to shaping your direction as your photographic skills—perhaps more so.

Self-knowledge is a lifetime pursuit, but as a photographer you can give yourself a head start by examining the visual evidence. Without getting into psychiatric quicksands, it is clear that your photography is an expression of yourself—how you see the world, feel about it, and respond to its various elements. Even if you are one of the rare photographers who does not find himself fascinating, you must work at reviewing and classifying your pictures.

Simply enough, you cannot sell something before you know what it is. In the language of the marketplace, photographs are products—not quite like cars or shoes, but no less tangible objects for which buyers must be found. It is important to realize that in almost every situation the burden of locating the consumer (editor, art director, agency executive) falls to the supplier—you. Most picture buyers have neither the time, the inclination nor the staff to scout for likely picture suppliers. Even if they wished to do so the difficulties would be monumental. There are no guidebooks that adequately list photographers and their credits, qualifications and personalities. Publications with steady needs maintain staff photographers to fill them if they can afford to do so, or they have picture editors to handle the problem. Except in rare cases where a photographer is recommended for a special assignment or tracked down by the buyer, most editors select the best candidate from those who present themselves to him.

Thus it is up to you, the seller, to locate the appropriate buyers and make known to them the suitability of your wares or talents. If you choose to find buyers for pictures you have in your files—that is, stock photography—you will want to use research guides that classify buyers' interests by subject. When you are soliciting assignments—that is, selling your ability—you must know your proven capabilities, know how they correspond to buyers' needs, and be able to talk about them intelligently.

A thorough cataloging of your photographs can give you immediate financial rewards. New uses can often be found for many types of pictures by seeing new combinations or experimenting with new contexts. The more ways any batch of images is classified, the more sales leads are created.

This applies equally to professionals and nonprofessionals with good files of photographs. Few things frustrate an editor more than knowing that somewhere there are scores of wonderful candidates to fill his particular need tucked away in dusty file cabinets. Before you start a thorough cataloging of your work, try the following experiment in classification to see if your photographic product and personality is what you think it is.

Analyzing your vision

Assemble a few hundred of your most recent photographs in whatever form they take—slides, prints, even contact sheets if you like. If you are a professional photographer, it may be more enlightening to concentrate on your leisure-time or experimental work rather than pictures produced on assignment. Pretend you have never seen your pictures before and begin sorting through them systematically. First, if you have not yet done so, group them according to the most obvious subject. Typical categories might include travel, people, nature, sports, scenics, children and animals. If your breakdown is more specific, all the better.

Next, look through one of your major categories for further subdivisions. We shall use travel pictures as our example here, since most photographers take them. Try the following classifications for your travel images: those which show panoramic scenes, city scenes, small town scenes, rural scenes, all pictures with people, and so forth. Many photographs will fit more than one category, but make an arbitrary decision. That is a crucial ability in itself.

Some people find, even at this point, that their cameras have been focusing more specifically than they thought.

Now take a subgroup within your travel category and go through it again—pictures of people, for example. Separate out images in which people occupy nearly the whole frame and those in which they form only a small portion. Group those in which your subjects are looking directly at the camera, at another person, or nowhere in particular; those with young people, old people, middle-aged people; people working or playing. Sort out pictures where people are moving or stationary; have animated expressions or indifferent ones. See whether you have any sequences covering an event or the various aspects of one place.

Another good topic to experiment with, especially if you are not a photog-

rapher of people, is pictures of buildings, as either a major category or as part of your travel group. Subclassifications might include: images that show an entire building, a middle view, or focus on details; those taken from street level or above (like another building's window or an aerial view); group "one shots" and series which explore the same subject from different angles, distances and perspectives. Try dividing old buildings from new; those primarily glass, stone or brick; those with people and those portraying groups of buildings; straight vs. interpretive; daytime and nighttime; and anything else especially relevant to your collection.

Any subject can be examined in this manner. Before looking at the pictures, compose a written list of every possibility you can imagine for the subject. Then sort through the material and add subdivisions for picture types you had not thought of.

The idea is to look at your work in greater depth than you ever have, and begin applying classifications. If you have doubts about the exercise, consider some of the benefits. You might discover for the first time what subjects you really prefer. This means not only recognizing that you like structures better than people, or small delicate objects better than large ones, but also identifying recurrent themes in your work.

I recall one photographer who was wholly unaware that, whether at home or abroad, he was amassing an extraordinary number of pictures involving windows. This was an interesting self-revelation, and it gave him a perspective by which to review years of photography. When he began consciously following up this theme, he emerged with some nice publication credits, a promising outlook for an exhibit, and a theme that could be attractive to book publishers.

A photographer who thought he was photographing humanity at large found that a large percentage of his work showed relationships between old people and young people. Another photographer of people was forced to face the fact that he recorded people's backs more often than anything else, which no doubt holds interesting psychological implications.

The selection of other categories would result in an entirely different organization of the same body of work. For example, one could concentrate on qualities, such as motion, rather than objects. Some photographers incorporate a sense of motion into many images. Motion can suggest ideas, such as action, spontaneity, impermanence or dynamism.

An awareness of the recurrent moods or emotions you infuse into your pictures can be enlightening and productive. A photographer's images can suggest either gaiety or somberness, human affinity or isolation, lyricism or

analysis, peacefulness or anger. Such effects are produced quite naturally by the choice of subject and photographic treatment. Every picture manifests your vision of the world and of life.

Notice that I have not suggested that you classify your work according to the techniques, lenses, apertures or formats used. Although analysis of how you use your tools is important to your photographic process, your primary concern in marketing is to identify what is in your image. After all, very few buyers are interested in photography for its own sake. They are looking for pictures that serve their purposes, most often illustrative. Besides, allowing your work to be classified according to technical details reduces your photography to a mechanical, rather than a communicative, level.

Identifying the content and trends of your work is no easy matter, and preoccupies many a fine photographer. Although some professionals claim to discard immediately all but their best results, most will admit to hoarding everything for obsessive, periodic review. Last year's second-rate could be this year's first-rate, once time has cooled the judgment and lengthened the perspective. New connections and correlations can be made in a body of work. Cross-indexing can suggest interesting new directions and viewpoints within which to reassemble images. Re-examining your stock of photographs should give you not only a set of new sales leads, but also insights into your thinking and interests.

As directed by your mind and eye, the camera is a highly selective instrument. Learning to comprehend your special selectiveness is a major effort and rewarding adventure. It is also the only reliable way to classify your skills so you can choose markets with corresponding needs. Picture buyers often seek specific qualities as well as subjects.

Classifying your work carefully develops your capacity to see what you do *not* have and to recognize subjects for which you have a natural aversion or lack of interest. Unless you are practicing photography solely as a psychological tool, there is no reason to sell yourself as a photographer of people if you do not like photographing people. More specifically, you will learn to better analyze your coverage of a subject.

A truly comprehensive coverage of a subject would account for every possibility. Good freelancers and photojournalists practice this way of thinking. Before an important assignment, they will research the subject and think through every possibility, event and circumstance. They are rarely caught surprised. Thorough preparation allows them to perform with seeming effortlessness, perhaps running through a mental checklist, while retaining the ability to capitalize on the unexpected. (Examination of this thought process is what edi-

tors have in mind when they request old contact sheets from a photographer.)

Your past photographic performance closely examined can show you what possibilities you missed so you can do better in the future. Is your travel coverage as comprehensive as you presumed, for example, or did you entirely omit some subjects? More to the point, can you think of additional subjects that deserve to be on the subject list?

You may not want to comprehensively cover a country or any other subject, but you must be conscious of your choices and aware of what you are omitting. Otherwise, you will be shooting haphazardly and far less productively than you could.

Cataloging yourself

In addition to examining the visual evidence, many photographers find it helpful to catalog their personal assets and preferences. Your personal strengths can be guides for new directions or new dimensions in your photographic career. Superficial factors must be taken into account. The amount of time you can devote to photography, your physical condition, current sources of income, family situation, present technical repertoire and equipment, and many other elements may affect your thinking. Relevant questions may include: the type of pictures you most enjoy making; the kind of people you are comfortable with; your preference for controlled situations or for the fast-moving and unexpected; your liking or disliking travel; whether you function best alone or as a part of a team; do better with live or still subjects; prefer routine or constant change; and so forth.

It is foolish to try to fashion an occupation, whether full-time or part-time, that necessitates work you do not enjoy. You may find this means refusing certain opportunities that come your way, but it is better to assume control over your direction rather than to let the winds of chance blow you.

Try to visualize what the ultimate achievement in photography means to you now. Do not think in vague terms of fame and fortune, but in specifics; imagine, for example, a set of particular types of images used in a specific medium. You may change your mind many times, but a goal makes it easier to formulate a working plan. It is a good idea to review your objective and refine it as far as possible after reading this book (and indeed, periodically throughout your photographic career). A basic tenet of any self-help philosophy is that the more closely a goal can be defined, the more readily opportunities can be recognized that otherwise might be overlooked.

Perhaps most important in this self-cataloging process, devote some time to

thinking through every area of expertise you possess. We are prone to take for granted what is familiar to us. A written list can help. Record all subjects you know something about by education, occupation, hobby, personal history, continuing interest, reading, nearness to a person or by geography.

Not by accident, a great nature photographer is an informed naturalist. A great sports photographer is an avid fan and often has been a participant. A good medical photographer must understand anatomy and terminology nearly as well as a doctor or he cannot function.

Nonspecialized photographers who perform a variety of editorial and commercial assignments must take advantage of everything they know and be willing to research the rest on short notice. A top photojournalist spends hours, days or weeks learning about a subject or event which may be over in a minute. Advertising photography can entail weeks of discussion, research and planning before the result desired by dozens of people is produced. Asked to provide a picture series showing how corn flakes are manufactured, an industrial photographer must find out how it's done before pressing the shutter release. The better portrait photographers, such as Arnold Newman or Yousuf Karsh, succeed not because of technical superiority, but because they take the trouble to know exactly who and what a major subject is beforehand and plan the expressive possibilities, as well as practicing some quick psychology on the spot.

There is a maxim for writers that one's best work will be of the subjects one knows best, and it applies every bit as much to photographers. The very best subjects are the closest to home.

I recall a photographer with commercial aspirations who decided to try it on his own after a few years as a studio apprentice. He made the rounds, but few jobs materialized in the fashion field he thought himself prepared for. With a great deal of time on his hands he began taking his 4-by-5 studio camera into the old slum neighborhoods in which he had grown up. The results were very distinctive—serious, appreciative portraits of youth gang members, drug addicts, and more respectable local residents usually pictured by other photographers less as individuals than objects of pity. This photographer was able to function on the basis of mutual respect and produce compelling images, especially by applying view camera techniques to street photography. Within months of including the first series in his portfolio, the photographer found major recognition in a leading photography magazine, obtained several good magazine assignments and planned long-range projects that earned foundation funding.

A young woman brought me a portfolio in which one group of images stood

out: photographs of children in everyday situations. Although children are among the most photographed subjects, editors have trouble getting the type they need. High-caliber pictures of natural-looking, spontaneous children are rare. This photographer was a full-time "houseperson" who had trouble getting out of the house; she had three young children. In frustration she began turning the camera on the children. She knew them better than anyone else and could record the revealing moments with the most patience. Once she understood the response the pictures of the children got, she was able to follow up with market research to find outlets for the pictures.

Another woman photographer in a similar position chose another direction. She used her excellent portrayals of her own children to launch herself on a career making children's portraits. She would visit customers on their own ground and make 35-mm candid photographs of the child at play. Parents found the candids a welcome alternative to the typical stiff studio portrait.

People who have been earning their living in some other way than by photography have advantages that can be exploited. Photographic specializations emerge from assets or interests already cultivated. A photographer now famous for literary portraits began as a writer who took snapshots of fellow writers. She built up a collection of informal portraits, and with her first market-scouting she found that the collection was valuable to magazines, book review sections and the writers themselves. Soon, when a portrait needed anywhere in the world was not already in her files, she was assigned to photograph the subject. Thus her file, reputation and income expand.

An architect, after years of generalized hobby photography, showed some shots he had taken of a new building to its architect. His colleague became excited, because architects have trouble obtaining pictures of their structures which are both dramatic and faithful to detail, rather than everything being sacrificed to graphic effect. Spurred by this enthusiasm, the photographer assembled the building photographs from his files and found that not only were some salable, but that assignments to photograph other buildings were being urged upon him. He does not want to pursue photography full-time and so he refuses the assignments, but the experience has led him to an interesting approach to the hobby. He is concentrating on architectural photography of specific places and periods, and his collection should ultimately enjoy significant use.

A teacher kept his camera handy during school hours for years. He recorded classroom scenes, playground activities, cafeteria periods, and everything else associated with his daily environment. He had tried for years to market his travel photography without success when a friend suggested he show some

school pictures to an agency. A large batch of the pictures was taken immediately by a stock house that receives frequent requests for illustration of educational subjects. Several times a year the photographer gets a tidy check for new sales and a host of new publication credits.

A woman with an art-history background works as a receptionist for a small art museum that is typically understaffed. To an emergency call for photographs of objects in the collection, she responded by offering her services. The results were usable, and as work came her way regularly, her work got better. She is responsible now for producing most of the slides sold in the museum shop, and she has illustrated a book about part of the collection. She is prepared if she wishes to seek further markets.

Whatever your profession, interests, hobbies, leanings and likings, you possess unique possibilities to be explored. This is as true for full-time professional photographers as it is for amateurs. The wider you have made your world, the more ways you can find to use your camera and find markets for the results. The reverse can work beautifully also. If you have a latent curiosity or interest in some subject, a camera could be your entrée to the learning process you never undertook.

In considering your various natural assets in connection to photography, take nothing for granted. Never assume everyone else, or anyone else, can offer the unique set of attributes you can. Many people take pictures of flowers, but if you are a horticulturist you know each genus and species—which makes *your* pictures salable. If you love opera, skiing, scuba diving, or horse racing, you can take better pictures of these subjects than ninety-nine percent of your competition, not just because you have the essential ingredient of enthusiam, or can recognize the high points or the unusual elements, but quite simply because you are there. Being on the scene, in both a literal and metaphorical sense, is what a lot of photography is about.

"Well," a cynical freelancer might interject, "it is all very well to know thyself, but it merits more to know thy enemy: the picture editor." The traditional antagonism between editor and photographer is usually based on mutual ignorance. The photographer can take the initiative. Making the effort to understand the editor's viewpoint can mean finding a friend.

2

How Editors
Look at Pictures

Photography and publishing

IN THE world of publishing, photography was a late starter. When photography arrived in the nineteenth century, the communications media were entrenched in a word orientation. This was only natural. Movable type was invented about 1450, and the ability to print photographs did not exist until some four centuries later.

The verbal tradition weighs heavily on our newspapers, magazines and books today. Progress has been made, but by any standard of time, space and money spent, photography must still be rated the poor relation of the publishing industry. Decisions concerning the selection and use of images are made by "word people," not by "picture people." Even the "Picture Editor," or "Photography Editor," is usually a word person. No formal training for the picture-editing job exists, and the person holding the job may not even have any training in photography, art or graphics. The picture editor probably studied English Lit or, as a photographer-friend of mine claims about all photo editors, "is a failed journalism major." Worse yet, the picture editor may well be low-man-on-the-totem-pole, with the least seniority, pay and influence on the publication.

There are many picture editors with celebrity status, revered by photographers and highly valued by editors, but if you are not dealing on the level of *National Geographic* you are unlikely to encounter them. In fact, being picture editor is rarely a full-time job, especially on small publications. It may be performed by the art director, the production manager, an assistant editor, the editor-in-chief or even the publisher, if it's a one-man operation. Viewing

photography is frequently the first function discarded by Low Man as he gets promoted or the publication hires more staff.

As bad as the system may sound, not all the results are bad. The picture editor is likely to be a young person, with a natural enthusiasm for photography and an open-minded attitude toward it. Senior staff members often have more rigid opinions about picture values and what they think are proper subjects. An editor who is himself a photographer may be the most narrow-minded of all. He may favor images which reflect his own beliefs about photography; he might also, to paraphrase my friend, be a failed photojournalist. Equally irritating may be the picture editor with formal training in art. One magazine that valued its good relations with photographers once deliberately hired a "qualified" picture editor with an art degree and an avocation for painting. More complaints about the picture department filtered back than before. Photographers didn't like being lectured on the principles of composition and artistic traditions. A less qualified person had to be hired.

For most publications, what counts more than training or knowledge is the picture editor's ability to understand the magazine's objectives and needs and explain them to photographers; to translate requirements into visual form within budgetary limitations; and possibly, to exercise a little imagination toward effective selection and use of pictures.

The picture editor will be reviewing portfolios with needs such as the following in mind:

1. Photographs of specific subjects for uses already named and criteria firmly established. Example: A sports magazine needs a cover shot for a winter issue. It must be color, vertical, dramatic, attention-getting from a distance, have room for a four-inch logo at the top and seven article titles on the left side, cost no more than $70, and be in-house on Thursday.

2. A photographer perfectly qualified to produce specific kinds of pictures to cover a given assignment. Example: The same editor needs someone to go to the Olympics and come back with great shots, guaranteed.

3. Keeping up to date with who is doing what so he can build up his file of photographers who can be called as needs arise. Example: A fashion magazine editor keeps a card on each capable photographer who visits, generalizing about his ability and personality. She can track down someone who is especially good with nine-year-olds, or functions well on difficult locations, or can provide elegance with sexual overtones, and so forth.

4. Good new ideas to supplement what the magazine staff comes up with. Example: The fashion editor is impressed with the brewery a photographer has used as background for his test shots, and thinks about a fashion essay

similarly set. The resulting assignment may or may not go to the photographer who stimulated it. The more honorable publications pay what they call a finder's fee for an idea which is handed on to someone else.

5. Photographs the editor likes very much, for which an application will have to be found. The photography in such a case might end up being used more or less for its own sake, or a special slant might be developed. Example: An editor loves the way a photographer has handled sea shells, and talks the staff into using them to illustrate "The Fragile State of our Environment."

Many factors have been omitted from this simple list, whose purpose has been to give photographers a broader idea of the picture editor's function. Can generalizations be made about the standards editors use to evaluate photography and make choices? Not easily. Since picture editors come from diverse backgrounds, get their training on the job, perform different functions with different degrees of responsibility for an extremely wide range of employers, and tend to work in isolation without even talking to other picture editors, few helpful guidelines have been established for either the photographer or the picture editor.

The subject of picture editing is only glancingly treated in the more modern manuals on editing and graphics, and a few books have discussed picture editing from the viewpoint of one-time superstars such as *Life* and *Look*. Even this scant coverage bogs down in boring questions like, "What is *really* a photo essay?" The only organization purportedly devoted to picture editors (the American Society of Picture Professionals, in New York) has a membership consisting mostly of picture researchers, which are not the same as picture editors.

So the question of what picture editors have in common with each other is more difficult, but more interesting, than might first appear. We can start by noting that largely speaking, purpose number 5 on our list—finding pictures the editor likes—is always last. Liking a photograph personally is nice, but it certainly is not necessary to the process of filling needs. The picture editor does not think of pure photographic quality, but of pictures that serve purposes, and the purposes are more often framed by other staff members.

Photography is almost never used for its own sake. Those who make photographs have a hard time accepting that.

Photography is used in most books, magazines and newspapers to illustrate something being written about, to illuminate and amplify points made by the text or to substitute for words when a visual depiction is quicker. Photography is also used for graphic effect: to attract the reader's attention to the text or to entertain the eye and give it a rest. The original way of employing pictures is

reflected in journalistic terminology like "breaking up the copy block" and "filling in the white space." Spokesmen for better use of photographs aren't kidding when they talk about stepchild status. A picture may be worth a thousand words in theory, but all too rare is the publication that treats photography as a full partner in the communications business.

If photography's effectiveness in communication has scarcely been tapped, photographers should think about their own roles before feeling too self-righteous. All too few practitioners see themselves as communicators, whose work is conveying information and ideas to other people, rather than as creators of art for its own sake or for self-expression. (There are important places for photography as fine art, of course, but rarely in publishing.) Therefore the imaginative photographer who sees himself as a communicator is valued.

Many elements of the publishing industry, however, fail to grasp the magnitude of photography's potential contribution. One reason for this is that outlooks and policies are often determined by money-oriented, post-middle-aged entrepreneurs with sales backgrounds and dim concepts of either good words or pictures.

I once edited a nationally circulated magazine for a publisher who stated outright that we should not use too many pictures, and should run only small ones, because "we want to look like we're giving the reader a lot for his money, and filling up space with pictures would look like we're cheap or can't get enough material for the issue." This was a professional photography magazine. In the thirty years of its history, this highly profitable magazine had never paid a photographer for a photograph.

Even organizations notable for extensive or innovative use of photographs may regard them as luxuries. From an editor's viewpoint, good photography is not cheap, and excellent reproduction is one of his more expensive production costs. When the economy is suffering, or when prices for printing, paper or postage increase greatly, the first cutbacks will likely include photography. Since these costs have all increased of late, some photographers have been looking for new work.

Despite the die-hards and the setbacks, exciting things have begun to happen. New publications are springing up directed by younger people and oriented to the younger generations. A great many publications are expanding their boundaries to use photographs more interpretively: to convey abstract ideas, symbolize emotions and suggest intellectual concepts. But note that even within the context of these trends, photography is seen as graphics and communications support.

Suppose an editor has a story called "The Anguish of Alcoholism." Not long ago, the natural thought would be a shot of some Scotch bottles. Today the editor might develop with a photographer, as a company magazine editor recently did, a composite image showing a man trapped inside the bottle. He might even run the image big and dramatic.

Suppose a news or interview article calls for pictures of the subject. Not so long ago, the picture specified would have been a "formal head-and-shoulders," but today a decent percentage of editors prefer the more natural "environmental portrait" or even something with a little movement and spontaneity. A picture that revealed personality might be given great prominence by today's art director.

The editor and the art director are inescapably part of the photographic process. Most picture requests originate with them, and the ultimate use of a photograph is determined by them. It is not accidental that the best examples of communications photography are collaborations. Better photography requires better editors, as well as better art directors and photographers. A photographer can claim that an editor is too dumb to recognize a great picture. But if he doesn't provide the great picture, he can't blame the editor—and anyway, maybe the photographer has some responsibility to help the "word people" understand photography better. The editor, on the other hand, should treat the photographer as an integral part of the team and solicit his visual expertise.

Good pictures are the best stimulus to progress. As better, more interesting photography reaches the public, it builds an expectation for excellence that must be met. Television and motion pictures also contribute to visual education.

If the photographer's Shangri-la is not yet here, progress is being made in moving publications people toward experimentation and innovation. The thinking photographer can make a special contribution in publishing, but he will need to understand the reasoning by which it functions.

The editor's criteria

Very few editors are competent picture critics. You will rarely hear an editor explain that he would prefer a given shot taken with a 90-mm lens, or that a different aperture would have solved your depth of field problem. What he might say is, "This picture is all right but I was looking for something a little more interesting," or "Do you have any more in this series," or "Thanks, we'll be in touch." After all, his job is not to tell you how to shoot but to evaluate what you are showing in terms of its usefulness to his publication.

Let us suppose you are submitting some stock pictures to an editor, and that they are generally appropriate to the situation. Further suppose a generalized sort of picture editor with a rather broad need that could be filled by many of the pictures available. Here is how he might judge your pictures against each other and your work against your competition.

Photo content

The editor's prime concern is: Which photographs will contribute most to the article they accompany and to the magazine as a whole? A single great image may be employed occasionally as a grabber, something to arouse immediate attention and curiosity, but the editor looks on such usage as a frill. The overwhelming majority of pictures are required to explain the subject of a story and get its point across clearly. The best picture is the one that best communicates the most important aspect of the story. The editor who uses pictures thoughtfully will use them as integral parts of his presentation, not as decorative objects to break up the copy.

The contemporary rule that photographs are integral elements in the story may be interpreted broadly to encompass the use of images and symbols or to establish mood, atmosphere or interest. The general lesson, however, is that photographs must be justified by their information content.

Photography is one of the editor's most potent means of establishing his magazine's overall style and tone. The kinds of images used and the ways they are used are carefully conceived matters; insofar as possible, every picture chosen must conform to the magazine's desired "image." The editor has this very much in mind when he buys photographs from a freelancer.

Graphics

The second major consideration is: Which photographs lend themselves to the most interesting graphic use? Your print or transparency is only raw material to the editor, who is obsessively concerned with how his pages will look. Factors like color or black-and-white, horizontal or vertical format are instant disqualifiers.

The editor looks for a photograph he can work with. Is it the sort of picture that must be used big? Is there enough space for that, and is the picture worth the space? Can it be run across two pages? Can it be cropped in interesting ways to emphasize the subject or refocus the interest? Can it be run long and narrow across the bottom of a spread, or cropped to eliminate the face of the unidentified man? How will it look next to the other pictures we want to use?

Can it be juxtaposed with another picture to create an interesting statement?

Before succumbing to horror, photographers may comfort themselves that such analysis is typical only of the best editors. Their intent is not to tamper with the image in order to come up with a gimmick (the worst editors do that) but to make the most of the picture's potential for communication. In ideal circumstances, manipulation of an image for graphic effect is done only because the image itself suggests it, though at other times size and shape are predetermined and the photograph is made to conform. The lines can be hard to draw, and opinions can clash.

An editor may alter a picture to the point of creating a new one, but this is not necessarily a crime. A famous example was produced during coverage of John F. Kennedy's funeral. Scanning countless numbers of negatives and contact sheets, an alert editor decided that the whole story was most effectively conveyed by the small figure of John-John saluting the coffin, too young to understand the event. This was recorded only as a part of a much larger scene. The editor cropped what he wanted from the picture and enlarged it. Since the figure of John-John occupied less than ten percent of a 35-mm negative, the resulting photograph was grainy, but effective. Many of us see that image to this day as the essence of the event. I have never heard of a photographer refusing credit or prizes for a picture an editor made this way.

Reproduction

A third consideration is: Which picture will best translate to the printed page? Not only is your image raw material, it is only a preliminary form. Wonderful as the possibilities of modern reproduction are, the printed version of a photograph will never look like the original. It's mostly a question of how close the result can get. Estimating the loss of quality in every picture possibility is a critical matter to the picture editor, art director and production department. More than almost any single factor, the judgment of quality loss eliminates many photo candidates. The other side of the coin, of course, is that the photographer who anticipates photomechanical criteria when printing his work, and often even in the original shooting stage, is the man with an advantage.

Your images can be reproduced by one of three basic systems. Gravure produces the finest picture quality; it is used by magazines and books when expense is no object. It is also used by many Sunday supplements because it becomes economical when a half million or more copies are to be run. Letterpress is the classic method employed by many newspapers and some maga-

zines; a growing number of both now use a third and newer process, photo offset (photolithography).

With some variation all three processes print images via the "screened halftone," which is made by rephotographing the original copy in a huge camera, with a screen of diagonally crossed lines interposed between lens and films. This gives the printer a converted image made up of tiny dots, so that his relatively insensitive printing machine can represent the long scale of a photograph with only black ink and white paper. The dot pattern creates the illusion of tonal gradations, and the system works the same way in color as it does in black and white.

The screen pattern (seen with slight magnification) can range from 65 lines per inch in newspapers to 120 lines for most magazines to as much as 300 for advertising material. The more lines per inch, the smaller the dots, the better (and more expensive) the process.

A critical, coordinated factor is the paper used—weight, quality, type of surface. Other factors include the size, speed and quality of the press; the kind of ink used; the expertise of the press crew; whether the publishing house owes the printer any money; and so forth. How, the intelligent photographer will want to know, can such a range of factors possibly be anticipated?

Some generalizations can be made about the kinds of images which are preferred for certain uses.

Newspapers, which use fast presses, cheap paper and coarse halftone screens, favor high-contrast originals with a minimum of detail and simple, block-like shapes. Strong lighting helps.

Magazines, which usually but not always use offset printing these days, will like sharp, fully detailed, snappy prints with good tonal scale.

Publications printed by the gravure process want full-toned images rather than contrasty prints.

If you are shooting on assignment for a publication, for advertising or for a commercial purpose, find out how your work will be used beforehand; you'll at least impress the art director by asking. When you can not anticipate the final use for a photograph, or when you want to accommodate a range of possible uses in your photography, the following guidelines will be helpful.

An editor will consider the following picture qualities risky:

Prints that are very dark overall or very light overall.

Pictures whose effect depends on very subtle tonal gradations that may blend completely together.

Images whose meaning or impact depends on tiny details which may disappear unless the picture is used giant size.

Soft focus.

Grainy prints that may come through the halftone process looking blotchy.

Textured print surfaces that will reproduce as cross-hatching and create a moire pattern.

Any picture quality, no matter how carefully controlled, that can look like a mistake by the photographer, editor or printer.

Picture editors must examine work submitted with a mental estimate of the worst that could happen to it in the production process. On several occasions I recall assuming personal responsibility for uses of images that others warned would be disastrous. Despite all possible care, the results could not be controlled, and nobody complained about the results more bitterly than the photographers. No matter how beautiful the original, the picture editor is doing nobody a favor by running a high-risk image.

The traditional 8-by-10-inch glossy print is still the preferred format for most submissions, because it offers maximum detail in a manageable size that can be reduced to fit any layout. Remember that more detail cannot be introduced than provided by your print. A tiny print cannot be considered for use in a large size. Unusually large prints, on the other hand (meaning those larger than 11 by 14 inches) are a nuisance. They are easily damaged, hard to handle and difficult to imagine scaled down to a small size.

There are innumerable exceptions to these suggestions, according to purpose. If you were printing for exhibition, none of them would apply. Part of a good photographer's business is to learn as much as possible about the ultimate use of his photographs and take the facts into account as early as possible.

Color printing

Thus far we have been talking about black-and-white photography. With color, the problems quadruple. One printing plate, with black ink and white paper, is needed to reproduce a black-and-white image. Four color plates are required for color printing: magenta (red), cyan (blue), yellow and black, hence the term, four-color reproduction. The color content of the original photograph is separated into the three primary colors plus black. Printing plates are made for each, and the colors thus separated are recombined on the

printing press to render the original photograph in a different medium. This is done at high speed; a thousand feet of paper per minute goes through the press.

The machinery and the process are expensive, and so is the product. Color printing is three to five times the cost of black-and-white.

Although cheaper four-color processes are helping to lower the cost of printing color, the expenses are still high enough to prevent most small publications from using much or any color. Even in big glossy magazines, four-color articles are often allowed only when there is four-color advertising running in the issue to bear the costs.

It is not surprising that even publications that use a lot of color are selective. As with black-and-white, distinct preference is given to razor-sharp images. Rich, fully saturated color often looks better in print than very delicate colors, and thus may get preference. Remember that if a transparency's appeal rests largely with qualities native to that medium—such as luminosity, or silvery and fluorescent effects—the printed version will look quite nondescript.

There are times when publications adopt a rather arbitrary outlook toward image degradation. A major photo magazine used to project all transparencies submitted onto an off-white, bumpy-textured wall, while calmly telling the complaining photographers that the result approximated the loss of quality their work would suffer in reproduction. The truth was that funds to buy a screen had never been allocated; as the years went by, however, the staff became dependent on the wall for making decisions.

Certain kinds of images are more expensive to publish than editorial common sense allows. For example, to print a reasonable facsimile of a two-color image—such as a picture with a blue or brown tint—you must use the entire four-color process.

The expense of four-color reproduction has always helped predispose editors toward wanting "a lot of color," so rich, vibrant images often have the advantage.

At many publications, all color material must be approved by executives who know more about accounting than photography. When a magazine's black-and-white photography is of much higher quality than its color, the approval procedure for color may be the reason.

In any case, decisions on which color pictures to use can often rest on factors which seem extraneous. The art director must consider the effects of juxtaposing images not only on the basis of how the originals look next to each other, but how the final production process may make them affect each other.

Editors try to see that color photographs are reproduced as well as the bud-

get will allow. If a photographer feels the fidelity to the original has not been carefully guarded, the editors can argue that—except in the case of skin tones—the readers have no way of knowing the difference anyway.

One of a picture editor's nightmares involves having to explain reproduction problems to an angry photographer. I once dealt with one who had submitted an attractive black-and-white print toned to a silvery blue; the image was enthusiastically accepted by the staff until we discovered that printing it would require six plates. The photographer was asked if he would like to provide a straight black-and-white version. His response was framed in a way that ensured we would never ask him anything again, and the incident brought me to the conclusion that technical explanations were a waste of time. Most editors eventually learn to say plain "No thanks," which unfortunately does not help the photographer.

An important effect of color production's myriad of complications is the desire of almost any publication concerned with quality to see your original transparency, rather than a duplicate. You cannot show an editor a duplicate and tell him that the original has better color and he can have it once he makes a definite commitment. He must have the original first in order to decide. A buyer would prefer not to handle your originals if there were an alternative, but there rarely is.

Neither is a color print a substitute for the original transparency. The second generation image will not have the original's sharpness, detail or color fidelity. The further away your picture gets from the camera exposure, the more degraded must the quality become. The only color prints at all suitable for submission for any purpose are those of excellent quality, whether done by yourself or a lab (not the drugstore variety). They need not be the prohibitively expensive dye transfer prints some publishers used to require—Type C and even Cibachrome are routinely used for reproduction. But if your images are in transparency form it will be both cheaper and better to show them that way, if acceptable to the particular market. If you are to make a presentation which calls for drama, however, to perhaps an ad agency or business executive, strong, big prints may well be in order. Such people are not thinking about reproduction problems and need to be impressed.

If some of the foregoing discussion of production processes seems irrelevant, remember at least that publication staffs are completely obsessed with the physical problems, failures and triumphs involved in putting out their products. Your cooperation and understanding on this level helps identify you as an intelligent professional.

The problem of language

We have said the editor evaluates each picture for its information content, graphic possibilities, and potential for printing well. You may be wondering where photographic criteria come in. They do not exactly enter the scene last, because in thinking about what a picture says and how it looks the editor is inevitably judging photographic quality. But it is somewhat true that his thoughts are haziest on the photo-technical level. The picture editor probably has not had formal training in photography, as we noted earlier, but the problem goes beyond that. Talking clearly about photography is difficult, because we do not have sufficient language for the task.

Our English language is notably desolate of words to do with visual matters. We use the word "reading" for the process of absorbing even a wordless collection of pictures. "To look at" an image suggests a very superficial process. "Communicate" is a catch-all word which can mean anything to anybody. Despite recent efforts to impose an art-history vocabulary on photographic esthetics, we have not developed a language with which to think and talk about photography.

The picture editor deserves brief sympathy on this score, because he is facing photographers who demand articulate explanations of why their pictures do not succeed. The photographer may never have carefully considered anyone's work outside his own further than "I like it" or "I don't like it," but does not understand why his pictures don't "speak for themselves" (another verbally-oriented term).

To begin with, as picture viewers we might all agree that in a way some pictures do speak for themselves, with content so clear and strong, photographic treatment so integral to what is conveyed, that we respond without intellectual process. Provided it fits his magazine's criteria of appropriateness, the editor simply says "great shot" and goes ahead without analyzing the matter further.

Other pictures are "must use" because they are virtually irreplaceable: the single sneak shot of a closed-door meeting; a still frame from the 8-mm motion picture film of John F. Kennedy's assassination; the picture of his presumed assassin, Oswald, being shot; the formal Supreme Court portrait which was the only picture permitted. The importance of opportunity can never be underestimated in photography. Photographers in this technological age often find their spirits dampened by the work of machines or nonphotographers. What is often considered the most impressive picture of the century—the beautiful earth-rise image—was taken by an astronaut.

Irreplaceable pictures can be more mundane than these examples, a fact that photographers often overlook. A person once photographed the writer Jacqueline Susann during animated conversation with friends at a press party. In an attempt to sell the picture through an agency, he discovered that he had something more in demand than he could have anticipated. Miss Susann was considered a difficult subject, and few good natural-looking portraits of her were made. Sales of that picture have continued and no doubt increased after the subject's death.

To look at it from the other side of the desk, many publications have needs which seem commonplace but are near impossible to fulfill. A creative director for a group of restaurant-food-industry magazines says his firm often pays top price for merely competent images showing people eating, because nobody takes pictures of that type. Such simple-seeming record shots are "irreplaceables" for this publishing house. These few instances should give you further reason to save as many pictures as you have room for, rather than throwing them away.

Few pictures are absolutely great or irreplaceable. Both the editor and photographer, most of the time, face the problem of rating quantities of images from mediocre to good on a comparative basis. It is here that the hard thinking starts.

Qualities editors value

The elements that make a fine photograph can be enormously diverse. If information is the standard of value, as we have said it tends to be to editors, in the simplest case this might mean the sharpest, clearest picture of a mineral specimen for a geological story. A straightforward documentary photograph of this type precludes any interpretation on the photographer's part; although an attractive presentation is desirable, the basic question is whether the photographer has the necessary skills to photograph the subject.

But when we begin to talk in a journalistic context of recording the fact or meaning of an event, we are entering a different arena. A typical editorial statement to a photographer might be, "I want a picture that communicates the essence of what happened." "Essence" according to whose judgment? Necessarily the photographer's who was on the scene; photographers who are able to make good judgments consistently sell pictures and are asked to be on the scene next time.

To make this more concrete, suppose we are talking about a specific event—the aftermath of a hurricane. Twenty photographers are assigned by

various parties to cover the scene. Allowed to use their own initiative on the site, ten photographers might walk around recording devastated buildings and landscapes. Five might hire helicopters and take aerial shots of the whole catastrophe. Three photographers might spend most of their time in the Red Cross Shelter where the victims are gathered. One photographer shoots ten rolls telling the story of one family's experience—their ruined house, sad faces and borrowed clothing. One photographer produces an image of a kitten stranded up a flooded telephone pole.

Which photographers were right, and which took the best pictures? Assuming all the photographs were equally competent, twenty editors might make twenty different decisions according to their personal tastes, the space available, their needs for spot news or feature material, and so forth. A newspaper editor with space for only one picture would have to pick one that told the overall story best. A magazine editor who thought the event deserved five pages might like one picture of each type. (If he had assigned a top professional to the scene he would expect *all* of the images to be supplied by the one photographer.)

Actually, one of the reasons that progress in journalistic photography is so slow is that the editor has scant way of knowing when his decisions are good. A publication's policy on photography tends to be self-reinforcing. Most newspapers, for example, are consistently excellent, mediocre, or poor in their use of pictures. Readers rarely comment on their pictorial likes and dislikes (although more and more they do comment on whether the coverage is believable). Left to his own judgment, an editor may hire bad photographers, make bad selections, and enforce poor decisions on cropping and sizing for years on end. This has long been a major problem, but the times are changing. Publishers who better understand the effect that dramatic photography can have on readers, even though the readers themselves often are unaware of it, as well as new generations of aggressive, articulate photographers are having their effect.

Some photographs succeed so superbly in capturing the core of an event, or seeming to, that they become part of our permanent public consciousness. They shape the way we perceive or think about the world. Think of Kent State—you may envision a young woman screaming over a prone body. Think of the Vietnam war, your mind may see Eddie Adams' pictures of a bound Viet Cong suspect being executed by a general, or perhaps Kyoichi Sawada's "flee to safety," a family wading across a river. Think of war in general and you may envision Robert Capa's famous moment of death during the Spanish Civil War. Think of JFK's funeral, you may recall the picture of John-John's salute.

Whether or not you remember all these pictures, you may notice that all are classic news shots which achieve the highest aim of photojournalism—to transcend the significance of the passing event. Further, all these images focus on people. Well, you may say, that is the nature of their subjects. Not so, or at least not necessarily so: Very often people are the whole or part of excellent photographs because the photographer took the trouble to find them, or more accurately, took the time to think out and develop a human angle for his pictures. In many, many cases people are the most effective focus for a story or visual report. A competent editor with limited space would probably, in situations like the hurricane scene we outlined, give secondary attention to the general devastation pictures and aerials. Where good people pictures are available they usually get priority. People respond most directly to people, especially when shown close up. You will rarely see an appeal for charity illustrated with twenty needy children; it is one child, seen directly, which moves the heart. In our hurricane example, the story of one family's experience would for many of us be the strongest way to tell the story.

Pictures which elicit emotional response get top consideration from the editor because his ultimate goal is to involve readers in his publication's material. The editor is the middleman between the possible contributions of writers and photographers, and the publication audience. He is looking for photographs that will pull the audience into the material by delivering information with impact and emotional appeal. Often without being aware of it, the editor uses images as the emotional side of the communication effort. Instinct can guide him in selecting photographs because he responds to the same pictures as his readers will.

When you have pictures that make the editor and audience smile, laugh, feel happy, thoughtful, inspired or optimistic, you may have a sale—provided you are in the right place. Negative emotional responses can also be good: Does a picture elicit anger, sadness, horror?

The last category can be a risky business, though it is interesting how inured we are becoming to the appalling. The pictures we saw of Vietnam were far more explicit than those seen during World War II. Our media is continually concerned with how "strong" their visuals may be in tacit acknowledgment of photography's immense power: public reaction to the investigation of Vietnam atrocities, for example, would have been different if photographs had not existed and been published. "Good taste" is another hard line to draw. As of fairly recently, one major picture service subjected questionable pictures to the criterion, "Could you show it to a pregnant woman at the breakfast table?"

Pictures that portray a major event by showing its effect on particular people

have immeasurable editorial value. Pictures which deal with the most everyday matters through people are equally valuable. With or without people, pictures may have strong "involving" capacity when they show something beautiful; entertaining; exciting; humorous; surprising. Provided the editor's publication can accommodate such pictures he may well use them.

World news being what it is, newspapers are constantly in search of happy pictures of any kind to cheer their reader's day. Photographs of the kids' Halloween, pretty girls, or even the first bud of spring are used prominently to help us face the grim news reports. Animal pictures work well and are in high demand—more than one editor would cover the hurricane with the kitten stranded up the telephone pole.

In his need to attract and interest readers in his publication, the editor has another basic problem: repetition. Whether seeking material for *Vogue, Sports Illustrated, American Machinist* or *Solid Waste Disposal*, a great deal of the editor's time is spent seeking new ways to handle old subjects, or at least ways that *look* new. The photographer who can supply the new angle or look is valuable. Top magazines like the first two listed above go to truly incredible lengths to get the most dramatic, interesting and distinctive pictorial coverage of their respective subjects. So does *American Machinist*, though you have probably never seen it, and even trade magazines such as *Solid Waste Disposal* will use superb cover material when they can get it.

When a publication can afford to hire a photographer for a given job—which means it is spending dollars for total exclusivity—an editor will work with the photographer to develop a special angle, mood or approach. If we are talking about assignment-seeking or even stock sales, what will grab an editor is a demonstrated ability to present his same old subject, or a comparable one, in a new light.

How to do this is nothing less than a basic test of the photographer's skills, but seeing it from the editor's side can help. Few art directors or editors want to spend precious budget dollars on photographs that merely record events; they will use such pictures only when nothing else is obtainable or affordable. Good publications pay expensive photographers not to click shutters on command, but to be thinking, intelligent picture-makers capable of developing unique and personal viewpoints on the subject of the assignment.

Infinite variations in seeing and recording subjects are within every photographer's power if he has reasonable competence and develops the habit of thinking his pictures through. An important aspect of this is how you take advantage of your freedom to specify the subject.

Few subjects are so cut-and-dried as to eliminate numerous possibilities of

interpretation. The way you define a subject is personal and individual. Suppose you are asked to cover the visit of Miss Wax Bean to a local department store. As many avenues are open as there would be in photographing the effects of a hurricane. You might stand with other photographers and photograph the prettily posed scenes set up by the store's P.R. man. You might rather include the whole entourage, including photographers. You could take the time to follow the celebrity around and record her reaction to things and people. You could instead photograph other people's faces as they respond to her, in effect photographing the scene from her viewpoint. And your pictures can have a character entirely different from those of others according to your choice—conscious or not—of seeing Miss Wax Bean as a sophisticated model, as the girl next door, or as a helpless young woman beset by admirers. Picture by picture and as a series, your results will be best when you think the possibilities through.

When an untrained young photographer is hired for a newspaper staff he will invariably start with the lowliest assignments—award presentations, retirements, Miss Wax Beans. This is not only because he cannot be risked on major assignments, but because he must develop his abilities by taking good pictures of dull subjects.

Editors stress the importance of covering the most trivial subject in an imaginative way. Since small events consume most of a publication's page space, they can influence the publication's look and be crucial to its effectiveness. One of the newest handbooks for editors advises them to spend their photography budgets not on the major events of their industries, or the most dramatic, but on the most commonplace. Exciting subjects are easy for anyone—even an editor—to photograph, but a ribbon-cutting ceremony requires the best photographer the publication can afford.

I asked one of the all-time great picture editors who, of all the photographers he had known or worked with, had been the best. I knew they included the prize-winners and household names of three decades. His eyes misted as he intoned a name I had never heard before and haven't heard since. Why so great? He said, "No event was ever too small for him . . . you could send him to a garden party and he'd come back with the most interesting pictures you ever saw. He never missed. I wish there were a hundred like him."

Every subject has been "done" so the need for intelligence and imagination is universal. Even newspapers deal with a limited body of information, with the possible categories making an amazingly short list: war, crime, birth, marriage, death, and a few others.

Many a smart photographer has built a career by doing a terrific job on

assignments that other photographers considered beneath their notice. The apparently trivial may provide the best showcase. Photographers for company magazines, for example, like their newspaper colleagues, often resent the endless assignments to photograph handshakes, retirements, plaque presentations and so forth. But one photographer discovered that these were precisely the pictures that magnetized everyone else, including the company's top management. He took a great deal of care with these company portraits, and eventually he became head of his department. He had other qualifications as well, but his superiors cannot be faulted for prizing the professionalism he showed.

"Outside" photographers, those not on staff, should note the frequent opportunities to provide what even top professionals on a staff can overlook. The ability to produce interesting, individualized images of ordinary subjects is highly salable and one of the qualities a good portfolio may demonstrate. The key to making such pictures lies less with technical expertise than with the photographer's attitude toward his work; when every retirement ceremony looks the same to him, so will his pictures. When he closely observes the people involved and waits for the event to crystallize, he may catch the tear on his subject's cheek as he takes the gold watch. The paradox of great reportage is that the closer it gets to portraying the truly personal, the more it may transcend the instance altogether.

This discussion has been oriented toward journalistic photography for several reasons. Journalism is the basic tradition from which magazine as well as newspaper photography is derived, and it remains a dominant influence on photography. It is important for photographers to absorb the principles of modern photojournalism even when their interests are purely commercial or purely artistic. Otherwise the photographer will find himself either reinventing the wheel or producing pictures which look like yesterday's newsroom rejects. Consider how the work of most portrait-studio photographers—who consider themselves a separate breed with their own traditions—looks hopelessly out of date.

What are the principles of modern photojournalism? A few have already been discussed. The photographs should exhibit what in the trade is called involving capacity, plus conciseness, believability, immediacy and honesty. The photographer should have an "alert eye."

Involving capacity is a picture's ability to draw the reader into the event and into the publication.

Conciseness means a view of the event that sums up its meaning and impact. The story is told of the photographer who rushes into the newsroom shouting, "I got it! I shot ten rolls of the big fire down the street!" "What's the matter,"

drawls the editor, "didn't you have time to take just one picture?"

"If every photographer could think of his film as being very expensive," a well-known picture editor said, "his pictures would be better, because he would have to think before shooting."

Believability is "not posed," or not looking posed, a critical quality for today's reportage. The days of lining people up for the camera, of rigid posing, and of manipulation and contrivance by the photographer are over, or should be. Not only does no one believe in the set-up shot any more, but readers are becoming highly skeptical of even perfectly authentic happenings. Convincing spontaneity and naturalness are essential qualities.

Immediacy means the picture makes its point instantly and without confusion. Pictures, like headlines and text, are selected for ease of comprehension and absorption; we like the instant message and will rarely spend any time trying to figure anything out which is not apparent.

Honesty in reportage requires a scrupulous fairness on the photographer's part. Accuracy and responsibility are expected in coverage of all events, major or minor. There is a point where "finding an angle" becomes "slanting the news," and today's editor is as sensitive to this question as is his public.

The photographer's *alert eye* is a universally important asset. Sometimes it means seeing what else is going on other than the main event. For example, many stories are best told through the faces of other observers, or portrayed by a reaction after the fact—like the losing coach sitting alone in the stadium. In other stories, the detail can speak for the whole, in the way that the kitten up the pole tells the story of a hurricane. An open-eyed attitude on the scene can result in the best pictures. (The young photographer comes into the newsroom slumped and dejected. "What's wrong, didn't you get the picture of the mayor's speech?" asks the editor. "No, I didn't," says the neophyte sadly, "I didn't get anything. City Hall burned down.")

The editor and photographic technique

Besides his ability to interpret subjects, the photographer has at his disposal all of photography's technical components to make his images interesting and effective.

To the photographer, imaginative and skilled use of his tools means thinking about format, film speed, lens, viewpoint, angle, lighting, filtering, composition, printing, and special effects. But to the editor, a picture is technically successful when the picture itself succeeds. The photographer will be judged by the result, not by any brilliance in the use of technique. If you balance on a

telephone pole for seven hours to catch the president's entrance from above, you may think your picture interesting, but if all you recorded was a crowd of people's backs, the editor will not agree.

This is not to say that editors do not appreciate imaginative technical approaches. In their search to have old subjects seen in new ways they are prepared to be sensitive to fresh uses and intelligent deployment of equipment or technique. In many areas of photography, simply having enough technical skill to record a subject accurately can be a great triumph. In innumerable other situations, however, a subject without any visual interest of its own must be portrayed as exciting, or at least pleasing. Here may lie the biggest challenges to the creative application of skills and techniques.

In every case your range of photographic skills—coupled with your ability to think—constitutes your personal repertoire of possibilities. Technical advice on the order of which lens to select is not this book's subject: our premise, in fact, is that most serious photographers already have at their disposal more than enough techniques if they would only use them as appropriate. It is in considering what is meant by "appropriate" that we find photographers getting into trouble.

Photographers frequently misunderstand the distinction between dramatic photography and gimmickry, which may be defined as over-use of technique. Most editors are not looking for tricky effects, though they may use them if desperate enough. Tinting all your images blue does not give you photographic style; taking fisheye pictures of any old subject does not automatically enhance their interest; combining two bad slides into a sandwich produces a third bad slide; combining several images into an abstract pattern will probably interest no one but you.

Since photography itself is not the subject of any media except photography books and magazines, no buyer cares for pictures that display technical cleverness and nothing more. (Photography magazines are as uninterested in gimmicks as other magazines.) The editor's usually unexpressed test for whether the photographic form was appropriate to the content of your photograph is likely to be this: Is the technique so obtrusive that it is all I am aware of in looking at the picture?

This standard applies whether we are talking about a news photo or one created to symbolize something more abstract. It is the photograph's message which should come across, not the technique by which it was rendered.

Certainly this does not rule out use of photographic techniques to increase interest in a subject, or to create interest in something which would otherwise be boring. The editor loves such successes. Examining the relationship be-

tween subject and treatment in your work can be especially illuminating.

The editor's concern with content may seem to minimize the importance of technical adequacy. He may value a blurred image because it conveys the feeling of motion in the subject better than a series of images perfectly frozen; the grainy blowup of a frame portion may be chosen because the image it bears tells the story best; a defect may be considered an enhancing factor. This does not contradict the importance attributed to excellence for reproduction purposes; it merely reaffirms that technical perfection is never an end in itself.

The single-mindedness of photographers toward their objectives can interfere with their function as self-editors. As judge for a steel-industry photo competition, I admired a picture of a barge carrying ore down the river, practically covered by birds rising from the banks. It emerged incidentally that the picture had been discarded by the photographer while he was editing the project, but was retrieved by a co-worker. Asked why he had rejected the picture, the photographer said, "My assignment was to photograph the barge, but all those birds are blocking it so badly you can hardly see it." "But that's what makes the picture interesting," said his colleague, and the prize earned by the picture proved others agreed.

There are times when the hand covering a face speaks more clearly than a picture of the face would; when lens flare seems to crystallize a feeling of heat; when distortion of something we see all the time makes us rethink our feelings about it.

The photographer, like the editor, must view his photographs objectively and dispassionately and judge them according to the criteria outlined here. Generalizations have necessarily been made which do not account for many specifics of need and preference so an overall framework can be established. Thereafter the challenge of understanding and anticipating the buyer's needs becomes linked more directly not only to what is he looking for, but to what the photographer wants from him.

The relationship between photographer and editor has always provoked strong feelings and controversy; arguments begun decades ago about the rights of photographer and editor are still raging. The frustration that a photographer can feel with an editor's intervention has been most classically represented by pioneer photojournalist W. Eugene Smith, who ultimately left *Life* magazine because of his refusal to allow his vision to be compromised.

In 1974 a camera magazine gave Gene Smith twenty-six pages in which to do the layout, write the text and select his own images from the powerful Minamata essay on industrial pollution in Japan. The result? "Superb photography," everyone agreed, but could fewer pictures have been

used—better? Did the layouts look a little like *Life* in the forties, and did they interfere with the photography's message? Did the text get rather overwritten and emotional, putting the photographer's efforts in less than the best light? Should an editor have had more control?

Some thought the result perfect. Others thought that it demonstrated the importance of the editor's contribution to the photographer: the ability to maximize his effectiveness by an intelligent, controlled coordination of words, graphics, and the selection and arrangement of pictures.

Whether or not you like the picture editor you deal with, or agree with his selections and opinions, remembering one fact may help your presentation greatly. An editor or art director considers himself a creative person with a creative job. He is motivated at least partly by a real love for the work, because there are any number of easier and more profitable ways to earn a living. So even an editor who has no love for photography or photographers—rare—can be counted on to love the publication. He will like your photography if it can make a real contribution to that publication.

3

Learning to Analyze
Pictures and Markets

Practicing photo-appreciation

WE ALL know that our favorite photographers have said, "I can't talk about my
own work," or even, "Photography can't be discussed at all." Actually neither
statement is accurate. I have never met a good or successful photographer who
could not be impressively articulate about his own images and photography in
general—when he or she chose.

The taciturnity ascribed to photographers is their own doing, because they
prefer taking pictures to discussing them, especially with argumentative art
directors and business executives. This should be true for all photographers.
The basic premise for improving your photography and developing a personal
style is simply to take as many pictures as you can and review them intel-
ligently. But this does require thinking, and that is our subject here.

The reputation of photographers for near illiteracy is reinforced when a pic-
ture buyer faces the glum recalcitrance of a photographer who insists, "My
pictures speak for themselves." This attitude does the pictures a disservice and
deprives the photographer of what can be welcome opportunities to explain
his objectives, feelings and dedication to someone who might prove quite
receptive.

One photographer, aware that ad agency buyers were insecure in dealing
with him and other photographers, went so far as to publish a little newsletter
in which he and his friends in the industry wrote about subjects such as,
"What is a good print?" Distributed to his personal mailing list, the newsletter
became very much in demand and contributed to his reputation considerably.

People in the commercial film industry expect to educate potential clients
about motion picture capabilities, objectives and—especially—expensiveness.

As I once heard it put, "To make a good film you have to have a good client. And usually you have to *make* him a good client by teaching him what you're doing and why, which ultimately contributes to the whole film-making industry."

Still photographers—less team-oriented, to say the least—could use a little of the same spirit. The ability to talk about photography is important to success because it helps sell you and your work. Even more important, it gives you a means with which to think about your pictures. Members of a "visual age" or not, we think in words. If you can't verbalize about photographs you can't think about them, and you will not advance your abilities. Even the most natural of talents needs a way to refine its potential strengths. Photographers who seem to shoot by instinct have simply mastered their physical and esthetic tools to the point of absorbing the thought process into their seeing.

The art of photography

Verbalizing about photography is mostly a matter of practice. Photography is everywhere for the looking, and the basic idea is to do so consciously. Most good photographers are self-confessed picture addicts who haunt photo galleries, museum collections and bookstores. They seek out photography wherever it is exhibited. Even professional photographers read the "fan books"—*Popular Photography, Modern Photography,* and others—as a way to keep up to date on image trends as well as on equipment. You should do the same. Most exhibits are free, and books and magazines can be looked at in libraries.

The way to begin your conscious looking is to pursue your responses in detail. Don't simply let your mind say, "That's nice" or "I like that"; put it to work on pinning down the reasons. Does the individual image suggest certain thoughts, or a mood, a feeling? What is its real subject or total content? How does it relate or not relate to the rest of the pictures in the group? Would you have eliminated any photograph from a group? Are there too many pictures, or would you want to see more?

Look at the photographs again. Do some give a different impression now that you've seen them all? Which pictures stopped you the first time around, which the second? Analyze the pictures you particularly like and do not like from the photographer's viewpoint. Determine how he has used important elements: subject, light, perspective, spatial relationships, posing and expression, composition, print tones, choice of focus. Are these elements integrated and used with control to convey what seems to be the picture's message? What

is the picture's message? Do any elements detract from what the photograph is saying?

The question of the photographer's intent suggests itself, a subject that will arouse debate in any art medium. Should a photograph be evaluated according to the photographer's intent? There are two ways of looking at this question, according to whether you are taking the picture or evaluating it. The photographer who wants to edit his own work should be aware of both and be aware also of the distinction between the two functions.

In taking the picture, the photographer must be concerned with stimulating the reactions he desires from those who will see his work. Control of the image is paramount, and this requires that the photographer have the right equipment for the job, know its capacities totally, and consciously apply all the photographic options to making a photograph which carries the desired meaning. If the photograph is meant to be purely informational—to show what a flower looks like in as much detail as possible, for example—the equipment and its use, focus, composition and so forth must be consciously chosen to work toward this object. To produce an esthetic statement from the same subject—the beauty of pure color and line, for example—the photographer would make different choices within a wider latitude.

Obviously you have the greatest chance of success when you can formulate a clear idea of what you want your picture to say, or at least clarify your feeling for a subject enough to crystallize the feeling visually.

But to expect the viewer or editor to take account of your intent is foolish, since that would require you to be on hand to inform him of what you had in mind. Your best informational pictures will convey the desired information to everyone. When the message is a mood or emotion or idea, however, the viewer's interpretation may differ extremely from the photographer's. Every person who looks at a photograph, like every person who makes one, does so from his own context of personal history, experience, ideas, and momentary state of mind. Some of the photographs considered the greatest are those with considerable ambiguity. The viewer is justified in forming his own conclusion of what a photograph is about. He will also have an individual opinion on whether the photographer used his tools well.

Each picture must be evaluated on its own terms, since the viewer must decide what the picture is saying and then, in an unavoidably circular sort of way, judge whether the message was presented effectively. The more a viewer knows about photographic techniques, history and esthetics, the better prepared he is to understand and appreciate photographs intelligently.

An excellent way to illuminate how various the responses to even obvious-looking pictures can be, and at the same time develop your critical skills, is to

tour an exhibit with other people. I once had to write a review of a photographic show that I thought had provoked very little reaction from me. As an experiment I asked three persons to accompany me on a second trip through the exhibit and talk about it; they were two professional photographers and a picture editor. The results were enlightening to all of us.

We agreed on similar responses to several pictures, and several others left us equally blank, but our opinions on everything else were strongly divided. Our responses to the portraits were often determined by whether we liked the people portrayed or not. We had different concepts of what was beautiful, or funny, or melancholy. The two photographers were most enthusiastic about pictures that seemed to them in line with their own photographic purposes; the editors tended to think about uses suggested by images.

For each of us, a few pictures seemed to crystallize certain personal ideas or problems while provoking no response at all from the others. We did tend to expand our views a bit, developing a liking for pictures when someone else expressed his reaction well, and so learned something about photography and ourselves. I particularly noted that my response to the show had been a great deal more coherent and opinionated than I had thought.

Discussions at camera clubs are fine ways to talk about pictures, provided everyone understands that candor is essential. It is preferable that each person at such a discussion show his own work. Besides viewing members' work try fostering a debate on outside work, some material recently published or by a classic photographer like Edward Weston. Even unanimous agreement that certain pictures are "great" will turn out to be based on divergent reasoning.

If you are a determined loner about such matters, you might find that writing your ideas down, as if you were doing a review for publication, will help a great deal. (If you like the results, you might find that local and even national publications may be interested in running such reviews.)

If you get stuck while trying to write about the pictures, an old approach from art-appreciation classes may work. Force yourself to provide a one-word summary of what the image conveyed to you: "loneliness," "isolation," "tranquility," and so forth. Then pursue the how and why.

Exhibitions offer an opportunity to practice a corollary useful skill: judging photographers as an editor would. After looking carefully at all the photographic work shown, register your opinion of each photographer. What skills, special abilities and strengths has he demonstrated? What shortcomings? What subjects interest him? Does he seem to specialize or is he diversified? Do any, or many, of the pictures suggest a use to you? If you were an editor, what kind of assignments would you think him qualified for?

It is not necessarily the exhibitor's intention to present his qualifications as a

photographer, but it should have been. It is important as a photographer to re-member that all the photographs you present—anywhere, at any time—demonstrate your interests and abilities and, unless you take care, will prob-ably indicate your limitations. Good self-editing is crucial to directing the viewer to judge you as you would wish.

Thorough review of photographic exhibits, books, annuals and magazines cannot be too strongly urged upon the serious photographer. To appreciate fine photography is to look at the world through another's eyes. There are few more effective ways to reveal yourself to yourself and expand your personal vision.

Commercial photography

Most of the photography we've been talking about is "artistic," produced for its own sake or at least for personal expression. But such imagery constitutes only a fraction of the photographs being produced, and an even smaller fraction of those that have earned money for their makers. Commercial work is not only available for the reviewing, it pretty well assaults our senses these days. A deliberate consideration of the pictures which daily surround you in newspapers, magazines, posters, billboards and greeting cards can be very rewarding. The opportunities to cultivate your marketing as well as esthetic sensibilities are rampant.

Commercial photographs, which mean images made for non-personal purposes, deserve your scrutiny in two ways: as pictures to be judged and as products which have been used. In pursuing the latter viewpoint, you want to think back to the rationale behind the picture. Usually you can determine a picture's essential purpose—the message it was designed to carry—by thinking about the image itself and its context, the object of the magazine that contains it, for example. You should also be able to figure out many of the corollary purposes which determine that a particular picture is used rather than any other.

Suppose we're talking about a fashion photograph in a women's magazine. Whether the magazine in question is *Vogue* or *Ladies Home Journal,* it might seem clear that the essential purpose of the picture was to display a dress. But depending on which magazine the photograph was in, the corollary purposes would be altogether different. Factors involved include the publication's defi-nition of its audience and its image. Consider the model: her age, expression, pose, general look. Is she one of the beautiful people or the housewife next door? What feeling does the picture project: cheerful, moody, sexy,

extravagant, bizarre, everyday, exciting, competent? What kind of accessories adorn the model and background? What sort of makeup is she wearing? How clearly can you really see the supposedly central factor, the dress?

Was the image really intended to create interest generally? Is the picture part of a series with a sort of story line? Is there a grouping of two, three or more models? If the editor, photographer, art director and stylist were halfway competent, every element of that fashion picture was carefully selected and controlled for the result desired. Analyze a picture carefully enough and you should be able to imagine the editorial conference that preceded it. The photographer can often anticipate editorial objectives before such a conference and come prepared with suggestions for translating these ideas into photography. It is the continuing determination to think things through that makes a photographer valuable to an editor and assures repeat assignments.

In examining magazines, include the advertising photography. In a national publication, every full-page ad was assembled with cost no object; this is where photographers traditionally earn the highest fees. The other costs are correspondingly high—the ad agency charges, model fees, costs of copy and art direction, the preparation of fine reproduction negatives and the purchase of space in high-priced national magazines. So the ad was most carefully planned and executed, whether you liked the ad or not.

To consider the ad from inside, figure out exactly to whom it was directed: sex, age, income level, interests. Then think about why the message was formulated as you see it, taking into account the basic advertising premise of attracting attention and selling not a product, but a desire, a dream or an illusion. Cosmetics, for example, are not chemicals, but youth and beauty. Liquor is masculinity, sophistication, sex or prestige.

Ask yourself how the photography relates to the text and layout and helps to promote the message. Is the picture an attention-getter on its own or only within the context of the ad? Do the photographic techniques employed help or hinder the message? Is the ad probably successful in selling merchandise? Is the photograph successful for its purpose?

As often as not, with all the mental effort you can put into rationalizing the ad and the picture, your opinion may be unfavorable. A great deal of advertising photography is unimaginative, uninteresting, and barely competent. This may seem paradoxical because buyers are paying for the best, but the reasons relate to the central problems of photographers breaking into advertising.

Leaving aside the advertisers who insist on old-fashioned or cliché material, bad photography gets bought because so much money is at stake. The ad

agency people who hire photographers are notoriously insecure, and with good reason. Their jobs are constantly in the balance on even the most trivial of matters which the client may feel strongly about. If because of personality conflict, failure of a major campaign, a model's rudeness to the client—whatever the reason—the customer goes to a new agency, every person working on that account, from account executive to copywriter, may be fired. So making the client happy is their goal.

Consider the poor art director who is responsible for obtaining the photography on a major account—as approved, of course, by a whole chain of agency executives and client's representatives. Are you going to hire Avedon for the fashion shot, or that enthusiastic young what's-his-name who brought a portfolio in last week? Or suppose you used Photographer X on the last job and think he might have done better—but the client didn't complain. Try something new and take the risk? Or keep safely to the established path?

The more money involved, the more conservative people are likely to be about how it gets spent. The predisposition to use established, even famous, names rather than the newcomer in such situations is inevitable. Further, the man to please—the all-important client—is usually the person with the least appreciation, taste or interest in photography. And even further: the people at the agency know that excellence, whether achieved with or without the client's cooperation, is not especially meaningful. Excellent ads (artistically excellent) may not be financially successful. (There can be good reasons for offensive advertisements, as there are for the offensive but memorable soap commercials on television.) Finally, it is not unusual for an account to relocate even though the present agency is doing a fantastic job. In fact, change being the essence of the ad business, a client may actually move because things are going well.

All these pressures move advertising in the direction of mediocrity and make advertising probably the toughest career in photography to develop. Many new photographers quickly find out that one way into advertising is through editorial work, which is more accessible, gives you experience and prominent credit. So, back to looking at magazines.

How to analyze magazines

Kinds of magazines

To broaden your awareness of the number and variety of magazines which represent your potential markets, keep in mind the basic classifications.

Consumer magazines are those available to anyone, for sale on newsstands or by subscription. This class used to be dominated by the "general-interest" magazines, such as *Life, Look* and *The Saturday Evening Post*, with circulations in the millions and generalized coverage of the world. Their passing taught publishers, among other things, that more specialized publications might be better for modern times. (Some magazine people think that a publication can be good in inverse proportion to its circulation: The more readers you have, the lower you must assume their common intelligence level to be, and the more people you must be careful not to offend, the more general and superficial your material must be.) Most consumer magazines being published today are in some sense specialized. They cater to chosen audiences which may be characterized by sex, as in *Vogue* or *Playboy*; by age group, as in *Seventeen* and *American Girl*; by religion or political viewpoint as in *Church & State*; or, most commonly of all, by a special interest, as in *Sports Illustrated, Car and Driver, Modern Bride, Popular Electronics*, and many others. The audience may be extremely narrow and small or it may be absolutely enormous; there may be one publication for a tiny audience or hundreds, depending on what the field can support. Payments to contributors vary accordingly. In competitive fields, whether there are two or twenty-two publications, the audience is further segmented or defined. So critical is the need for a different audience image for every magazine that in some cases they must be artificially created. This is necessary not only because putting together a magazine with a coherent viewpoint is more productive and simpler, but to give the magazine a distinctive product and audience to market.

Most people are unaware that magazines are not supported by their purchasers, but by their advertisers. Often subscription prices do not cover the costs of selling the subscriptions, keeping the list and mailing the copies, let alone producing the magazine. But the circulation figures are sold to advertisers. The magazine ad salesman's basic pitch to advertisers is "cost per thousand"—what the magazine charges for guaranteed delivery of the message per thousand souls.

Trade magazines ("the business and professional press," in publisher's current jargon) serve audiences of specific businesses, professions, and trades. Like special-interest magazines, their frequency, size and wealth depend on the field they serve. There are scant publications for the small candy store owner, for example, but there are hundreds of magazines for doctors, who have high, guaranteed incomes and the money to afford luxuries.

Trade "books" (jargon) serve industry trends in interesting ways. One publishing house used to have a profitable magazine for the restaurateur, and a

smart editor there saw an opportunity for a new magazine in the emerging fast-food industry. Recently the restaurant magazine was discontinued altogther, but the offspring runs fatter and has more four-color pages than most consumer publications.

Another magazine publishing house had included two divisions: a group of magazines for the laundry and dry-cleaning industry and an initially smaller group in the communications field—photography and audio-visuals. The world dropped out from under the dry-cleaning group with permanent press fabrics, and the laundromat, dry cleaner and institutional launderer magazines gradually consolidated, as they say in the trade, into one small publication. On the other hand, the communications business took off in the late 1960s and new magazines were endlessly born from the old ones for increasingly specialized audiences. New magazines were created for television specialists, graphics specialists, communicators in bioscience, communicators in law enforcement and so on. The process becomes abortive if carried too far, as the publisher ends up with a lot of slim little books competing against each other instead of a few nice, fat, profitable ones. But some publishers find the urge to reproduce absolutely irresistible.

Advice for the smart photographer is: 1. Become familiar with the trade magazines in your field of interest. 2. Think about modern trends, so you can figure out where the money is going. Many trade magazines pay better than consumer magazines, and they are every bit as modern, interesting and expensively produced. The proliferation of reading material for professionals has tended to give the trade magazines a wider range of interest and coverage. They have steadily moved toward providing a broader interpretation of their subject, so that the reader ends up seeing the whole world through his professional eye. This approach appeals to many people, and it tends to provide broad opportunities for photographers. Trade magazines, incidentally, are supported by advertising and sold to advertisers just the same as consumer publications. Practically all, however, are circulated by subscription only to closed lists: that is, recipients must be qualified by showing proof (like a letterhead or official title) of being bona fide members of the trade or profession to which the publication is addressed. Several large, independent companies exist to check up on the circulation claims of members and furnish statements for distribution to potential advertisers and such. That is what the little symbols on the contents page mean: ABC is Audit Bureau of Circulation; BPA is Business Press of America.

But how can you find out about and get hold of these restricted magazines? Since many of them need freelance material just as much as consumer pub-

lications, they will send copies on request. To locate them, you use certain guidebooks, which we'll get to later.

Not to be forgotten in magazine classifications are regional magazines and Sunday supplements, which can offer excellent markets to freelancers. The former include state publications such as *Arizona Highways,* often state supported, and large city magazines such as *New York* and *Boston.*

Sponsored publications, or "house organs" as they used to be called, constitute another market of which many top professionals are very much aware. Unlike all the other types of magazine mentioned, these are not sustained by advertising but run by companies, institutions and government agencies as a service to employees and as public relations material for customers and stockholders. They range from mimeographed gossip sheets to slick feature magazines more lavishly reproduced than those that commercial publishers could afford. Very large companies, such as General Electric, might have twenty or more different company publications. Circulations of several hundred thousand are not uncommon, nor are the credit lines of well-known photographers in many of the best. In theory, the house magazine market has been expanding because industry has placed increasing emphasis on employee communications programs. However, in times of tight money, these luxuries—which most companies do consider them—are trimmed, reduced or suspended.

There are other types of publications, such as fiction magazines and "small magazines" (literary magazines), which we will not cover as they are not substantially interested in photography.

You have researched the newsstands, directories and source books to compile a list of magazines that might be markets for your work. What clues should you look for? You want to form a thorough opinion of the publication, its attitude toward photography, its subject orientations, editorial viewpoint, quality and accessibility to a newcomer. Further, you want to find the common meeting ground—to formulate ideas that would interest both you and the editor.

Take account of the following factors, in more or less degree depending on the type of publication. Note that I am suggesting you take some trouble to evaluate the magazine's overall quality and success in its field. This is because while certainly there are some publications so prestigious that contributors clamor for acceptance without pay, roughly speaking, a magazine's quality and rank in its field corresponds directly to its rate of payment and the publicity value it can give you. This is a relative matter, naturally, varying according to the wealth in each field. And obviously the best paying magazines will provide the most intense competition, so the number-one magazine in a field may not

be your best choice at first. Smaller magazines may be more open to innovation and special viewpoints than large ones.

There are nearly a dozen points of comparison that make a difference between magazines, and analyzing them will help determine if there are meeting points between each publication and your photography. The points, described subsequently, are: The cover, the size of each issue, proportions of advertising and editorial matter, the size and makeup of the staff, departments, advertising, articles, graphics, general tone and, at last, what kind of photography do they use?

The cover

Newsstand magazines and many others as well go to nearly incredible lengths in cover selection. In many cases, the cover is considered so important (newsstand sales can mean the difference between being in the red and black each issue) that it cannot be entrusted to mere editors, and marketing VPs and other corporate types make the decisions. (This is why cover selections are particularly conservative.) The cover must be a concise statement of the magazine's image. It has to attract attention—no easy matter in the newsstand jumble—hence the bright colors and simple shapes. The cover should encourage the buyer who's picked it up to leaf through; that's why the article titles are on it. The magazine must be readily identifiable at a distance to the fairly faithful buyer who needs reminding that the new issue is out. This is why there is an unchanging format, with a title type style (logo), and other elements of repeatability. The cover must be all this and more, plus be different every month. Magazines like *Time* and *Newsweek* regularly produce two or more potential covers every week to be voted on; if a bigger story breaks, they both go out. Photography magazines constantly search for appropriate pictures. The cover can tell you a lot about the magazine.

Size of issue

Considered in relation to its competitors, this is a good success indicator. (So is circulation, which is listed in various market guides.) Big, fat, rich books have more money to spend.

Proportions of advertising and editorial matter

This is called "advertising ratio" and is regulated by law. You can get exact

figures by collating pages and page fractions for each, but you really just want an idea of how much space is available to be filled by editorial material. New magazines must establish themselves with a low ad ratio—first satisfying the largest possible audience editorially so there will be a basis upon which to sell the ads. Magazines aim to provide the least possible editorial material that will satisfy legal requirements and the demands of its audience. But those who sell the most ads need corresponding large amounts of editorial material. For example: Although *Petersen's PhotoGraphic* seems to run more editorial because the issues carry fewer ads in proportion to editorial, *Popular Photography* with a lower editorial ratio actually uses far more articles, pictures and so forth. That means they buy more.

Staff

Be aware of who the editor is, who is in apparent charge of photography, where the art director and picture editor rank on the masthead, whether there are any photographers on staff and how large the staff is. For all but the tiniest of magazines, staff credits for editors, production and art signify inside people. Contributing editors and consultants are usually outsiders.

Departments

These are what magazines call the regular running material, usually in the front of the magazine, by staff members or regular contributors. These are the columns, editorials, product news and letters to the editor. Agency media buyers who decide which publications to advertise in always look at such material—especially the letters—for important keys to the quality of both the magazine and its readership.

Advertising

What kind of products? To whom addressed—age, education, income level, probable interests? What proportion of four-color pages?

Articles

By whom—staff members? People identified as freelancers? Famous names? Publications accessible to the non-famous writer with a good idea are often equivalently open to photographers. If articles are illustrated with photog-

raphy, you want to note whether the writer took his own or from what source they came. Are the articles well written, edited, and proofread? How can you categorize their type and subjects: news, feature, how-tos? Wide or narrow range of subject? Deep or superficial? Writers as well as photographers are often amazed at how little space is actually devoted to the ostensible subjects of many magazines and how open magazines are to many topics provided they are properly slanted to the special audience.

Graphics

Interesting? Modern? How would you evaluate the reproduction quality? How are the pictures used—large or miniscule? Few or many? Intelligently presented? Well chosen? These are crucial matters for the photographer.

General tone

Adding up all these elements gives you the publication's content, in a manner similar to assessing an individual image. You should have a feel for subjects, the audience, and the magazine's attitude toward them. This is the editorial viewpoint. Now you want to think in particular about your part of the magazine, at least potentially.

The photography

How much photography is there; what is the proportion of four-color to black-and-white? How many pictures are strictly informational without any photographic creativity? This means the routine how-to illustrations, new product pictures, publicity handouts of faces and events and record shots. Are pictures credited, and to whom—staff? agency? archive? photographer—someone you've heard of?

How integral to the magazine's subject and viewpoint does photography seem to be? There are scientific magazines that use few pictures of indifferent quality and others that find photographs critical to their treatment. This is also true for many special-interest magazines. Sometimes the publication's use of photography is solely by personal predilection of the editor and the art director. Where photography is appreciated and well used, more money is spent on more pictures and better photographers.

Can you tell which pictures were bought from stock and which done on

special assignment? Are there any purely photographic articles—photo essays or picture stories? How would you characterize the style of all the imagery that shows choice was involved (all except the routine informational pictures)? Is it technically competent, or even excellent? Is it interesting to you, innovative, clichéd, routine or dramatically different? Could you do better or not?

Many editors, when asked how a contributor of any sort can best prepare for working with them, beg, "Read one entire issue word for word." If the magazine proves of interest to you as a photographer, do it. Before you're through you will know the magazine's editorial viewpoint in detail. You should be able to describe the typical reader and know how it ranks against competitors (with quick reference to a market guide). You will be able to guess how much freelance material is bought from writers and photographers every issue and where it comes from.

Why go to all this trouble? To the despair of magazine editors, almost no one does. If the competitive edge to be gained by doing so is not sufficient reason, then honestly consider: How can you possibly develop appropriate salable ideas for an outlet without a thorough understanding of the outlet's needs and interests?

The idea applies equally outside print journalism. I have heard dozens of photographers ask, "How can I get a gallery exhibit?" Asked in turn what photo exhibits or galleries they have recently visited, nearly all have admitted, "None." How did they think they could evaluate the needs and interests of the showcases they have chosen?

In-depth analysis of magazines, newspapers, and other photography showcases can teach you a great deal about photography and how it is being used. You can gain easily a quite incredible advantage over your competition that is well worth the time involved. In fact, this kind of preparation will end up saving you far more time than you've invested, because you will automatically avoid going to the wrong places to sell work or solicit assignments. In selecting those outlets most appropriate to you personally, you will have already created major guideposts for tailoring your portfolio to the occasion. This is where the real challenge begins of applying your theoretical information about market orientations to your own capabilities, and it brings us in the next chapter to the subject of the portfolio itself.

The Portfolio:
How to Self-edit

WHILE I was screening work for a photographic annual one day, a young man arrived to present his work in person. He had called for an appointment a week earlier. After saying good morning he began unpacking his photographs, box after box after box.

Finding the first box jammed full of single-weight unmounted prints, I ventured feebly "Are they in any special order?"

"No," replied my guest, "I've simply brought everything I've done for the last year."

"Why?" I asked.

"So you can pick the best ones," he said.

"But you must have more than a thousand prints here . . . I couldn't possibly look at them all in a limited amount of time, with the attention I hope they deserve."

"Look," said the self-described professional in mounting irritation, "*I'm* the photographer. I can not edit my own work, and I certainly will not try. *You're* the editor, and that's what you're supposed to do." I offered to scan one box-full while he pulled together some favorites from the rest. He was furious at this approach, and my mood soon equalled his. We had both wasted our time—but my living did not depend on the interview, as his presumably did.

This experience is a somewhat extreme instance of similar happenings that crowd the schedules of picture editors. The photographer who begins his editing at the interview, or the one who proudly disdains any selectivity or order in his presentation, is as familiar to the potential buyer as those who insist you use their black-and-white shots for the cover even though the magazine has used only color for nineteen years. There are others: the man who left his best

work at home because your magazine will prefer the trash; the guy who tells you that you are unequipped to appreciate his sensitive and pioneer work; and on and on.

The professional approach

Such approaches are unproductive for the photographer, not just because they represent total contradictions of common sense in salesmanship, but because they fail to present the product. The man-with-a-dozen-boxes was not showing a portfolio. He was carrying around a grab-bag of pictures.

Even more: The professional editor and art director are alert to signs of professionalism in those who attempt to sell to them. They respond favorably—often unconsciously—to the photographer who is well prepared for the confrontation, who seems informed about the publication's apparent needs, and who presents a well-edited portfolio concentrating on those potential needs. The editor and art director will respond unfavorably to a sloppy presentation of random material by a photographer whose nervousness stems from total ignorance of the situation he's in.

These perfectly human responses would be important in any selling situation, but when the product is a creative one for which no absolute standards of value apply, they become crucial. If you show a buyer that selecting your best work is a matter beyond your capabilities, how can he have confidence in your photography? You are judged on what you show. A poor portfolio identifies you as a photographer who has no criteria of success and is thus more properly a snapshooter. If in spite of this failure, you get an editor to review hundreds of images and pick a few, you may make a stock sale. But don't hold your breath waiting for assignments.

The portfolio is critically important to a serious photographer. It is your essential sales tool and your best yardstick of personal growth, your best result and your tool of self-evaluation and development. The portfolio is your statement of your photographic skills, talents and interests. If you are reading this book, you should begin assembling a portfolio now if you haven't already done so.

Many of the most prestigious photographers are obsessive in their dedication to the constant upgrading of their portfolios. The busiest commercial pros know they must find time to incorporate personal, experimental work in their sales presentations. Even staff photographers who need not sell themselves daily find it necessary to maintain good personal portfolios to keep their photography alive and diverse.

Building a portfolio will focus every esthetic and technical value you possess and encourage you to learn more. Where can you start?

Review past work

Why not start with what you have? This is not so simple-minded a principle as might appear. It means a thorough review of all your work, going as far back as you choose, so you can assemble a representation that shows off your particular talents. You may decide that more of certain types of images would provide a wider demonstration of your capabilities. In that case you can always shoot more, but analyzing your old work will give you direction and build confidence in your judgment. The selectivity that makes you a good photographer will not fail you in the editing process if you give it a chance.

Despite most photographers' disclaimer about editing ability, I have found that it is a rare photographer who does not identify his real best. Time after time in reviewing portfolios I have complimented a photographer on one or two pictures and heard, "I'm glad you like that; it's always been my favorite."

Editing skill can be practiced and developed; some photographers will find it easier than others. Doing so will immensely benefit your photography. Before talking about the form of your portfolio—the number of photographs, sequencing and so forth—we'll discuss some ideas to help you become a good self-editor.

Equipment and lighting

First, on the most practical level: Do you need any special equipment or tools? Essentially speaking, no. The most experienced picture editors can make superb selections from 35-mm black-and-white negatives held up to a light. But few of us are that experienced, so a few basic aids can be helpful.

A magnifying glass can reveal detail and sharpness on transparencies, prints and even on negatives, if you wish to learn to evaluate negatives before making prints.

Transparencies can best be examined on a slide projector, especially if they are 35-mm; a good screen is desirable but many get by with a smooth white wall. You can manage without a projector, but you will probably want some sort of light box for viewing transparencies. Light boxes are expensive and occupy considerable space, but inexpensive desk-top models are available at camera shops. The camera magazines periodically tell you how to build your

own. Light boxes, or viewers that hold several images at one time, are invaluable for slide comparisons.

The question of proper lighting for viewing photographs is increasingly under discussion. That viewing conditions are never uniform from office to office can create problems. An image may look wonderful at home and terrible in the editor's office, but until everyone agrees on uniform systems there is little to be done about it. The "standard" viewing light for slides is considered to be 5,000K, and light boxes can be equipped for this. A slide will look different projected, however—usually toward the red side. Some photographers shoot slides for the viewing medium to be used, but this is going pretty far. Try always to examine images with the same lighting, at least.

A grease pencil, or erasable crayon pencil, is useful for marking or cropping contact sheets and prints.

Objective and subjective

The usual advice given for analyzing your own images is: "Be objective." In the sense that this means removing yourself from your work and evaluating it irrespective of the photographic effort and intent involved, the advice is sound. Once you have the image in hand, you should be unconcerned with the difficulty required to make it, or perhaps how casual the process seemed at the time. There are instances when you will hardly recall taking a successful photograph at all, but that doesn't mean you should throw it away. And if what you got in your print was not exactly what you were trying to get, that need not be of great concern either. Maybe your subconscious had a better idea than your rational mind.

So few photographers pay attention to this simple idea of self-removal that I suspect many others can take great advantage of its possibilities.

Imagine two photographers at a close level of talent and development. Each takes 1,000 pictures a month and picks 20 for his portfolio. One selects his best technical achievements or triumphs over circumstance—such as the shot he waited four hours in the snow for, or almost missed because his flash failed. He adds the travel shots of Venice, where he had a wonderful time, and one or two of his new girl friend who must be the most beautiful girl ever to anybody, and so forth.

The second photographer sorts through his output as if he had never seen any of it before, as if he were evaluating another photographer's work. He picks pictures that he considers interesting as viewing experiences, and that

demonstrate specific kinds of photographic capability. He does not indulge his emotional attachments to subjects or photographic processes.

Which portfolio will be better? The first is a profile of a person who takes pictures, the second is a profile of a photographer.

Practice objectivity. Measure your photographs against the same standards as anyone else's. But remember that there is no absolute standard for photography and no way to ensure total objectivity as a critic.

Do not ignore your emotional reactions to pictures but pursue them far enough to ascertain their validity. A favorite image should be considered carefully. Are your feelings a response to what is in the image or something that is not—a feeling or idea you must admit is extraneous to what you recorded?

If you are responding to content, your picture may be working on the all-important communication level. An idea, a mood, a frozen instant of action or expression—can you verbalize what your picture is really about, or the feeling it inspires? If so, then you can decide whether the form you rendered it in is successful and likely to be intelligible to others.

Analyzing favorite pictures closely is useful, because they can be used to measure the rest of your work against. The qualities they embody can help you define your personal criteria of photographic success and help you figure out why other pictures do not work as well. When you understand what is being communicated, these keynote images will help you concentrate on picture content rather than mere mechanics in examining the rest of your work. You do not want a portfolio of technically perfect and uniformly boring photo-exercises.

Suppose you're not yet sure whether your emotional bests are worthy of representing you, or you want to move beyond them. What should you look for? We have said there are no absolute objective standards lying around handy for application. The basic idea is both simpler and trickier than any list of "ten things that make a great picture," which every photographer is tempted to want. Every image sets its own standards for success or failure.

Content and interpretation

Your picture consists of what you photographed and how you photographed it: subject + treatment = content. Change either element and you have a new picture. In editing, you start with the result, content. Decide what the content is and you are able to evaluate how well your treatment handles it. Remember, you are functioning as an editor, not a photographer, with complete concentration on the result, the image.

Push yourself to verbalize what your picture is about. You need not think of some abstruse, ethereal purpose like truth, or beauty, to justify every shot as high art.

Photography's special gift is reality; a practical, down-to-earth approach will take you much further. The purpose of a photograph may simply be, "To show what such-and-such looked like at a particular moment." This would be a documentary type of photograph whose purpose was solely to deliver visual information. The purpose suggests criteria: Is the subject presented fully, clearly, in the appropriate degree of detail? Does every element of presentation contribute and support this message?

Most work is more subjective. Its purpose might be "To show what such-and-such looked like *to me* at a particular moment," or "How I felt" at the place and time. This is where the serious photographer, consciously or not, begins using his photographic tools interpretively. From choice of lens and selection of the zone of sharp focus to composition and printing, he is shaping and reinforcing this message. Often it is only when the process is substantially or completely finished that a photographer may be able to verbalize about the statement he wanted to make.

Part of photography's fascination is this potential for discovery. You can end up with a picture that explains your unconscious feelings about a situation or person. (Sensitive photography teachers know that assignments such as "Photograph your family" must be handled delicately, because they can prove traumatic for some students.)

The photographic process is often a search to define the subject. Some photographers can conceive a final result first—an image or an emotional response desired from viewers—and then work back to the subject and the treatment that will give them the result. That is how their minds work, but certainly it is not the only way to take good pictures. I have seen photographers fresh from a photography course or from reading an influential book on photography who have become incapable of taking any picture at all. So obsessed are they with the idea of creating only meaningful, major statements that no subject worthy enough seems to present itself. To "say something" need not be a self-conscious undertaking; your pictures are going to say something whether you like it or not. Seeing what they say is the trick.

Incidentally, there is no way of telling from someone else's pictures whether he started with the message or ended with it, let alone whether you're seeing the message he intended. With your work you should practice objectivity with an open mind: When you have some grasp of what your image was working toward you can better evaluate whether it got there, or how you can help it

arrive. But don't ignore your grab shots or seemingly superficial photographs without evaluation.

Portraiture

Look at content in an existing image—regardless of how it got there—to decide what criteria it suggests for the photograph. Is it a picture of a person? If the person is the sole interest of your shot, we may be talking about a portrait. A whole set of criteria is then implicit: Can the person be seen clearly in a way that embodies or reflects his nature (as far as you can tell) or individuality? Reality has a high value in a portrait: realistic skin tones and coloring, a pose that is natural-looking and relaxed if the portrait is formal, spontaneous-looking if candid. Expressions should correspond to the circumstance in either case, and not seem imposed (though they can also be revealing if they are assumed by the subject himself).

A portrait suggests certain compositional necessities: complete focus on the person, with non-distracting and probably minimal background. Even "environmental" portraits (those showing the subject in his customary environment) will take care to subordinate surroundings by careful use of lighting, color contrasts and selective focus. Control of perspective, lighting, and other technical factors contribute to the success of your portrait.

A portrait could embody something more, some universal human quality or emotion. To develop such a statement, you will use your photographic options to heighten or even exaggerate the idea. Distortion, drastic cropping of a face, extreme lighting, dark or light printing and other techniques become useful.

Or suppose the person you've photographed is not at all important in himself but part of a scene. Perhaps the human figure is there to give scale to a building or be part of a landscape, as in "man fishing at sunset." In such cases you may wish to suppress individual qualities, minimize expression, or even darken the figure into a mere silhouette. The criteria of composition are now different.

Between the landscape-with-figure and the portrait are a host of other possibilities and new criteria. You might decide to portray an experience, for example, a child staring with awe at a flower. This might suggest a new compositional balance of your two major elements, a tendency toward a rather high-key print, perhaps a softness of focus.

None of these criteria are absolutes. We're simply saying that you can make many types of images and statements with any subject, but that you should

maximize each picture's effectiveness by following the logic it suggests for itself.

This approach is especially useful when you're trying to figure out what's wrong with a picture, or why it doesn't seem to do much for you. Look at your result and decide what its strongest or most promising direction could be. Figure out what options are still available in cropping, printing and so forth to increase the impact of the idea. You might be inspired to reshoot the subject. And very likely your next shooting session will be better because of the thought process you're cultivating.

Sports

Other kinds of images suggest altogether different criteria. Sports photography, for example, attaches maximum value to catching the excitement of the action. The photographer will be aiming for the high points, the dramatic moments, for the human qualities which can be observed in competitive situations. The most memorable sports shots will probably have fine compositional and technical qualities, but as in all news work, being in precisely the right place at the right time with the camera ready is what counts most.

What this means for your editing effort and portfolio is that some particularized thought about the type of photographs you take can be very helpful. By studying your own work and that of specialists with similar interests, you should be able to develop a list of the assets most important to your kind of subject or orientation. This will eventually give you a checklist of the qualities and capabilities your portfolio should emphasize.

Every image may be deserving of evaluation on its own terms, but a framework is nonetheless needed. Building your reference framework with your own pictures (and perhaps some you most admire by other photographers) will help you cultivate your uniqueness as a photographer. The alternative—following rule books—will only foster slavish imitation of other people's work.

Although our purpose is not to teach technique, some observations on factors often overlooked in preparing portfolios may be useful. The following comments are based on an editor's experience in evaluating hundreds of portfolios. Taking account of these common mistakes can give you a head start.

Color as color

Probably two-thirds of the images shown to editors today (outside news-

paper offices) are in color. Unfortunately, three-quarters of them could have been shot in black-and-white. "Could have" means "should have" considering the expense to both photographer and publisher. That is to say, color was not essential to the visualization of the image nor to the appreciation of results.

Look at some of your transparencies and ask yourself whether they could have been black-and-whites without losing what is essential to their effectiveness. Did you shoot what could have been a black-and-white picture, but with color added? That's not a color picture. If you can't imagine the image in black-and-white at all, or a close variation of it, you may have a color image.

A true color picture does not necessarily mean "a lot of color" garishly used. Some of the best-used color I recall include an image composed of three shades of yellow, and one which was all gray with one small red light.

It is ironic with all the color photography done that only a handful of photographers is justly famous for seeing in color (Pete Turner, Ernst Haas and Jay Maisel). Photography's black-and white base has remained a dominant one, although it looks like this is starting to shift dramatically as younger photographers, many of whom have never worked in black-and-white at all, come into their own. But certain subjects continue to dictate the choice.

Gimmickry versus innovation

Misuse of technique is like misuse of color: Was an unusual approach intrinsic from the image's first visualization, or was it added on later to make a dull picture more interesting? If the latter, chances are good that's what it looks like. There are times when an editor has no choice but to use a gimmick if a boring picture must be used. Also, there are photographers such as Jerry Uelsmann whose special genius in the darkroom is what makes their work characteristic and interesting. But generally the effort put into jazzing-up dull pictures is wasted.

The sandwiching of two transparencies has been popular in recent years and I must admit, after screening the work of dozens of sandwich enthusiasts, that I found one superb practitioner of the art. Analyzing why his work succeeded showed how others were failing. He used the sandwich technique to produce altogether different ideas (surrealistic in his case) that were otherwise unachievable. He took enormous care with final composition and color clarity; many sandwich artists combine slides without regard to the muddiness and messiness produced. In fact, he photographed images with the combination technique in mind, rather than just sorting through ineffective work for gimmicks. Incidentally—but not accidentally—his straight images were just as interesting.

The principle for combination printing techniques is similar. Technical excellence is just as necessary as for straight printing. Use of the unusual technique leads the viewer to expect something philosophically interesting or suggestive in the image. Otherwise, he thinks, why did you bother?

Extreme techniques such as fisheye lenses court danger also. Rather than automatically making ordinary scenes more interesting, they are apt to place even higher demands on your skills. Editors, after all, see literally everything paraded into their offices, so fisheyes are not new to them, and their standards for fisheye pictures are going to be more stringent, not less so. Also, the distortion imposed by an unusual lens may not be deemed appropriate to the subject: Would you show a fisheye image of a building to its architect? Don't be surprised if he's not impressed.

These principles hold for multiple-image and extreme wide-angle lenses, special films such as infra-red, and tricky printing. The special effect must seem truly integral with the subject, and it must function for the image's total expressiveness. Technique itself expresses nothing, and an obtrusive technique usually makes a bad picture.

Focus

It may seem idiotic to ask photographers to check whether their pictures are in focus, but many a professional presentation proves otherwise. Actually, of course, not everything need be or should be in focus. Selective focus is one of the most useful but little-used options photographers have. It is an enormous control on how your viewer sees your picture, and should consciously be used to direct attention as you wish. But do check that something is in focus or the whole picture will look like a mistake. And sometimes certain parts demand sharp focus. With people, for example, the eyes must be in good focus if any semblance of sharpness is desired. The amount of sharp detail should be just sufficient to the subject: Too much is distracting, too little is frustrating.

Perspective

What makes a picture interesting often is related to the photographer's vantage point and the effect of his lens. Know how your lens sees a scene, and remember the critical difference that exploring different levels of vision can make to your result.

Photographers often overlook what perspective reveals about their attitude toward the subject. Compare most people's children pictures to those of well-

known, professional child photographers' and one factor is paramount—perspective. The child is seen from above, from the adult's level and attitude by the amateur and on his own level by the professional.

Composition

This unquestionably is the biggest failing not only for amateurs, but for professionals in a great deal of their work. There are those who claim that only through years of studying art history are the principles of good composition truly understood. Although some reading couldn't hurt, and careful attention to how all sorts of artists assemble their picture is bound to help, a more down-to-earth approach for photography is easily justified. Photography can be considered an art form without our imposing art-history principles on it. Photography is new enough that basic principles are still being formulated—and after the fact. That is, successful work is analyzed so that rules can be made.

No less a master than Edward Weston said, "Following rules of composition can only lead to a tedious repetition of pictorial clichés. Good composition is only the strongest way of seeing the subject. It cannot be taught because, like all creative effort, it is a matter of personal growth."

Composition is your style of seeing. Analyzing your pictures to see how you handled their composition can be extremely rewarding (as can similarly examining work by other photographers). Observe how the eye travels, for example, when looking at a picture. Is there a natural center of interest and is it the one you intended? The eye is directed by lines (which may converge or wander) and by lights and darks. The eye will go immediately to the lightest or brightest area of the image. This is relative: The center of interest could be a gray spot in a black picture, or a black spot on a white background. Reds and yellows are very strong, magnetic colors, and color photographers use them carefully. Naturally, the proximity of colors will produce effects of which you must be aware. A portrait photographer usually will not want a subject to wear green or blue. These colors tend to distract attention from the face and lend it undesirable tints.

Focus and lighting are important in telling the eye how to perceive an image. Many photographers forget to look where the shadows are falling, as well as where the highlights are. Look too at the lines of your image, which play a strong part not only in shaping perspective but in carrying emotional content. Horizontals imply peace, stability, and boredom if carried too far; diagonals suggest action and movement. The way in which vertical, horizontal and diag-

onal lines are combines is what makes your picture, possibly more than any other element.

You should not need art-history classes to train your eye to analyze how well you've used the space you gave yourself for each image. If as earlier suggested you have identified your content, you can decide whether a lot of the space is actually extraneous. Are there vast empty areas, particularly near the borders? Even if not exactly empty, if they are not functioning toward the concentrated presentation of your subject, they constitute wasted space. (Unless, of course, you are deliberately choosing to show something as a tiny part of a vast surrounding.)

If you're working with prints try drastic cropping—you may be surprised at the difference. Extra space produces visual boredom faster than any other quality. The most productive general approach to composition is, "The less the better." How much can you take away from the picture before you lose it? Frequently this approach can help you identify what your picture is saying. The idea is really a natural one since the whole essence of your photography is a selective, deductive process in the first place. To record all of the reality you see is not only a hopeless task but would be infinitely dull. Selectivity is what you are offering, and the more concise you can get your imagery, the better it will communicate.

On the other hand, as is frequently encountered: are there any missing edges to your subject? Any distracting elements which interfere with the appreciation of your true subject? An overall "busyness" that confuses the eye?

Composition—what you put in your picture and where you put it—is the single most important element of visual interest or boredom. When you've analyzed what may be the compositional shortcomings of a set of images, take the time to do some follow-up experimentation at your next shooting session.

A photographer whose work has been bought by museums and galleries and recently began publishing some fine monographs devised an interesting self-teaching technique along these lines. She was shooting black-and-white Polaroid prints as a casual hobbyist but found the results unsatisfying. But often she would like small parts of her pictures, so she began cutting up the relatively cheap prints and pinning them to a board for contemplation. She asked herself why these fragments worked compositionally, and why the pictures overall did not. Eventually she trained her eye to recognize the picture possibilities she wanted while shooting. The process took a few years in her case, starting really from scratch and ending with a body of work now earning considerable acclaim.

Editing groups and series

Often the object of your editing will be to select one image from a group of similar images, whether made at the same time or related by subject. Selection is important to your portfolio, so that you show the best only and avoid repetitiveness. Nothing dilutes the value of a good picture more than seeing a number like it. Unless you have a special reason for doing so or are assembling a one-subject portfolio, resist the temptation to include more than one or two images from one shooting no matter how excellent they are.

Line up the similar pictures and compare them. Eliminate all but the very best. Transparencies should be examined together on a light box; trying to compare pictures by memory is difficult. A projector can help with seeing detail.

If you have trouble eliminating anything you do, or you reach a point where further cutting down makes you uneasy but seems necessary, try this: Compare two images at random and pick the one you like better. This will automatically cut your selection in half; and of course you can repeat the process. A friend of mine assembles exhibits this way, picking the better of every picture pair regardless of subject until he has the number he wants.

Sometime try rating how well you like each of your images on a scale of 1 to 10. You can do it with other people's work too and learn something.

I was once asked to rate every picture in a photography annual as part of a job application, so my prospective employers could see how I "thought about pictures." They really wanted to see who I agreed with most. The effort was personally enlightening and applied to your own work gives you a new comparative scope.

You might group all the 1's and see if they share any attributes. Grouping and regrouping can be extremely valuable to your overall progress, not only to reveal correspondences and repetitive problems, but because context is bound to affect picture value. I have seen photographers emerge from a strenuous editing session with a better understanding of their photography and excited by some area of significance previously overlooked. This can be a general observation, such as identifying a common theme like humor or loneliness in a body of work. Or it can bring a selection of pictures into meaningful focus.

I recall one photographer who brought to a class a reel of slides he described simply as, "pictures I took during Christmas." We began cutting down the selection with a group discussion of likes and dislikes as we went along. When about ten images were left, we looked at them again and saw that a theme was emerging. The images we thought best showed a big-city Christmas, with

elaborate but tinselly street decorations and expensive glass-enclosed displays. The feeling engendered by them viewed together was sad rather than gay, a combination of impersonality, artificiality and fragility. A viewpoint had been buried in the abundance of images. Once the viewpoint became crystallized by editing—a process of concentration—the photographer became excited about the possibilities he could envision. A follow-up could be planned for next Christmas; he could shoot other holidays as typically celebrated in the big city; or he could photograph small town or country holidays for contrast. Such ideas in turn suggest possible editorial uses: perhaps a story on "Christmas in the city" for a local magazine or for a children's collection, or ultimately—why not?—a book on Christmas all around the country or the world. Or something altogether different might emerge if the photographer accumulated more work.

Think of editing as a distillation process which seeks to abstract the essence of your photography from the mass of raw material you've produced. Remember that the more photographs you shoot, the better your distillation is apt to be. Considering your portfolio in relation to all the photography you do will provide a natural focus for your self-editing while giving you a host of side-benefits. You can derive direction and inspiration from the process while refining your perceptions: What could be better for your photography?

One final suggestion: If a set of pictures presents editing problems with which no idea offered here seems to help, and you cannot come up with a decision-making basis, don't let yourself get stuck endlessly in the groove. Make an arbitrary decision. Many professionals find this necessary. They are prepared to make a selection and review it again another day and again next month, especially when they have observed a response from an editor or art director. Half the point of assembling a portfolio, after all, is the opportunity to get feedback from intelligent, informed viewers.

So never give up on the self-editing process. One of the best all-around photographers I have recently encountered was also the least successful. He had come to me for marketing advice with a book containing thousands of transparencies of any number of subjects. "They are excellent," I said honestly, "why don't you edit down severely along any lines you choose: subject, theme, style, etc., and we can work out some places for you to go." A week later he returned with a different selection of several thousand transparencies saying, "To me they are all good so I can't eliminate any." Well, even granted that every image he took was equally wonderful, he was defeating himself this way. Any decision is at least a starting point which gives you a chance to find out if it was a good decision. If this photographer had drastically

cut down his portfolio collection on even the most arbitrary, superficial basis, he would have been able to select a potential market, present an editor with a manageable number of examples, and go on from there.

There is no need to work in a vacuum. People will look willingly at your work and give you opinions. They will tell you whether your selections were right, by buying them or giving you an assignment.

The best photography in the world will never be published or seen if kept in a desk drawer or file cabinet. You must get it out, edit it for showing and present it. In the process you will learn how it might be better. Let your motto be: Make a decision today. You can always make a different one tomorrow, but only after you've made a beginning.

5

The Portfolio:
Assembly Techniques

BEGINNING photographers are invariably concerned with the portfolio's form and content, as if it were something apart from their photography. Actually, the portfolio is or should be the concentrated presentation of your abilities and accomplishments, so its nature will derive from your work. The people you want to impress will not care particularly about the form your images are in or the kind of container you use for them, but about their quality and usefulness. Thus, as with photography itself, there are no absolute rules for assembly of a portfolio, but working within reasonable professional standards can do a lot for your confidence. Just remember that the overriding object of your portfolio is to present you and your photography in the best light, with maximum effectiveness. Only you know which suggestions are appropriate to your work and aims and can apply them with the imagination that is part of the best presentations.

If this is your first venture into preparing a portfolio, you will want to start with the photographs already on hand, as we said earlier. This may determine what media you'll be working with.

Transparencies

For example, is all your work 35-mm color transparencies? Fine, at least for the moment, if that's what you want to shoot and you're selling to markets that accept the format. As we said earlier, maximizing impact for transparencies means showing the originals. (Many pros keep duplicates to avoid a total loss of irreplaceable photographs, or they shoot extras to avoid this anxiety about damage.) So you need only decide whether to place them in storage boxes, in plastic slide sheets, or in a projector tray.

People will usually view your work just as you present it. If you give them slides in the little boxes that came back from the processor, they'll stack the slides on the desk and hold them up to the light—any old light. Maybe they'll throw some on a light box, if one is handy. Practically never will they take the trouble to load them onto a projector. Meanwhile, you'll be nervously watching the editor thumb-print his way through the stack. None of this does your work much good, so don't show it this way.

If you present plastic sheets, a light box will be used to view the transparencies. (Incidentally, film manufacturers caution against long-range storage of slides in plastic, which can affect color stability.)

The last alternative, presenting your 35-mm transparencies in a slide tray ready to drop into a projector, is the one favored by common sense whenever feasible. Nothing rivals the impact of a slide projected in a dark room. How can you find out if your editor has a projector on hand? Ask. If he doesn't, carry one to the interview. Kodak Carousel projectors will be found in most offices that possess projectors, so use Carousel trays.

Keeping your transparencies in the tray is the best protection you can give them, and if you leave your "book" somewhere overnight, reviewers may remove those images in which they are specifically interested. Since this happens often, never overlook the necessity of identifying every item you circulate; many photographers label everything they produce. Preferably your name, phone number, address and some sort of image identification (so you'll know which picture someone is talking about over the phone) should all appear. The information may be written on the slide mount or you can use a tiny rubber stamp. If you use adhesive labels, take care; they tend to jam when projected. Prints can be labelled on the back, with your name rubber-stamped or written. Be careful not to indent the surface or use anything that will smear onto an adjacent print. (It is also wise to include a proper copyright notice, a matter covered in Chapter 18.)

If you are ever tempted to get careless about labelling your work, envision a 10-by-14-foot room (which really existed at a photography publication I worked for) with floor-to-ceiling file cabinets full of prints lining the walls, boxes of pictures stacked all around the floor, and three small cabinets full of transparencies—thousands of pictures permanently "on file" because the photographers couldn't be identified or located. Large boxes of pictures would arrive in the mail, and only later would it be realized that the only identification with them was on the wrapping that had been discarded. Photographs would be removed from a group for possible use, and end up nonusable and nonreturnable because there was no name on them, or simply "Tom Smith."

Standard cardboard mounts are fine for slides, but the mounts should be checked for frayed edges and the slides remounted as called for. Jamming the projector during a presentation is embarrassing and wastes your time. If you want to mount transparencies in glass, O.K., so long as you use the appropriate tray and check that they drop properly. But never mail glass-mounted transparencies, because no matter how well you cushion them they can smash, ruining your work and presenting a God-awful mess to the editor.

Transparencies larger then 35-mm will generally be examined on a light box, so keeping them in little boxes is fine. Individual plastic or cellophane sleeves, made for each format, are recommended, and these allow you to identify each picture with labels or grease pencil, outside the image area.

Some photographers present transparencies in black mats, 8 by 10 or larger, with cut-out spaces for the images. This is a custom technique requiring some effort but can be very effective. A group of transparencies can be interestingly arranged on one mat and conveniently viewed on a light box and individual images can be cropped as you wish. Appropriate mats may be found in frame shops—precut ones may be adaptable to your needs.

Prints

As mentioned earlier, color prints not expertly produced by you or a competent custom lab (the corner drugstore won't do) have no place in a sales portfolio.

The opposite is true for black-and-white. Except in special situations, nobody wants to see negatives or contact sheets. The presentation form for black-and-white is the print. The reasons are obvious. In black-and-white photography, the negative is a preliminary form. It can be used to produce an infinite number of variations in prints—even with straight printing. If the photography, rather than the event portrayed, is relevant, you must show the editor your final picture. Printing is integral to any image's content and impact; presenting a contact or negative would mean you've only finished part of the photographic decision-making process.

I am assuming that most readers are serious enough about their photographic craft to do at least some of their own black-and-white printing. If you don't, alternatives do exist, though they make things a little harder.

The custom labs can do a good job for you provided you become thoroughly familiar with their capabilities and learn to give them directions that can be followed. In order to speed the learning, you might ask to work with a printer for a while. Many top photojournalists work this way. Images can be cropped

according to your instructions, printed to a desired range of tone and contrast, dodged or burned in to give more or less detail in specific areas, spotted, even retouched or airbrushed to eliminate something. Of course, such services are very expensive.

A second alternative is to locate a photography student or young photographer who will be your personal lab man for cash or in exchange for darkroom privileges and supplies. Incidentally, you can learn about darkroom work and print your own without buying the equipment by joining a camera club or interest group that keeps supplies for members. Some large equipment retailers offer darkrooms for use at reasonable fees.

Print quality

So, whether you're printing your own or telling someone else how to do it, what kind of prints do you want? The principle is the same all along the line: You want prints that are suitable to your work and will maximize its impact. This means first of all that only truly excellent, first-rate prints belong in your portfolio.

There is no excuse for prints with uneven borders; sloppy, fuzzy gray prints; scratched prints; torn, bent or dog-eared prints; or prints that need spotting. Do not include in a portfolio any prints that tempt you to explain or apologize for them. "I didn't have time to make a good print yet," or, "Imagine how beautiful the picture would be if I printed it lighter here and darker there," are statements heard ceaselessly by picture editors that do not improve with repetition. The prints you show anyone should be your final intent (at least for the moment) and your best work. The technically good print that is custom-produced to serve its content and your intent and shown in fine condition speaks for your attention to craft and respect for the medium.

Reproduction quality

There may be a difference between the print produced for your artistic satisfaction and one excellent for reproduction. Some photographers resolve this problem by showing reproduction-type prints, but sometimes these will lose a great deal or even all of the desired effect. Other photographs will show the artistic version and mention that a "fuller" print (see Chapter 2) can be provided on request; they might even have one with them anticipating the question. The answer must be individually determined according to the picture

and the type of buyer to whom you're trying to appeal. The editor is not necessarily being arbitrary in talking about prints which are too dark, or light, or whatever, but is likely concerned with the printed result. At times there is no meeting point between an ideal print and a magazine's needs, much as everyone may regret it.

Size and format

What size should your images be? Again, the best approach will be the one intrinsic to your kind of photography. If you shoot Polaroid print film, you know what size you've got. If you're fascinated with small tight pictures, fine, just remember that you're providing the viewer a particular kind of experience, perhaps a concentration of experience, a sort of emotional removal, and that you are limiting reproduction to the same small size. Very large prints tend to draw viewers inside themselves, but the meaning can be lost. Some photographers choose sizes that the eye can take in completely at a normal desk-viewing distance (about 14 inches) and which are large enough to hold full detail. Unless you have a special reason or stylistic approach to consider, 8-by-10- to 11-by-14-inch prints are safe.

Should they all be the same size? Ideally, yes. Variety of size distracts the viewer from concentrating on the images and provides a less-than-professional impression. However, if you have one set of pictures deliberately printed in, say, 4-by-5 because they were envisioned that way and another set in 8-by-10, it's perfectly all right to show both in a portfolio but they should be grouped that way. Some fine portfolios get around variation in image size by mounting every picture in the same size cardboard mount, even transparencies. This gives the reviewer a picture stack that is easy to handle and a helpful impression of uniformity.

Borders and mounting

How about borders and mounting? That's according to preference, but have one or the other. Unmounted, borderless prints are not long for this world and when in less than excellent shape, are no good to you at all. If you protect prints with borders, make them clean and even and uniform. Single-weight paper is apt to present a flimsy appearance and curl up and crackle easily; your best work is worth more of an investment. Dry-mounting or matting your work, if carefully done, can enhance your presentation. Uniform size is

desirable and your mats or mounts should all be the same color, preferably a shade of white. Other colors are distracting and do a disservice to most photographs (although black mounts, as mentioned, work well for transparencies).

Printing paper should suit your photographic style; uniformity helps here too. You will want to avoid very dull surfaces, which render detail poorly, and probably those that are so glossy they reflect light into the viewer's eyes, making them difficult to look at. Special textures and screens are never desirable unless they are essential to the picture's effect or message, and then only if suited to a special buyer. Such gimmicks, like heart-shaped prints, belong only in wedding albums at best (or worst).

Packaging

What container should you put your precious prints in? I have seen superb presentations stacked in print-paper boxes. Many photographers prefer leather-type portfolios with plastic pages. They are fine provided you constantly check and change the plastic sheets; they scratch and fog easily. If the viewer is inspired to look closely at an image partly concealed by fogged plastic he will tug it out, so you haven't really protected the picture anyway.

I have watched people looking through portfolios, and it is interesting that they treat the pictures with the same care that apparently went into their making. Grubby, dog-eared prints are flipped through carelessly; fine prints with mounts or clean borders get finger-tipped reverently around the edges. Heavy-weight prints will last longer and do you more credit as a photographer, but wear and tear will show nonetheless. It's worth the time to review your showcase selections often and replace scruffy or damaged prints.

Caution: There is a point beyond which you're hurting yourself in trying to protect your work. Nothing maddens the busy editor or art director more than having to wait fifteen minutes for the photographer to unwrap his wares. If you want to store your prints and slides individually in envelopes or wrapped in tissue paper, fine, but don't unwrap and rewrap them in the editor's office. Even tissue overlays can be frustrating to the reviewer accustomed to forming an opinion by an apparently speedy, but quite thorough, flip-through. He won't mind the trouble if the work is really superb—just be sure that what you're showing is unusually wonderful before putting the reviewer to extra effort. Don't use tissue between pictures or folded over the front unless you're carrying exhibition-quality prints.

Combining formats

Now we've got you lugging around 35-mm slides in a Carousel tray, 2¼ or larger slides in boxes, and black-and white prints in boxes or portfolios. What happens when you want to show some of each? Show each one in the way it will look best. It's perfectly all right to show 35-mm transparencies on the projector and then a small stack of larger transparencies on a light box. And it's O.K. to show color and black-and-white in the same presentation. You may even choose to show your black-and-white photographs as slides on the same reel as the color.

This approach is useful when work must be left overnight or longer. It works best for photographers whose primary medium is color but want also to demonstrate capability with black-and-white. It is better for obtaining assignments than for making stock sales. A camera magazine will only reluctantly evaluate a black-and-white image in slide form; they must see the print.

If you decide to use black-and-white slides, group them, usually at the end, rather than scatter them among the color. Be sure the quality of the slide is excellent and the original black-and-white print first-rate. Photography manuals will tell you how to make good copies, or a lab can do the work, although not cheaply; ask the lab to use color film—it will give a fuller rendering of your print.

How much material?

If there is any single question which most plagues new self-salesmen about their portfolios it is, "How much material?" There is no rule, although certainly there are reasonable limits. The right amount is the number of pictures which shows off your abilities, strengths and range without repetition or excess. Appropriateness is part of the problem too: 100 pictures may not be enough if they're the wrong ones for the place you're trying to sell. (Either you brought the wrong selection or you shouldn't be there at all.)

Assignment hunting usually suggests a broader demonstration of abilities, and thus more pictures, than stock selling. In either case, though, you have too much material when you're showing weaknesses rather than only strengths. Viewers tend to judge portfolios by the portfolio's worst rather than best work. With too much material, your work can level out toward the low end in the reviewer's mind.

A concise portfolio can earn you extra credit with editors, who appreciate

how well you've evaluated their needs. A panel of highly experienced picture editors and critics who assembled a photography annual were asked to vote on the best portfolios submitted. When the results were tallied it was found that one top-scoring portfolio consisted of only two pictures, and another of only four pictures. Quality counted more than numbers, the panelists felt, and those who were most selective about presenting themselves were actually demonstrating superior qualifications as photographers.

There is a story that one of the best-known fashion photographers approached *Vogue*, the ultimate magazine in his field, with one transparency. The one image was so interesting and such a fine testimony to his talent and ability to meet their needs that he was hired on the spot. True or not, I have seen many instances where one or two well chosen pictures were gratefully received by editors for important use.

This is not to say showing a few is usually advisable—just that you need never feel impelled to show more than your current status as a photographer suggests. Reviewers won't criticize you for what you omitted, but for what you included.

The most effective portfolios I have screened generally comprised up to one Carousel tray of eighty slides and thirty prints or larger transparencies. Exercise your judgment on relative and total quantities not only in the interest of representing your capabilities, but in line with the psychology of picture viewing.

Slides are in many ways the easiest and most entertaining still photo form despite the initial inconvenience of setting up the projector and screen, and you can take advantage of this. Viewing of 2¼ or larger slides on a light box is more trying for your critic, so the quantity should be less.

The number of prints someone can look at with concentration is also limited. Showing no transparencies does not mean you can show 110 prints. If you have good work in both media, show both since variety and versatility are advantages. But don't show too much.

Consider also that, especially if you leave work overnight, reviewers will simply stop when they get bored. This can leave your best work unscreened forever if your presentation is too diffuse or longer than your proven talent warrants. Practically no photographer takes into account the fact that his work is not the only photography being screened. Ego is fine, but you can boost your photo-appeal and sales by taking human factors into account. Can you look through even your own pictures for more than a few hours at a time? The editor's eyes will glaze over just as fast when you show too much work in the middle of a day full of too many photographers who also showed too much.

Concentration is the key. Maximum attention will be given to the concise well-wrought presentation.

You can always carry some backup, such as another box of prints or a second Carousel reel, in case the editor is terrifically enthusiastic or expresses interest in a particular type of series. Bring the extra eighty pictures if you absolutely cannot leave them at home—but always ask the editor whether he wants to see the second set, and don't be disgruntled if he doesn't.

Credits

Should you include publication credits in your portfolio? They can do you some good, but they should be regarded as backup to the original photography. Since many photo buyers are somewhat insecure about judging images, examples of work used by similar buyers or published in somewhat impressive places can be useful. "Impressive" does not necesarily mean *National Geographic*; photography magazines, for example, are evidence that you are respected by your peers, and tear sheets of work published in them can be used to good advantage. (Not all are difficult to get published in—advice on this is offered later.) If you are seeking photojournalistic assignments, tear sheets from local newspapers, even modest ones, can be very helpful testimony to your ability to work on assignment, covering people and "live" action as called for.

Naturally, it is preferable to include published examples of your good work, well reproduced and handled. When a published picture looks bad, however, you might show also an original print with the published picture. If you're using a portfolio with plastic leaves this is easy, although generally you will want to group tear sheets in the back, following your original prints, so it won't matter if the art director stops midway. If your presentation is the print-box kind, neatly trimmed tear sheets can be laminated or mounted; these should also be placed for showing last.

If you have no published work to your credit yet, do not be concerned. Some of the best portfolios seen are composed entirely of test shots, and many of the most successful professionals show only unused work on principle.

Appropriate range

The body of work you have done so far will determine the variety you can include in your portfolio. Variety is relative: If all your pictures were of women, it would be to your advantage to demonstrate your capability with as

many situations and moods as your pictures justify. A more "all-around" photographer might have several categories, such as travel, people and fashion, and would want to show broad capability within each area, in condensed form.

There is nothing wrong with a highly focused portfolio that concentrates on a single theme, subject, person, or particular stylistic quality. You would need such a portfolio if your object were to publish a book, have a gallery showing or sell a very specific idea. But the basic portfolio will be appropriate to a fairly wide range of markets to which you can potentially sell your skills.

A photographer may have a basic portfolio to earn the bread-and-butter sales and assignments and one or more specialized ones for carefully-thought-out purposes. The broader the portfolio's range, the more kinds of uses it will be suitable for; as you narrow its scope, you narrow its markets. This means you can gear a portfolio to the special interests of a particular publication in order to improve your chances for a sale.

You can orient your portfolio wherever you wish along the scale of narrow focus to broad coverage, provided you make it correspond with your objectives. But keep away from extremes. Showing fifty pictures of one kitten must become boring and is only appropriate if the only thing you want published is a few pictures of the kitten. On the other hand, trying to present yourself as a jack-of-all trades in photography will not do you much good.

Defining your market may dictate or suggest the scope your portfolio should possess. What this means will become more clear as we go along.

Sequence

How should you sequence your pictures? The best presentations will have an order that enhances individual images. Categories that are altogether distinct from each other, such as fashion and landscapes, should be grouped to avoid a confusing experience. Other than such instances, you may choose to pace and contrast your images according to how they seem to work best. Especially with a slide presentation, some time spent on experimenting with an effective picture order can be most worthwhile. Context and juxtaposition can enormously affect how a picture is perceived as well as the overall impression fostered by the presentation as a whole.

Slides should be shuffled around on a light box of some sort so you can evaluate relationships and try out combinations directly. Check for accords or jarring notes in mood and color and make substitutions. Let your instinct function and keep going until you're satisfied, even if the differences seem

minor. Then examine the effect when projected—you're working now with a motion factor as well. I have seen some slide portfolios so effectively sequenced that everyone's reaction at a showing was "great photographs!" It was only when trying to take out a few images for use that editors found that, apart from their context, the pictures did not hold up very well individually. Photographers such as these often have a predisposition for movie-making.

You might have some fun experimenting with a record or soundtrack while sequencing. Slides-plus-music can be among the most emotionally appealing presentation methods of any media and provides a wonderful way to give slide shows at home without boring people. You shouldn't bring the soundtrack to professional interviews, but trying music out with your color or black-and-white slides can help increase your sensitivity to the relationship and flow of images.

To intensify the effect of a slide reel, begin with a few of your strongest pictures and end with a very strong sequence. The end may often be a good place for your personal all-time favorites which illustrate your photographic ability regardless of subject.

Incidentally, do not allow your slide show to end with a flash of light which blinds your viewers. Make a dark slide with exposed film, or better yet photograph your business card or your name for the finale signal.

Sequencing prints is another matter. If you're presenting a stack of prints they will be looked at in the order you've given them, so check for general grouping and sequence. More attention must be given if you're using a portfolio with plastic leaves and arranging pictures on facing pages. Juxtaposed images affect not only the way viewers perceive tone and composition, but the idea each image conveys. This is of concern to the editor and art director whenever images are close to each other.

Graphics

To heighten your awareness of the problem look carefully through a photography book or exhibit. Sheer graphics determine many decisions. For instance, note how hard it is for two horizontal images to face each other in a standard book format. A lot of empty white space is left when a 35-mm-format horizontal picture is displayed on its own page, which in both magazines or your portfolio is nearly always vertical. Trivial concerns such as this affect picture selection enough to horrify most photographers.

In photographic collections such as books and annuals, every two-page unit or "spread," as it's called, is most carefully composed so that the images

enhance each other without imposing their content on each other. The most popular format these days is 35-mm, and photographers who use it tend to take more horizontals than verticals. But verticals look better in print. They can be printed larger without leaving excess white space, and they go well with other verticals or with horizontals. What inevitably happens is that horizontals are judged more stringently than verticals—simple supply and demand. Check a photo annual sometime and see if the overall quality of the horizontals is higher than the verticals.

Clichés

Awareness of such problems will not only give you a new sensitivity toward sequencing your images, but some tips on what to include in the portfolio. Obviously, it isn't desirable to exclude horizontals, but a strong representation of verticals won't hurt a magazine presentation and could give you an advantage. A similar principle of supply and demand applies to picture content as well as shape. Certain categories automatically assure you of the most intense competition. Take sunsets, for example. They are beautiful and everyone who uses a camera records some, so editors get to see phenomenal numbers of sunsets, in every shade, every locale. Sunsets in a portfolio will do you more harm than good unless they are truly unusual. Postcard-pretty sunsets are trite to the editor's surfeited eye, and they mark you as a photographer who hasn't been around very long. But there may be a special demand in special quarters, such as greeting card manufacturers. Or possibly your sunset is so spectacular it proves that a fine photographer can triumph even over a cliché. All the guidelines given must be interpreted creatively in light of what you have and where you're going with it.

Travel pictures are like sunsets in that everyone takes them, and the excitement of the experience prevents most photographers from seeing that they are not automatically interesting. Learn to edit your travel pictures and you're well on the way to making your vision objective. Cast an especially cold, critical eye on pictures of popular subjects and those deriving from emotional experiences.

Stoppers

Some images have particular portfolio value and merit inclusion when you have them. The "stopper," in editor's jargon, is any picture so strong that it instantly attracts attention and keeps the eye focused upon it longer than

usual. The effect varies with each viewer, but you'll know when you have one and others will tell you as well. A stopper can be dramatic because of its subject, its unusual photographic treatment, an intense communicative feeling, or some other factor. Such a picture belongs in even a highly tailored portfolio because, as experienced self-salesmen know, the main point is to be remembered. A fashion specialist I know attributes some excellent assignments to a few spectacular travel shots in his portfolio; they stick in the viewer's mind and lift him out of the "merely excellent" class of photographers they constantly review.

For this reason do not overlook pictures that have evoked great enthusiasm from others, whether friends or buyers, provided you can determine that it is the picture and not the subject which is communicating. (Relatives are not to be relied on when your picture is of a grandchild or nephew; but if they love your shot of a child they don't know, you may have something.) See if you can state the reason the picture gets response, or ask your friends if they can. Self-consciously artistic photographers may sneer at taking the opinions of Instamatic-shooters seriously, but what works is what matters.

Expertise

Be sure to consider for your portfolio the best images deriving from a special skill. A subject to which you can bring professional knowledge or a hobbyist's enthusiasm may offer outstanding opportunities. We tend to take our knowledge for granted but you may have a particular combination of interest and understanding that is unique. One who sails his own boat takes different pictures of boats than someone who doesn't, consciously or not. If you go to the track every week you have the opportunity and knowledge to get great racing pictures. You should be taking pictures of what you know and of things you want to learn about, and you should not be relegating the results to your file cabinet.

Personal work

Your personal photographic series and experiments may showcase your abilities as no other work can. Photographers accumulate images of a favorite subject or locale over a period of years. You may have explored in depth a theme or technical approach. In either case your best results may be worth representing in your portfolio. They should be included as a show-within-a-show, and not scattered around the rest. Many photographers like to put such work

at the end of their presentations. Even top-name professionals who are in demand rely on personal work to show they are still enthusiastic enough to experiment with their medium and innovative enough not to rest on their laurels.

Extreme images

They know, too, that to get many assignments it's necessary to show work ten times as creative as anything the client will actually want. Why? Supply and demand. In advertising there are more art directors, copywriters and photographers competing for work than there is work to go around. Therefore, standards become unreasonably high, and a spectacular portfolio becomes crucial.

A top portfolio in art or copywriting takes years to develop, and a successful one may be passed from hand to hand. A portfolio can get twenty people jobs without as much risk as one might encounter in another industry, since those doing the hiring turn over as fast as their underlings. I have never heard of a photographic portfolio being used by anyone other than its creator, however, which speaks not so much for the integrity of photographers as for their competitiveness and the nature of the freelance jungle.

This means that some extreme examples of your work are probably in order. Certainly they should not be ignored in deference to conservative buyers. They may want you to work conservatively for them, but are unlikely to give you that chance unless impressed by the experimental, interpretive abilities you portray.

Editorial material

Any image that suggests an editorial use should be considered. Some pictures seem to suggest an idea, or even a copy line, in the most graphic terms. They tend to be memorable even if they don't provoke a fast sale. For example, I recall seeing a beautifully detailed black-and-white closeup of a strong hand carefully grasping a small plant with the roots exposed. Such a picture is a copywriter's dream: "Young things need nurturing—give to the college of your choice." "Universe-wide Movers helps transplant lives, not things." "Build the future with an account at Fourth National Savings." A picture of this type can be used symbolically for any number of purposes.

Incidentally, a good self-teaching technique is to specify a concept or emotion and then work backward to a picture. Take the idea of birth, for example,

and see what you can develop graphically, or an emotion such as fear. A good result may merit presentation space and in any case will teach you to think like an editor.

It can be important to show concept photography if you're competing for editorial illustration assignments. Interesting ways of visually presenting facts, ideas or events can include a variety of photographic approaches and printing techniques. Remember, if you're after such work, that fulfilling the assignments can require considerable technical expertise and quite possibly a sophisticated studio facility. You may have to execute other people's concepts, or your own, with great fidelity, as advertising photographers often must. This is a different kind of publication work from journalistic assignments to cover real people or uncontrollable events.

In sum, your portfolio should be worked upon with the large purpose as perspective. It should present concisely an honest picture of you as a photographer, but in the best light: your range, your capability in handling subjects and conveying ideas and emotions, your special areas of knowledge and interest. It should display a totally professional attention to photographic craftsmanship and the techniques of presentation. The portfolio should show that you are a skilled self-editor who has established high standards for himself. Ideally, it will provide elements of memorability which will fix your skills and name in the reviewer's mind or card file. Even further, it should demonstrate that you've taken the trouble to analyze and understand the needs of the viewing editor, and to tailor the presentation to those needs.

For more perspectives on assembling portfolios, including advice on specific techniques, try *Portfolio Preparation: A Guide for Students and Professionals* by Ed Marquand (Art Direction Books, New York), addressed to visual artists of all varieties.

The Portfolio:
The Hows and Whys
of Tailoring

UNLESS the marketing possibilities you envision are unusually narrow, few people will see your basic portfolio. The general representation of your work is a central core of images to be adjusted to immediate purposes as they arise. Changing a relatively minor number of photographs can considerably affect your presentation's balance and the impression it produces. You should expect to review your book for substitutions, deletions and additions before every presentation, or at least every important one.

Never regard your portfolio as a finished work of art. It should rather be a fluid embodiment of your talents, always under review for improvement and appropriateness. The portfolio reflects your constant evolution as a photographer and your sensitivity to market needs.

First, evaluate your portfolio from the perspective of your market as a whole. Adapting it to a particular part of the market, like a magazine, is then a simple matter.

Marketing objectives will be obvious to some photographers, while others must develop their directions through trial and error. You should by now have some idea of your abilities and how they might be best applied, so that you can go ahead on one or more bases and see if it works out.

Analysis

How can you orient yourself and your portfolio to a chosen market? It's a thinking process. You want to learn about the market; to do so, you use the classic learning techniques: Talk to anyone who is knowledgeable about the field. Collect and study as many examples as possible of work that has been

used. Read periodicals and books about the field. Generalize about the information you accumulate—the range of the market, the opportunities, the photographic qualities it seems to value.

This process will leave you not only with specific information but with the most concrete sales leads you are apt to get. You should keep a file of the publications you amass, along with your notes on each magazine and its photographic orientation, as outlined in Chapter 3. For if you haven't yet learned the trick of writing things down, learn it now.

Writing is an invaluable aid to crystallizing your ideas and responses and forming generalizations. Here's another way it can do you enormous service: based on your analysis of the market, write a script for your portfolio. The script will be the working plan for your presentation; it will help solidify your ideas about what you want to show and why.

Let's suppose we're talking about an aspiring fashion photographer with few or no professional credits to date. Here is how he might analyze his market presentation; the method is adapted from that used by media specialists in planning new productions:

Main objective: To win assignments in fashion and beauty industry.

Secondary objectives: To get travel assignments, sell stock images, and gain useful publication credits.

Primary audience: Editors of women's fashion and beauty magazines, teen magazines, bridal magazines. Ad agency art directors and account executives for large cosmetic and beauty accounts.

Secondary audience: Editors of photography and travel magazines; the travel industry.

Audience analysis: This is a highly sophisticated group of image viewers accustomed to the best photography and interested in using it competitively. Beyond total technical competence they are looking for something distinctive—a special style, imagination, originality, a flair for presenting their subject.

Central message: This photographer has a cohesive, unusual style with strong compositional qualities and intense but realistic color. He is able to convey emotion and feeling, eliciting from models a warm response that will communicate to the viewer and suit today's individualistic but natural fashion look. He can originate and execute essays.

Corollary messages: He has an eye for unusual backgrounds and settings and is versatile.

Images to prove these points:

Group 1: a variety of female models depicted in various moods, gay to pen-

sive; dressed formally and informally; photographed variously full figure, waist up, and in closeups of face; outdoors and in studio. Pictures with more than one model demonstrating ability to coordinate interaction and compositional interest. Images incorporating a feeling of motion. Images showing an interesting use of unusual backgrounds and settings. At least one image series demonstrating ability to conceive and carry a photographic narrative.

Group 2: A smaller selection of travel images, some unusual in choice of subject matter, others of cliche subjects dramatically handled. Group to include landscapes, urban scenes, and candid shots of people.

Group 3: Current personal experimental work including nudes.

Medium: A Carousel reel of eighty slides, all color. Sequence is Groups 1, 2, 3.

Visualized in this way, it becomes evident how simple it can be to tailor the portfolio as needs arise.

If going to *Vogue*, our photographer might show his fifty-five best fashion-beauty images, fifteen travel pictures (viewers respond strongly to them and they support his claim to a special talent for background) and ten fine examples of personal work, showing him at his most creative.

The balance for a *Seventeen* editor might be similar but he would adjust the fashion pictures in favor of younger models and a fresher, far less sophisticated look. For a cosmetic account, he could shift the balance toward portrait-type closeups.

For *Modern Photography*, he would drastically cut back on the formal, posed, commercial-looking fashion shots and add many more from his experimental collection.

For a travel magazine he would show mostly his Group 2 images.

He might well make more subtle distinctions between the fashion magazine and the qualities valued by each. An examination of recent issues might tell him one was favoring a sensual look, another a spontaneous look, and another one a narrative approach. He would have to remember, however, that even the current issue was probably photographed six months ago and a new look may be wanted. This is one of the reasons a slavish imitation of work already published in a magazine will usually get ignored—it's already been done, who needs it? The photographer must discern the fine line between selecting work suitable to a magazine's overall viewpoint and giving them last month's idea.

In the sample portfolio script, many decisions were made for the photographer, but many more remain. For example, one could choose with equal validity to show a range of moods and expressions, or restrict the presentation

to one mood. The latter can give particular impact and memorability, but the wise photographer checks out his destination even more carefully when using it.

One young photographer assembled a handsome portfolio carefully pervaded with an elegiac, slightly haunted feeling. He showed it to a teen magazine editor, who sat through the presentation fascinated. Finally the editor said, "That's really wonderful; certainly you are a fine photographer. Unfortunately, we've spent a great deal of time and energy building our magazine's image of the cheerful, bouncy, radiant teenager, and your work is exactly the opposite."

"Well," thought the photographer with the resilience essential to success in his field, "what she means is that if I produce a new selection in the right mood I'll get serious consideration. But no," he decided upon further reflection, "I've spent a lot of my own time and energy cultivating this moody feeling and it would be silly to work in a contrary direction just for one opportunity. I'll do better taking my work elsewhere." Reevaluations like this will often be forced on you when you're out there with your portfolio and will benefit your work.

In the sample script we developed, a number of questions were decided on the basis of the photographer's personal objectives. Fashion work definitely suggests color, but many fashion pros would show black-and-white prints or slides as well; our theoretical photographer showed only color because he only wanted to shoot color.

The photographer could have covered subjects such as men or couples, but the travel photography sideline happens to work well with the fashion work. You should be somewhat judicious about your basic combinations. Fashion images and bird photography are not so naturally juxtaposed, unless you want to suggest a really exotic fashion essay.

A portfolio like our example, geared to a highly sophisticated market, is not assembled overnight. Its demands are stringent and may require access to at least semiprofessional models and a professional photo-stylist to take care of dress, make-up and so forth. It was selected to illustrate the way a photographer might script a specialized subject that would display his skills in depth.

How would a script designed to showcase a more general expertise work? Here's one version of an industrial photographer's script:

Main objective: To get freelance assignments from large companies to photograph for annual reports, audio-visual presentations, and other work they may need.

Secondary objective: Persuade company to use more photography in more ways.

Primary audience: Company executives, such as corporate officers, communication and P.R. department heads, and personnel managers.

Secondary audience: Advertising and P.R. agency executives who may hire photographers for clients or advise clients on photography.

Audience analysis: Primary group generally knows little about photography and is uninterested in its techniques. They will be concerned with cost and productivity and will probably be impressed by a businesslike approach, good credentials and apparent efficiency. They will likely have conservative taste and a distrust of "creative types."

Central message: This photographer can be relied upon to understand company needs and apply his top professional skills to carrying the desired corporate messages. He has the versatility needed to portray all aspects of the modern corporate setting with impact and accuracy. He can provide both strong conventional photography and interpretive originality which will make publications such as annual reports distinctive.

Medium: Carousel tray of transparencies, all color. Backup is a portfolio book with tear sheets of work for well-known clients and good editorial credits.

Checklist of images—Industrial landscapes: a substantial group, including a number where an ordinary sort of building is made interesting by unusual angle, lens, or filtering.

Industrial interiors and office situations—people and machines at work: Close-up views of buildings and machines, showing an eye for detail and design.

People: A few formal portraits of executives, a larger number of interesting environmental portraits, some executive meetings, interestingly posed groups, pictures of people at work with a strong candid feeling.

Specialized photography which may be relevant to the company, such as aerial, photomicrography, or underwater photography.

Personal work, including scenics to provide mood and context and photojournalism where ability to handle people well is paramount.

Sequence: More or less in the order listed.

Note that in formalizing his approach this way our industrial photographer has identified ways in which he can rise above his competition. He knows he is trying to appeal to an unsophisticated photographic taste probably coupled with a quick intelligence and the ability to grasp well-presented ideas immediately. This client wants a photographer who is competent, authoritative yet respectful, creative, but willing to harness his creativity to the specific purposes of the company. Prima donnas with portfolios showing they want solely to portray their personal visions had better apply elsewhere.

Businessmen tend to shy away from extremes of any sort, not only because of their personal conservatism and a dislike of artiness, but for fear of offending their customers. I remember once congratulating an ad agency executive on a very imaginative annual report. The report, for a major client, included some fine experimental photography that has since been shown in museums. "Yeah, thanks," the executive said. "We really like it, too, but you should hear the client since the feedback from the stockholders started coming in—'What's all that weirdo photography for?' and stuff like that. We're lucky we haven't lost the account. We sure won't do anything like that again."

The freelance industrial photographer must anticipate that a large company probably does not need him for routine photography. There is usually a company photo department for day-to-day functions. If he's hired, it will be for the glamor side of the job, so his portfolio must display imagination and an eye for the interesting.

Balancing the portfolio between the conservative and more experimental will form a large part of this photographer's tailoring effort. As a well prepared freelancer, he will search for clues to the client's probable attitude toward photography. The clues are to be found in previous annual reports, the company's advertising, the kind of people it employs, the design of its stationery, the agencies that represent it—all the factors that testify to the image the company wants to project. The photographer valued by business is the one who seems to understand the needs and problems of modern industry, and is ready to use his special skills as a communicator to contribute toward solutions.

It is not accidental, I think, that many of the most successful industrial photographers are especially articulate people. They are able to explain photography's value to persons who can appreciate a professional contribution by another specialist; taste in photography is not an issue. These photographers are not offended by a dollars-and-cents attitude toward their craft.

Rather, they are able to point out ways in which multiple use can be made of a shooting: First use for an annual report and later for a company brochure and a multimedia show, for example. They expect to learn new things constantly and are good at learning: To take interesting pictures of how aluminum is made, you must know the details of how it's done.

To a sometimes amusing extent, photographers script themselves as well as their portfolios, altogether unconsciously in many cases. Certain personalities are attracted to certain specialities, and the result is enhanced by appearances. Among the most carefully garbed photographers are the industrial freelancers, who dress their part with care and individuality. If a well tailored business suit

is part of the look, so may be a flowered shirt, a felt hat or even a cape. The younger set may go for very well cut jeans, expensive silk shirts, handsome belts and boots. Such looks say success—individuality with self-discipline—and alertness to contemporary trends, but with discrimination. Ironically, photographers associated with the fashion industry tend to be far less flamboyant than others in the field as if reinforcing the idea that they are the portrayers of glamor, and not themselves the center of interest.

Such concepts may seem irrelevant, but they affect self-definition. An overall scripting effort is a way of helping you define your role as photographer in the largest possible terms. If you can develop a concept of yourself as a photographer in a broad rather than a narrow framework, you will think differently about your images and project your capabilities to potential buyers in different ways. A photographer who thinks of himself as a cameraman for hire who clicks the shutter on someone else's command is unlikely to formulate creative suggestions for the picture user. By contrast, a photographer who sees himself as a communicator with special skills and a talent for translating abstract ideas into visual form will naturally think in imaginative ways and will be far more valued. The latter photographer will come across as entirely different from his mechanical-minded competitor before a picture has been taken.

Defining your role as a visual communicator means thinking in terms of your buyer's needs and problems rather than just his ability to provide you with a creative outlet or a day rate. Note the level of analysis applied by the fashion and industrial photographers in the sample scripts. Neither tried to demonstrate every sill of the photographic craft in his presentation, because expecting any serious reviewer of the portfolio to have such a technical interest is silly. So the photographers wished not to show off their photographic tools, but their ability to anticipate the user's needs on a level beyond the obvious superfical ones.

Thus our fashion photograppher did not, as a newcomer to the specialty might, try to show how well he could portray every detail of his model's clothing. He understands that the market to shich he wants to sell—high fashion magazines—are only minimally interested in showing off a dress. They are more concerned with conveying a total look for the women they want visually to create; the mood or feeling an image can convey is more important.

A glance at fashion magazines, Sunday supplements and fashion catalogs will support this point. Sometimes you can hardly see the dress at all, but you do see an image of sophistication, sensuality, youthfulness, or some other quality. The dress acquires these characteristics by association.

The purpose of much photography is not to show fact but to portray a quality, a feeling, a mood or an idea. To comprehend this principle and apply it to

your portfolio is to put yourself many steps ahead of competitors. The idea can have various implications for different kinds of photography.

The fashion photographer may try to say "*joie de vivre*" rather than "what a beautiful dress." A news photographer will try not just for the fact of an event, but a record of its emotional meaning in human terms. Good nature photography does more than show what something looks like. I once heard *National Geographic*'s photography director explain why so many fine photographers could not meet their needs. Hundreds of photographers could be handed an assignment and come back with adequate results, he said, but hardly any came to the editors with interesting, well-developed ideas for photographic stories. And a good nature picture was not simply a pretty picture, he noted, but an image that illuminated an aspect of an animal's behavior pattern, for example. Even photographers wise enough to examine back issues frequently failed to make this generalization.

It is extraordinary that all of us can look at pictures and respond so unthinkingly to their content. We have apparently learned that anything visual is obvious and requires no thought. Such a superficial attitude may not hurt most of us, but for photographers it is fatal. Choose, if you wish, to use instinct alone for your own images, but don't expect to market pictures successfully if you look at other's work like that.

Preparing for a screening

Having oriented yourself and your portfolio to a market in general, you're ready to have your work reviewed by a specific buyer. How do you go about this?

Novice sellers may be surprised to hear that getting people to look at their work is the easiest part of the whole business. Depending on your location in relation to the chosen market you can: 1. Mail your portfolio in, preferably preceded by a letter and confirmation of interest. 2. Leave it for screening for an agreed-upon period of time. 3. Bring it in for a personal interview. The latter is preferable when you have a choice in the matter.

To get an appointment you call for one, as in any other life situation. Explain that you want to show a photographic portfolio, and try to reach whoever is responsible for appointment schedules. You may be told that screenings are one day a week or month and just show up with your work, or you may be given a specific personal appointment.

If you have an appointment, for your own good keep it punctually, or call and explain and cancel if you can't. Editors understand that photographers can

have unpredictable schedules, but they are irritated at no-shows. (Believe it or not, no-shows run at least one out of five appointments.) Coming early or late without regard to the time specified, can upset an editor's carefully arranged day and may count against you. For many photographers, this is a childish act of assertion that they are independent of the boring 9-to-5 drudgery—unlike the stupid editor. Nearly one out of three photographers does this.

Getting an edge on the competition can be as simple as good manners. When you make the appointment, take the opportunity to ask whatever questions you need answered. Like: do you have a Carousel projector? Any limit on number of pictures? Are you looking for anything special right now? Might you be interested in X or Y? Do you have a contributor's requirement sheet available in advance of the appointment?

Once your appointment is set, examine what is available from that market even more closely than you should already have done. Now that your screening has an imminent reality, check back through Chapter 3 for what to look for in a magazine. Read through three or more issues carefully and think about what you're reading and looking at. Be sure to generalize your conclusions, even write them down as an aid to the thinking process. Note any special requirements of subject or format.

When I was picture-editing a photo publication, photographer after photographer asked for special consideration for the highly visible and top-paying cover spot. That's not unusual. But no more than two photographers that I can recall ever noticed that our cover shot had unusual format requirements. Solely because the inside front cover had been purchased by an advertiser as a two-page foldout, Cover 1 had to be that format.

This meant that every month we needed a dramatic, cover-worthy image that not only was an extreme horizontal (unusual for a cover shot) but also was capable of looking terrific as a vertical when divided more or less down the middle. So half the image had to look complete and strong enough to attract newsstand attention, and the whole image had to be almost as interesting when folded out into its full form.

Add this peculiar requirement to a hundred other criteria that a cover shot must meet, and you had a staff that went crazy every month trying to come up with something suitable. And our competitive magazines were looking for the same pictures, because the same advertiser had bought their inside cover foldout space for the same ad. Why didn't we combine several images to make up the strange shape needed? Simply because the result wasn't as strong that way, although there were months when we or our competitors had no choice but to do so.

I'm sure that "out there somewhere" were hundreds of appropriate pictures by hundreds of photographers who would have loved the opportunity, but they never looked at the magazines they were reading. More surprising was that fine photographers scoured their files for good cover possibilities and came in with wonderful verticals we couldn't use, never noticing the odd way our covers ran every month.

There in a nutshell is the enormous problem editors can have (how do you call a hundred photographers and ask if they have a horizontal convertible to a vertical?) and the corresponding opportunity open to the alert photographer who makes an intelligent analysis of the market he wants to hit—or, indeed, of everything within his view.

On the basis of your media analysis and any information gleaned from your phone call, review your portfolio straight through. You will want to take out any picture now judged inappropriate and add others that seem especially appropriate to the buyer. Recheck for sequencing, general impressions and overall balance. Don't forget the obvious, such as whether your market uses all color or black-or-white.

As in every part of the photographic process, exercise your judgment in this final tailoring. Try to avoid the danger of second-guessing the buyer too much. If you succeed in showing only what would look familiar to him or her you have failed. Be prepared to take risks in including the extreme or unusual, or anything which is special to you in some way you can justify. Even if your reviewer can't use that shot he may remember you because of it, or be impressed with a capability if demonstrated. If you show him something that stimulates his imagination to a new angle on his material you'll probably make a friend. Can your idea be stolen? Yes, it happens, but not as often as photographers fear.

So preserving your integrity as a photographer in the sense of reflecting yourself and your interests makes sound practical sense. Why show work that will earn you assignments you will hate, or have difficulty fulfilling? If you have to tamper with your basic portfolio very much you may be taking it to the wrong place. But certainly there will be times when a portion of the portfolio, or an amplified portion, is appropriate. Only you can draw the lines as you go along.

When considering such matters in your pre-screening run-through, do not overlook such mundane details as whether any damaged prints or slides should be replaced, whether your slides are falling right side up without jamming, and so forth. Many carefully developed presentations fall prey to carelessness on this simple level.

Shooting for the portfolio

When you have given some thought to your market and worked out a script you think suitable, you will undoubtedly find gaps in what you actually have. When important subjects or types of pictures are absent, you should remedy the deficiency by giving yourself assignments.

Make the assignments specific. If you tell yourself to go out and take ten great pictures, don't be surprised if it proves impossible. Try working with a time deadline as well. It will simulate a real situation, making you more comfortable when you're getting paid to perform. Also, most of us work most imaginatively under limitations.

You may find that seriously shooting for presentation or sales purposes suggests some adjustments in your equipment and technique. A switch from color-print film to transparencies may be in order, for example; and if so, the need to crop carefully in the camera may become more critical. You want to take your photographs in a format that shows well and is appropriate to your market. For sports pictures, 35-mm is the natural choice. Food photography still relies on the large formats.

The mistake more often made by novice professionals lies not with the technique but the style in which they shoot. A misapprehension of the qualities valued by the market frequently leads portfolio-builders in the wrong direction. A photographer who believed *Vogue* wanted images that showed every detail of every garment would gear all his composition, lighting and so forth to portraying this in image after image. Or an industrial photographer might choose to show General Motor's P.R. man nothing but pictures of machines. There are, to be sure, situations when such portfolios would be functional, but both photographers would be severely limiting the kind of assignment they might gain.

There is no fool-proof method for analyzing market needs accurately other than a continuing, thoughtful review of what that market uses. Photo magazines, books, and professional-level photo conferences offer valuable clues and are seriously pursued by even those photographers whose names are household words. You can do the same and, as we keep stressing, sensitize yourself by constantly exercising your critical skills.

Some beginners err at the other extreme by devoting their energies to reproducing the same style and mood they see in print. To some extent every photographer is an imitator, because wanting to incorporate what you most admire in other work into your own is a natural tendency. The danger is in stop-

ping at the imitative level rather than going on from there. Whether shooting for enjoyment or for a portfolio, too, many photographers place unnecessary limits on themselves and fail to take advantage of the freedom they can exercise.

Sometimes this self-limitation is revealed in choice of subject. I have seen hundreds of portfolios, for example, by photographers aspiring to fashion-beauty markets, who have gone to apparently incredible lengths to produce images of bored, artificially posed models. They succeed in making a girl-next-door-type into the haughty, cold mannequin that to them spells high fashion. They may well have bypassed wonderful opportunities to make spontaneous, natural-looking and interesting pictures. Fashion pros spend a lot of time trying to evoke warmth and naturalness from jaded professional models—why try to imitate their worst problems?

Many superb portfolio shots of women in male photographers' presentations, whether portrait, fashion or figure images, prove to be of a wife or girl friend. Warmth and comfortableness are intrinsic to the situation. Asked for the secrets of their success, many top fashion pros talk instantly of their system for making the model feel relaxed, beautiful, and well disposed toward the photographer. Again, it is usually not mere fact you want to record but a quality or feeling. When it's there naturally, capitalize on the opportunity.

Some photographers select subjects carefully to build stylistic links into their portfolio. I knew one who deliberately picked similar-looking models, in his case, dark and fragile types, to give his portfolio a unity he thought would be missing otherwise. This is really an interim measure—he found it unnecessary once sufficient work had accumulated—but it can be a useful trick.

Most important to portfolio shooting is using your freedom to explore and experiment. Try portraying new subjects, different moods and emotions; use new techniques. Try creating pictures which use photography symbolically. Photography courses often assign to students themes such as, "Make a picture that symbolizes time," or "Peace" or "Loss," and such exercises can be rewarding. Your portfolio is the place for your most personal interpretive work as well as your public showcase. The best portfolios express the most individuality, for what else is "style" than the visual crystallization of a private viewpoint?

Developing a fine portfolio will be a matter that cuts to the very heart of your feelings for photography and the world you portray with your craft. It can be a profound learning experience. It should be an adventure.

7

How and Where
to Submit Pictures

THE mechanics of submitting pictures is largely common sense: Get your work seen by the appropriate person at the appropriate market. Simple as this might sound, it calls for some ingenuity and a little research.

We have talked about the need to review material perceptively in order to determine meeting points between the needs of the marketplace and what you can provide. If you decide that a particular market matches with something you can offer, examine what's at hand for clues to the person you want to address. A publication's masthead, for example, should tell you who is most likely to be responsible for pictures.

Most photographers will mail their submission to a title—"Picture Editor" or "Art Director"—rather than to a person. Their images will arrive at the right place, but the recipient will know before opening the package that it is from someone who did not familiarize himself with the publication. Others will take the trouble to write personal letters to editors who left years before, suggesting out-of-date address files and equally out-of-date market knowledge.

Does this seem a trivial matter? Maybe, but consider that addressing your precious work to a real person not only demonstrates your intelligence but helps protect the pictures. A personally addressed recipient feels responsible for reviewing the portfolio and for returning it safely. Take all the opportunities you can to personalize your picture submission situations.

When you are not dealing with print media or you have no information on whom to contact, try asking. If you're making contact by mail, it should be one of the questions included in a query letter (the letter written before sending anything to ask if it is welcome). Or use your phone. Full-time freelancers often spend half of their working day on the phone, asking questions, tracking down leads and people, and making appointments.

There's another reason you want to know who to deal with. At most ad agencies, and some magazines, the chain of command can be quite intricate and unpredictable. Even the experienced pro will find himself making a pitch to someone not remotely responsible for making decisions about picture purchases. In agencies, especially, nobody ever admits that he is not completely in charge. The situation is hard to handle, because a lower echelon person can effectively shut the door to you even if he does not have the authority to say yes. If you know the person whom you are seeing is low in the organization, at least you'll be prepared for a drawn-out series of presentations rather than an instant sale.

Should you bypass the chain of command when you have the chance? A review by a higher-up can sometimes be achieved by using even a remote personal contact or a little extra nerve. There is more to the question, however, than whether you can pull off such a coup. A publisher or agency president who is impressed with your work may then send you through channels with his endorsement, and you'll find yourself dealing with resentful underlings. If you go over a picture editor's head and score a sale, he may not call you for future jobs even if you perform well. Media people tend to be touchy about their authority.

In-person presentations

Say you've picked a market, analyzed it, and shaped your portfolio to it. What do you do next? Call for an appointment.

Most places except the very smallest will have a policy on reviewing photography, so you needn't prepare a sales pitch to get the interview. You'll be told either to come in, probably at a specific time, and leave your portfolio or to send your pictures through the mail. This is rarely open to argument.

The presentation in person is always your first choice, because it personalizes the selling situation. (Some editors try to avoid it for the same reason: Turning people down in their presence isn't fun, contrary to popular belief.) More important, valuable feedback and your best sales leads result from these confrontations.

Even while involved in your self-presentation, the more aware you remain of your viewer's response, the further you'll get. General reaction is important: Did the editor stop halfway through the slide tray? Perhaps you should cut the volume. Did he linger over certain images? Perhaps more of that type should be included next time. Specific comments, whether favorable or unfavorable, deserve note. If praise is offered, it's probably honest; if criticism, at least your buyer is saying something besides "No thanks." Think about his suggestions.

An editor or art director will only bother to criticize what you've brought if he thinks it is in some way promising.

I've heard photographers relate things like, "That _____ editor gave me the brush-off, told me to bring the pictures back in four months." Or, "He wanted me to bring back different stuff; what a waste of time." No picture buyer asks a photographer to come back unless he thinks a sale or future arrangement may develop, because his last desire is to needlessly clutter up his schedule.

Other photographers muff their chances with attitudes like, "He told me to go see some other art director just to get rid of me." People don't make suggestions about other places to go unless they think it's productive for you and, even more important, for the person they're recommending—who is probably a friend.

In certain photographic specialties, entire careers rest on such seemingly casual recommendations. The first personal reference is a starting point, because a professional reviewer has observed a clear direction to a portfolio in market terms, and because calling Joe at Harry's suggestion can be an all-important difference from calling blind.

Freelancers who succeed listen to other people. Since your receptivity is totally obvious to others, you yourself determine how much useful commentary will emerge from the interview. Being known as a photographer who can be talked to is absolutely critical if you are assignment-hunting. Why would anyone hire an unresponsive person whose mind seems closed to everything outside himself? The most spectacular portfolio may not be the one that gets the assignment. Try to use personality factors to your advantage rather than against it.

How seriously should you take the picture editor's opinion of your work? We have no trouble accepting compliments, so the question is really how much an unfavorable judgment should count. This depends on the speaker and the kind of comment involved. A statement such as, "Very nice but we can't use anything of this type," must be taken seriously as a marketing judgment, at least in regard to that place at that time. (Needs and policies can change as fast as picture editors or management change.) Your response should be, "What are you looking for?" You may have just what is wanted at home, can call when you think you have it or can cross the market off your list.

Judgments on your photographic abilities merit more skepticism. One opinion is only one opinion, and provided you consider it fairmindedly, it does not warrant your becoming discouraged. Without persistence, many outstanding professionals would have remained in obscurity. Naturally, if you hear

similar opinions from a number of people, you should do some intense thinking about your photography, or try a completely different kind of market. Often, a harsh evaluation from a qualified critic has sent a good photographer off in a better direction, or saved him years of experimentation on his own. Or the photographer decides never to risk rejection again, and he never takes another picture. How you react to feedback is up to you.

Do not forget that the interview should benefit both parties, not just the picture buyer. At the same time you are being evaluated, you should be evaluating the other person. Does she or he seem to know photography? Your judgment will determine how much weight the person's opinion should carry. If you're after an assignment, is this a person you can work with? If the market is important to you, what clues are provided to the reviewer's tastes? Do his views seem to reflect an official policy of that market, or personal criteria?

The statement, "*I* like your pictures a lot but the company can't make use of them" is sometimes a polite way of saying "No thanks." Just as often, however, it can mean that this buyer would like to give you a chance if you can meet him halfway. As in all human encounters, you must size up the other party and interpret his response. If you're in doubt, interpret events to your advantage or take his words as encouragement. If you don't come back when asked, you'll never know if the invitation was sincere; and even if it wasn't, the new work you'll bring may be just what is wanted.

The "Come back next week or month or year" is such an intrinsic part of the selling effort that a few more comments may be helpful.

First, understand that when you're competing for well-paying commercial or editorial assignments, getting the job on first visit is the rarity rather than the norm. In the high-fashion industry, for example, selling is a building process whereby you hope gradually to become remembered for your pictures so that when the right assignments come along, you'll be associated with them. As one professional in this field explained, even though he was rather well-established, "I never go home from a screening and wait for the phone to ring. Results may come six months later or a year, and that's fine. Why frazzle your nerves about it, as long as you're eating meanwhile?"

Editors and A.D.s look at portfolios to build their files, whether in their minds or in reality, against needs that may not yet be identified. A fashion magazine editor can ask a photographer to come back every six months not to palm him off, but because she sees something she likes, can't use at the moment, and wants to ensure that it is brought to her attention again. Such an editor also wishes to review a good photographer's work periodically to see if something he's done stimulates that all-important idea process in her mind.

In magazines especially use of pictures can be specified by a very tight schedule. A subject you have photographed may be covered in a future issue that is already established. An annual publication may be actively worked on only during a set period of months. Knowing that photographers are reluctant to leave work for long periods of time, editors in these situations will suggest that relevant work be brought back at a certain date. Few photographers take this seriously or remember to come back at the time asked; many are probably disposed to regard the delay as a rejection, and others just don't keep track of their calendars. One magazine had to take the initiative and make Polaroid copies of images for consideration at deadline and contact the photographers, lest too poor a selection be available when needed.

Use of an image in any competitive situation will only be determined after the competition closes; when you show your portfolio, you won't get a definite decision. Often the first reviewer is only authorized to preselect or screen work, with the decision to buy reserved to someone else or to a panel. If you are asked to leave work for an extended period of time, you'll have to use your judgment on whether to do so. Try asking if you can bring the picture back at a set time instead, or if the reviewer can narrow down the selection.

Always bring back pictures as requested, on schedule. Bring the ones in which interest was expressed and bring some new ones as well, unless the reviewer says they are not wanted. When you are invited to return on a more general basis, for instance to bring your portfolio back in six months, incorporate some new work. Showing the same book can earn you repeat judgments of not-quite-usable. But images can be resubmitted to the same market when you have reason to feel they were not used because of extraneous factors, such as too much competition in the category or lack of space.

Make written notes on dates, particular pictures admired by an editor or requested for some future date, and any general impressions about the editor's picture needs and orientations. Such records are valuable not just as date reminders (a day-by-day calendar is also in order) but as part of your market research. Interviews offer chances for first-hand explanations of policy and reasoning not to be lightly passed up.

A good market will call for return visits even if the first try produced no sale. Editors and art directors expect photographers to try again and will avoid seeing a particular photographer only if he made himself memorable by outstandingly offensive behavior. How often should you schedule a new appointment? That depends on a great many factors, but many commercial pros think in terms of twice a year for a promising account that doesn't complain.

A word on manners and mores: What to wear to a portfolio presentation and

what to say are not of much concern. Be comfortable; as they used to tell teen-agers, "Be yourself." Of course, the president of First National Bank will not be impressed by your 200-year-old blue jeans, and if you're not prepared to accommodate his attitudes you shouldn't be asking him for work. On the other hand, he isn't likely to expect a creative type to show up in a three-piece suit.

Dealing with prospective buyers carries the same simple rules of human be-havior as any other exchange situation—but don't forget that you're the seller. A hard sales pitch about your qualifications is rarely called for and is usually out of line, because your presentation should speak for you. Certainly answer questions and participate in conversations as much as you like. Ask relevant questions; your reviewer is usually glad to clarify things. Pretend you think of him as a person, rather than some unappreciative hack who's bent on sup-pressing your genius. If you can't do that, at least try to mask your hostility so you don't turn your buyer off. Sounds too obvious to state? When I first worked as a full-time picture editor a good day was one on which I had to re-mind myself only four times that many photographers are so hostile and un-friendly only because they feel defensive.

Mailing your work

If you don't have time or live too far away to pay sales calls, it is altogether possible to deal by mail with most markets. Between the cost of postage, mail-ing materials and your photographs, it is hardly an inexpensive process. Therefore, do it intelligently and know exactly why you're sending each pic-ture to each buyer. Your market research and presentation, in other words, should not be done sloppily just because you don't have to confront the buyer personally. In fact, you'll have to prepare more carefully because your work will be reviewed in your absence.

A cover letter should be included so your buyer knows why you're sending him the package. The letter should be neatly typed but a hand-written note is O.K. if also neat. Always include your full current address and phone number—and your name, of course; some photographers forget. The message itself can be quite simple. For a photography magazine, for example, some-thing like this is sufficient: "Enclosed are ten black-and-white prints for your annual. Please return any not used at your earliest convenience. A self-addressed stamped envelope is enclosed." The envelope, or a mailing label and postage, is your best assurance that the work will be returned.

If you're trying to sell stock images to the buyer, you will want a letter of a promotional nature or some of the promotional material described in Chapter

14. Examples would be a brochure with some illustrations describing your file material and an alphabetical listing of the subjects you cover. If you are submitting a written text with photographs, an interesting descriptive letter should be prepared. And so on; common sense will dictate.

The situation will also determine the kind of pictures you are sending. What you send should be ready for use. Do not mail negatives, contact sheets or poor prints. Never mail glass-mounted slides. Prints should be packed flat. To look and stay their best they should be matted or have margins, and they should be double-weight. For most purposes, the 8-by-10-inch print is suitable, although bigger prints may be better for artistic outlets.

Try to avoid sending exhibition-quality prints through the mail. If you must (such as when submitting work to a gallery in another city, frequently done by mail) the packaging will be a lot of trouble, but it must be done well. Obtain large illustration boards for packing to protect the prints or make, or have made, a special wooden crate for the purpose.

Portfolio cases can also be mailed if necessary, wrapped, but they are heavy.

Transparencies are best mailed in the plastic sheets that hold twenty 35-mm or a smaller group of 2¼-square transparencies. Larger transparencies can be stacked in individual plastic or glassine envelopes inside the package. Some photographers mail Carousel reels of transparencies, which is fine if they are carefully boxed.

Prints and transparencies should be protected with at least two pieces of stiff cardboard larger than the images, and held together over the prints with diagonally looped rubber bands. Stack the prints in an envelope, put the envelope inside the cardboards, secure the cardboards and place in another envelope (not forgetting your SASE and cover letter). The outer envelope should be marked "Photographs—do not bend"; rubber stamps saying that can be readily purchased. For that matter, so can ready-made photo mailers.

Avoid packaging that brings paper clips, tape or staples in contact with pictures.

If you're mailing something that is important to you, it is not a bad idea to register, certify or insure your package.

Keep track of what you mail, when, and to whom. If considerable time passes and nothing is heard, write or call to ask what is happening with your pictures. If you certified and got a return receipt, a photocopy of that will guarantee a speedy response to your inquiry.

It is not necessary to include copies of model releases if you're submitting work without knowing whether it will be used. Your cover letter can indicate that you have the model releases, however, which may be a point in your favor.

Technical information on the photography is almost never necessary—those few buyers who may want it will ask for it later.

If your submission is of an informational nature (for example, product application pictures), you will need to provide detailed captions and identification material without which buying decisions are unlikely to be made. Submissions such as these are not likely to be returned.

The point we stress repeatedly: Label each and every item with your full name, address, phone number, and an identifying number or title. A copyright statement is also desirable, as explained in Chapter 18. The information can be written or stamped on slide mounts and the backs of prints. On prints, do not use anything that will indent the paper or show through; hard lead pencils and ball-point pens are out. Never stack prints before the ink on their backs is dry—something that people who should know better often do.

How to locate markets

In terms of accessibility, there are two kinds of markets: those that present themselves to you naturally and those you have to look for. In the first category can be included every newsstand magazine displayed in your locale.

Looking

Most unwealthy freelance writers and photographers cultivate a friendly newsstand where unlimited browsing is smiled upon. A well-stocked newsstand offers such an extraordinary range of material it will surprise you if you've never looked closely. You should become thoroughly familiar with every publication vaguely related to your scope of interests, and check regularly for current orientations and new magazines.

Publishing reflects contemporary interests and living styles faster than almost any other industry. Collectively, it truly mirrors our time. For an interesting and productive experiment, ask your friends and relatives what publications they read, and ask to see those you don't recognize. A great many consumer magazines never appear on the average magazine rack; they reach their special-interest audiences primarily by subscription.

Also within your view are newspapers, advertising, postcard and greeting card publishers, poster and calendar makers, photographic and art galleries, television stations, and so forth. Your receptive eye, combined with a habit of tracking down where such things come from, is your best marketing weapon.

There are no great secrets to discovering who is doing what and buying what, just a little detective work. A poster or greeting card is labelled with the company's name, and often address, as clearly as any publication. If you want to try selling them some pictures for their photographic line, you're now as prepared as any professional.

Remember that such a company can be as eager to hear from you as you are to find a buyer. Good markets can be near desperate for input, customarily using the least awful submissions because so few were received. It is very, very hard to sufficiently publicize picture needs.

Never assume any outlet is overwhelmed with submissions before trying it yourself. Your fellow photographers are unreliable on such matters, because no one readily admits that talent, rather than opportunity, was lacking.

Also within your scope of vision may be trade or professional magazines relevant to your working life or special-interest magazines devoted to your hobbies. As we said earlier, publications oriented to any expertise you possess present fine possibilities. Don't assume that every skier takes his camera to the trail top or every chef photographs his barbecue. Knowledge and interest are your best qualifications.

Opportunities that seem off the beaten path to many may be just up someone else's alley. I knew one photographer who travelled heavily for his professional work, which was industrial documentation. For reasons of his own temperament and perhaps as a relief from the noisy factories he worked in, he developed a somewhat esoteric enthusiasm: locating and visiting old cemeteries in each new town. Naturally, he brought his camera and recorded items of particular interest. Reflecting one day on how large the collection of images resulting from these excursions had grown, he decided to look into the marketing potential. Farfetched? In fact, he discovered that several publications directed to undertakers and monument designers were eager to get pictures of historic "funerary art." They needed cover shots and inside material not only for "atmosphere" but also for inspiration. It seems that funerary artists are always on the lookout for good old ideas to copy for today's trade. Not only that—our social priorities being what they are—these publications proved to be wealthy, handsomely produced, and quite prepared to pay goodly sums for publishable material. Further, the advertisers need photographers able to do justice to their special product for promotion and advertising. The photographer developed quite a nice little sideline.

The $64,000 question that you want answered is probably, "How did this photographer find these publications?" That brings us to the second general category we outlined, the markets you have to look for. Thousands of maga-

zines are carefully circulated to select audiences and just as carefully kept off the newsstands. If you were a funeral director, would you want your clients to know you were reading articles on how to sell them the most extravagant coffin in the line? More importantly, advertisers want a guaranteed, specialized audience.

Well, in line with the theory that there are books and magazines to fulfill every need and interest, there are some designed to provide you with the research information you need. Leaving aside the professional photography magazines, which run marketing information sporadically, there are some excellent source books you should examine.

How to research your market

Most of the books described here are available in reasonably well-stocked public libraries, usually in the reference sections. You may wish to spend happy hours there perusing them, or may want to buy them. The most important are available in many bookstores and are not that expensive. Check the library first to see which is most suited to your own needs and goals.

The two volumes probably most valuable for most photographers are both issued annually by the publishers of the periodical *Writer's Digest*. One is called *Writer's Market*, which was first issued some 50 years ago. The second is called *Photographer's Market* which, in recognition of cultural trends, was first published in the 1970s. The writer's version may be of more help to many readers than the photographer's, but you can make up your mind after reading the descriptions here and scanning both books.

Writer's Market, although published for the freelance writer, also includes information for photographers. The introductory material is well worth reading if you are at all editorially oriented, but most of the nearly 1,000 pages are devoted to market listings. The listings are divided into categories, such as consumer publications (further divided into animals, art, aviation, black, and so on); sponsored publications; farm publications; trade, technical and professional journals; book publishers; subsidy book publishers; miscellaneous freelance markets and services (audiovisual markets, authors agents, and so forth) and foreign markets.

The material on the publications is especially good, the most useful rundown available. Each publication is described and its needs defined in information provided by each editor. (They receive a questionnaire in the mail each year.) Some publications are covered in a full page. The publication's name and address, the name and title of the relevant editor, the kind of

material he is looking for, topics of most interest, pay rates, specifications, and a helpful "How to Break in" section are usually given.

What makes the book so valuable is the fact that the information comes directly from the editors, who are often quoted. This not only gives you the flavor of each publication but a very good idea of how receptive it is to freelance material from newcomers. The more detail an editor provided to *Writer's Market*, the more interested he is in new material.

Photographer's Market has the advantage of being directed purely to your side of communication marketing. Introductory material is very brief, but hints are scattered around the book, usually from professional freelancers. Among the places suggested for a photographer to know about are ad agencies, architectural firms, audiovisual firms, book publishers, paper-product manufacturers (regarding greeting cards, postcards, calendars, posters), businesses (chambers of commerce, for example), publications, P.R. firms, stock photo agencies, competitions and exhibitions, foundations and grants, galleries and exposition space.

Many categories are only partially covered. Architectural firms, for example, occupies a scant three pages. It takes a long time for information of this kind to be accumulated. But unquestionably, in the publication area, this is your most complete research guide (except for *Writer's Market*).

The reason that the writer's book will be more useful to some photographers than the one done solely for them is that the former is more idea-oriented. Descriptions and editors' quotes are geared to provide a total picture of the publication's aims and to stimulate the conception of appropriate story ideas, rather than being addressed to the use of photography as illustrative material. So if by the time you've finished reading this book your imagination is fired by the possibilities of originating your own feature stories, you'll find *Writer's Market* a strong resource to help the thinking process in relation to specific outlets.

Both guides (and a few others available but not as good) can be useful in several ways. First, individual publications are indexed by name so if you want to know what a magazine you're interested in might buy, you can simply look it up. Second, and more productive, you can look up general topics, from "basketball" to "nature, conservation and ecology," "pets," "travel" and "religion."

In virtually every subject area, you will probably find a number of publications you have never heard of. Many will surprise you with their circulation figures, payment rates, and often, the range of their interests. The facts, figures and individual outlook of all are available for ready comparison shopping.

A third good way to use these books is for pure browsing. It would take you at least fifty years to collect that much first-hand marketing advice. An intelligent scanning can tell you a great deal about trends in the market, promising new paths and directions relevant to your personal objectives. Many, many writers have built successful careers this way. Photographers are only beginning to catch on to "the method," so you might still be the first in your neighborhood.

You will already understand something important about the potential market just by a preliminary look at such books, which may vividly bring home the point that a lot of money is out there to be made if you work on those meeting points we keep talking about. The thousands of relatively small markets add up to an excellent living for thousands of writers and photographers that you never heard of. Fortune is easier to come by than fame in this game.

Raiding the research guides is only the beginning of your task, of course. When you have found a listing that intrigues you, especially if it is a publication not available at the library or newsstand, you can write to request a sample copy. The guidebook indicates whether a publication routinely fulfills such requests or requires payment for the sample. Often S.A.S.E. will be specified—send a self-addressed stamped envelope with your request.

Such expressions of interest are rarely disregarded by publishers. When the staff is large there is always someone to fulfill the task; when small, not that many requests come in. This is typical of the work of zeroing in on markets. Those with special needs are often the happiest to hear from someone potentially qualified to fill them.

As a friend who was creative director of a business-management magazine once remarked, "Everyone wants to be in *Popular Photography* but nobody wants to be in my magazine. But we need pictures, and they must be taken by capable people who understand the field. We'll pay as well as we have to, but usually our choice is between a horrible picture and a merely bad one." He had never in his memory refused to see a portfolio.

You may be equally surprised to find that major, well-known magazines are also accessible. Few can afford to close themselves off to new blood. Editors recognize that an in-bred publication, one produced entirely by the same small group of people issue after issue, can become boring and lose touch with its audience. The most interesting new angles in both writing and photography are often provided by new talent. That you are a potential source of ideas for a publication may be more important than the precise set of skills you offer.

Naturally the better-known and higher the payment rates, the more competitive the situation is. There are some small benefits from this. Publications that receive a number of queries from interested contributors often have spec

sheets available. The spec sheet will contain a general statement of the kinds of photographs wanted with some indication of format and other requirements. These will help you not only understand the particular magazine's outlook but develop your general editorial viewpoint. Spec sheets and free sample copies may be obtained by asking, via phone or mail.

Many photographers find it useful to produce their own form letter, addressed to "Dear Editor" and requesting contributor information and sample copy. A batch of such letters can be individually addressed to each magazine which is of interest to you. From a small publication with no spec sheet you may get a personal reply, but usually only if your request was individually done and indicates some qualification suitable to that publication's probable needs.

A copy of the publication along with any information supplied is all you need to decide whether to proceed and how. Make a detailed examination of the publication as outlined in Chapter 3. Think through all the possible meeting points between your abilities and the magazine's needs. If you are interested only in submitting stock images for covers or other particular purposes, and the information you have gathered does not seem to preclude that purpose, you can plan in line with any suggestions given for mailing or personal submission. If the magazine is geared toward packages—words plus pictures—your challenge is to develop ideas that may interest the editors. Or, if the situation suggests a portfolio screening so you can compete in the assignment game, you have as many clues as even the most established professional as to what to present.

At this point, consider yourself to be dealing on a completely personal basis. You have all the materials you need to present your case intelligently and you know with whom you should deal. If location allows, you may wish to try for an appointment by telephone when you are ready with your tailored presentation.

If you will be dealing by mail, send a query letter first. This is especially true if you are planning to send anything that you will want returned, or if you will be producing pictures or text especially for the publication. Sometimes it is better to complete a project before asking the planned recipient if he is interested, but then the same rule applies: Write to ask permission to send the material, and send it only after receiving a response.

Why? All too often, mailing unsolicited material is like sending it into a great void. Large publishing concerns may have scant respect for it and return it routinely several months later without reviewing it at all. Once they have expressed interest in something, however, even if only by replying with a form

letter saying you may mail the material in, it becomes "solicited" and you are far more assured of serious consideration and prompt handling. In the case of a small publication whose name you have unearthed from a research guide, you are really dealing with the unknown. Most of them, no matter how under-staffed, will respond to a query letter if they are interested. If they don't respond, a fair conclusion is that they are indifferent to your material (so why send it) or irresponsible. The small percentage of times you would have had better results going in cold is the price of safety.

Any letter you send to a potential market should be well prepared. Editors and art directors will make conclusions about your suitability on the basis of it. There is good reason for their attitude. I have found people to be remarkably consistent in this context: A well-done query letter usually presages a well-done story. (Query letters for editorial ideas are discussed in Chapter 9.) It may seem farfetched that a simple letter asking for a portfolio screening or permission to mail in a submission should also reflect the quality of photog-raphy involved, but nonetheless it is true. I have questioned a number of art directors and editors on this and they have found the same thing. It probably relates to the marketing thesis we are developing here—that an informed, reasoned approach has a high chance of success because it means you are in the right place, at the right time, with the right photographs and the best possible presentation.

The letter is part of your presentation. Take care with it; type it on your letterhead stationery. If you are asking for permission to mail work in, say so in a straightforward manner, and indicate very briefly exactly what you plan to send, why, and your experience and credits that qualify you to make the sub-mission.

Such a letter can be essential even when you are addressing a photography gallery. Some of the best-known ones, in response to a great many portfolio submissions, have announced policies of not reviewing unsolicited work, or even not reviewing anything which has not been recommended by another gallery or photographer known to the gallery director. In a growing number of situations a good query letter is your only chance.

Once you've received an encouraging reply send the promised material as soon as possible, not forgetting to include a cover letter as previously mentioned. Address it, and the package, to the person whose name is on the letter you received and be sure to state that you are submitting the enclosed in response to their request for you to do so. Otherwise, you may join the ranks of the unsolicited again.

More research guides

A more specialized source book than those discussed so far which may be invaluable to some photographers is called the *Gebbie House Magazine Directory*, first published in 1934 and updated frequently since. It is now part of an exhaustive work called *The Working Press of the Nation* (see Bibliography at the end of this chapter) and is available at many libraries or can be purchased if the information is up your special alley.

What *Gebbie* offers is several hundred pages on house magazines, or sponsored publications, produced by business and industry. (*Writer's Market* incorporates some of these listings but by no means as many.) The information is geared to public relations people and freelance contributors and offers some good introductory material on the nature of sponsored magazines and tips for freelancers. The publications are described in an alphabetical listing (by company name) and then indexed by: geographic location; magazine title; industry (hospitals, meat products, and so on), circulation, location and name of printer, and, most interestingly, by "editorial material wanted."

The latter is a subject listing with such promising categories as "scenic photos" (six columns of magazine names), cheesecake, ecology, how-to stories, and some seven columns on travel. The directory notes that this subject listing is designed for use by public relations persons rather than freelancers, who are advised to delve more carefully.

Some delving in any case is worth the time, because house magazines can indeed, as *Gebbie* claims, be a goldmine to contributors who can adopt the right frame of mind. The multitude and variety of sponsored publications will surprise you. So will the circulation figures, range of interests and lack of uniformity: A sponsored magazine takes the size, shape, orientation and cash input individually determined by each company. Many issue half a dozen or more publications variously directed to employees, stockholders, customers and the general public.

You will find instances where these publications give assignments to freelance photographers at consumer-magazine rates, pay $1,500 for illustrated articles, and have circulations in the several hundred thousand range. Many state an interest in material not specially related to the company, including political, economic and social happenings.

As with other magazines a query will often bring you a free sample issue and probably a contributors' spec sheet. Those that sound most interesting and financially rewarding may also look as slick and sophisticated as the best newsstand magazines. House publications can look like 1932 or 1992. They fre-

quently offer private forums to small, sometimes experimentally-minded staffs. You may find some recognizable names in the credits for feature material, because well-known writers and photographers are very much aware of the lucrative possibilities of these publications.

This is hardly a noncompetitive market. The better publications will demand your best work and idea-producing efforts. On the other hand, some of the less expensively produced examples of the breed can be a nice starting point if getting publication credits is more important than a lot of money. And everything you learn from the experience will be applicable to all publication work.

Photography Market Place is another source of useful information. The range of information can be gathered from the chapter headings: picture buyers, technical services, equipment sources, supportive services (photographers' representatives and model agencies), picture sources, publishers and publications, organizations, and career opportunities. This is a compact reference paperback that lists names and addresses with little explanatory information. There is a useful listing of galleries and museums that buy and sell photographs, a guide to publishers of picture books, and a list of photo publications, including the professional and foreign ones. The latter are hard to find on your own.

The "Picture Buyers" section covers various types of magazines, including Sunday and regional magazines, plus ad agencies, annual reports, design studios, and record album and filmstrip producers. In the original edition, trade and house magazines together accounted for only ten pages, making the guides previously discussed better in this area. *Photographer's Market* now provides a lot of the coverage included but you may want to refer to both.

One pretty well indispensable source book is the *Yellow Pages Telephone Directory.* Find out what ad agencies, P.R. firms, magazines, wire services, design studios and large businesses have offices in your area. Photographers who are aggressive about marketing make a point of checking out the phone book as well as other sources when they are traveling. Directories for other cities can be examined in the library or ordered from the phone company. A Manhattan Yellow Pages is useful to many freelancers outside New York.

An art director responsible for illustrating medical magazines once told me of a photographer who called him and was anxious to present his portfolio. The photographer did not say who had referred him, but the art director, who worked enough off the beaten track that he had to look for photographers rather than the other way around, was glad enough to grant an appointment. (People like looking at pictures; photographers ought not to overlook that, but

they often do.) The portfolio proved unsuitable for the art director's needs but he thought it good nonetheless and suggested a fellow art director who might be looking for precisely those talents. When he learned that the photographer had simply dug his magazine's name out of the New York phone book he was not in the least disturbed. The photographer's initiative seemed impressive to him, in fact. So try out some blind leads like that; you are at least sure to learn something.

Some cautions in using source books

Do bear in mind that a potential market can be in and out of business during the time a new or updated research guide is prepared. New magazines are born every day and only a fraction survive. Even the most conscientiously revised directory is months out of date right off the press.

Further, no directory can take account of how responsible, legitimate or honest any entry is. So do not mail valuable or irreplacable material to any unknown place or person without at least sending the query letter first and receiving a response.

Material that can be replaced with relative ease, like a repro quality black-and-white print, can be mailed off at your discretion. For example, submitting product-application pictures to a house magazine (photographs of a company product being used in some way) does not justify an exchange of letters. Be aware, though, that your pictures will probably be discarded if they are not used.

It will pay to familiarize yourself with these guidebooks at your library. Note in examining them that except for those that contain nearly every example of their subject, and are correspondingly clumsy to use, the listings may differ markedly between guides. This testifies not only to the market's size but to the problems of compiling a truly comprehensive list. And some omissions may be quite arbitrary. For example, a guidebook for photographers that is not recommended here excludes all publications produced by one major publishing house, even though they are very important to photographers, because some of those magazines compete with those issued by the guidebook publisher.

So if you're going to base your personal marketing program on research guide information, check out more than one. Make sure to examine the copyright date when it is not prominently displayed, remembering that if it is more than a year old, the information is really two years old at least.

In addition to the market-listing guides are a few books like this one, with information on a portion of the subjects covered here, but often out of date in overall attitude even if partially updated since original issue. The better ones

are included in the following highly selective bibliography.

The information in all these books must be sifted from a personal perspective to do you any good.

List of research guides

Ahlers, Arvel W. *Where and How to Sell Your Photographs.* Ninth Edition. Garden City: Amphoto, 1979. General information about freelancing; some articles on specific subjects; and about fifty pages of market listings, mostly publications and broadly classified, as for example "animals and pets," or "male interest."

Audiovisual Market Place. New York: R.R. Bowker. Includes firms that buy photographs for filmstrips.

Business Publications Rates and Data. Skokie: Standard Rates and Data Service. Most complete guide to trade magazines. Like its companion guide to consumer magazines, it is directed to advertising-space buyers. Categorized by subject.

Consumer Magazines and Farm Publications Rates and Data. Skokie: Standard Rates and Data Service. Comprehensive guide to consumer magazines. Compiled for advertising-space buyers; gives concise descriptions of publications and audiences. Sometimes available in libraries. Most magazine, advertising agency and P.R. offices have it; ask if you can look at their SRDS.

Hillman, Bruce Joel, Editor. *Writer's Market.* Annual. Cincinnati: Writer's Digest. Available in many book stores and libraries.

McDarrah, Fred W., Editor. *Photography Market Place.* New York: R.R. Bowker.

Milar, Melissa, and Brohaugh, William, Editors. *Photographer's Market.* Annual. Cincinnati: Writer's Digest. Available in many book stores and libraries.

Working Press of the Nation. Chicago: National Research Bureau. Five volumes. One volume is the *Gebbie House Magazine Directory.* Available in many libraries. Covers newspapers, magazines, group index, specs, payment

policies, editorial analysis, radio-TV, writers and their specialties, editors, description of article needs, and a list of freelance photographers.

The proper use of these research guidebooks is not in looking up markets for every picture as you produce it, but as a base for developing a market list. Selling pictures or photographic services can be done on a hit-and-miss basis, but your most rewarding experiences will be with markets with which you deal more than once.

Cultivating Your Personal Market

WHETHER the photographer's market in the broadest sense is expanding or contracting is a question debated endlessly at professional conferences. On the optimistic side, it is pointed out that the number of publications is higher than ever before. Negativists note that even if this is so, the proliferation represents small, very specialized publications that scarcely equal the market lost with the great picture magazines. But note that when the original *Life* finally went down, many professionals were pleased at the new opportunities ironically provided to freelancers. Without a medium that would present the "ultimate" coverage of every major event, photographers could relax and offer specialized, slanted coverage of events to a multitude of small audiences. On the other hand, it must be acknowledged that so is the competition greater than ever before. Not only ex-*Life* and *Look* staff members but thousands of young men and women are attracted each year to photography's magic aura. To this, our optimist might reply that photography's expanding future is with the *new* uses to which it is being put. This is not just because better appreciation of good visuals is affecting every kind of publication today, but because forward-thinking people in industry, education, government, television, greeting cards and on down to place-mat makers are recognizing the power of fine still photographs.

A debate on this expansion-versus-contraction question could go on forever, but meanwhile the photographer who is researching and building his private market network can do exactly as well as his imagination directs. It is here that we enter the domain of serious salesmanship, and everyone must draw his own lines of how far he wants to go. Many photographers find no compromise whatever in applying creative skills to meeting challenges posed by others who

are paying for the privilege. Others wish to preserve the purity of photography for its own sake, so their interest in this phase of selling will be low. And many others will draw their own lines between images made for self-satisfaction and those made for money, recognizing that in an imperfect world the latter must support the former. You may agree with one famous photographer's statement: "I got into photography the same way a woman gets into prostitution. First I did it for myself. Then I did it for friends. Now I do it for money."

Here are some ways to do it for money—or, if you prefer, for the satisfaction of using photography to communicate to an audience beyond your immediate circles.

Vertical market building

Thinking vertically means exploring every possibility for getting a picture, or category of pictures, used. Sometimes a single image may be worth the trouble. Suppose as a simple instance you ran to the scene of a fire with camera in hand and got a good shot of a fireman carrying a child down the ladder, flames dramatically leaping around them. What might you do with it? Try composing your own list before checking the following one over.

Sales reflex

First of all, if you act instantly you have a spot news picture in your hands. A newspaper or wire service will rush your film through development and into distribution within hours. But let any time at all elapse and your picture must be reclassified as "feature"—of general interest, unconnected with time. The wire service may still be interested because your shot has strong human interest, but consider also the following other uses for it: Sunday supplements (often staffed separately from the daily newspaper); firefighting magazines, both professional and volunteer services; insurance companies, which produce advertising and house magazines and are extremely communications-oriented; publications that use inspirational material, such as religious, family and community-minded magazines; television news, which uses hundreds of still shots; safety publications; encyclopedias; and textbooks. And what about the companies that produced the fireman's helmet, hose, ladder, coat and truck? Such pictures are "product-application" images, in great demand by many firms and providing more than one photographer with a good living.

A sales-minded photographer who wanted maximum return and exposure for his one picture might investigate all such ideas through his market guides

and telephone calls. If he had taken a series of shots and could offer a photo essay, the possibilities would expand much further. He might even offer to provide a text-plus-picture story to some of the markets. The photographer might stop only at the point where he had sold all rights or all subsequent rights, whereupon he would have relinquished ownership.

If you think that there are not many professional photographers who function this way, think again. Like any others who produce something, many photographers want as much return on their input as possible. In an example not far removed from our theoretical firefighting one, I once heard a well-established young pro lecture an audience of fellow-professionals on his working methods. He had been invited to speak because of his association with social-protest movements, but his subject was, "How I make a living to support the idealistic projects that might not sell right away." He cited his recent coverage of a natural disaster which "luckily" occurred only several hundred miles from his home base. After rushing to the scene he shot from every angle that emerged: the overall setting, the people, rescue efforts, emergency shelters, and so forth. Early in the day, he was able to decide on several likely markets, which included a newspaper, a safety magazine and a religious publication. Then he spotted a bonus: a truck unloading cases of soup at the disaster scene and a sure bet with the soup company's very glossy house magazine, annual report, advertising and P.R. program. He may also have contacted the truck manufacturer. This idealistic young photographer stated firmly, "If a photo story is worth selling once it's worth selling six times." This is an important principle. It presumes your coverage of the subject is broad enough to allow you to develop, on the scene or afterward, six different angles for six different audiences. (You can't sell one angle to six different insurance companies, for example.) It became clear that this photographer had applied the principle equally to his social conscience photography. His original reputation was based on a small number of images used successively in newspapers, magazines, a book, exhibits and a lecture series.

The agressive marketer

There are other ways to parlay one set of pictures into numerous sales. An aggressive photographer moved from the West Coast to New York and found it necessary to establish himself anew. He had a good many travel pictures. After some thought, he took a selection to the Spanish Embassy. When they expressed mild pleasure, he asked would they not like to have an exhibit of large color prints of Spain in the embassy—at no cost whatever to themselves.

Why not, they said. He made a similar overture to El-Al Airlines, showing the appropriate pictures, and got the same result.

He then set to work producing the prints with the assistance of a lab. A friend helped him design and build some simple, transportable stucco mounts for the pictures. The installation could be almost instantly accomplished. The Spanish Embassy was quite pleased with the effect and held a formal opening, attended by their ambassador and members of the press. A similar procedure was developed at El-Al. At the cost of a few hundred dollars, the photographer found himself with two floodlit exhibits on Rockefeller Center. Not wishing to fail in capitalizing on this, the photographer explained the situation to the distributor of the camera he had employed in his travels. He pointed out that in each exhibit was a picture of the photographer himself with three of those cameras around his neck. This excellent publicity was acknowledged in ways which included a national ad by the company featuring the photographer and his work. The photographer also developed an angle on part of his trip which was salable to a glossy travel magazine.

Around this time he approached a professional photography magazine and inquired as to whether a story on this experience would not be of interest. It was, and illustrated with his travel photographs and half a dozen images of him building the exhibits, an article called "There's No Business Without Show Business" was published, and he was paid for it. Shortly thereafter, several countries requested that he render similar services to their landscapes, and he went off around the world, but not, this time, at his own expense.

Most interesting, perhaps, is the fact that while quite nice and certainly competent, the original pictures were less than extraordinary. The photographer had taken some time to evaluate needs, and spent a little money to back himself up. Usually the investment will be one of time rather than cash, but the principle may still apply.

Especially if you are trying to break into print for the first time or want pictures to help you get assignments, supporting your own expeditions in one way or another may be necessary. You ought to have as much faith in your abilities as you are asking others to demonstrate. If sometimes this means paying your own expenses for travel or exhibits, recall that many top professionals do so. They call it "shooting on speculation."

Until quite recently, virtually no photography gallery could even approach a self-supporting status. Every photographer shown, including the most famous, had not only to supply his own mounted prints but often the cost of invitations, painting the walls, and maybe the gallery's operation expenses as well. This is still frequently the case, but getting an exhibit hung is no less

competitive. Note that our travel photographer chose to spend his money another way without facing competition. Exhibit opportunities abound for those with some initiative.

Showcasing

You may have to support your career by contributing your work to publications that pay close to nothing. Many represent excellent opportunties for self-promotion, rather than personal insults, as many clever professionals know. Among the publications that pay least may be the most prestigious, either in their own field or for your special purposes. Consumer and trade magazines may have influence because of the makeup, rather than size, of their audiences. A photography magazine may pay nothing for a cover picture to hundreds of dollars. Photographers compete for even the nonpaying positions because of the exposure they gain.

What we are talking about is the idea of a showcase. You want to show off your abilities by getting your photographs shown in ways that reach either a very large audience, or a very special one. Many markets, such as the commercial and corporate ones, need some testimony of your capabilities before risking complex campaigns and large sums on you. Even further, a good showcase brings you to the attention of buyers who are difficult to locate or approach directly. The best showcases for many purposes are magazines, because they reach your selected audience in reaching their own, and give you publication credit.

Make sure that a publication will run your name with your images. Pay is less essential. A publication that uses your photographs, gives you credit, and makes your work look good is a salesman for you.

To think that professionalism requires you to be paid at standard rates for every picture is a foolish attitude not shared by those with long-range goals. Of course, you do not want to squander your energies in directions that will not pay off in the long run. You need a personally determined list of good showcases to strive toward. These can include magazines that cover your hobbies or professional interests, and also newspapers and other locally circulated media which may establish you as an expert in your own community.

You may also wish to occasionally take advantage of your nonprofessional status by offering to cover an event for an interested party without charge, or asking payment only for the photographs used. Local newspapers, for example, seldom have enough staff to go around and may welcome an offer to provide pictures of routine events such as a Boy Scout Jamboree. After all,

nothing is risked if your coverage is poor; but if you take the time to make it good—especially with interesting, candid closeups of the children involved in something—you can make an editorial friend who might think of you next time he needs help.

Countless analogous situations exist wherever you live if you orient yourself to notice them. Giving yourself assignments, with or without a buyer alerted, will be of enormous help to you. There is absolutely no substitute for experience. Editors do not hire proven professionals when they can afford to from some snobbish preference, but because they need photographers upon whom they can depend. Resourcefulness in any situation is built through experience. You need not be hired for large sums to find opportunities for gaining experience. Photographing famous people is essentially the same as photographing your relatives and neighbors; making an interesting image of the church down the block is as easy, or hard, as a medieval one in France. One of the best portfolios I ever saw, assembled by a photographer who wanted travel assignments, consisted entirely of images made within a few miles' radius.

Exploring your market

To take the idea of vertical market-building further, you may want to do a little easy detective work. Once you have identified a subject as interesting to you, pick a starting point and use your wits. Magazines provide excellent take-off points.

Animals

Suppose you like photographing cats and want to find out if this skill is marketable. The market guides list several magazines for people with professional or sentimental interest in cats. And their circulations are not negligible: *Cat Fancy*, 75,000, and *Cats*, 50,000. Listings in *Photographer's* or *Writer's Market* indicate requirements as to type of image (both prefer transparencies at least 2¼) and tell you payment rates and kind of material wanted. You send away for sample issues and contributors' information.

Studying the magazine can give you some helpful insights about the overall market because it is a showcase for all sorts of goods and services besides photography. Here is a list drawn up by scanning just one issue of *Cat Fancy*:

Advertising: Cat products are shown in use or with "portraits" of cats.

Packaging: Great variety of products use picture of cats on the package.

Breeders: Champion prizewinners are photographed apparently for their breeders. Some are professional quality, others are poor. The pictures are used in the breeders' advertising and supplied to the magazine for editorial use.

Posters and calendars: Produced for sale to cat lovers.

Books: A surprising number of books is produced on cats. The range is from cute story books to pet care manuals and cat encyclopedias. The books use cover and inside illustration.

Picture agencies: Several images are credited to agencies, suggesting that a good collection of cat images might interest stock houses.

The magazine: Seems to use color covers of cats selected for impact and quality. There is some general editorial illustration. Good pictures of cats are used to illustrate general stories. Others, of specific breeds and situations, seem done on assignment. Nearly all are credited to a specific photographer. Several color seasonal images of good caliber are used dramatically to make the issue attractive; they appeal to the idea of "Give a cat for Christmas."

An observant reviewer can emerge from one issue of a magazine with a reasonable idea of the range of markets a subject suggests and some leads that could be worth pursuing. Personal articles and stories with illustrations might suggest themselves.

The photographer would have a context for exploring his own experience and that of friends for story ideas which would appeal to the magazine's audience. He would find other potential markets to follow up on, with the support of his source directories. And if he is really alert, his analysis of the issue will indicate some opportunities that are not being adequately handled.

The reviewer of *Cat Fancy* would notice that the images of their animals supplied by breeders and competition winners are frequently extremely poor in quality. The magazine obviously has no choice but to publish many such pictures. Breeders might be interested in paying for better photographs of their animals. It is easy to think of a sales pitch that would increase their awareness of how excellent photography will be profitable for them.

How would you find such people?

The magazine content immediately suggests at least two ways: You could find out whether the national breeders' associations, several of which are discussed, would supply you with membership lists, and you could select those which are near to you. Or two, you could attend a cat show in your area and bring your camera.

The latter approach would provide new possibilities, such as photographing the competition winners and the cats of other proud owners or photographing

the overall scene as a human interest story for a local medium. Most important, you would be building up your files of images in the subject. Especially if you kept track of "who" you were photographing and the breed, you could develop a photo collection of legitimate interest to book publishers, photo agencies, and animal magazines. (Note that many users may require model releases provided by the animal's owner, just as for people.) Building a comprehensive stock file puts you into a whole new game where your objective becomes to promote your files as a resource to a broad range of possible buyers.

Meanwhile, accumulating good pictures is developing your skills, giving you material for a strong portfolio and providing you with the experience needed to undertake assignments.

You might also think about utilizing your work in exhibits that you would offer to breeders' associations and cat fancier clubs, or to local showcases such as banks, clubhouses, or perhaps the children's ward of a hospital. You might offer to lecture a local pet or breeding group about how to take better pictures of their animals, establishing your expertise for the time something really fine is needed. You might want to promote your abilities to produce appealing pet portraits for fond owners. There are many such professional specialists working today, and charging fees comparable to the best photographers of human portraits.

The larger market for animal pictures can be observed all around you once you're tuned in to it. Consider calendars, greeting cards, posters—and newspapers. Newspapers never seem to have enough cute animal pictures. Local publications and Sunday supplements are often in the market. And animal pictures always make good contest entries. They are first-rate attention getters and thus employed by a great variety of users for purposes not really related to the photographic subject: advertising and public relations campaigns, fundraising projects, window decoration, and so on.

A specialized field such as animal photography really repays some time spent on picture-scripting, suggested earlier. This means analyzing the qualities of a good picture to evaluate what you've done and visualize what you're working toward. You're apt to find that the most arresting animal pictures in whatever medium share certain qualities. Interesting expressions are valuable: for instance, appealing, alert, interested, curious. So are interesting poses or positions, as long as they look natural (except in the formal champion pictures). Cuteness and humor usually work, and good closeups often do. Favorites with many viewers are pictures that seem to show human qualities and those which combine unlikely playmates, such as the puppy and the kitten or the dog and the turtle.

Ideas for selling animal pictures are surprisingly limitless once you start thinking about it, because you're dealing with that wonderful commodity called human interest. This gives you a product that is universally appealing, not datable, and endlessly resalable.

Travel

Cultivating a market vertically takes an amount of imagination corresponding to the degree of competition in your chosen field. Just about every photographer takes travel pictures, for example, and would like to sell them or obtain assignments to go somewhere and take them. The obvious buyers are pretty well saturated with travel picture submissions; these are the travel magazines, calendar manufacturers and airlines. (Which is not to say you cannot sell to them—they may not need random pretty pictures, but they do need ideas.)

A whole volume could be devoted to the subject of marketing travel pictures, but for a start consider the following possible markets where the competition is apt to be far less:

Local newspapers, especially the Sunday supplements and travel sections of large newspapers, are good bets. Television stations often maintain stock files of pictures. Book publishers use travel images for text books, language books, travel guides, cookbooks, encyclopedias, and a wide variety of illustrative purposes, as for instance on dust jackets. Large book publishers often employ picture researchers or editors who review portfolios against current needs, and see photographers by appointment just like magazines.

House magazines may have operations or offices in the locale, or may run general travel material. If you work for a company or have a relative who does, it will probably give your submission special preference.

Publications other than travel magazines may include travel subjects and may use travel pictures for covers. The magazine may be slanted toward a particular audience—doctors, for example. A surprising number of publications are published for doctors because they are a select, high-income readership. Advertisers anxious to reach them include not only pharmaceutical manufacturers and other suppliers, but purveyors of expensive luxury products such as travel. When hotels and airlines advertise, the magazine must provide editorial backup, i.e., travel stories.

Material may be oriented to a special interest group: the same city would be seen differently by *Cosmopolitan, True, Ms.* and *Ladies' Home Journal.*

Clearly when you develop an angle for a special audience, either before making the trip or on the spot, you are better equipped to get the pictures you

would need and to market them. Travel photography is a particularly strong example of the initial premise we made: Selling demands a salable product brought to the right buyer.

Remember that if you are aiming for a fairly glamorous showcase buyer, such as a good newsstand magazine, your pictures of frequently-seen attractions will have to be highly imaginative. Such buyers will want a new view of an old subject. Other buyers, however, like some stock picture agencies and text book publishers, will find technically excellent standard shots of familiar attractions quite acceptable. Often they need images which instantly say "Paris" or "London" to the casual reader, so straightforward Eiffel Towers and Towers of London are wanted. Both kinds of markets may be interested in coverage of out-of-the-way places from a photographer who paid for the trip himself.

Whether you are shooting a travel story on assignment or speculation, attention to the following can help you please the editor.

Shoot black-and-white as well as color. Most photographers tend to shoot color only, but no matter how beautiful the results, many buyers cannot use them. A publication may be able to print only a few color images but can run black-and-white for the balance. Some photographers carry two cameras; others prefer one camera with color negative film which will yield acceptable results in either color or b & w.

Try more often for images which explain something important about the place you are covering rather than just pretty pictures. This may mean images which reflect a country's economy—agriculture or shipping or whatever—or geography, culture, ethnic makeup, and entertainment.

Be alert for events, such as a carnival, open market, festival, athletic competition, parade or fair. Activities which are accessible to you can be goldmines for interesting pictures. When you do find something like this try to cover it as a journalist would—telling the whole story, not just shooting a few random pictures.

Use people in your pictures as often as possible. If you are photographing a sports event, remember the audience. In a 500-year-old cathedral, modern-day worshippers will add another dimension. People are the most effective means for creating general interest. Many beginning photographers seem to carefully eliminate all human traces from the scenes they record and end up with a boring set of postcard pictures. Remember, too, that the most effective people pictures show lively expression or a genuine-looking involvement in what the subjects are doing. Travel photographers make a point of hiring local guides

not only to save time in site-hunting, but to assure that a willing model is available when needed. Fellow-tourists are not to be overlooked either: many kinds of travel articles use pictures of happy tourists to advantage.

Provide, whenever possible, a long, medium and closeup view of important subjects. The first gives overall context and may be essential; the last often gives the something extra to create interest. If you are photographing an archeological dig you will want views which show the site in relation to its environment, pictures of the people working, and closeups of the artifacts produced. If the subject is a building your closeup might be a quite small detail area; if it is a crowd, closeups of faces will add drama. Often travel pictures and resulting slide shows are boring because this simple way of adding variety is ignored.

Experiment with your photographic options on the scene—selective focus, lens choice, background-foreground juxtapositions, perspective and angle. To see something in a new way requires you to look carefully, explore, and work at it. You may have to return to the scene more than once for the weather, light, or situation to be just as you want. Variety can be added with nighttime scenes, rain, or different time of day.

In short, travel photography is just like any other photography. You must observe closely to find interesting things happening, use your photographic tools to create interest in what may be commonplace, and choose naturally interesting subjects when you can. And don't forget that photographs of Detroit are travel pictures just like pictures of Paris—provided your audience doesn't live in Detroit.

In-depth coverage of American cities and locales is important travel coverage in every medium. The dollar's decline in relation to foreign currency has put new emphasis on travel in America, and travel magazines, airlines and so forth have shown a corresponding interest in American attractions. Even further, visitors from other continents are travelling in the U.S. in great number because now they can afford to, so foreign publications are better markets for stories about American locales. The American way of life and outlook are fascinating to others.

Establishing yourself in a market of your choice is a building process. Every new opportunity is created by the foundation you have laid for it. This is true because you are developing not only photographic skills but also your marketing skills. Opportunities are recognized only by those prepared to see them. Intelligent awareness of your potential markets will reveal continually expanding possibilities.

Horizontal building

One simple technique of classification proves enlightening to many photographers. The same stock of photographs can be reviewed from many viewpoints, and the process is one of analyzing a photographic subject to see what else it is in addition to its primary classification. For instance, it might be productive to categorize a set of travel pictures for possible other interests, such as anthropology, architecture, people, sports, food, celebrations, religious scenes, folklore, crafts, children, animals, women, landscapes, or parades. Why? Because each such category suggests an entire new range of markets. Each might be investigated separately according to your personal predilections and stock files. You might find that the secondary classifications markets offer better chances than the original ones.

Sometimes a little investigation can yield wholly unanticipated advantages. For example, if you have a good collection of people pictures taken in your travels, you might find them relatively in demand for general illustration purposes for a particular reason: Many publishers will use such images only if signed model releases are provided, when the pictures are of U.S. subjects; but most will not require this for foreign subjects. This is why a disproportionate number of overseas people-pictures are represented in some domestic photo magazines.

At other times you can zero in on ideas for a special interest audience, or seasonal concepts, by in-depth review of your files. Good Christmas pictures taken last year may be highly salable in July, for next Christmas's magazine covers. Or you may have good shots of a subject or place that is now in the news. Or you can develop photo-story ideas by cross-referencing material shot in different locations, even over an extended period of time. You may isolate some interesting subjects: thatched roofs of Europe, doors of Spain, or mountain flowers. Other ideas may be thematic: confrontation of old and new in the Yucatan, working children of South America, and so forth.

Because of such possibilities and for many other reasons, professional photographers who want to maximize use of their pictures place considerable emphasis on careful filing. It is important to know what you have in the greatest possible detail; you may wish to develop a system of cross-referencing. This means assigning some sort of code number to every good image, filing it in a logical sequence for retrieval, and entering the code number on index sheets labeled by subject, location, and other relevant factors. One picture may merit a dozen classification labels. If this sounds time-consuming, it certainly is; but it will prove a necessity if you hope to sell heavily from stock.

Another way to horizontally extend your market is to consciously apply your skills to one or more new subject areas allied to one already cultivated. If you have developed a skill for photographing cats, it will be natural to add dogs to your repertoire and double the marketing possibilities. Less obviously, you might move into farm animals, which is a whole new game and very much alive in farming areas. Or you might even move into child photography and find many similarities of approach.

Good photographers are restless for new challenges and new markets. The most successful of all animal photographers, Walter Chandoha, decided fairly recently to widen his horizons by marketing nature and farm scenes. Although his market for animal pictures was thoroughly established, no doubt he had to research the newer area just as you would.

You may choose to encompass a new subject area which seems quite contrary to one you have previously worked with. There is no reason not to do so, but some caution may be advisable regarding your portfolio. A photographer I know decided that photographing children had become tiresome and he would much rather solicit assignments to photograph buildings. He began showing a portfolio composed of the new pictures plus a handful of the children pictures, and found to his frustration that viewers focused almost totally on the children. It was a simple case of the pictures of the children being much better than those of the buildings. Eventually that photographer may shoot buildings very impressively, but in the meantime discarding his existing skill with children would be foolish. Remember, things that come to you most easily may give you your best results. Do not assume that the particular subject is equally easy for everyone else. Seeking new challenges is fine, but it is silly to throw away your most natural talent and advantage.

Further, when you add new subjects to your list, think carefully about the overall direction in which you want to move. I was surprised to learn that the photographer just mentioned thought that adding pictures of buildings to his portfolio would give him better chances at travel and journalistic assignments. He would have done better to analyze the market needs in more depth, which might have led him to conclude that pictures of people would be useful additions to his portfolio—and certainly a more logical extension of his skills with children.

Some photographers find it productive to analyze their specialties in terms of a larger field. A photographer particularly adept at photographing architecture would find no problem taking excellent pictures of restaurants and hotels, for example. I recall one photographer who, travelling a lot on industrial assignments, developed a habit of routinely photographing the res-

taurants and motels he frequented. He often did so at night, which produced dramatic pictures of a caliber ususual in the eyes of the managers of these establishments. When mailed a sample photograph, they often were glad to make a good financial arrangement for postcard and promotional use, because hiring a qualified photographer for the purpose would be much more expensive. An architectural photographer could also make excellent construction site images, which offer endless possibilties for the product application pictures prized by manufacturers and suppliers.

Another market development technique is to figure out which additional markets need the same kinds of qualities cultivated for your existing work. A photographer in the food industry for example might become expert at taking clear, natural-looking pictures of people working in small kitchen areas. Such a set of skills would apply handsomely to picture needs of hospitals and medical laboratories, to name just a few. The better art directors and editors will understand this principle. You need not always show a picture of a perfume bottle to show your capability to photograph one—a well-handled wine glass or test tube will make the point. A closeup of an olive shows you can probably do a variety of small still lifes. The demonstrated ability to get action sports shots will indicate you can get good fashion-show pictures. So examine your work to see what skills it shows off; then do some thinking about markets that need these skills. Once you have thought of a new potential outlet from this angle, you may already have the presentation you need for it, or you may need to do some tailoring.

Creative marketing involves some blue-sky thinking, some research and a lot of follow-through. No one likes rejection, but a certain amount is preliminary to success for just about everybody. Once you put your mind to work on searching out appropriate markets, preparing material for them and making submissions, you will be amazed at how quickly you learn a great deal: about marketing, photography and yourself.

The Power of the Idea

THE photographer who is satisfied with placing an occasional image before an audience can follow the methods described in this book when the impulse arises. It is possible to make money and reputation by selling from stock and making the rounds with a fine portfolio. But there is one asset that can put you head and shoulders above the crowd: the ability to originate ideas.

An idea can be contained in one image or a group. An idea may be expressed in purely visual terms, in words, or by a combination of the two. (Ideas can also be expressed in mathematics and music, but these do not concern us.)

An idea can be an observation on experience, a viewpoint on events, an opinion, a framework for facts, an exploration of a thought or feeling. The capacity for generating ideas, and realizing them, is of inestimable value to virtually every kind of photography. In the commercial and advertising arenas, a photographer's creativity is rated not according to how well he can carry out orders, but how imaginatively he can interpret needs, suggest solutions and devise strong visual *concepts*. Artistic photographers who want to see their work accorded major exhibits, or published as monographs, must think not in terms of random images but of assembling *themes*. The photojournalist on assignment is expected not to record everything he sees, but to make meaningful, thoughtful selections that deliver *messages*. And perhaps most of all, photographers interested in magazine assignments—editorial photography—must concentrate less on selling pictures, and more on selling *ideas*.

Can the ability to create ideas be learned? Absolutely, in the case of many photographers, provided they practice the kind of thinking necessary. It is mostly a matter of mental exercise. The reason so few photographers are oriented to idea-making is because of the historical undervaluation of their role in communication.

When photography is viewed as merely a frill, or at best a secondary support to words, one must expect that the primary impulse will come from writers. It should not be surprising that the ideas that writers originate are geared to show off *their* talents, not a photographer's; so the potential of the visual aspect is inherently limited. All too many photographers have passively accepted this state of affairs. Many continue to execute other people's ideas for a fee, or retreat to a photography-for-art's-sake ethic in which only self-expression need be considered.

The obvious way out of this immensely wasteful situation is for the photographer to take the lead. If he wants publishers to take better notice of communication's visual side he must himself originate stories and concepts that will prove the point, while showcasing his own special talents.

As I heard one well-known editor put it, "Talent? Who needs talent? The country is lousy with talented photographers. But give me a photographer with an idea...." Scan volumes like *Photographer's Market* or *Writer's Market* and you will see similar statements more genteely phrased by hundreds of editors of consumer, professional, trade or house publications.

Generating ideas gives you an unparalleled chance to take control of things. Try marketing your experience and skills purely through images and you are dependent on luck: Do you happen to have something which is needed at that moment, will anyone remember you if an appropriate job comes up, is someone with more experience available, will they take a chance on a new photographer, and so on. Originating ideas gives you the power to fashion your own opportunities rather than hoping accident and luck will throw things your way. Moreover, it puts your photographic skills at the disposal of a vastly expanded market.

Here are some illustrations of why the idea process works and how it functions. Put yourself in the editor's mind and compare queries 1. and 2. in each case.

1. "I am an experienced photographer who will be travelling around the Far East next month. Is there anything I can do for *Kitty World*?"

2. "I am an experienced photographer who will be travelling around the Far East next month. Would you be interested in a story on 'Cats in the East: Sacred or Supper' for *Kitty World*?"

1. "I have just returned from the Yucatan with a lot of pictures. Would you like to see them for use in *Cosmotripping*?"

2. "I am assembling a photo essay from my extensive coverage of the Yucatan on the theme, 'Ancient Rites and Modern Mayans—a very private tour of the Yucatan.' Would *Cosmotripping* like to see it?"

1. "Since Fourth of July is coming I thought you folks at *Sunday Lifescene* might be interested in a seasonal story. Please let me know."

2. "Every Fourth of July a group called the White Witches of Seaport salutes American Independence in a unique way which is nevertheless fit for family consumption. Luckily I photographed the entire proceedings last year—I am the only photographer ever admitted. Would you like first crack for this year's *Sunday Lifescene* July 4 issue?"

1. "I am an excellent photographer—samples enclosed—why not let me know if the *Human Weekly* needs any material shot in Tortilla Heights, New Mexico."

2. "In my little home town of Tortilla Heights, New Mexico, lives a 120-year-old man who was a slave trader in his youth, a rum-runner during prohibition, and a great humanitarian in later years; he is now launching a new career by running for mayor. Would *Human Weekly* be interested in a photo feature on this unusual man? Samples of my previous work are enclosed."

1. "I am very sympathetic to the subject of your new magazine, *Karatelady*. As the enclosed will show I am very good at photographing male karate events and am sure I can do the same for you. I am available for assignment at the rates listed on my card."

2. "Congratulations on your new magazine *Karatelady*. In my town there is a growing movement which endorses the principles set forth in your opening editorial and a class for three-year-old girls has already been established with considerable success. I think this would make an exciting photo feature for your magazine and hope you agree."

These letters are incomplete. More details on the suggested subject and the writer's qualification would be desirable, and it is unclear whether the photographers are offering to provide written material as well as pictures. But several enormous advantages of suggesting specific ideas are demonstrated.

First, you are far more likely to give a publication editor something that is needed rather than presenting yourself as just-another-good-photographer. Second, you are, or should be, setting yourself up for something you are particularly suited to handle competently. Third, you are creating interest in an idea and thus providing a way for the editor to use you, rather than hoping someone chances to hit on an idea and chances to ask you to do it. Fourth, in taking the inititative, you put yourself in the position of offering something rather than asking for work, a psychological as well as practical advantage.

Your story suggestions will be valued according to their originality, their specificness, and the shrewdness with which you have analyzed the publication's interests. A magazine editor does not need you to suggest ideas that his

staff can easily think of. Certain ideas are obvious to every publication, and in the course of some very long histories, everything may have been done at least once. A carefully thought out new angle to an old story, repeated event, or person well known in whatever the field; or a highly specific approach to a major event, like through a particular person, will always deserve a hearing.

Editors also appreciate suggestions that are so specific that their own thinking process is stimulated. The editor who got the White Witches query letter, for example, might not like it for some reason, but might think about having the celebrations of various odd-ball groups covered (we hope by the person who wrote the letter). In the case of cats in the East, the editor might ask the contributor to skip the supper part and concentrate on the sacred side; he would be most unlikely to get another photographer for this job, considering the inconvenience involved.

Partly for reasons of your own self-protection, most of your best story ideas should derive from some special qualification you can provide. This can be a matter of location, skills or experience, knowledge of the subject, or accessibility to it. Even competitive publications who generally close doors to newcomers open them to those who can get inside places where others can not. An interview or picture story on Greta Garbo would open doors for the contributor, but subjects need not be quite that esoteric. The story of the 120-year-old man would be practically as good for the right buyer, and the letter-writer's rapport with and knowledge of the subject would probably assure him the assignment.

Before delving into the key matter of how to get story ideas, it should be noted that written material can be provided as well as pictures. A certain percentage of story ideas may be purely visual: that is, consist only of images. If a series of pictures with only a little copy is used to tell a story, the result is a photo-essay. Since the great picture magazines arose in the 1940s this format has been idealized as the photojournalist's most magnificent showcase—a one-man exhibit in print. It is very nice indeed to gain this kind of exposure for your work, whether in a newspaper, mass-market or trade magazine, but several limitations are implicit: 1. The market for such work is severely limited, since pictures alone, no matter how excellent, represent an unwarranted luxury for most publications. 2. Most stories require some text, even if only caption material. (Many of the great photo-essays run by *Life* or *Look* and company actually had quite a lot of text.) 3. You may be placing too heavy a burden on your pictures by always requiring that they make complete statements on their own.

Trying to keep solely to visual expressions of ideas is unduly restricting and eliminates you from the major part of the market. There are several ways to get the writing provided, so do not be worried about the problem in considering the following suggestions for creating ideas.

Twelve ways to develop editorial ideas

Developing ideas for stories is a habit that, once cultivated, can become a preoccupation. It is surprisingly easy to invent subject matter once you begin, though many writers and photographers find it harder to determine which concepts are worthwhile in terms of time and money. This does not mean you should lock yourself in a room until you have thought of a dozen good ideas. On the contrary, the most productive approach is to pursue more activities than ever, while consciously observing things around you. Trying to work in a vacuum makes no sense. Here are some ways to get into idea production.

1. *Explore your personal expertise.*

Knowledge has no substitute in cooking up ideas. Whether it derives from your working or leisure time, investigating the possibilities it provides can suggest many of your best concepts. If you ski regularly, for example, you are specially prepared to develop stories on skiing personalities, locales, fashions, and competitions, possibly for other skiers and wider audiences. Before deciding that you have no such special knowledge or interests—what about photography? You may not feel qualified to give advice to fellow photographers (although perusing the professional magazines may change your mind), but certainly you can consider giving the benefit of your experience to a broader audience. A skier could suggest an article such as "How to take smashing ski pictures" to a ski magazine, or to a local publication or Sunday supplement in a skiing area. If child photography is up your alley, marketing possibilities abound in women's, local and other publications for the theme, "How to take better pictures of your children."

Any specialty you have should suggest a how-to story for an audience less informed than you are. The article can be illustrated with your best work and provide you with a showcase. Do not fear that a story on how to photograph your hobby will cultivate competition for yourself. Experience is not easily duplicated by reading an article; what you are doing is establishing yourself as the expert in the field. For this reason, daily and Sunday newspapers in your own area can be excellent outlets for photo how-to stories; the same is true of publications serving specialized audiences.

2. Explore a chosen medium.

Starting with a target buyer can stimulate your thinking process. Besides analyzing a publication to determine its audience, viewpoint, subject interests and so forth as set forth in Chapter 3, you can make a detailed survey of its content over many issues. If one segment of its coverage interests you, such as its travel features, try to generalize the kind of orientation taken in them so you can develop appropriate approaches from your experience.

Do not overlook the editorial indexes made available by many magazines yearly or every few years. These lists of all material published are sometimes run in the magazine, sometimes printed separately; either way, the indexes are usually available on request. Having the index will help you avoid developing something already done. If you think of a new angle on a subject already done, it may still be worth suggesting—certain subjects are covered repeatedly, and the editors search for treatments as new as possible. A hobby magazine, for example, is obliged to repeat the basics frequently, because new readers must be attracted and served; it cannot be assumed that the same people read the magazine every issue to conveniently enable the use of more and more advanced material. Analyzing a number of issues (or editorial indexes, if you want to take the fast way) will clearly reveal repeating patterns. Think about a slightly new angle to some old subject.

Look for possibilities for an updating or follow-up story. A story in an issue last year, or five years ago or ten, might merit new coverage. Perhaps a controversial action bore fruit, or an interesting change has occurred in a place (especially useful if it can be seen in a photograph), or somebody in the news then is doing something new now (or has completely withdrawn, for that matter). A new development may merit coverage which is largely a rehashing of old material. How many articles in camera and TV magazines have you seen, for example, on "What's new in video disc technology?"

A magazine will often supply their editorial calendar. This is the magazine's plan for future issues, prepared for marketing, not editorial purposes; it commonly provides an issue-by-issue breakdown of themes or topics. Such plans provide the focus—often unstated in the issue itself—upon which the sales people can base their selling strategy. The editors must develop corresponding material. A photo magazine might list "Lenses," "Darkroom Work" or "Motion Picture" as subjects-of-the-month for future issues. This does not mean that material in these categories is already collected. The opposite is more often true: the subject is specified but interesting ways to cover it have not been determined. Consider the editorial calendar to be a list of needs.

3. *Explore a subject in depth.*

We said it before and we'll say it again: Knowledge is indispensable for suggesting ideas and angles. The more you know about anything, the better you can exercise your imagination.

The creative personnel of an advertising or P.R. agency do not dream up selling concepts in their offices. They go to the account—its management, plant, facilities—to learn facts upon which ideas may be based. This means not only exploring things you know something about in a general way, but taking a systematic approach to keeping up to date with a subject or specialty. Once you have defined an area of interest even roughly, a really intense search for information is often in order. If your subject is a person, you will want to know in as much detail as possible what makes him interesting or unique, preferably before you even speak to him. A good reporter (whether using words, pictures or both) does not dream of presenting himself without preparation. The preparation may involve biographical research, as well as reading a writer's books, looking at an artist's paintings, and probably checking out some criticism of his work by others in both instances. If your subject is a place—somewhere you're going on a trip—some time spent reading about its history, geography, economy, people, problems, sites and so forth may stimulate fairly specific story ideas even before you get there, including some that might be pre-sold. A base of information will get your mind going, suggest things worth looking into on the scene and prepare you to understand and interpret what you see. This is not to suggest that you should formulate complete opinions in advance, closing your mind to what you see and experience. Your object is to expand your consciousness, not to diminish or limit it.

4. *Stay alert to your environment and follow up hints.*

When something interesting happens to you, or someone tells you an interesting story, or you catch a glimpse of something that piques your curiosity, pursue it. It is not only reporters of hard news that need bloodhound spirit. Think of the world as full of clues to fascinating things waiting to be noticed by an alert eye. Your family, neighbors, friends, newspapers, television set, office acquaintances, trade magazines, store displays and street corners are thrusting information at you all the time. We filter out most of it, selecting only a minimal portion for review, lest we be overwhelmed. (It is theorized that we limit our senses to such a degree that we have virtually, for example, eliminated our sense of smell because so much of our modern environment smells bad.)

Just as you can consciously extend the observational capabilities of your

photographic eye, you can expand your mental receptivity with a little atten-
tion. Besides practicing a closer examination of things you encounter, you will
want to review your experience for story leads. You may recall individuals or
events worth following up now. Moreover, new connections and insights are
always evolving in our minds and can offer fascinating perspectives. Free
association is one of the key characteristics ascribed to creativity and seeing
contrasts and relationships can stimulate excellent ideas. You may find it help-
ful to jot down notations of possible leads as they occur—many writers carry
small notebooks or index cards for this purpose, and of course in your case a
camera might make the record. Good ideas do not necessarily spring full-
blown upon us, but must often be nurtured. So keep track of the seeds for later
reflection and as a resource for even years to come.

 5. *Specify an audience.*

 Story possibilities and angles can become easier to see by thinking of an au-
dience to whom you want to appeal. The audience may be one that shares a
professional interest, leisure activity, religious or political outlook or concern;
it may be of a certain age, sex or status. The better you understand the audi-
ence the better you can interpret its interests. For example, if you were
planning to visit a city and wanted to explore it for material, you might com-
pose a list of potential audiences such as: doctors, conservationists, single
women, children, church groups, fraternal orders, sportsmen and gardening
enthusiasts. The list should correspond generally to the place in question or
your own areas of knowledge. An event can be analyzed from the viewpoints of
possible audiences and help you see more facets than you otherwise might.

 The market guidebooks are useful for stimulating this kind of thinking and
for helping you determine realistically whether particular audiences might be
good ones.

 6. *Be an alert reader, ready to adapt from what you see in print.*

 You should not need to copy or imitate something already done, but
examining the media for suggestions is perfectly legitimate; a good topic is
rarely exhausted by one presentation. A detailed follow-up piece may earn
more attention than the initial coverage. And many media are addressed to
only a local or specialized segment of readers.

 Newspapers are important to keeping you informed. An article, or even a
paragraph from one, may be worth further development as a magazine feature
or for a larger audience. A magazine article may suggest book treatment to
another author. A story slanted for one special audience may suggest another
story with a different angle for a new audience. The material in trade maga-
zines can provide fine ideas for consumer magazines; in fact, the trade maga-

zines are scouted by the consumer press for the early news and technical depth they provide. The reverse is also possible. One can find in a general-interest magazine something that with different treatment can interest a specialized audience.

Since your prime concern is visual ideas, do not overlook television as such a resource, either.

We are not recommending in any of these cases that you simply reword or rephotograph something for submission elsewhere; we're talking about finding starting points for your own explorations. You'll have to do whatever research or legwork is needed to back up the project. You may end up with something that scarcely resembles the borrowed idea at all.

7. *Look for people subjects.*

Important or interesting personalities are prime material for newspapers, Sunday supplements, general interest magazines and specialized publications of every type. The "fascinating character in our midst" is a desirable story, especially in company and community publications. The visiting celebrity is another story that can almost always find a market, not only locally, but well beyond if you get pictures that are special in some way. (I knew one photographer who earned considerable income photographing well-known people who wandered into his small resort town. He had the ability to capture relaxed, informal moments, always appealing to others. Celebrities showing human qualities, such as playing with a child or participating in a charity drive, are also in demand.)

Picture or interview stories may be merited by innumerable people who are not generally famous, but are in some way outstanding or special to a narrow audience. Every magazine readership has its own heros and heroines. And big magazines from *Playboy* to *People* depend on aspiring contributors to bring interesting new personalities to their attention. So know thy neighbor. I can think of more than one enterprising photographer who has supported an expensive trip by seeking out salable personalities along the way—again, not necessarily the most famous, except to a special interest audience. Several have even interviewed and photographed photographers who are well-known in various obscure countries and sold the results to photo magazines.

You will find an astonishing percentage of people ready and willing to sit through your picture-taking and interview efforts, no matter how famous they may be. Celebrities of many sorts absolutely require publicity and many others find it hard to resist. Most will cooperate and give you valuable time, even when you don't have an outlet established in advance (although it is better to have one) or can't guarantee that the results will be used at all (which

is usually the case). Special-subject celebrities—the insurance salesman of the year, the new company president, the winner of the national poker championship—are apt to find the prospect of being interviewed and photographed enchanting—wouldn't you?

People love reading about people and even better, seeing pictures of them—witness all those *People*-like publications and the growing amount of space other kinds of magazines give such stories. So keep track of anyone who is interesting, uniquely accomplished or of special authority on any subject whatsoever, and work backward toward possible buying media.

8. *Look for a human angle.*

Many so-called "human interest" stories are not about people so much as they are about subjects that can be approached most effectively *through* people. Practically any event, situation or place can with enough thought be personalized through particular people. Reporters have always known the advantage of handling huge events—wars, earthquakes, revolutions, elections—through little people. The human-interest approach makes the event easier to grasp (for both reporter and reader) and more importantly, it directly engages the emotions. Which would be more interesting: an illustrated story about yet another space launching, or a picture story about a ten-year-old boy watching the lift-off from his nearby farm and showing off the miniature launching pad he's building himself? Which would be more effective in a newspaper: an article describing the opening of a local charity campaign with pictures of the organizers, or a picture-interview story about a local victim of the affliction in question who was helped and is now participating in the campaign so others may be helped? What more aptly suggests the unemployment crisis: a long economic analysis or a photo story about one unemployed young man spending his time at the unemployment office and dispiritedly applying for jobs and watching soap operas?

Focusing on one person is a superb communicative approach applicable to almost any topic. For a good demonstration of how even a brief focusing on individuals can draw you into many kinds of stories, read some issues of the *Wall Street Journal* or *Reader's Digest*; both use this kind of lead to great effect. If you take the tip from them, you will think whenever possible of who is affected by a given event or situation as a possible subject for coverage. There are also many instances where you might think about who is a good commentator on the event. Is the weather terrible? Find out what the meteorologist has to say about world trends. Has someone seen another UFO? Find out who's the nearest expert, or track down several experts on the subject for diverse opinions which might identify a controversy.

Focusing on subjects through people allows you to handle topics you would not have the authority or knowledge to engage on your own. And, most important of all, slanting stories through people almost invariably gives an immediate visual potential to subjects that might otherwise have none. Subjects that are in themselves nonvisual can be made wonderful material for the camera by this simple technique. It can also work beautifully for making something out of intrinsically boring subjects.

9. *Think down—from the general to the specific.*

The narrowest angle may be the most effective and practical. Also, the more variables you can devise, the more markets you can find. Simply break your subject down into as many units as you can think of. Earlier in this chapter we suggested that a child photographer might prepare a story on "How to take better pictures of your children." This seems fairly specific, but could be further subdivided: how to photograph an infant; taking pictures of mother and baby; outdoor portraiture of children; photographing your children at play; taking family portraits; portraits that teenagers will like; how and why to interest your child in photography; how to frame and hang a family gallery; ad infinitum. Several distinct markets could be approached with such topics, or one buyer might be interested in several articles. In a similar way, an event, situation or occasion can be analyzed and divided into its components. A forest fire, for example, encompasses such factors as ecological considerations—shift in animal and plant balance; inspiration—people helping each other; adventure—the work of parachuting firemen; and women's lib—one of the parachutists is a woman.

Many excellent stories can be developed by focusing a universal theme, fact or problem through a specific example. "Changing America" can be embodied in the experience of one small village; old age through a local nursing home; the new rage for rollerskating through the local rink. The idea is to be alert to contemporary trends and interests, and think through to instances which illustrate or illuminate them in even a small way. Issues that are controversial or emotion-provoking can be especially good bets for this process.

10. *Think up—from the specific to the general.*

Sometimes your interest may be aroused by something that fails to suggest a market, or seems too trivial to be worth developing. But you might be able to bring in additional elements to expand the story's interest or give it significance.

A child receiving a pet for Christmas is an idea of limited depth; but "Christmas at the Animal Shelter," with pictures of children taking possession of newly adopted animals, could have universal appeal. Consider things as

examples of something larger, and try different generalizations. This can be a useful way to make something materialize from your own curiosities. Suppose you know an Indian whose family lives on a reservation. A story about life on the reservation could be interesting; if you were ambitious, you might visit several reservations.

Another approach is to group various examples of something together in order to show contrasts. For example, a photo story on ethnic weddings could show traditional Italian, Jewish, Chinese and Polish weddings held in the same town (a natural for a wedding photographer). It could just as well be a travel story, showing weddings in different parts of the world. Giving a meaningful context to specifics is a basic type of creative activity.

11. *Make up headlines first.*

Have you ever suspected that romance and movie-star magazines invent headlines and then devise stories to go with them? (Like, "How do you ask the man you love if he's a vampire?" Or, "The shocking thing Lizzie said to her husband's ex-wife.") Well, you're right, they do. Beginning with a headline might work for you, too; it could help you focus your thought and make you define what is interesting about a subject.

Suppose you are doing a story about photographing children. You might call it simply, "How to take better pictures of children." But what if you named it instead, before doing anything at all, "Photographing children as they really are." The second title reflects a viewpoint; having a definite viewpoint might give you direction in working the story out. (It is also a better title. It tells the reader more of what the story is about and is more likely to persuade him to read it; moreover, it would sell the editor better.) Don't forget, though, that unless you're working for the romance magazines, a good headline must accurately summarize the range and thrust of a story; if it doesn't, the editor or reader will be disappointed at your failure to meet the expectation you established.

12. *Look for ways to explore the unique capacities of the camera.*

Many of the foregoing suggestions will seem essentially verbal, although most story ideas can be slanted toward photography if enough thought is given to the possibilities of using people or photographing specific events. But some ideas can only be carried visually, and they represent some of your best opportunities. Many of these are so specific that it is hard to generalize about them. But consider every photographer's missed opportunities to show what things look like or what it is like to be somewhere—at a camp, on a fast new sailboat, at a country fair, a revival meeting, a rock concert, behind the scenes at an election campaign. The camera can record someone's experience in a very involving way—how a forest ranger spends his day, Johnny pitches his first

Little League game, Janie finds a flower, Jimmy goes to boot camp.

The camera can take people into places they can't go themselves but feel curiosity for: a steel mill or coal mine, a prison, a mental institution, underwater, inside a cave or in the cockpit of a new jet.

The camera has the unique ability, prized by many an editor, to make something visual and entertaining from something intangible. Thus the landscape or frolicking children that say "first day of spring," the bird huddling on an icy tree that says "frigid weather," the pictures of children and parents that say "family life."

In a similar way, a photographer can make complex abstract ideas visual. For example, the "trapped housewife" can be a woman staring out her kitchen window; "child abuse" can be a crumpled, abandoned doll. The ability to illustrate such concepts may be called on during assignments; if you can deliver what is needed, you will be called again.

Clues for good visual ideas can be obtained by reading the media for topics that are covered verbally, but might be interestingly or more effectively covered with photographs.

Finding story ideas is basically a way of looking at the world. Many photographers find it intensifies their experiences by increasing their alertness and powers of observation. It is a game you can play with your own mind. Of course, you can only follow up a percentage of your ideas, or you will find yourself going madly off in all directions. How can you decide which ideas are best?

Feasibility must obviously be considered. A project must be evaluated in terms of time, expense, perhaps distance. And you will not want to choose projects that don't match your abilities and sympathies. Why try to carry out an idea you don't like or that may be beyond your competence, honestly evaluated?

You will want ideas that make your photographic skills of paramount importance, even if you are also providing text. Therefore, choose maximally visual subjects that assure you of good picture possibilities. As we've said, many subjects lend themselves to a visual interpretation if given enough thought.

Salability counts too, of course. If you begin sending query letters to publications you'll eventually find that a certain percentage of return is typical. One writer found that for every ten letters she sent, she could anticipate receiving two "yes" answers (usually on speculation). So she knew that she could keep busy by mailing (and remailing ideas to other markets) ten query letters a week, following through on the proposals that were accepted.

Don't forget the multiple-market principle outlined in an earlier chapter,

whereby any good subject is seen as potentially interesting to half a dozen or more separate audiences. Exercise your imagination before appearing on the scene. If, for example, you arranged the visit to the Indian reservation referred to previously, an initial run-through of possibilities for specific audiences might encompass: modern Indian craft-making; Indian recipes; attitudes toward current questions such as the Indian power movement, women's liberation and others; changes over the last fifty years as seen by the oldest inhabitants; Indian folklore and ceremonies; and Indian medicine.

This does not mean you should come to a subject with a rigid attitude and pre-decided opinions. Preparation should only help you think better, not narrow your vision. Many of the best story concepts may be arrived at on the scene itself. You must keep alert to the unexpected, peripheral and accidental and include it—maybe even switch directions altogether because a better idea emerges. (If an editor is waiting for something predetermined, shoot both stories: his and yours.)

Don't ignore your impulses. I recall one photographer-writer recounting how she had assigned herself (being, luckily, editor of a company magazine) to cover a story on some massive new equipment being installed at a forestry site. The machinery was as awesome as she'd hoped, but she found herself entranced with the rugged oldtimer who was in charge of the operation. After trying for hours to concentrate on the original subject, she finally gave up and directed both camera and tape recorder at the man. The results were superb and won for her a national award.

One key to originating ideas and choosing among them is to assume that what interests you will interest everyone else, that what makes you angry, sad, happy or excited will arouse the same response in everyone else if you succeed in communicating the cause of that emotion. Emerson defined genius as that capacity: "To believe your own thought, to believe what is true for you in your private heart is true for all men."

Your best work is apt to be that which you feel most strongly about. You may be surprised to find that even in documentary photography, supposedly objective, many of your photographs are nonetheless about yourself. Like it or not, you reveal your feelings and attitudes. That is why it is so difficult to draw lines in photography as, for example, between documentary and expressive art.

Because personal involvement can make for especially meaningful photography, long-range projects undertaken without specific markets in mind are valuable to photographers. The in-depth exploration of a subject that excites your interest, emotions or curiosity can be the most rewarding of all on every

level. Many professionals keep such projects going while fulfilling numerous short-term projects to pay the bills. The luxury you can give yourself of discovering your best directions as you proceed, making mistakes and doing things over, and experimenting has a value that can not be approached by deadline projects for fussy editors. Many pros help support the personal ventures by finding outlets for portions of the work along the way.

You may find that a surprising number of strong story projects, especially when pictures are the dominating element, are simple to an extreme. The ideas are often discovered by their inventors not by grace of an exotic location or exceptional opportunity, but because they are close to home, where what they know and care about exists. International prizes are given not only for coverage of war and assassinations but for photo stories like "Birth," the story of a couple's experience in having a child (winner of a Pulitzer Prize a few years back). Universal, timeless themes are always fascinating if individualized by the photographer's vision and the people he focuses upon. Note which stories in the media most attract and hold your interest, whether pictures or words, and apply the lesson to your own projects.

One final tip: We all may be drawn to violence and disaster, but are likely to get all too steady a diet of that sort from our news media. As a result magazines and even newspapers give special value to uplifting stories that make readers feel good about the universe. Examine your environment for happy events—a personal triumph over disaster, a happy solution to a problem, people getting together to help each other or someone else. When you are developing an angle to some subject be sure to consider any positive-seeming leads to at least balance the negative ones. For example, old age could be covered with images and words describing an old age home, perhaps to encourage readers' concern with the sad conditions. Or you might cover families having elderly relatives live with them successfully. Or you can do both. You have the power to select the viewpoint.

Almost any audience rejoices in stories that look to the good side. This can mean not only general-interest stories portraying teenagers who work for charitable causes rather than smoking pot, but also stories of specific problem-solving in a profession, trade or place.Such subjects are interesting to the local or specialized audience and often to quite a wide one as well. Most major problems today, after all, are really national in scope. So if your town develops a productive approach to unemployment, or conservation of wilderness, or municipal cost-cutting, many people across the country would like to know about it. Selecting the nice things of your world can be worth your while.

10

Assembling
and Writing the Story

Where to get the writing

AN editorial story can consist of a picture narrative, or series, supported by a
copy block or captions; a words and pictures coverage where the two com-
ponents have equal balance; a text presentation in which images play an illus-
trative role, perhaps forming a self-contained unit within the text; or it may be
any variation along this scale. There really aren't any hard and fast rules that
make sense, so talking about photo essays and such is unimportant. However,
it is clear that some kind of writing is intrinsic to nearly all "editorial
packages." What can a photographer do about that? There are some choices.

"Get a writer to do the words"

You can solicit only the photographic side of a story idea, asking the publi-
cation to provide a staff writer or freelance writer. This is feasible if you are
dealing with a magazine large enough to take the trouble and pay two fees, and
your idea is excellent and thoroughly thought out. Even so, your reception will
in large part depend on factors beyond your control, like whether a publication
has a writer based near you or can find one. If you are asking for a writer to be
sent overseas, as many a photographer blithely does, then your idea will have
to be extraordinary.

Most publications are geared to value written contributions as the major
component of almost any story and find it more natural to fill in the photog-
raphy rather than the writing. If you suggest a good idea but offer to do the
photography only, an editor might indeed assign a writer—plus a photog-

rapher already known to the staff. Or if the publication is one that does not value fine photography, the editor might even hire a writer and suggest he shoot a few pictures himself.

Not to be overlooked is the rate of payment. When you ask for writing support, the publication pays you less. Also, many magazines still pay much lower rates for pictures than for text; you don't want to get five dollars a picture for a few photographs while the writer of the text gets hundreds for his part of your idea. So some caution must be observed. You will probably want to suggest ideas that make you part of the package because of your special knowledge or access to the subject.

Despite all these problems, demonstrating your ability to originate good ideas will make you stand out. Editors expect ideas to come from writers because photographers rarely contribute any. Generally speaking, editors are fairly intelligent people whose interest can be sparked by a new idea. If the idea you are selling has unusually strong visual potential, it will merit serious consideration. Moreover, a thoughtful editor or art director will feel that someone capable of generating ideas and expressing them somewhat articulately will be capable of intelligent thought on the scene of an assignment. You may make a friend for the future.

"I'll get a writer"

You can choose to supply your own writer. Working with someone in a team effort can be highly stimulating and offers many advantages. A good partner can help refine your ideas and generate his own. You will be able to submit complete packages to chosen markets, and expect a yes or no response, instead of depending on the publication to find a writer. When you query for advance interest in a story idea, you will be able to sell a complete editorial package, the writing as well as the photography, greatly increasing your chance for approval. Furthermore, a writer may prove to be an experienced salesman for your work, more accustomed to market research than you and able to present the idea in the best light. He may also have some contacts.

A partnership confers advantages in executing the story, as well. You will be able to eliminate all considerations other than your photography when working on the subject, and there won't be the waste of time that always results from sending a writer and photographer to the scene separately. When the subject is people, questions can keep them occupied while you get the pictures you want. Uncoordinated words and pictures will not result when the writer and photographer function as a team.

Where can you find a suitable writer? Naturally you might first review your acquaintances, including club, church, and other membership groups for candidates. Attend meetings of writers' groups. The kind of writer you want to know may already be aware that a photographer could be a productive asset. Some soft-sell at a meeting or a note to the club newsletter could advise members that a skilled photographer is available to carry out their ideas.

How do you determine whether a writer can carry out your ideas? Your best clues will come from talking to the person and reading his material, which he will gladly provide. His outlook and interests should be sympathetic to your own, and you should like the way he expresses himself in writing. Reviewing someone else's qualifications will, incidentally, give you an illuminating sidelight into the way you present yourself and are evaluated.

Another fine way to locate a writer is by contacting someone whose work you enjoyed. A letter to the writer will be forwarded by the publication. Scarcely a writer alive will not respond to your appreciation, and he may well be interested in talking with you about trying a collaboration. Other sources of writers are newspapers and local magazines, whose staff members may be delighted to do some moonlighting.

The drawbacks of working in tandem with a writer are those common to any human collaboration, compounded by creative ego. It will be clear when you are into the first project whether your team will work or not. Do take care to clarify all business arrangements before beginning serious work: Know exactly what each partner should supply, the deadlines, followup responsibility for selling, and the arrangements for paying expenses. Make sure you are agreed on proper credit for your work, since left to their own devices all too many publications will give minimal credit to the photographer. You want equal billing to the writer, but within your team you both should know you deserve it by virtue of time and effort.

Money can be a great stumbling block: The buyer may not allocate specific payment for pictures, may cut drastically the selection used, or may specify minimal payment for them. All possibilities should be discussed and agreed upon in advance, and a fair arrangement formulated between you according to the work involved in every particular case. Take into account not only the relative importance of each contribution to the story, but how the idea originated, whose responsibility marketing will be, and so forth. There are many pitfalls to a relationship of this sort, but if you find the right collaborator you may have a wonderful time and more than double your capabilities.

"I'll write it"

You can do the writing yourself. It is not necessary to have great literary talent to do so. In the course of your school background, personal correspondence and perhaps daily work, you very likely have plenty of practice already. Scores of writers learn photography because the advantages of being able to illustrate their own articles are enormous. You have been using language all your life, so accomplishing the reverse can be easier. Many photographers do so. I can think of cases where reputations have been built and excellent incomes earned by people who provided wholly uninspired text *and* pictures. The only important talent they were marketing was the willingness to do both parts. Among the ranks of such practitioners are some who instruct photographers in the columns and articles of photography magazines. The professional-level photography publications are especially ridden with mediocrity of this sort, because the busiest pros do not want to spend time priming the competition.

Once you accept the idea of trying your hand at writing, the possibilities become infinite. The main stumbling block many photographers place in their own path is a self-imposed fear of writing and a corresponding belief that they are "not verbal." Even if you have not written a caption, letter, report or memo lately, you must have had a conversation with someone. Writing salable stories for publication will not require you to express personal emotions or attempt to communicate anything you feel is better said visually.

The aim of article writing is to present information of some sort in a clear, understandable way. Few editors expect a polished presentation from a contributor unless they are dealing with top literary talent—and a lot of that requires very heavy editing indeed. Many a famous author would secretly acknowledge that an editor should get substantial credit for his work. Yet the raw material supplied by the author is indispensable, less because of how it was said than because of what was said. This is even truer of magazine material. Just as informational content is a major factor the editor looks for in photographs, so is it the essential ingredient of written material.

This means your literary style is of little value compared to the idea and the information presented. You should do your best and check spellings and such, but an editor expects to make corrections, and do a certain amount of rewriting. An editor may ask for a revision if the information is incomplete or may want a total reorganization, and may work with you closely. This is most

apt to happen when you contribute to small magazines that are not paying the
rates required by well-established contributors. These magazines are geared to
helping contributors develop good material rather than expecting it ready
made. For this and other reasons, professional and specialized publications
can make fine starting points.

Note that if your interest is in what is called advocacy journalism—reporting
that deliberately involves the reporter's personal viewpoint and attempts to
emotionally involve the reader—your only real choice is to do your own
writing. You will probably be subject nonetheless to other people's editing
and layout decisions, but at least you will have substantially controlled the
crucially important text.

To help you get started and overcome the mystique associated with "the
writer" (second only to the mystique generated by "the photographer" and
perhaps "the doctor"), here are some practical guidelines. They may be
helpful even if you plan to avoid substantial writing yourself, because
photographing without any informational context is often short-sighted.

A very short course in writing

The process

Think in journalistic terms. Good writing is a process of thinking the
subject through and presenting the relevant information in the simplest
possible form. To tell a story you must have one, but it need not come out of
thin air. Worry less about being a creative artist; think of yourself as a reporter
who can use both words and pictures. Once you have identified your objective
as relating something outside yourself (even though your personal viewpoint
may be intrinsic to the story) you will find the communication process much
easier.

Subject

Pick your subject carefully. It should be within your capabilities and
something you feel enthusiastic or curious about. It should have limitations
you can define: You do not want to find yourself attempting an illustrated
history of the Western world. You should know enough about it to at least
figure out how to get more information.

Market

Think of one or more specific markets, and think through the audience's interests and concerns in relation to the subject. This enables you to develop a suitable angle as the work progresses. Naturally you can accumulate information for more than one version of a story at the same time, but avoid offering superficial coverage for any audience.

Like the Boy Scouts, be prepared

Have the right equipment and be ready to use it productively. In order to be sure you will have written material to work with later, analyze beforehand what you need to find out. Some background research may be called for. If the situation is one where you will ask questions make up a written list in advance. The situation will take off on its own course if you're lucky, but you will need to start it off, prime it periodically and check back later to see that the important points have been covered. The security of having the written list will allow you to concentrate on what is being said. Write or type your list on one sheet of paper or a card, legibly, and in order of descending importance, so you do not find yourself with pure trivia should your time be up midway through.

Who, what, when, where, why

Remember the five W's in preparing your list and while you are at the scene of any event. Who, what, when, where and why are the journalist's constant guides. Answer these questions and you have established the informational framework of your subject. Other questions can explore the special interests of your audience, points of personal curiosity, controversial topics, and anything interesting that happens to emerge, even if it doesn't seem directly relevant to your subject at first.

Write everything down

Obtain and record all the information you can think of at the scene. Don't trust to memory or think you can follow up later; you may not get the chance. This rule applies even when the most you expect to write is captions. If you are photographing people, at least get their names and addresses if you ever

envision publishing the pictures. As the saying goes, I wish I had a nickel for every photographer whose photographs were wasted because he didn't have a model release. Even if you're not asked to produce the model release, an editor may want the subject's name. Write the information down on whatever you like to use. Steno pads are good. Or use one of the marvelous little cassette recorders that are now available quite cheaply; it will leave your hands free. Just be sure to check periodically for battery failure or other foul-up—like the tape's run out. (I wish I had a nickel for every writer who forgot to check and found himself without a note to stand on.)

Tape recording is a superb way to avoid a lot of writing you don't want to do. But don't be surprised at the pages of words you'll have. Using a tape is not so easy a thing as it might seem; transcribing it is time-consuming even if you type well, and good editing and intelligent rearrangement of the material is usually necessary if the story is to have any interest at all.

In some situations, you might want to construct a question-and-answer story straight from the tape. Another very promising option is to build your story around direct quotes from the people involved. Nearly always you will need some narrative to pull the piece together, but pictures-plus-quotes can form a very attractive core to the treatment of a good many subjects.

Check for accuracy

Try to check information for accuracy insofar as possible. Questionable statements can be dangerous to everyone, including you. If you are relating technical information, at least check with your source anything unclear. Every source will prefer to give you the extra time, rather than be misrepresented. Do not hesitate to either phone your subject with more questions or even arrange a new visit, if something important has been omitted. Most interviewees are very nice about such things, for their own protection.

News story

If you are dealing with strictly news information, whether in an article or in a caption, use the inverted-pyramid format. This means you begin with the most important facts (often the five W's) and follow them with further detail and information in descending order of importance. This draws the reader into the story and allows him to stop whenever he wants without losing the major points. Equally significant, it lets the editor review material and cut it to required length without tampering with the basic presentation.

News is meant to be absorbed with maximum speed, so clarity and logic are critical. For examples of this style, see any decent newspaper.

Feature story

In a feature story, you have more leeway in choosing an approach to the subject, but the writing problem is a little more complicated.

It is essential to interest a reader in your subject so he will read it. For this reason, the most important element is the lead, the first sentence. The lead sets the tone and direction for both you and the reader, and so is worth considerable thought. One approach is to think out the aspect of the story that is the most interesting, either to you or to the audience you're addressing. Some stories are best begun with a paragraph or two establishing why that which follows is interesting, useful or relevant to the reader.

Decide before writing the text what length is appropriate. On an assignment this is determined by the editor; don't forget to ask him about it at the outset. But even on assignment, and always when you're not, length must be decided by the story itself. How long a treatment is justified? Not too long. No one wants stories that are mostly filler, nonessential and uninteresting information to make a piece longer. (This habit was fostered long ago by publications that paid by the word.) Today readers get the point fast or stop looking for it, and editors need to make the most of their page space, so conciseness is valued.

Putting the story together

If you are going to write from notes, start by putting them into a form that can be examined conveniently. Tapes will have to be transcribed, probably on a typewriter, since it is nearly impossible to write from the tapes directly. This can be tiresome, as noted earlier. Your hand-written notes should also be typed, to make them easier to work from.

One useful approach to organizing your material, especially if it rambles, is to break it down into small topics. The notes from an interview, for example, might include: biographical data and qualifications; latest accomplishments; opinion of modern trends; plans for the future; and so on. You might type each such topic on a separate sheet of paper. You can then shuffle the sheets into an order which seems logical or pleasing to you and find that a substantial part of the writing task is magically accomplished. You are ready to make effective use of your material.

Remember that there is no right or wrong way to present a feature story.

Twenty professional writers would prepare twenty different versions of the same body of information. Rarely will they actually have the same body of information, even if they have attended the same event or press conference. People just hear and think differently, so you may as well assume that your judgment is as valid as anyone's.

Writing style

The rule is: The simpler the better. Clarity, directness, straightforwardness and conciseness are the qualities valued today, a circumstance that offers new writers exceptional opportunity. Sentences may be kept short, but not so short that you have to repeat key words often. A favorite technique for many writers is to alternate long and short sentences, which tends to establish a more interesting pattern than you get with all sentences the same length. Paragraphs should also be fairly short—perhaps three to six sentences—and should begin when a new thought is introduced. A feeling of immediacy is helped by using active rather than passive verbs whenever possible. Avoid anything cute or cloyingly sentimental, and, in all but the rarest occasion, disdain exclamation points.

Edit yourself

When your first draft is finished, review it carefully—or, maybe better, put it away for a few days and then review it. Check whether your theme seems logically developed; if not, try rearranging sections, perhaps cutting up the pages to do so. See if you can find any gaps in your coverage—questions raised but not answered or a missing piece of information—and remedy the lack if you can. When it is not possible to obtain more information, rewrite in order to make the lacking information not needed; a good presentation offers what you have to advantage, but by no means need it be exhaustive.

Look for repetition of ideas and words and eliminate them whenever you can. Also look for excess verbiage—words that can be eliminated without changing your meaning; phrases and sentences that become clearer when condensed. Quite probably, enough changes will be necessary to require a second draft. Many writers expect to prepare a number of successive drafts before being satisfied. Your written material, like your pictures, should be the best you can do.

A writer's reference books

Keep a dictionary on hand, and a thesaurus, both available in inexpensive paperback editions. If you want advice on style and grammar, a beautifully brief and readable companion is the Strunk and White classic, *The Elements of Style*. *The New York Times Manual of Style and Usage*, 1976 edition, is also useful. Other fine, practical writing aids include Jacques Barzun's *Simple and Direct: A Rhetoric for Writers* and William Zinsser's *On Writing Well: An Informal Guide to Writing Nonfiction*, which contains samples of good contemporary nonfiction and gives special attention to travel, sports and criticism writing. A great deal can be learned by reading and analyzing the writing of any author you admire or whose style is suitable to the kind of material you want to produce. That's how most writers work toward developing their own styles.

Some hints on interviewing

Eliciting information, ideas and opinions from people is a major part of communications. There is no trick to it; if there is one, it is to remember that you are involved in a basic human exchange. As in any other situation when you meet or talk with a person, he or she will react to your attitude. If you are nervous, uncomfortable and hostile, you will get terse, withdrawn responses. If you are genuinely interested in the person, curious and courteous, you will find it simple to draw your subject out. After all, what could be more appealing than a chance to explain one's self, talents and opinions to a spellbound listener? Let the subject know you appreciate the time he's giving you and, if relevant, his accomplishment or standing. Make it clear you know who the person is and feel positively toward him. Hold any intimate or very controversial questions until later. The best beginning is often a review of your subject's professional or personal history: whatever is relevant.

Many interviewees may be apprehensive about the interview setup, especially those who've had bad experiences with the press, which unfortunately is often the case. You can make your role easier by directly or subtly reassuring him that you have no desire to trap him into thoughtless statements nor to produce some kind of exposé article. Almost always it is to your advantage to make the subject look good. Why discredit your own expert, or debunk the myth of a great man when no one wants you to? (Most of you, we're assuming, are not investigative reporters.)

It is sometimes a good idea to explain exactly what you have in mind and what you are after, so that the limits of your interest are clear. If someone says he is nervous about being quoted, especially if you are recording the conversation, you might offer him the chance to later "retract" anything he said. Usually, he will forget he said it, but if he takes you up on the offer, be prepared to honor your commitment.

Establish at the outset the amount of time your subject can give you. If time is tight you must gear yourself to covering the major points quickly, without forgetting the time needed for photography, if that has been planned for the same session.

Be a naturally responsive listener. This can mean that queries are directed to you which, without monopolizing the conversation to waste your own time, you should answer as honestly as you want the other person to answer your questions. You may find your very best interviews are the ones where you talked almost as much as your interviewee. A good personal situation requires interplay.

Listening also means staying alert to new facts or implications introduced by the subject. Follow up such leads thoroughly because the most worthwhile areas will suggest themselves this way. When a degree of leeway is possible in your coverage, it is often best to follow where the subject's inclinations lead. People tend to be most interesting and informative when discussing their special enthusiasms. Having a detailed list of questions with you, as recommended earlier, helps this process by freeing you from the worry of, "What shall I ask next?" Do not worry if the entire interview goes off in a new direction, provided it seems productive. Unless there is a tight time limit you can always go back to your logical list later. If your subject meanders into an area in which you are definitely not interested, place your next question when courtesy allows.

Be sure to provide an opening at the end of the interview, if not sooner, for the person's special interest or opinion. By the end you are both as relaxed as you are going to be and you can get fine results with something along the lines, "Is there anything you consider important to this subject which I haven't asked you about or anything you would like said?"

An alternative way to end an interview is with a bombshell question: a direct query on a sensitive issue or anything liable to arouse your subject's temper. Certainly you do not want to begin with such a question.

Any interview puts you under an obligation of total honesty and accuracy. If you quote directly do not do so in a context that gives different meaning than intended. A quote may be cleaned up a little grammatically to make spoken

language accord better with the written, but you do not have the right to tamper with what was said. Be logical and fair-minded about the effects you are creating in your story; it is all too easy to slant your report in a way that can affect your subject in a major way.

If you do any amount of interviewing you will encounter people who remain hostile, or who refuse to answer beyond yes or no. Sometimes they are simply not on your wavelength. In such a case, decide on the spot whether the matter is important. If it is, make the best of things and get what you can. If you are not fulfilling an assignment but following up an idea on your own, it may be best to end the interview and pursue another. An offer by you to leave immediately can sometimes provoke a better atmosphere, but do not count on it.

The best approach is to be prepared and be yourself, like they always told you. One of the magnificent side benefits of collecting your own information and conducting the interview comes when you are finished. The logical approach is to make your photographs after the word part is done. If you have left enough time for it, and the interview up to that point has been fairly pleasant, your subject should be wonderfully ready for the camera.

11

Photographing and Submitting the Story

WHETHER you are on assignment for an editor or by your own initiative, supplying both words and pictures or functioning as part of a team, certain requirements should be met. The purpose of the following checklist is not to suggest photographic techniques, but to put you into the framework of publishing. Photographs that best serve editorial objectives are those that function integrally with the overall package. Understand the viewpoints of the other members of your team—the editor, the art director, and perhaps the writer—and you can make the best contribution as photographer. Ensure that the final picture-editing and layout process makes you look good by providing material that can be worked with well. Some of the suggestions relate to the professionalism with which you are expected to function.

Before the assignment

1. *Don't overreach your ability.* Take only those assignments you feel confident to handle. You do not want the pressure of possibly blowing a once-only chance for something important; you may not get another chance.

2. *Research* and review anything you can find relating to the subject. As the photographer, you are especially responsible for asking questions about matters that affect your part of the work: the time of day, the site, probable lighting situation, distances, and the time limits on photography.

3. *Get guidance* from the assigning editor or the editor who has agreed to review your results, if it is on speculation. It is in the editor's interest for you to do a good job but quite often it does not occur to him or her to discuss the impending assignment in detail with you. When necessary, take the initiative in

seeking information; most editors will be pleased when you do. Find out if there is a viewpoint to the story. What is thought most important about it? Who are the prime people involved? Ask how much space has been allocated to the story and whether there are any special requirements concerning format or subject. What ideas do the editors have about the pictures they want?

Sometimes the answers to these questions will be so specific you will realize that without the information, your chances of achieving the desired results would have been small. At other times you will find that nobody has given much thought to the photography, and as the visual expert you should express your ideas about it. Frequently it is possible to secure a larger part for photography in the final product by making good suggestions. Secondary uses for pictures can also emerge, such as a company's P.R. campaign or a slide show.

Outside the ideal, rarely existent, story conference in which everyone discusses the idea thoroughly, a prevalent situation is for the photographer to be called in too late to influence basic thinking. But you can make it clear that you will willingly give the time needed for an advance meeting without payment or appear at the editor's convenience for at least a conversation beforehand. Even in an informal situation it may be advisable to think of this as an interview and make up a list of questions to ask, as suggested earlier in the preceding chapter.

4. *Take the time to think* out interesting picture possibilities. You may want to assemble a checklist of must pictures besides anticipating any special views or interpretations for which you will want to watch.

5. *Run through all possible equipment* that may be needed, with some allowance for the unexpected circumstance. If you plan to work outdoors, for example, consider that bad weather might move the event indoors and that in any case even some outdoor lighting situations call for flash fill. When weight or distance limits your kit, find out where emergency equipment, as well as any backup service you may need, can be obtained at the location. Treat an important assignment like a safari: Have everything that may be needed in good working order, because a missing or malfunctioning piece of equipment can throw the schedule off and make you look incompetent. Provide for your own creative flexibility; bring whatever extra lenses, filters, film and such you may want to draw upon.

6. *Spell out all financial arrangements* of an assignment—the rates, travel and other expenses, payment for models or other people hired, wardrobe and props. Know what rights are being purchased—whether one-time or all-time, whether every image will belong to the buyer or only certain selections. Ask what kind of use is covered in the price. You don't want to be paid at an editorial rate for an image that ends up in an advertising campaign. Check on

when to expect payment, too. Be equally clear on the full extent of your responsibilities. Find out whether you are expected to hire and care for models, props, trucks and special equipment. Ask who is expected to take care of all the processing and printing.

On the scene

1. *Present yourself* and behave as appropriate to the situation. On an assignment, you are considered a full-fledged representative of the organization that hired you, and if you are found badly dressed, rude, overbearing or otherwise offensive, your next employment will have to be elsewhere. Whoever is footing the bill may appreciate talent but rarely at the expense of his own reputation. This does not necessarily mean suit and tie—look as freelance as you like within intelligent limits. And give a thought to your demeanor. When not actively working, an unobtrusiveness may become you, but try not to look too bored, let alone impatient. Nothing can so quickly turn off your subjects and fellow-workers. Even when you are doing something on a self-assigned basis remember that you'll get better cooperation from your subjects by appearing compatible with their lifestyle. People will give you their time as a favor, and put their trust in you, if you seem to deserve it.

2. *Be straightforward* in saying what you need to do a good job; people respond to professionalism. Your confidence will be effective no matter how important a person is involved. They hope you can reassure them that you know your business, because they are placing themselves in your hands. Be honest if you have made a mistake. A friend of mine once showed up for a big shooting and found herself without the lighting equipment needed. She explained the situation and the session was postponed a few hours while she corrected the omission—much preferable, in everyone's view, to wasting time producing poor results.

3. *Cover all bets*: Shoot verticals and horizontals, black-and-white and color. Back up important shots by bracketing your exposures. Consciously vary the coverage in your shots—get long views for context, medium and closeup views. Try different angles, perspectives and lenses if you have time. Be sure to provide anything you have been asked for but add to it your experimental approaches and interpretations. Faced with highly specific buyers whose views probably differ from his own, wise photographers will shoot both "my way" and "his way." The editor may appreciate having his vision expanded. Besides, unless your agreement is for every picture you shoot, you should be

photographing for your files as well as the editor's. An assignment can offer opportunities which you might never have again.

4. *Shoot with a viewpoint* rather than trying to record everyone and everything on the scene. If you have already accumulated background information, your natural instinct will be to decide what is essential, less essential, interesting, and illuminating about the subject. You can choose to fully cover a narrow but apparently productive aspect of the situation, but this should be in addition to broader coverage that tells the whole story. Take time to think while shooting and analyze whether or not some other element will tell the story even better—a member of the audience, someone on the sidelines, the great person after the posed pictures have been made, your fellow photographers.

5. *Try for a summary picture,* one strong, technically excellent image that, if used as the sole selection, would most fully tell the story factually as well as emotionally. The number of pictures to be used with a story can rarely be determined much before press time and will depend on several outside factors—space, relative importance of the story, the quality of other visual material. The art director may only be able to use one of your pictures. And even when ample space has been allowed for photographs, an A.D. loves to have an outstanding lead picture to use, big and eye-catching. Moreover, provide one fine picture of this sort and your work will be approved even if the rest fails to be of interest.

6. *Shoot a time sequence wherever you can.* An event may call for pictures before, during and after the big moment. A situation may suggest a beginning-middle-end approach so that your camera tells a full story. Look for these opportunities and cover them. Besides creating opportunities for use of pictures that would not otherwise exist, a photo sequence gives the editor another option with which to work.

7. *Consciously apply your photographic tools and esthetic choices* to make meaningful selections from the scene at large and emphasize important aspects. Good composition always is called for; selective focus can be critical; interesting angles of view should get attention. Simplicity of background can be especially important. If a picture is to be used small on the printed page, a busy-looking one will be confusing. Plain backgrounds are almost always preferable. They are commonly achieved by throwing the background into a blur, out of focus, or by choosing a perspective that places the sky or a contrasting blank wall behind the subject. Take care when framing your pictures to allow some working margin around the subject and its elements—the missing top of a head or a hand off the picture edge may later rule out some otherwise best

shots. You must keep this in mind if your pictures might be used for a cover; know the requirements for logo space and cover copy so you can figure them into an appropriate image while shooting. When basic requirements have been met, try some personal experimentation or an unconventional approach. The editor will consider it a bonus, or you can use it another time.

8. *Get convincingly real pictures of people.* Sometimes this means staying around long enough so your subjects forget your presence and behave naturally. To speed the process, let them smile and pose for the camera if that is what they want to do, and then continue shooting when they think they have finished. When you want an eyeball-to-camera confrontation—a person looking directly at you—you can provoke a spontaneous expression by your attitude. A tense, nervous photographer gets subjects to reflect those emotions; a bored photographer gets bored-looking subjects; a photographer who smiles and looks like he is having a good time often records similar expressions. The communication of mood is altogether natural; try checking your own pictures sometime to see what reactions you got when photographing with different personal moods. Some well-known photographers take advantage of this human fact by cultivating a clown-like appearance and manner. They travel around the world making people laugh and making superb photographs. But you have to be quick: One such photographer said, "The moment of direct communication is very short. As soon as you get that special response, one person looking at another, you have to shoot like crazy because in a few seconds the person withdraws back into his shell."

In other circumstances it can be very helpful to give your subject something to do. A personality can be encouraged to proceed with his normal activities; a child can be given a toy; good animal photographs usually result from some careful bait or appealing toy. A person being interviewed can be photographed in animated conversation. When you are too intrusive, however, neither the photography nor the interview will produce the results you want. People can be asked to show you things. They can also be encouraged to use props which are natural to them—a pen, pair of glasses, cigarette—to help you get the characteristic gesture on film. Motion, like a moving hand, can provide a wonderful spontaneity.

Study a human subject before shooting, and watch for the nuances of expression and gesture which convey personality.

9. *Be ready to act as a judicious director.* On occasion it is desirable to have people reenact something that happened, but usually you must specify that you have done so when the picture is used. A background may be unsuitable or uninformative and you have to stage-manage the scene. Or the lighting may be

wrong, the people too scattered, a group not photogenically arranged. The freedom with which you can direct such situations depends on what you are covering—the greatest care must be exercised with a news event, which should not be produced or altered by the photographer. At the other extreme would be a posed portrait, or group portrait, where it is to everyone's advantage to show subjects interestingly.

There are many instances which call for a "posed candid"; an industrial photographer taking pictures of people at work often sets up his subject to maximum advantage, so that what he is doing is clear and photogenic. Well done, such an image looks natural. But the technique can easily become boring. Certain newspapers run shot after shot of posed candids, made by photographers trained to combine meaningful backgrounds with the relevant person. So we get the bereaved mother looking at her dead son's portrait. The newspaper looks stilted and false. In trying to replace the old head-and-shoulders portrait, journalism tends to go to the other extreme—the environmental or symbolic portrait—at great cost. There is absolutely no substitute for the real thing. The moving expression, meaningful gesture, and most interesting situations are photographed by those who take the time to observe what really happens rather than stage-managing a shortcut.

10. *Record the information relevant to the photographs* before leaving the scene. This includes obtaining signed model releases when appropriate and any other documentation for which you are responsible. Even when you are working with a writer, the responsibility for knowing exactly what and who is on your film belongs to you. Total accuracy is expected. Many a picture goes unused because people who should be identified are not known.

It is also advisable to check whether you have indeed been photographing the right person. Years back, a wire service sent its best photographer on a trek to photograph a Himalayan holy man who had rarely, or never, been photographed before. The formal appearance was made, photographed, and to the photographer's delight, the resulting film beat the competition by arriving in New York through a highly complex and devious routing. But one problem emerged: The photographer had focused throughout on the wrong holy man, carefully cropping the hitherto unphotographed one out of every frame.

11. *Spend time to ensure your results.* If you have traveled a hundred miles to make some pictures, why not take a few more hours to return to the scene later? You may find an interesting aftermath, a better lighting situation for a scene, or an interesting variation in the weather. Many of the seemingly effortless images you admire in print were made by photographers who sought the desired conditions obsessively. Think of going back for your own sake and per-

haps the editor's. As in the case of the other recommendations, come through with something extra and you will be a photographer remembered. Look for the opportunity every occasion allows.

After shooting an assignment

1. *Follow through.* Pay meticulous attention to deadlines and delivery dates, because no matter how superb your results are, they are useless if not received on time. If your work is processed by a commercial lab, check that the lab meets delivery deadlines. Be sure prints are prepared to the specifications of the user. A lab should know as much as possible about the intended use, and if you are making your own prints, so should you. Whenever possible, you should review the results before they are delivered to the client; don't let the lab mail the results to the user without your seeing them. Some famous photojournalists may work a contrary way, but they have earned the right to such confidence by long years of production.

Be sure to provide all information, releases and permits the customer may need.

2. *Follow up.* If you are submitting contact sheets, go over them and circle those you think most successful. Indicate interesting cropping possibilities with your grease pencil. If dealing with transparencies or prints, separate out those which are your personal choices. This will help the editor and art director and show them you care.

Telephone to check whether what was sent was also received, whether it is as expected, whether anything else might be helpful, and whether anything else might be coming up which requires your talents. You might even mention you enjoyed the assignment and working with the staff.

Ideally, you should review the shooting with the publication staff personally. Not only does this give you a chance to express your opinions and promote your views, but it may help you inestimably in understanding the user's viewpoint. (Remember, final decisions are his.) Further, your presence promotes a predisposition to like the results; a batch of unsorted prints or contact sheets delivered impersonally is more likely to raise objections.

Such attention to follow-up detail can be almost as important as your photographic abilities. It identifies your professionalism, reliability and responsibility. Moreover it helps make you a nice person to work with. People who hire photographers place a good working relationship high on their list of priorities. The unpleasant or unreliable genius will be rehired only in des-

peration. The cooperative, imaginative, helpful photographer is remembered in a field with so many who think solely of their own needs. That is one more reason why so much mediocrity ends up published and it points up another advantage you can give yourself.

Assembling an editorial package

If you have executed a story idea yourself and wish to submit it for publication, the way you present it may be dictated by the story itself. Certain basic guides may be used, however, so that you can be sure your approach to presenting it is acceptable.

The text portion: Although a handwritten caption may get by, even a short manuscript should be typed. Use standard 8½-by-11-inch typing paper, double-space between lines and paragraphs, and leave fairly wide margins (1¼ to 1½ inches). A manuscript need not be perfectly typed but it should be completely legible and neat, with possibly a few small written corrections.

Even a small magazine will respond best to an obviously individual submission, so send the original copy, but be absolutely sure you have a carbon or Xerox copy yourself. The one copy is usually sufficient for an editor. The first page should contain your full name, address and telephone number in the upper left corner. Some professional writers add a statement about rights offered such as "First North American rights" and an approximate word count in the upper right-hand corner, but it is not necessary. About a third of the way down the page type the title of your story in capital letters, centered; under that goes your by-line in upper and lower case. Begin the article about halfway down the page.

Avoid colored paper, unusually colored typewriter ribbons, and typefaces that are hard to read. Number your pages consecutively in the upper right corner; your last name should appear in the upper left corners. Paperclip the pages together. You should also prepare a cover letter explaining what is enclosed and referring to any arrangements previously made with the recipient. Although the length of your text is determined by your subject and the purpose of the story, it can be said that many editors expect an article to be at least five typed pages long, about 1,250 words, plus pictures, to merit full-scale feature treatment. If the magazine has any pretention to thorough coverage, the figure would be closer to ten typed pages, about 2,500 words. Of course, this is a basic matter most properly determined way before the final typing stage. You should know whether the publication you are aiming for

habitually runs a great many short, superficial articles (which looks like the reader is getting more for his money), middle-length features, or very long detailed articles. While some publications balance each issue from short to long, many have an editorial philosophy which predisposes them toward preferring a specific length and corresponding detail.

The photographs

The number of illustrations also depends on the article, but an art director likes a selection at least twice as large as he can use in final form. If your perusal of the magazine indicates that five pictures is typical, or seems appropriate to your article, you should provide at least ten, and fifteen would not be too much. You are thus allowing for differences in opinion and format and the options essential to good layout.

Provide black-and-white and color photographs according to what the magazine uses and the needs of your story. If your article can be illustrated with black-and-white photographs, and the publication uses more black-and-white than color, it is foolish to court rejection by supplying only color. Unless you are advised differently, black-and-whites should always be supplied as prints—never negatives or contact sheets—usually 8-by-10s, glossy or semiglossy, with white borders. The borders allow the art director to place his crop marks outside the picture area, and they ensure that the whole picture can be used; a bent corner on a cornerless print can mean a severe loss of image content. Prints should be in excellent condition and appropriate for photo-offset reproduction (see Chapter 2), unless you know the publication uses another process.

What kind of images to include in a story has to be decided case by case, but the following factors can be taken into account:

Logical coverage: Choose a group of images that tells the whole story, or at least its most important elements. Think through the time sequence and match your pictures to it.

Photographic variety: Include a range of views and subjects, within the context of your story. "A Day on a Fishing Boat," for example, might call for a shot of the boat from the distance, medium views of the crew at work, birds circling overhead, closeup portraits of crew members, action shots of bringing fish in, closeups of the catch, a view of the shore from the boat as it comes in, and the after-docking talk and drink.

Impact: There is almost always a good rationale for including those pictures

with the most impact. This can mean mood shots, or even a landscape, and pictures with emotional appeal; or beautiful images that are related to some aspect of the story. Pictures that show people related to the subject, or as individuals, are valuable, especially those with strong expressions.

Sequences: A series may be appropriate to many subjects and be offered as a unit, in addition to the pictures being used singly as illustrations.

How-to: Pictorial coverage is highly desirable in how-to articles. It is a good way to save words and put the focus on your primary skill, photography.

Results: In a how-to article, pictures of the results are needed; this requirement is often overlooked. A story about an archeological excavation should, for example, include some interesting-looking objects or fragments recovered. A story on how to build a bookcase might be helped by a shot of the finished bookcase in use and nicely decorated. Result pictures can offer scope for your photographic imagination even when the rest of the story is purely factual. When preparing a selection of pictures for editorial use, remember what an editor looks for: information content, attention-getting power, human appeal, and potential for interesting use in a layout.

A good selection of photographs will be appreciated, but you should not send so many that they become unwieldy to evaluate. You can always indicate that more are available on request. Your selection should establish the basic shape the story should take, while offering leeway for personal esthetic preferences, the needs of a layout, and the choice of an emphasis.

Captions

Captions may constitute the whole text or be no more than identification numbers noted in the text ("See Illustration 1."). Very long captions are hard to read because magazines set captions in small type, or they may clutter up the layout in a limiting and detrimental way. Other than those situations in which only a number or a few words are needed, captions can run from one to several sentences. If longer, perhaps one copy block can be provided to accompany all of the pictures; a sequence can be approached this way.

A caption can be done in telegraphic style, but it is best to write in full detail and full grammatical sentences and let the editor cut words to fit. Your captions should be typed on a sheet of paper separate from the rest of the text and in a numbered order which corresponds to the pictures (which can be numbered carefully on the back or the front border). You can head the page "captions" and then simply proceed one at a time, starting with a new line with each new number.

Alternatively, you can type each caption separately and carefully tape it to the back of the print. The first method is more generally useful.

Not every picture needs its own caption, but no picture should be without a caption. If you are enclosing a batch of prints from which one or a few may be selected for "general illustration," simply group those images together in one envelope or folder marked that way. (Identifying information should be with them or on them.) Or, the caption on your sheet may be identified, "Pictures 1 through 14," and the editor will understand he can select from among those pictures.

Mailing

Your final package of manuscript and pictures should fit in a 9-by-12-inch envelope, if you have been following the guidelines suggested. Even a manuscript by itself should be protected with one or two sheets of cardboard. If pictures are included great care should be taken to protect them. Place a rigid board both front and back; keep paper clips away from picture surfaces; mark the envelope "Do not bend—photographs enclosed." Count the pictures in the package and note the number of pictures in your cover letter so there is no question about it later. You may want to insure your package if irreplaceable transparencies are in it; at least consider registering or certifying the material. That way you will never have to worry whether it was received properly and there are cases when you will be glad indeed to have that receipt in hand.

Submission procedures

You have several choices in how to submit a story, according to when in the production process you want to seek a publisher.

Perhaps the most obvious way is to submit a complete, finished package to a magazine: the typed manuscript, a selection of pictures with captions, and a cover letter offering the enclosed to the editor. This approach presumes you have thought out your subject and its execution carefully enough to have a good chance of acceptance. Even when you are confident about gauging the market correctly, it is a good idea to precede submission of the story with a query letter. The letter will identify your material in brief terms and ask whether the editor would like to see it. If you get no response within two weeks or so, the editor is either not interested or will not handle your material responsibly. Go elsewhere. You will have saved a considerable amount of time,

because many publications take several months to respond on material received, even when an immediate negative judgment is made.

A second possibility is to query an editor when your story is underway but not completed. Having someone express interest in advance gives you a nice incentive to doing a good job, and allows for special slanting of the material at the editor's request. Some writers and photographers, when they feel they are onto something promising, will mail queries to various publications that might be interested in some aspect of the subject and develop appropriate versions for those that respond positively. Care should be taken not to approach competing publications simultaneously. It is safer to query magazines in the same field one by one.

A variation of this approach is to write your query letter before you undertake serious work on the idea at all. An expression of interest can provide great encouragement and even more room for special slanting. Quite often an editor will discuss the idea with you thoroughly in an interview, by letter or by telephone, giving you all possible guidance to help you produce good material. In many cases an editor will provide you with the credentials required to gain access to a person, place or organization that would otherwise not admit you. Many professionals try to have at least one tentative commitment in hand because they know people respond differently when you say "I am doing a story for the *Greengrocer Gazette*, may I ask you . . . " as opposed to "I'm a freelancer and am going to try and sell a story to . . . "

But the advance query has limitations. You might drop a good idea because the first one or two editors did not appreciate it. Sometimes it is better to finish a story you believe in and then market it. If your story will be primarily visual, or if the excellence of your photography is a strong selling point for the eventual package, you are undercutting your sales potential by relying on a verbal pitch. Another serious drawback is the possibility that a good idea will be handed on to an editor's friend or staff member while its originator gets a "thanks but no thanks" letter.

Do ideas get stolen frequently? Probably far less often than you might imagine, and less often than it seems to many professionals, who are more likely the victims of simultaneous suggestions rather than copy-catting. But it happens, and not only with fly-by-night operators. Some of the highest-toned magazines deal high-handedly with suggestions. They see their behavior not as stealing, but as loyalty to their regular contributors and simple discrimination against a lesser contributor's qualifications. They do not want a great idea ruined by some unknown. The more honorable editors in such instances will pay a finder's fee.

Idea-copping is relatively rare, and at least the practitioners do not take your finished work and bury it forever as *Life* and *Look* often did in their heyday. These giants assigned so much work that only a percentage was ever published. Some great staffers worked for years in this fashion, never reaching publication, and more than one freelancer got payment in full or a holding fee for never-used material. The idea, many thought, was to prevent fine contributions from appearing in the competition even when they chose not to use it themselves. (Fortunately it is a rare magazine that can afford this game any more.)

Your best protection is to submit ideas that you are obviously well qualified to do and that would be too much trouble for most general writers. You may also be safe where you have some special entrée, even small. If neither of these refuges is possible, take care how much you spell out in your query letter. A paragraph or two is better than giving away a detailed outline to someone you do not know. More information can be provided upon request, as your letter can suggest.

The decision of whether to query in advance or to finish the material first must be made individually according to the nature of your story, the markets you have in mind, and sometimes the amount of time involved. As we pointed out in describing the evaluation of ideas, you will probably wish to develop material for several markets. Several angles can be developed, or the same piece can be tried at a succession of places. Most fields are served by more than one publication.

You have probably noticed that the magic word "money" has not yet been mentioned. Payment rates at most publications are the same for everyone, beginner or pro. The competition to get published is simply stiffer in those that pay $1,000 per article than those which pay $100. You can get an idea of rates from the market guidebooks, or simply ask in your letter—the guidebooks are often out of date. But when do you get paid?

There is an important distinction between being hired to prepare material or shoot pictures, and agreeing to submit material "on speculation." In the first case, a definite money commitment has been made and the terms concerning rates, rights, timing, and so forth are spelled out (or should be). This is the situation usually when a publication needs something in particular and asks you to do it, whether they have dealt with you previously or not. A New York editor who needed a picture shot in Des Moines would check around for a recommendation, or would contact a local newspaper.

However, when you are trying to interest an editor in an idea you have conceived and wish to market, you are usually talking "on speculation." That is,

you will prepare final material without guarantee of its being used or paid for. Exceptions might be if the contributor is famous, can offer an important exclusive, or is for some reason in a strong bargaining position.

Some magazines pay for material if they have approved the idea beforehand. If they are disappointed in the results, however, they will pay for it only partially—this is called a "kill fee."

It may seem a risky business to spend considerable time and perhaps money on a project when an editor has agreed only to review the results. Consider first of all that you often have no choice. Few magazines want to pay for anything that is not already successfully produced and usable. Smaller magazines rarely pay advances to anyone, especially not anyone new to that magazine. Experience elsewhere cannot guarantee that you can produce for them. Many magazines pay "on acceptance"—that is, when officially approved by the magazine—but many more, especially smaller magazines, pay "on publication."

Payment on publication means you will not get paid for a long time. A magazine might accept a contribution two months after final submission but not publish it for six months or more. After the rush of getting the issue out is over, they will begin to think about paying contributors. If you are beginning editorial work this way, you have to make sure your rent is covered by some other means.

But the fact is, too, that freelancing on speculation isn't always so risky as it sounds. If you have written to an editor at some point to query him on an idea, and he has expressed interest in it, your chances are reasonably good. Few editors approve a concept lightly; they carefully consider the idea, the intelligence with which your letter is composed, your qualifications, upcoming issues, complementary material and so forth before telling you to send it when ready. Often they have spent time giving you guidelines to ensure results, which means they have an investment in your work.

So even without payment of money, an editor may be planning on your subject and possibly saving the necessary space in an issue. Provided you meet whatever deadlines were indicated, or better yet, beat them, and have performed more or less as promised with reasonable competence, the editor is predisposed to accept your work.

A magazine staff will often back you up to the hilt if you have given them something to work with. When time allows they may ask for a rewrite of text according to very detailed specifications and guidelines. They will edit and polish rough writing; they may essentially rewrite the text themselves. Equal effort can go into salvaging photographs, but we must assume that the photo-

graphic portion of your story exceeds expectations—that's one reason your text may get a helping hand.

Magazine policies differ, incidentally, on the extent to which they will edit written material and indeed photographs without consulting the creator. Ask about this beforehand if it concerns you.

So, doing stories on speculation should be regarded as an opportunity. As we keep saying here, all editors need good ideas, well executed. Still, there are times when your opinion of well executed and the editor's diverge. What then?

Responding to rejection

Creative people need pretty tough skin because the route to fame and fortune is fraught with rejection. After all, you are not selling a product that can be measured or weighed. But easily said as it may seem, the way you respond to a rejection can be all-important.

Just as when you are showing a portfolio for assignment purposes, you will be ahead if you can determine the reasons for a rejection. Unsolicited material (that is, anything not requested by an editor, either in answer to a query or on his own) is likely to be returned with only a brief form letter: "Thank you, but the enclosed is not of interest to us at this time." An idea that was requested nearly always merits a genuine criticism. A letter of this type should be carefully analyzed for direct information or clues. When no real information is given, it is sometimes useful to confront directly (but politely) the editor by telephone. When you are inviting criticism, however, be prepared to face it.

An editor may be asked whether a revision along the lines of his criticism might prove acceptable. He may have hesitated to ask for more of your time without guaranteeing a return. You must decide whether it is worth the trouble of a redraft or a reshooting if the pictures were considered unsatisfactory (assuming the subject is still available), and you must consider whether you can deliver what is wanted. If you feel you can, it may be worthwhile.

One of the best working relationships I have had as an editor, with a contributor I never met, began with a query letter suggesting a story idea. It sounded good and I invited a submission on speculation. It arrived a month later in very disappointing shape, and after considering its possibilities carefully I rejected it. I saw no evidence that the person could do better. My letter covering the return briefly indicated the story was too superficial for the professional audience we published for.

A few weeks later an unrequested new article arrived, entirely rewritten, twice as long and beautifully detailed. I was delighted to use the article immediately, and I was impressed with the contributor's initiative. Convinced that she had fully understood our audience the second time around, I was glad to get more story suggestions from her, provide assignments in her area, and recommend her to some fellow-editors who could use other material within her capability.

What if your picture story or words-and-pictures piece is rejected but you still like it the way it is? Send it to the market next in line. Many rejections are based on personal bias and the magazine's outlook, both impossible to predict. Many, many rejections are based on timing—certain things are terrific one month and not the next. Something similar may have just been used, even though distinctly inferior to your treatment of the subject. A magazine may even occasionally have too much material in house or may have spent its budget for the period. And to be brutally honest, what may not meet one publication's standards may be plenty good enough for another. Editors constantly see material they rejected in competitive magazines and have mixed feelings about it: Did they make a mistake? Or did their competitors make fools of themselves?

One of the best pieces of advice I ever heard was offered by an instructor to a fiction writers' workshop; it is just as valid for photographers and writers of nonfiction. Make up not one envelope for a completed story, he advised, but a whole batch, completely addressed and stamped, to different potential buyers. They should be in rough order of your market preference. Mail your work in the envelope on top. If it comes back with a rejection slip, just put it in the next envelope and mail that one (although with a new cover letter). Keep going down the line till your envelopes are exhausted, by which time it may be clear that you should think some more about your submission. The idea is that you can prepare for rejection and set the situation up to encourage yourself to try again. Throwing the stuff in a desk drawer and leaving it there because it was rejected is all too easy a temptation, but it does you no good whatever. Keep going and either you will hit the right market—because the magazine business is a people business and human tastes are genuinely different—or at the very least, you will emerge with some good advice.

12

Selling Photography as Art

ALTHOUGH it has not always been so, today's attitudes require that art objects must not be useful in any way beyond the creator's personal intent. "Commercial" and "applied" art are carefully distinguished from "serious" art. Probably because all photographers unavoidably share the same technical base, such lines are much harder to draw with photography. The efforts of critics and photographers themselves to separate "art" photography from the rest usually end in nonsense.

Yesterday's spot news shot is today's classic. A picture run in a magazine may be equally appropriate to a museum wall. Superbly expressive images are created daily under the aegis of advertising, industry or publishing, while dull photographs are produced in the name of art. Demonstrably many of the photographers who achieved photography's first entrées to the museum galleries are those who established their reputations at *Vogue, Life* or BBD&O. Reversing this situation, many a new photographer shrewdly makes his name via photo magazines, galleries or even books so he may more rapidly storm the most commercial citadels.

Outlets that show photography for its own sake are important to all photographers. For many photographers, such showcases are part of a total marketing effort, or are sought for the satisfaction of reaching an audience with a personal expression. Other photographers, who do not anticipate ever making images dictated by needs outside themselves, may find creative-photography channels constituting their entire sales interest. Whatever lines you choose to draw for yourself—whether artistic, noncommercial work will be all or only a part of your photography—you will want to consider getting your work appreciated as art.

You can count the ways on less than one hand: photography magazines,

exhibits and books. This is not necessarily cause for discouragement. Within the last few years the growing appreciation of both the art world and public for photography has dramatically expanded the scope of this little list. There is every sign that new opportunities will continue to unfold, especially for the photographer directing imagination toward the use of his pictures.

A skeptic might say the competition is growing as fast as the outlets, and in terms of simple arithmetic this is true. More people are taking photographs on a serious level; many have taken courses in schools. But few of these photographers have given thought to getting their work into view, and school courses rarely cover such problems. As a result, publishers and exhibit directors may be overwhelmed with the number of submissions, but certainly not with their suitability. Only the smallest fraction of contributors sends the right material to the right place. Buyers receive far more work than they can use and ask for more submissions. Some fine outlets receive amazingly few entries to begin with.

Understand that gaining attention for your creative photography is an enterprise not entirely free of commercialism. Photography galleries, like art galleries, consider salability an important factor in accepting work for showing. So do many publishers of photographic monographs. Photography magazines, even when looking simply for the best images for their pages, have their own peculiar definitions and standards in mind. Many of the principles suggested earlier for dealing successfully with commercial buyers must be applied when dealing with the noncommercial ones.

Painters and photographers alike can do outstanding work purely according to their own reference points and gain excellent reception nonetheless. But much more frequent are instances where superb work is never seen because its creator did not know how to approach the outlets while mediocre work receives spectacular attention because the photographer was promotion-minded or happened to bring the right pictures to the right buyer at the right time.

Again as with the older arts, you ought not to expect artistic channels to make you rich. If your aim is to produce noncommercial photographs without any outside influence or direction, it is unreasonable to expect great sums of money to result. It can be done—there are photographers earning livings selling prints and books—but it has taken most of them quite a long time.

But if you are prepared to manage on a low financial return, you have opportunities that many a commercial practitioner will envy. The art channels can be immensely helpful in developing money-making potential in the long range. Photo magazines, gallery shows and books are magnificent showcases, and they build reputation and marketability.

Whether your aims are artistic, commercial or both, one caution should be

observed: you cannot assume that any achievement will impress buyers enough so you can sit back and expect them to come to you. Considering the multitude of uses to which photography is put and the many outlets of all kinds, the field is too fragmented for such universal recognition to be easily achieved.

Many photographers make mistakes of this sort. Having achieved a one-man show, for example, they sit waiting to hear from the world—perhaps even come to a creative standstill—in what can be a very long interim indeed. Others may receive an impressive spread in a camera magazine and feel disappointed when instant preeminence does not materialize. Things simply do not work that way. It is not in the nature of the market.

Even within strictly artistic channels, few gallery directors, photo magazine editors or book publishers seek out particular photographers. More typically, the user simply evaluates what is brought to him on a relative basis—often the only procedure allowed by a crowded schedule. Once again we're saying that initiating contact is up to the photographer. Thus selections from the most acclaimed photography book may be published in a camera magazine only because the photographer (or a representative) came in and showed the images, often via the same route open to the rankest beginner. An exhibit in a major gallery is achieved not because the director was impressed by an earlier show elsewhere (he probably did not see it) but more often because the photographer submitted the work anew. In any creative enterprise, recognition is a perpetual building process. Even the most famous artist must keep selling, or have an agent do so, lest buyers not think of his work in relation to their needs, or lest they assume that so established a person is unavailable to them.

What counts are initiative, persistence and an imaginative continuing review of the outlets that interest you. Given these qualities, it is hard to overestimate what a reasonably competent photographer can achieve. The following discussion should provide you with the information you need to deal most effectively with users of creative photography.

Photography magazines

You may need no urging to recognize the benefits of publication in photography magazines, but then again, you may have a higher artistic vision. A snobbish attitude toward photography publications is current in photography-as-art circles. It is true that these publications follow policies dictated by commercial considerations, but this is true of virtually all magazines that wish to survive. Picture selections, however, are almost never influenced by salability

or advertiser pressure. They are made purely on their own terms or, more properly, on the personal terms of those in charge. Nonetheless, your personal experience may say that the "fan books" seem arrogant, arbitrary, difficult and highly time-consuming to deal with. They are staffed predominantly by word people, whose training in photography is on the job, plus a certain percentage of photographers and technical types.

Like many special-interest publishing industries, the photo-mag business is like a large fishtank with a circulating population that moves from point to point according to local currents. A few young fish may be added periodically as natural attrition—mostly due to much better salary offers from advertising and P.R. firms—draws off a few older fish, but it is typical for an editor to work at a series of photography magazines and end up where he started. Naturally the results appear inbred; if you find it hard to distinguish between the more widely read American photo magazines, remember that yesterday's *Camera 35* editor later moved on to run the annuals division at *Popular Photography*.

Nevertheless, photography magazines constitute a market which cannot be ignored. In the first place, other than photo books, they provide virtually the only print outlet to consistently show photography for its own sake rather than some other communication purpose. They must therefore be depended upon for insight into experimental and esthetic trends, both by photographers of every level and those outside—including the buyers. This makes for another reason they're important: publication in one gives you wide exposure of a reputation-building type. It's a seal of approval, identifying you as fit for consumption by others—especially those who are insecure about making visual decisions.

Photo magazines can boost sales, because some buyers use them as shopping catalogs. Particular pictures may be just what a book cover or promotion poster called for, or a photographer's special style or technique may achieve just the mood wanted for an ad campaign. Photo magazines usually purchase only one-time rights, so you are free to proceed happily. Further, photo magazines do pay for pictures. Depending on the magazine, the kind of use and space accorded, this can reach well over a hundred dollars per image. So it is better to get work published before feeling too snobbish about this opportunity.

The big four on the American scene, *Popular Photography, Modern Photography, Camera 35,* and *Petersen's PhotoGraphic* are largely devoted to how-to material rather than "just pictures." Magazines that concentrate more on portfolios than on processes range from the venerable *Aperture* to *American Photog-*

rapher. But even the how-to magazines represent a larger picture market than many photographers realize. *Popular Photography,* for example, publishes the prestigious *Photography Annual* every year, a collection of images. And new, smaller magazines are appearing, such as *Lens* (distributed through retailers) and a darkroom publication.

In addition to the magazines already named are the professional photo magazines. "Professional" does not mean that material they use is on a higher level (the contrary is more often true) but that the publications are circulated to professionals. Unfortunately, no one magazine attempts to serve all professionals; rather the field is fragmented for commercial reasons so a magazine is oriented to the commercial processor, portrait studio, industrial staff photographer, and so forth, doing no one much good. They are run by mostly small-minded entrepreneurs for maximal profit with minimal outlay. They can be good showcases when you can devise a professional-sounding orientation for your pictures and don't expect a lot of money.

Another group of photo magazines is published by camera manufacturers and distributors. Naturally, they are interested in images produced with their equipment. A Hasselblad image won't do so well at *Nikon World*, but how are they to recognize a Canon picture?

Probably more significant than these latter groups are the foreign photo magazines. Just about every European country has several fine magazines for amateurs and professionals, not always making the same distinctions as are made here. If you can find a photo gallery or camera shop that stocks them, you may be surprised by how many of these magazines there are and how often they run American work. Not only are they open to submissions from American photographers, many may even give preference to them because the American viewpoint has a fascination overseas, for the same reason that Japanese photography is interesting to us. Pictures that may seem commonplace in the U.S., such as street photographs, are less so abroad. A foreign magazine may be dealt with by mail just like one in this country, although you hope that someone there reads English. Your reason for sending work will be perfectly obvious, and pictures are a universal language. A useful listing of foreign photo magazines, with the address and editor's name for each, is included in *Photography Market Place*. Many American publications are also listed.

An often overlooked opportunity is the idea of dealing with foreign magazines when you are traveling. Keep in mind that many of these publications also publish annuals, some of superb quality. Despite the language barriers, you might have an interesting experience showing your portfolio abroad. More than one aspiring photographer I know of has taken advantage

of this chance to get his first work published in an attractive medium, then used the credit to good effect back home. This conveys the idea of possessing an international reputation with quite little effort.

One of the more favorable aspects of dealing with all photo magazines is their accessibility. I can think of no photo magazine that will refuse to look at anyone's work whether it comes to them via the mails or by personal interview. From the enormous volume of submissions they receive, they select the small fraction of special work they need. And unlike some other buyers you will encounter, photography magazines generally do not care whether you have published anything before. They will credit themselves with a discovery when a newcomer brings in suitable work.

So what are they looking for?

They value images that are "photographically interesting." This is not so meaningless as it might seem. Photography published for its own sake is not judged on its subject or content, but purely on its success as photography. The way your photographic tools and visual options are employed is what counts.

A good photo-magazine image possesses complete technical excellence and usually, a special graphic strength. Its qualities may be the products of sharp observation on the scene or endless manipulation in the darkroom. It is most often a controlled photograph, in which every element contributes to the visual statement. Its interest usually does not derive from association with an event, subject or person, but only from what is contained within its own borders. Its value as information or news is beside the point. Except in rare cases the image should be interesting without supporting material, or with only a minimal amount.

The subject is the photographer—his feelings, his ideas, his way of seeing—and photography itself. This may be clearer if we outline the kind of work you should consider for a portfolio for a photography magazine:

• Personal interpretive-type images.

• Your most dramatic pictures, especially those with strong graphic value.

• The best pictures in your favorite categories or specialties, and your all-time bests provided they do not look out of date.

• Technically experimental images. These should not use a technique for its own sake, but employ an original or interestingly applied technical approach as an integral part of the picture for an expressive purpose.

• Photographs that suggest emotional, abstract or intellectual qualities such as mystery, symbolism or surrealism.

• Photographs that provoke strong responses such as surprise, shock, curiosity or humor.

• Images that transform something banal or commonplace into something visually arresting via photographic tools or unusual vision.

• Photographs of people that are interesting, appealing, highly spontaneous in expression. These are apt to be in short supply, especially when model releases are required.

• Good black-and-white images (also likely to be in demand relative to color).

• Seasonal pictures (Christmas, summer, winter sports), especially if they are of cover quality. Seasonal pictures need to be shown about six months in advance of the issue.

• A strong series of images. This does not mean batches that look nearly identical (like ten shots from the same shooting session), but groups that explore a subject, idea or technical approach in depth, or are related by style even though they may be of diverse subjects, or are sequential images, if that is among your interests (although these are hard for magazines to use).

• Single unrelated images. These can be useful for filling spots in annuals, picture sections that include work by several photographers, or subject-oriented portfolios. One or two good pictures of skiing, windows, infants, etc. may inspire such a use, or an editor may gradually be collecting such a group for a specified purpose.

Hard to pin down but important is the desire of most photography magazines for images that can be discussed in some way. Although their subject is visual these publications conceive their primary purpose to be teaching. Photographs that will in some manner expand the readers' perceptions, expertise or understanding of good photography can earn special treatment. The portfolio articles in monthly magazines are justified this way. Thus images that can carry a useful explanation—like how they were achieved or how the photographer thinks—are at a premium. You can gear for the star status of a portfolio treatment in a magazine by a sensitive examination of your work for links in feeling, mood, subject or technique. But like consciously striving for style, this is difficult and more often must be left to the eye of the beholder.

The following are usually not acceptable to consumer photography magazines.

• Blatantly commercial images, obviously taken for a product-promotion purpose. Promotional photographs will be welcome only if the commercial origin is invisible.

• Pictures with a technical weakness of any kind, or which could be interpreted as failing technically in any way. If blurriness is your thing and you have several dozen such images to prove it, however, don't exclude the possibility.

- Contact sheets, negatives, poor black-and-white prints or drugstore color prints.
- Photographs that you know cannot be used because of a copyright problem, the lack of a model release, or some other difficulty. The magazine's policy on such matters can be checked by phone.
- Repetitive, unedited-looking work.
- Pictures that have appeared, or are being considered for use, in another domestic photography magazine addressed to a similar audience.
- Any image you do not want published.

Since you are aiming to show off your photography in the purest sense, your presentation for a photo magazine is important. Prepare for it with the same care that we have described in earlier chapters for presentation of your work.

In deciding how much to take (or send, if you're submitting by mail) aim toward the compact end of the scale since excessive length is particularly liable to kill response by this audience. You are being evaluated as a photographer—the trend is largely away from single-image use and toward representation of good photographers—so you do not want to imply that your best work was just lucky. If it's your first visit to that office try for a range of work, so you can gauge what is of most interest, but include your in-depth type material too.

It is a good idea to ask when scheduling an appointment whether anything special is wanted or if an annual of some kind is in the works. A contributor information sheet outlining the yearly schedule may be available, and many contributors plan to show work during the "active" collection periods prior to publication of a photo annual; obviously this increases the chance for a sale because more space for pictures is open.

Never feel too disappointed if a photography magazine rejects your work, because many factors unrelated to its quality are involved: for example, space, timing, competition and whim. Also, the difficulty of selecting the "best" from a large number of excellent images is apt to warp any editor's judgment somewhat. Probably unwarranted stress is inevitably given the unusual image, the "stopper," because visual appetite like any other becomes jaded. This is why you should always include your most extreme pictures.

Persistence can be especially rewarding in approaching photography magazines. When you believe in a picture, submit it again, to another publication or the same one. (Show new work as well, naturally.) I have seen pictures used prominently that had been submitted a dozen times. Needs change daily, and so does the staff. Many photographers feel that a new picture editor means a new chance to show the same photo-mag portfolios all over again. Incidentally,

it is not out of line to show your work two or three times a year to the editor of a photo magazine, unless the editor tells you outright to go away (which is very rare).

Observe the differences in audience orientation among photo publications. Several are devoted entirely to 35-mm photography, suggesting not only that submissions on 2¼ film won't do, but that certain types of images probably will. The editors can be expected to appreciate pictures that show off 35-mm's special capabilities, such as candids, sports and action photography. Pictures that apply 35-mm to subjects not formerly associated with small format (architecture, for example), will also be appreciated.

Before we leave photography magazines, it should be pointed out that there is another way entirely to get published in them. This is to apply the principles explicated in Chapters 9 and 10 for writing self-illustrated articles. How-to stories—naturals for almost any photo magazine—can derive from a photographic specialty, and the more esoteric the better. You may be the only living expert on, say, "How to Photograph Sailboats," "How to Photograph Microcircuits," "How to Photograph Graffiti," and so forth. Stories can also be done on interesting ways to use photographs—say as personal postcards, in multi-media effects, or hung with unique frames. Specialized sales and promotion approaches can appeal to the professional magazines. You need not recount such knowledge first-hand. The story can be based on an interview, whereby you write the story about somebody else's special techniques. Your subject will be getting superb publicity of his own and will usually be delighted. Celebrity interviews with noted photographers to whom you have access can also get you into print. Even the experience of taking pictures for one article can be salable later in another, like "How I Photographed the Famous Author."

How high are standards for information and writing style in the photography magazines? Your own perusal of the newsstand magazines may reveal that they are fairly high, and the problems of breaking in are increased by their buddy system: A small number of contributors writes many articles. The professional magazines are far more open to outside material; they are hungry, in fact, because of small staffs and budgets. Send for some and you may be amazed at what they publish. For example, all the story ideas cited in the last few paragraphs are from real articles used in such media. And often a few sentences may be enough to justify a little portfolio of your pictures. The magic part is that only you and a few others will know your material was not selected from hundreds of entries.

The principle holds true for a great many specialized publications for which you may have particular assets.

Pictures for an exhibition

Few ideas are so attractive to photographers as an exhibit, preferably one-person, in which the print is shown as the ultimate product rather than as an intermediate form. That kind of singular attention is highly satisfying, and although the primary audience is small compared to the audiences available in print, there are chances your work will be reviewed—which may offer the ultimate in snob appeal. You may even sell a few pictures.

There is little question that exhibit credits are superb additions to your resumé. Before dismissing this point in the belief that a good photographer needs no resumé, consider its uses:

• In a future application for a staff position in photography, teaching, or more remotely related areas.

• As backup for your portfolio presentation. Many wise photographers include a formal resumé at the end or beginning of the print presentation.

• Biographical data for book or magazine illustration.

• In your presentation for the next exhibit; etc. etc.

Think of your photographic market as a series of buyers subliminally influenced by the decisions of others you have already approached, and you will be not far wrong. Where no absolute standard of value exists and formal knowledge is scarce, buyers look to their like for support.

Given the manifold advantages of exhibition, then, is getting your work shown feasible? Definitely. It is only a question of where it can be hung and your degree of determination. Exhibition space is proliferating, to the point where a shortage of suitable material could develop. Moreover, no other field of photography so reflects a lack of universal standard. Unlike most magazines, ad agencies, companies and so forth, a gallery's decisions are nearly always made by one person. Judgment by committee is rare, so a photographic show usually mirrors a single individual's taste.

In theory, a photographer who worked at it long enough could eventually achieve an exhibit, no matter what the quality of his work. In practice this is very nearly true. There are gallery directors who have special obsessions for the snapshot look, the totally obscure, the completely repellent, the symbolic, the literal. And you cannot anticipate such preferences on the basis of the gallery's prestige or the prices charged. Insofar as possible you must visit the galleries to know which are most in sympathy with your imagery, and often you will have to take your portfolio to one after another. You can also deal with them by mail, but advance queries to determine their interest are advisable. Be prepared for additional expenses, such as meticulous packaging, insurance, and the costs of safe return of your material.

Note a few restricting factors. Many showplaces are still oriented to black-and-white photography, because of the expense and relative instability of color. It is thought unfair to sell an object that may change drastically in a few years' time. This is in a way lucky for the photographer, who is usually expected to support the total cost of supplying exhibition-quality, exhibition-ready prints. Costs for required special mounting or framing may often fall to the photographer as well. So clearly the financial matters must be taken into thorough account before you get carried away by the excitement of an interested response. Discuss precisely in what form your work must be, who pays for any shipping costs, insurance, publicity, gallery operation costs for the show's duration, opening night parties and invitations, posters, and, of course, the gallery's commission on sales.

Do not be surprised if you are responsible for many of the costs and the gallery keeps fifty percent of the sales. It is only within the last few years that any gallery was run as a profit-making enterprise, rather than a labor of love or a sideshow to some other enterprise, and even the most established photographers have had to meet the cost. Even today, few galleries are self-supporting, and those that are make money by concentrating on the famous names. If you still think you are being ripped off, find out what kind of sales were enjoyed by the gallery's last few exhibits. It is not in the least unusual for a show to run a month, receive fine reviews, and sell nothing at all. An exhibit is often an investment, then, and you must evaluate your objectives yourself.

Also keep in mind that the appearance of your presentation is extremely important. Lab-made prints are often acceptable but all prints must be excellent and in first-class condition. Printing should be done for maximum esthetic satisfaction and can include subtle effects, unlike prints destined for publication. You should have an idea of their effect hung on a wall, however, which can affect decisions on size, contrast, and so forth.

Your work should give an impression of consistency, so that all effects look deliberate and controlled, even if the images are abstract or in snapshot style. Lucky shots are out of place here, unless you're trying to get just a few images into a group show. This means you should exert your very best self-editing efforts in selecting images. You do not need a large portfolio. Ten images is often enough, and more than two dozen is rarely called for; the exhibit director knows he can ask for more if he is interested. In the interest of consistency, also, take care to provide uniform sizes and mountings. Mounts other than a shade of white usually do you harm.

The professionalism of your presentation is crucial. Photographers who are highly serious about getting exhibits will sometimes purchase formal presen-

tation cases, of the sort that look like large attaché cases. This may not be necessary, but in this marketplace more than any other your craftsmanship and apparent dedication is evaluated.

If your aim is an extensive, one-man showing at a high-prestige place, consider the coherence of your presentation. Note that the majority of large shows usually have a title of some kind identifying their subject or approach. "John Smith's Spain," or "Neogothic Experiments by John Smith" is more frequently announced than "Photographs by John Smith." A good show has a focus; is is not a random collection of images. This quality benefits everyone: The photographer is led to explore a subject or idea in depth; the exhibit director is able to assemble a more interesting, meaningful viewing experience, and a larger audience can be attracted because of an interest in a subject.

So we come back to the power of the idea. It can be more effective to offer a unified show with a theme—whether resulting from a long-range project or intelligent editing of your collection—than to ask for a retrospective you do not yet deserve.

Even small galleries often schedule exhibits a year or even more in advance. Accordingly, do not be insulted if you are offered a far-off date; cancellations could give you a faster chance. Once you have made a commitment to deliver your work, take scrupulous care that you are not responsible for such a cancellation by failing to deliver on time. Nothing is more humiliating to a gallery operator than the prospect of empty walls at show time, and nothing gets around the photo world faster.

The increased numbers of galleries of every variety make an up-to-date list not easily available. A state-by-state breakdown appears periodically in one or another of the photo magazines. Newspapers, local magazines, art publications and advertising can bring others readily to view. The thinking photographer haunts galleries to see what others are doing as well as to scout his own opportunities, so it is most worthwhile to take advantage of the growing spotlight turned to photography. The following breakdown may help you better analyze the extent of current opportunity.

The museum

The first American museum devoted exclusively to photography, The International Center for Photography, opened in New York in 1975. Several exhibits per month are scheduled there with a tendency toward either thoroughly established, classic names or trendy topics. Such shows are

achieved via complex processes and funding programs. Another museum you should know about is George Eastman House in Rochester, New York. In addition to many educational and research programs, this organization assembles exhibits not only for its own premises but for travel around the country. Friends of Photography in Carmel, California, fills a similarly prestigious position on the West Coast.

Far more accessible to many photographers are museums that mount photographic shows on a frequent, fairly regular, or sometime basis as part of their larger art function. More and more museums are acknowledging that photography belongs within their domain; many a curator of prints is brushing up on the esthetics of photography or even hiring a photo curator. Not unnaturally, many begin by housing works by the classic photographers of unimpeachable reputation. It is difficult to get a show in one of the first-rate museums, which presumably try to meet the highest standards of excellence, historic importance, and probable influence.

But many local and regional institutions are eager to exhibit locally produced work and give it preference. In trying to serve the community that supports it, many a museum will choose images in line with public taste which might be laughed out of court elsewhere. New York's Museum of Modern Art sometimes displays, with a full-scale high-art treatment, what look like crude snapshots to other people. In Seattle's leading museum, I have seen huge exhibitions of what the Museum of Modern Art would regard as simple-minded landscapes. These are differences in regional tastes.

Also presenting an unusual opportunity for the local photographer: the fact that prints by famous photographers have gotten so expensive that many museums have been priced out of the market.

Does it surprise you to think of museums buying photography, rather than just showing it? Most photographers overlook this point.

Museums buy—or "accept"—works of art for their collections quite without regard to exhibitions they have planned. Museums display only a fraction of what they own, an infinitesmal fraction if it's a big, rich museum. They regard their function as not merely that of a showcase, but as a repository for important objects. A particular object may be brought out for exhibit as occasion allows: next year or next century—museums think in terms of the long pull. Meanwhile the thing is an acquisition, part of the archive, and available to the serious scholar or student for examination. The Museum of Modern Art's entire photography collection has been available on this basis.

The photography collections at museums, historical societies, libraries, and universitites have been so grossly neglected, by many who should have known better, that the photographic archives are now an embarrassment. Many a

curator is scrambling around collecting photography trying to make up for lost time in an increasingly competitive market. Good contemporary work is in demand and relatively affordable.

Museum curators review portfolios just as editorial or ad agency people do. A telephone call should tell you whether a given museum is collecting, who's in charge and how appointments may be scheduled. If you follow through and find there is interest in acquiring some of your work, be ready and agreeable to the idea of donating the work regardless of payment. It is not only an honor to have a photograph accepted, you will thereby entitle yourself to the citation, "in the collection of...," an extremely useful credit and addition to your professional resumé. Donating works of art to museums is an established method for building reputation used by sculptors and painters; the time is right for applying this technique to photography. Moreover, don't forget that museums and wealthy private collectors make a point of knowing what a regional museum elsewhere has discovered.

Just remember that those who buy for museums, libraries, universitites, historical societies and governmental agencies (for example, the City of Boston or Los Angeles County) tend to choose from what is brought to them, since it's hard to scout for submissions. The more rarified the atmosphere the more inertia is apt to overcome your competitors, so you may have a far better opportunity at the lofty places than you might logically expect. It should go without saying that opportunities to participate in group shows, by various photographers or artists of many kinds, should be actively sought and welcomed.

The commercial gallery

The best-known and highest-priced galleries, such as Light and Witkin in New York, are internationally attractive to photographers and thus most competitive. Among your rivals there will be the best-established names, both living and dead. Still, such galleries also show work by newcomers, and they welcome "discoveries," sometimes in alternate months or back chambers. Consequently they review portfolios. Additionally, many accept selected work for viewing off the walls, in racks, or in bins of pictures through which customers can browse. A gallery has your work for sale "on consignment," usually meaning you will get your share of the sale price when someone buys your picture. Do not expect that your work will fetch the same price as Ansel Adams'; "unknown" photographers are frequently represented by established galleries precisely to give the less affluent collector something to buy.

According to your personal esthetics and temperament, it may matter that the big-money galleries often achieve their success by catering to current taste. Work is chosen for its salability, so reputation, pictorial content and style can heavily influence a photographer's reception. The chic photo galleries tend to assume that their buyers will have either superficial responses to photography (favoring pretty landscapes, for example) or extreme, high-art preferences (for example, the trendy snapshot look or photo-sculpture). So, somewhat ironically, many photographers find the less successful galleries, or those which do not sell pictures for a living at all, better for their needs.

As commercial galleries proliferate, networks are beginning to be established for putting shows on the road via exchanges with galleries in other cities. Thus a New York gallery will make available to galleries in California or the Midwest an exhibit of Irving Penn's work, for example. This is a significant matter, because exclusive representation is becoming a critical part of the gallery scene. Irving Penn and others like him are exclusively committed to funneling work through a single gallery. The only way a gallery in Podunk or Los Angeles can show Penn is by dealing with that gallery and meeting its terms.

But it also looks like more and more galleries in smaller cities will be circulating their best shows elsewhere, even to New York, Los Angeles and San Francisco; especially since they are signing up good local talent to exclusive arrangements. Some can be quite creative about promoting photographers they represent, not only via exhibit exchange programs, but by selling behind-the-scenes to markets that individual photographers find inaccessible.

Some are becoming sophisticated at pitching businessmen, for example, employing fulltime salespersons to make the rounds of these markets. Aiming for such big game can be remarkably successful in specific locales, as determined by factors as unlikely as construction law. For example, the City of Seattle requires that a company erecting a new headquarter building spend at least one percent of the cost on art works of its own selection. In at least one case that has meant bonanza time for a gallery and the photographers it recommended for inclusion in the collection, and the appetites of other galleries were nicely whetted.

There are many varieties of photo gallery today and especially in the big cities, they run the gamut of personality, organizational type, and degree of commercialism. A few are photographers' collectives or co-ops, such as SoHo Photo in New York. These usually run shows by outside photographers and also feature members' work to different degrees; they may sponsor projects and activities. Co-ops try to be selective about new members, reviewing port-

folios for admission, but most need additional members to support costs and quite possibly help gallery-sit. A number of photographers have found it profitable to join such groups for the camaraderie and exchange of information as well as for the opportunities for exhibiting.

Somewhat similarly, camera clubs often seek good photography from any source for presentation. They offer members learning programs that can be very sophisticated, and some offer the use of excellent equipment and facilities.

A number of galleries are sponsored by businesses that have something to gain by promoting the cause of photography. Polaroid operates a prestigious gallery at Cambridge, Massachusetts; Nikon House has one in New York; Eastman Kodak has some at various points around the world. Modernage Custom Labs runs three small galleries that present monthly shows at their Manhattan lab locations. All these and many more have someone reviewing portfolios for what are usually monthly showings.

Other regularly operative, genuine galleries are run in Y's, libraries, coffee-houses, lobbies of large buildings, ad agencies, bookshops, camera shops, schools, portrait studios, universities, ad infinitum. Ad nauseam, some might say. The situation in some cities is so competitive that galleries must specialize, with new ones showing only sequential photography or portraiture, for instance.

Again, a gallery's location or apparent prestige does not automatically provide an accurate gauge for its appropriateness to your work. A tiny gallery may have excellent attendance by a good audience, better promote the exhibit and have fine prospects for getting shows reviewed. One in Milwaukee may regularly sell more prints than many in New York. Those run by business enterprises have certain advantages in being independent of income from exhibits, so can select the most truly innovative and experimental work. As with magazines, however, the bigger the gallery or audience it wants to attract, the safer the route it chooses in trying to appeal to many kinds of people while offending none.

Certainly you should familiarize yourself with any galleries in your area. An exhibit close to home can produce highly tangible benefits, and the local gallery is predisposed toward local talent. Having one exhibit does not preclude having others; quite the opposite. Reconnoiter places you travel through for relevant galleries. Visit them, see if what they hang has any relation to what you're producing. Talk to the people running the gallery; most such galleries are small operations, and the people are happy to talk shop with serious photographers. Ask if they will review a portfolio; if you have it with you mention

that you're only in town temporarily and you're pretty sure to get a viewing. Or follow up at home later by mail with a small, carefully chosen initial selection. You can send work blind to galleries anywhere in the country (or world) for viewing—most of them will look at it—but considering the quality of prints you should be providing, the careful packaging and expensive mailing, this can be a hard tack to take.

Some photographers send a small group of transparencies of their photographs, avoiding the trouble and expense of shipping prints. If you do this, be sure to indicate in your cover letter the actual size of your prints or other material. Obviously, select samples of your work that look good in slides if you try this method.

If you're trying to learn about photo galleries in a new place and find the information hard to come by—many haven't been around very long and others are notably bad at getting known—the nearest university is usually the best place to ask. In addition to having art departments, many today have their own art galleries; a few have photography galleries. These galleries are increasingly important, especially in areas where creative activity revolves around the colleges.

The art gallery

Proliferating even faster than photo galleries are outlets that feature photography in exhibit schedules but are not devoted solely to it. Art galleries are starting to have tremendous impact on photography, especially on how it gets priced. Some of the oldest, most glamorous art galleries are turning the spotlight on photography and photo-related imagery more and more, since it has become clear that the times are ready to provide the level of profit the art galleries require. Many such enterprises are oriented toward big-name, big-money stuff, but many aren't, or aren't equipped to play in that league.

Small galleries can serve excellently. So can local ones. A gallery director may be well aware of the new public interest in photography and its salability. Or you can make him so, by an intelligent, informed, soft-sell discussion of what's happening around the country—something you are an expert on, or should be. Your enthusiasm can help make the point. A gallery that represents local artists can quite happily add a photographer to its pool given the chance and maybe a little persuasion.

Don't overlook the fact that an art gallery may be a better host for certain kinds of photographs than would a photo gallery. If you're into abstraction, photo-collage, photo-sculpture, hand-colored images, montage, Xerography,

printing on textiles, X-ray, conceptual-art-type imagery, empty frames, combining camera work with any other kind of media, or any kind of work at the fringes (or forefront, if you prefer) of photographic technology, you might be more welcome at the art gallery. Photography galleries are often quite single-minded in their devotion to straight photographic seeing and printing. Art galleries often don't make such distinctions. In fact, given a sufficiently polished presentation, many may admire some kinds of poorly executed work that a photo gallery would lift an eyebrow over.

Still more showcases

There is no reason to cloister photography within the walls of museums and galleries. Its universality of interest makes it a wonderful medium for display in other locales, and here opportunity is truly limited only by your imagination.

Possible exhibit places of two types abound: Commercial locations—banks, insurance offices, bookstores, movie theaters, doctors' offices and lobbies of large buildings.

Community centers—government buildings, church facilities, libraries, hospitals, and clubhouses of every sort.

All such places—and you should be able to think of scores more in your own habitat—have a common need to entertain people or make them comfortable. Commercial institutions like banks, and company headquarters offices, place great value on good community relations and welcome opportunities to demonstrate their public-spiritedness; some have even come to realize that drawing people to their windows or interiors with photographs and other exhibits certainly can't hurt.

Such ideas may not be obvious to them, and here is where a little salesmanship can pay off. It can be quite simple to explain the benefits of mounting a show of your pictures, especially because your visual aids are built-in. You probably aren't asking for any monetary backing, and you are prepared to present prints ready to show and do the installation yourself. What can the other party lose? If he doesn't see the point, try someone else with a window or hall. In the past few years I have noticed photo shows set up in a fair number of banks or other commercial centers, and observed that in all but a single case, the selection was extremely poor—technically lacking, dullish pictures. Why with so much better work around did it get hung? It's the same principle we've been stressing over and over: The photographer had the initiative to assemble his pictures, bring them to the bank people, and maybe throw in a little sales pitch. So take the trouble.

A desirable exhibit location can sometimes suggest a theme against which to edit your work, or even organize a project. A travel bureau or airline office, or even an airport lounge, would be a good spot for your best travel pictures, for instance, especially if they portray a destination encouraged by the group. Photographs shot in a skyscraper's vicinity might interest the firm that owns the building or even a firm that uses part of it. Often, however, a collection of images that seems interesting, attractive or appealing to the general viewer will serve the purpose quite nicely.

Some banks and insurance companies are starting to get into art collecting quite heavily, so presenting your work to one of them as art for an exhibition might pay especially handsome dividends.

Community service organizations can also be easily tempted by a suitable theme. A boys' club headquarters could find it hard to resist an exhibit highlighting its activities, or perhaps any child-related images. Fascinating opportunities for group endeavors of this sort exist for the trouble. A camera club in England attracted widespread attention a few years back with several exhibits assembled from long-range member projects. The first was called "Manchester Seen," and consisted of the most interesting photographs of the city taken by participants over a period of time. Success led to a second project, "Manchester Cares," also culled from members' work, that came from photographing aspects of local life that deserved public attention and improvement.

Local exhibition can be both exciting and good for your career. If you can be responsible for assembly of the exhibit, all the better in some ways—the experience of self-editing and hanging your exhibit will open new dimensions for you. There are no hard and fast rules for how images should be mounted and hung, so your budget can dictate the options. Provided your prints are fine—and anything you show anywhere ought to be—mounting can be as simple as tacking a mounted picture to a bulletin board with tiny pushpins at the outer corners.

Wherever your exhibit, do remember to credit yourself prominently with name, address and phone, purchasing information if you wish, even business cards. Any investment in making prints or buying exhibit equipment can of course go a lot further than a single exhibit, so keep your eyes open for more promising locations.

Pay some attention to publicity. If your pictures are going to be hung on a wall, you want as many people as possible to see them. Even many of the fine commercial galleries haven't the time or don't know how to attend properly to such matters; a less formal showcase location may be unable to give it any time whatever. You may need to take things into your own hands or at least oversee the preparation and mailing of announcements or opening night invitations, if

appropriate; the provision of press material, and so forth. Chapter 15 discusses this subject in some detail, but for the moment, at least don't forget to take some pictures of your exhibit while it is up (be it ever so humble), of the opening celebration if you have one, and of visitors viewing your work. These pictures can be used for a great many purposes later, and you'll never be able to duplicate the situation.

Perhaps the paramount fact to keep in mind regarding exhibits is that people love looking at pictures. Many professional photographers overlook this truism in their preoccupation with technical matters related to image-making. Just as the chance to review a portfolio can prompt potential customers into giving you their time even when they have no preexisting need for photographs, blank walls exist all around you that can be had for the asking. If your town or neighborhood does not have any showcases for photography, your effort may produce some.

Photographic books

When most photographers express an interest in books, they are thinking of monographs—collections of their images, excellently reproduced, with scant text, if any. A book of this type may be the ultimate accolade, but do not expect instant fame, and certainly not instant wealth. It is true that a good many publishers have begun to issue photography books lately, often as part of a prestige line. "Prestige" means they rarely expect to make a profit with these books, which are among the most expensive and pitfall-ridden ventures a publisher can undertake. As was true of the successful galleries, preference is given to the well-established classic names, in order to make the best of probably a losing proposition. Even so, I have seen even household-name photographers with impeccable credits seeking publishers year after year for completed projects, to no avail. Getting a book published is the chanciest of all photographic endeavors.

Part of the reason for this, besides the fact that most picture books do not sell many copies, is that the staff of a big publishing house may know even less about photography than magazine people. A new line of photo books may be added to the publishing house's regular activity without much increase in staff, so that editors who have never dealt with photography may make the buying decisions. Sometimes they have previously handled other varieties of pictorial work; this tends to predispose them to the classic look in photography: Nature, still lifes, landscapes and portraits are thus pretty well represented.

An important factor affecting selection is that publishers want books that

can be promoted for sale in some clear way. It is useful for a book to appeal to a special audience, so that it can be promoted to some specific segment of the population, such as sports enthusiasts, naturalists or celebrity watchers. There is a disposition toward photo books with strong themes, such as Rome, the Sierra Nevadas, cats, barns or transvestites. Also books with special moods, such as one of surrealism. And books that purport to teach readers the things they want to know about creative techniques. Topical issues, however personally interpreted, can have sales appeal. Examples over the past few years include books related to the women's movement, ecology and conservation, more "liberated" photography of nudes, both male and female. Photo books have made connections with the new mysticism; for example, books on witches and books on Kirlian photography, which purports to record the human aura. Another promotable concept is the book of regional interest, which can be given concentrated promotion and distribution in a limited area. There are publishers whose entire output is geared this way; for example, to books on the Pacific Northwest or books just on San Francisco.

The big-time commercial book process is likely to stay away from work that might be offensive to general taste. Documentary work of many types can be hard to sell. The desire to attract a wide interest and "guarantee" sales of 10,000 to 20,000 copies (even a modest photo book probably can't break even at much less than 5,000) favors books that hinge on some gimmick rather than on photographic quality.

There are other problems with marketing a photographic collection. For one thing, before even submitting an idea or finished work, you must find a publisher to review it. A great many of the big publishers will only look at submissions made through agents or referred by someone they know. And if you are asked to mail in your material or present it, you may find that you are required to show not just a set of prints, but a layout dummy of the book. This is a facsimile of what the finished product would look like, page by page, with at least some of the pictures shown in position in their proper size and order. And it may be necessary, just to get your book seriously considered, to provide a preface or introduction from a super-famous person or at least get a commitment from one that he will instantly produce one should the book be published. (This can be no easy matter; I once dealt with one of the most reputable of all publishing houses who issued this requirement, but unfortunately had only heard of three photographers—Ansel Adams, Avedon and Halsmann. No one else counted with them.) Preparing a book dummy is a big project and can be expensive. The rationale is that only thus can the publisher understand the book and evaluate its production cost against probable sales.

A publishing house may hold your submission for three months to a year before finally making up its mind. If the house is a large one, many voices will be heard from (especially those emanating from the sales offices) before the decision is final. Even a tentative acceptance—spoken, before the contract is signed and a few dollars actually handed over—is fraught with risk. Did somebody else publish a somewhat similar book during the year it took your publisher to say yes? The yes may become a no after all, and you may be left with unmarketable material.

When your book is accepted, the problems aren't over. The degree of control and influence a creator can have over the final product is always at issue and is often resolved only by legal authority. (A contract usually includes your giving up control over the final product.) Decisions on the number of pages, paper stock, choice of images, layout, text, the cover and quality of reproduction are routinely made by the editors, and you may easily find yourself without the right of approval once production is under way. Even if you are allowed to participate and voice your opinions, the publisher virtually always has the last word, and the influence of sales and promotion personnel carries great weight in certain areas, such as the design of the cover.

The reason the big publishers are able to act this way is that despite all the trouble, it's so nice to get a book published. You'll bear the burdens just to get into print. Another reason is that with all the publishers' tight control, the odds are still no better than even that they could lose money on the project. And note that if your book doesn't sell, you don't earn royalties, so the economics of publishing are your problem, too. But to avoid some of the hassles of dealing with the sometimes overbearing book houses, here are a few alternatives.

Try to find an agent to represent the book, either a literary agent or a photographic agent. (Photographic agents are discussed in Chapter 13; literary agents are listed in *Writer's Market* and *Literary Market Place*.) The trouble with this idea is that it is far easier said than done. It is at least as hard to convince an agent that you have a salable photo-book property as it is to convince a publisher. If you find one who is interested, expect him or her to want to participate in the book-shaping process before judging a submission to be ready.

Small publishers

Perhaps a more genuine alternative, which happily is becoming more and more feasible, is to deal with a small publisher, perhaps a local or regional

publisher. A growing number of small publishing houses has been springing up all over the country in unlikely places, as entrepreneurs decide that not being in a large publishing center has advantages. Most of these people are in the business as much for love as money, because publishing is a hard way to make money. A number are younger people with far more sympathy for and understanding of photography than allowed at the giant houses. Often they do not discourage the author or photographer from working with them in polishing or producing the book; they may encourage such participation. And, of course, they aren't assaulted with the sheer number of submissions that a large New York house receives. Distribution has traditionally been a problem for the little houses, but as they develop and in some cases prosper, quite effective new channels are being cultivated.

A small publisher can lavish attention on a photographic book and will sometimes spend more than a major publisher would consider. Even better, a small house can be satisfied with lower sales than a giant. And whereas the giant is in a position to take or leave a submission without putting anything at all into its development or improvement, a small house often expects to work closely with a contributor in cultivating a good product.

If all this sounds ideal for newcomers to book publishing and especially for photographers, it does seem, at least, a lot closer to it than breaking in through the biggies. It can be very worthwhile to find out what small houses exist in your area. Check of course on their reputation and output before committing your work to them. Look them up in *Writer's Market* or *Literary Market Place* and see how many books they put out last year. Half a dozen or more? O.K.

Before you sign a contract with a small publisher, be sure the royalty is somewhere near ten percent of list, or cover, price. Some publishers pay as little as two percent of list or try to disguise a low royalty by saying ten percent of "receipts," or "income," or "gross revenue." It's a dodge: A publisher's "income" is about half of list price, and such a contract cuts your potential royalty in half. See if you can do better.

You may find the little house a friendly sort of place and, if that publisher can't publish your work, someone there might give you valuable advice and possibly suggest another small publisher better suited to your idea.

Also remember to check into any university presses in your area, many of whom share your interest in local material, and many of whom are publishing books of high quality. Since most university presses publish academic material, they may welcome the chance to publish photography. And, compared to some of their other books, photo books may be profitable.

Vanity publishers

Vanity publishers are companies that put out books at the author's expense. They provide the necessary production and printing services and, they claim, a certain amount of promotion and distribution facilities. There is at least one major drawback to consider in dealing with a vanity publisher which the publisher will probably not mention to you. Many people in the book business do not like or trust vanity publishers, and most bookstores will refuse to carry any book produced by one. Neither will book reviewers review it. So you may be better off if thinking of going to that extreme to go just a little further, and do it yourself.

Self-publishing

Self-publishing puts into your hands not only total control of every element of your project but also total responsibility. You do the editing, design, printing and—always hardest of all—distribution. You will need to finance the project yourself. Such ventures are not considered good credit risks, so you must expect to pay for all materials and services in advance—not out of theoretical profits from book sales.

A good printer is indispensible as a source of advice. Good professional design help may also be desirable unless you have a special capability for it. Bad layout proves one of the most devastating pitfalls for ambitious photographers who assume that their image-making skills extend to design. Assume that they don't, and hire a graphic designer.

Consider distribution before you commit yourself in any other way, lest you end up with a house full of books with no conceivable way to get them sold. You might consider trying to deal directly with bookstores yourself, placing mail order ads and fulfilling them yourself or through a service, or advertising in local media if that will work for your subject. Don't overlook any special factors that can help market a book; if the book is of interest to local people or to tourists, for example, you might try card shops, gift shops and such. If you're really lucky a distributor or commercial publisher may become interested in your book and will carry the ball.

Obviously the problems of self-publishing are very great and beyond our scope here, though much of this book is relevant. If you are tempted to research the possibility it can be said as encouragement that some of the most outstanding of all photographic books on the market have been produced by the photographers themselves.

Collaboration

A collaboration with a writer, as was suggested for preparing articles, can be interesting and productive. A book can combine text, photographs and perhaps even drawings to cover a subject. A book organized around a subject can find readier acceptance than one whose only purpose is to display photographs. And it's nice to work on a long-range project with others—providing you're still talking to each other by the time you're finished. The trouble with collaboration is that when it falls apart, the subject is usually killed by the issue of who has rights to it.

Anthologies

Anthologies offer interesting opportunities. Many of them begin with open invitations for submissions, to everyone the editors can think of, and may end as handsome, well-produced volumes, sometimes by highly prestigious publishers. Many are undertaken as labors of love by people who do the work of preparing a draft or dummy of the book to sell to publishers; no guarantees can be made at time of solicitation about eventual use or payment. Nevertheless the chance for useful exposure may justify contributing some images. Anthologies can be organized by organizations such as photographers' co-ops and camera clubs. Many anthologies are subject-oriented; for example, woman today, photography of the Southwest, children.

Book illustration is a market that many photographers overlook in their hunt for the perfect monograph. Book publishers provide a fine market for stock photos from your files. Large publishers have whole departments of picture researchers who review portfolios for useful images. Their needs are so diverse that only the researchers know what is wanted at a given moment. A constant supply of pictures is sought for such books as encyclopedias, cook books, travel books, text books of every type, children's books, hobbyists' books, how-to books and scientific books. Photographs for dust jackets, covers and illustrations are always needed. Most photograph needs will be determined by subject, but mood shots can also be in demand. Make appointments to show your portfolio, as for magazines, but take care to represent a broad range of subject matter much as you would for a photo agency.

Grants and contests

As photography joins the world of art, money allocated by government and private agencies is increasingly available to photographers.

Grants

Grants, unlike contest prizes, are given in support of projects, not as awards for achievement. Each applicant submits a detailed rundown of his idea, samples of his work to demonstrate his qualifications, and perhaps references from persons whose opinion carries weight—picture editors, art directors, academic people or whoever is relevant. The Guggenheim Fellowships are awarded on this basis by the John Simon Guggenheim Memorial Foundation, New York City. Others are astonishingly easy to apply for. The prestigious National Endowment for the Arts (NEA), Washington, D.C., asks only for a two-page biographical summary of the applicant accompanied by up to ten examples of his work. Grants of $10,000 are available to any photographer (except to students) "To enable photographers to set aside time and purchase materials and generally to advance their careers as they see fit." If you're lucky enough to get one, you can immediately apply for another the following year.

Besides such national programs there are state, regional, city and county grant programs. These sometimes have trouble finding people to give their grant money to. Strange but true. Especially if the funding program is new, it can be hard to get word around at first that applicants are in demand. The NEA itself had such difficulty getting publicity in the beginning that for the first few years practically everyone who applied got a grant, I was once told. That is no longer true for NEA, but may be true for some smaller and more recently founded programs. Besides watching for new programs, remember the principle we've stressed many times before: Never assume that any competitive situation is overwhelmed with submissions. More competition than you'll ever know about is scared off before trying.

Beyond the government agencies don't forget about the ever-increasing number of private ones—foundations, institutions, individuals, ethnic organizations—seeking to do their bit for art. If you meet specific eligibility requirements, like being part of a certain community, a member of an ethnic minority, or unemployed—the field of competition may be quite narrow and your chances excellent.

To find out about government-type programs, you can check directly with the state capitol, city hall or county headquarters. Don't be surprised if even a county issues a formal newsletter describing funding programs and reporting on results. For private-type fundings, check the art-news publications, watch the photo magazines and newspapers for announcements, and scout the bulletin boards at universities, museums, galleries, camera shops and photography schools.

Note that we aren't distinguishing between programs especially for photog-

raphers and those for artists in general. In fact, you should investigate humanities programs as well. Many fund-givers assume that photographers know they are eligible even if that is not specifically stated in their material. Others may not have thought about it. Occasionally the adminstrators may refuse to consider photography applicants, but this would be bucking the general trend. In applying to a program that does not specifically include photographers, you may actually get special attention and consideration as the first and only photographer ever to apply.

There is more than one way to play the game of "grantsmanship," as it is called. Instead of applying for a grant as an individual, you can apply as a group, for example. You don't have an appropriate group? Consider the following real-life history.

A photographer became interested, through friends, in an ethnic minority with a large colony in his city and a number of others across the country. He made contact with an organization dedicated to promoting this minority's interests, suggesting that a photographic documentation of their culture and problems might be a very nice thing. Perhaps such an interesting project could be supported not by funds from anyone directly involved, but by government funding (oh, magic words) from a major arts agency. The minority organization said O.K., and he applied in its name to the funding agency. They came through handsomely with funds for this idealistic project. Several private foundations kicked in additional sums. He appointed himself Project Director, hired several internationally famous photographers to participate in the project, hired himself as another, and lo and behold: A very splashy exhibit was created to travel round the country, a book was produced, and a lot of magazine coverage materialized. The initiating photographer became famous himself on top of getting paid for photographs he wanted to take. Not bad, considering he wasn't even a member of the minority.

I am not suggesting that this project was a con job. The organizer undertook a tremendous responsibility and an amount of work for which he was not in the least financially compensated, I'm sure. But what creative grantsmanship. More such projects will come, with groups of photographers working on assignment and funded simultaneously by government and private foundation money. This is not a bad thing. Consider, for example, what the alternatives are for supporting documentary photography. There are darned few. Documentary photography doesn't sell well in galleries, it's hard to sell to book publishers, and most photographers who are inclined to making documentary photographs aren't rich. Interesting questions will be raised, of course, about who selects the subjects, who has the right to edit the results, and so on.

On a more mundane level, if you're applying for a grant by filling out a form, it is important to read the instructions most carefully and analyze what is expected of you. Pictures must adhere strictly to the regulations about number, size, form and so forth. If you are asked to specify a project, remember the interests of the granting agency. If you or the agency is geared toward documentary projects, formulate something specific and worthwhile-sounding. Perhaps the funding is for overseas work, thereby asking you for a foreign project that will do something terrific like advance international understanding. Unfortunately, few grant programs have much followup to determine whether their money was productively employed. But you're the real loser if you fail to come up with something to justify the project.

Do not be discouraged if you do not win the first time you apply, even if it's a prestigious national program. Many, many artists win the second time around. It can be helpful to request a list of the winners, especially if it is a project-oriented program, to see what was successful and how you might better fit into the context desired.

There is a book available on just this subject—*Grants in Photography: How to Get Them*, by Lida Moser.

Contests

Picture contests are sponsored by photographic societies, magazines, newspapers, manufacturers, photo equipment distributors, municipalities, professional societies, industries, drug stores, schools, foundations, camera clubs and a host of others. Some are annual events, others may be one-shots. Some are oriented to photojournalism, many to art photography, and a number to specific subjects such as a make of automobile, a company headquarters building, or pets.

Don't snub contests. Legendary careers have been launched by winning them, and professionals are happy to accept the added income when they are eligible to compete. Quite a few competitions are not open to professionals. ("Professional" is usually defined as someone earning more than half his income from photography.) If you qualify as an amateur, you might have a very nice shot at being a winner.

Photographers look at contest results and say, "Surely they could do better than that." The fact is that often it's necessary for competition judges—among whose ranks this writer has frequently numbered—to make the best of a poor turnout. Experienced contest sponsors know that great effort must go toward publicizing the event and offering good incentives, lest the results prove

positively embarrassing. I have seen some reasonably significant awards in some significant competitions go to as many as half the entrants.

Most contests solicit your stock images rather than asking you to take something special, so once again, it's mostly a matter of overcoming that old enemy, inertia.

Try for images that have immediate impact—appealing subjects, dramatic use of technique, strong graphic effects—like the stoppers you might seek out for photo magazines, but allowing for more cliches. Kids and pets and sunsets never fade from this arena.

Observe the usual cautions for mailing your work: scrupulous packaging, inclusion of return postage, careful labeling of every item, and registered or insured mailing. Read *all* the contest regulations in complete detail. You may not wish to send your favorite slide to a contest whose rules proclaim, "All entries become the property of this organization." What a way to get thousands of free pictures! Note whether submissions will be returned to nonwinners, how long entries will be held, exactly what rights the sponsor claims to the winning pictures, the precise use to be made of them, and, of course, any rules concerning the nature of submissions. A substantial number of entries is rejected in contests because of failure to comply with stated regulations—size of prints, number of entries, type of subject matter, even the manner of labeling each image, or failure to include the official entry form. Screening is frequently done by clerical personnel who are instructed to omit any entry not fully complying with the rules; if you don't read the rules, your work may not get to the contest at all.

Contests that are regularly run are listed in *Photography Market Place* and in a bulletin called *Photo Contest News* (Box 1269, Glendora, California 91740). Local and state competitions will be mentioned in your newspaper; camera clubs, schools, colleges and libraries may post such news on bulletin boards.

You can also get leads to contests—as well as to artistic and commercial opportunites—from newsletters issued by arts councils, professional photographers' organizations, galleries and other photo-related businesses. Look at art magazines in libraries or galleries and subscribe to professional photography magazines (your letterhead might get you free subscriptions).

As was suggested in the discussion of grant applications, don't overlook art events that may include photography as well as sculpture and painting. Since photography is a craft as well as an art, craft fairs and contests can also be good opportunities for you.

Don't dismiss any chance to get your work hung or published to good advantage, even when prize money, a world tour, or a new car is not part of the benefit package.

And, to sum up this chapter, remember to put any artistic accomplishment to *use* rather than resting on your laurels and expecting universal admiration. Whether you want to open commercial doors or explore more artistic outlets, a tearsheet of your published picture in a photography magazine belongs in your sales portfolio and might even merit a special promotion; so does a story by you or about you in any of these publications. Winning a contest or grant probably belongs on your professional resumé. So does the inclusion of even a single one of your images in a group exhibit or in a collection. Ways to capitalize upon such achievements will become clearer further along in this book.

13

Some Special
Selling Routes

Photographic agencies

ALTHOUGH selling through a photo agency is not for everyone, and is a marketing cure-all for few, it offers promise in a variety of ways. The agency business had its origins in the period that nurtured the great picture magazines. As these began to decline, the agencies that were to flourish started expanding their markets, and several of them are aggressively developing new outlets today. Each agency has its specialties, methods and working systems. Given a little background information, the reader can decide whether to pursue the idea of working with an agency.

Most agencies have their home offices in New York where about seventy-five percent of the total photography market is located. A few have offices in other cities, such as Los Angeles, as well. There are two types of agency operations: stock and assignment. Their endeavors usually shade into each other, so that both functions may be performed by the same agency.

The stock agencies, which are in the majority, act as picture libraries. They keep thousands of images on file, filed by subject and cross-indexed. Most sales—to ad agencies, publications, industry, calendar manufacturers and every other type of buyer—are the result of a request for a subject. The buyer will tell the agency that it wants a black-and-white photograph of a kangaroo, hurricane, church-going scene, college campus, red rose, alcoholic or any of a million other possibilities. The agency serves the function of a clearing house, stocking a large supply of pictures from many photographers in order to fulfill requests. Many stock agencies specialize in subjects in order to service requests better. Glamor, animals, nature and industrial photographs are typical

specialties. All stock agencies continually collect pictures for their files, and they usually have an open-door policy toward potential new suppliers.

The second type of agency (or division of the stock agency) is oriented to assignments. Typically a certain number of photographers are represented; they may be on the agency's staff, be under a contract to funnel all their work through the agency or associate with the agency as stringers. The stringers are photographers in various locations around the country (or world) who may be called upon when projects materialize in their locale or in their specialties; most of them also derive income from sources they develop on their own.

Some of the leading assignment agencies take the initiative in developing salable projects. Photographers who can produce ideas as well as pictures are highly valued by them. Because assignment agencies need a continuing input of new talent and new ideas, they too must keep their doors open and constantly review portfolios.

The middleman function of agencies suggests what they can accomplish for you. An agency can sell pictures to markets that are not accessible to photographers, whether because of location (particularly if you do not live in New York), knowledge of the market or the market's approachability. Some buyers prefer to review only work that has been preselected by a reliable intermediary; others have infrequent or unusual needs for pictures that make it unproductive to deal with photographers directly. As a picture repository, the agency is a known source of supply to thousands of users who could not otherwise locate the photography they need. Conversely, it can provide the photographer with a multitude of markets he could not possibly find for himself. The agency reaches markets all over the country and, in a number of cases, overseas, often acting through sub-agencies around the world.

A good agency functions with full professional knowledge of legal rights, often marketing the same picture many times over in a complex network of sales rights. (There are instances of a single image accumulating over $10,000.) It is often able to negotiate higher prices for both assignments and single pictures than a photographer would ask for. A good agent can offer a photographer invaluable advice, stimulate him to develop strong ideas, and help shape his career direction. A good agent is dedicated to maximizing the financial return on a photographer's production because that is the way he too makes money.

The last point introduces some of the drawbacks of this miraculous-sounding situation. For all the aforementioned types of effort, and to support what can be a very expensive overhead, the agency gets paid: often fifty percent commission on each picture sale (the range can be forty to sixty percent),

the sale price generally being determined by the kind of use to be made of the photograph. All things considered, this is not really exorbitant.

A second problem is that although almost any agency will review your work, most are quite selective about whom they will represent. This is especially true if you are hoping for the kind of agency that will give you highly personal attention and will try to promote you as a photographer rather than filing your images and selling them according to subject request. To sell through an agency you must first sell yourself to the agency.

This brings us back to the principle of showing a good portfolio. Just as a good photograph is defined many different ways, a good portfolio will vary depending on the agency you go to and what you expect from it. To save themselves time, most agencies will send you an information sheet on request, as magazines do. You will help yourself by collecting a batch of these and going through them for specialties, services, general tips and any format requirements. Some may only handle 2¼ or larger transparencies, some may concentrate on black-and-white; pay careful attention to such matters. There are not all that many agencies; they are listed in the New York City Yellow Pages and in *Photography Marketplace,* which also includes some foreign listings.

If you decide to try for an assignment agency, you will need an excellent portfolio to show off your skills to some of the most experienced critics in the world. It should exhibit complete technical mastery, diversity of subject, ruthless self-editing, wide-ranging capability and a thinking mind behind the camera. You are trying to prove yourself qualified to handle many different subjects on demand, capable of an individual but honest viewpoint on events, and able to shape meaning through your camera rather than just capturing what passes in front of it. The orientation of your portfolio, unless some special outlook of the agency is indicated (such as advertising), should be toward photojournalism. An assignment agency is mainly concerned with covering all kinds of events, personalities and subjects as they arise, as they are requested by a client, or as they can be originated by the photographer and agent together. Overall the assignment agency values proven talent, versatility and indication of a continuing output. While an individual vision is highly desirable, a photographer showing a purely esthetic portfolio (artistic abstractions, for example), is not favored nor, except in rare cases, are those photographers seeking encouragement to begin a freelance career.

Assignment agencies can also provide good opportunities for specialized photographers with outstanding skills. Some agencies themselves specialize in areas such as fashion, product photography and annual report photography; you will want to investigate those that most closely match your orientation. Do

not be disappointed if an assignment agency declines to represent you; its demands are very stringent. Your best chance may be as a stringer from "out of town" (outside of New York). Demonstrate a capacity for seeing ideas in your own milieu and executing them imaginatively.

A stock agency is a much easier starting point. It will tend to evaluate the salability of the material you show rather than your total accomplishment. I once heard an agency professional reply to the question, "What should a photographer bring to a stock house?" with "Everything. There are so many kinds of pictures needed that it is impossible for us to advise photographers, or for photographers to anticipate what we will be interested in." She did not mean literally that you should bring your whole collection, but that you should submit a representative variety. As in other situations the reviewer can always ask for more. A portfolio prepared for an agency, however, can contain more images than one for most other purposes. Several hundred transparencies in plastic sheets is not too much.

Questioned directly, most photo agency representatives will stress the increasing importance of image quality to today's discriminating art director and editor, the agency's customers. In practice, the stock houses have their own definitions of quality. Certainly technical excellence is the constant prerequisite: Sharp, well-composed, defect-free images are the only kind acceptable. Originality, however, is far less sought than clarity of communication. A picture to illustrate an article on Cincinnati must immediately say Cincinnati; if the story is on problems in the schools, photographs that come as close as possible to picturing those areas will be chosen, but first they must obviously show school scenes.

The result is a tendency for stock agencies to prefer photographs that are "good clichés," as I once heard it phrased. Photographs that represent a subject most directly and quickly, with the least possible confusion, are wanted by buyers and thus by the agencies supplying them. A good picture of the Eiffel Tower still says Paris. This outlook has a more subtle effect on content. Think how the "average American" is depicted. Picture buyers still hold that he or she is white, Anglo-Saxon, Protestant, middle-class and midwestern. (Unless of course the picture is for *Ebony* or an ad aimed at a particular ethnic group.)

The stock agency's system of classification by subject in itself militates against assessing creative elements in photography. Most agencies have neither the facilities, the time nor the staff to do more than provide a batch of photographs that match, by subject and format, what the client requested. It's hard to dial in a criterion for something so subjective as creativity, whether a computer or a researcher is doing the matching.

Stock agencies are simply not equipped to deal on the level of "photographically interesting." And, whether as cause or effect, buyers who use stock houses tend to choose conventional imagery. This does not mean that creatively done pictures will be refused by either agency or client, as long as the pictures are technically good, just that they probably won't sell better than run-of-the-mill work.

Therefore: Good but unremarkable photography can sell through an agency. If you are honest enough in your self-appraisal to feel that that's what you've got, at least in part, this can be a prime opportunity.

Subject is all or nearly all. What subjects are most in demand? Agencies must continually add to their files on perennial interest subjects such as pretty girls, seasonals, animals, nudes, babies, scenics, family life and tourist attractions. Travel pictures can be a good bet if you can provide a selection that mirrors many aspects of a nation's life—economy, industry, people, landmarks, scenery, way of life and customers. Some agencies particularly welcome photographers who can offer such collections for three or four countries.

People pictures are always needed, especially those of ordinary-looking men and women (not glamorous models) in everyday activities. Happy, positive-looking images tend to sell better than gloomy ones. Subjects in demand can be inferred by observing current events and interests—attention to ecology and conservation has created a corresponding need for nature pictures, for example, and the enthusiasm for physical fitness produces a demand for suitable illustrative images.

Photographs should not be dated by hairstyles or dress fashions that will go out of style (although pictures that say America in the Fifties or the Thirties could be big sellers now given recent nostalgia, fashion revivals and concerns over economic recession). Model releases are highly desirable. When they are lacking, an agency may decline to accept the picture at all; the agency definitely cannot sell the picture to commercial (non-editorial) buyers. Lack of a model release eliminates many of the highest-paying possibilities.

Captioning information is also worth attention. An agency's indexing system depends on your subject identification, and a potential buyer often rejects a submission because insufficient data was provided. Follow the Five W's rule (Who, What, Where, When, Why—and How); take the trouble to look up technical information like the name of an animal or plant. Such details can notably expand your market. Check with the agency you're dealing with for its preferences on how to provide the written information. A brief identification is usually desirable on the picture itself—that is, attached to the back of a print

or written on a slide mount—so no question can emerge about which image is which even when more information is keyed on a separate piece of paper. Your name should always appear, but it may be better not to include your address, since the agency will affix its own.

Inquire of any agency you approach if it handles photo essays or features. Many do, and will give you guidelines on what is most in demand if such work is up your alley.

If an agency expresses interest in your work, it may offer you a contract. You will receive a "standard" contract form (standard for that agency) which you should read in complete detail. Note especially the commission percentage; whether you are giving the agency exclusive representation rights to your work and whether you retain the right to sell for yourself without paying a commission; whether there is any compensation for loss or damage; and the minimum time your work is to be left with them—three years, or even five, is not unusual.

The agency's indexing of your work and selling it by mail is a time-consuming process. Your work will be circulated continually, perhaps all over the world, and it can easily take years to get your pictures back after you demand them.

Many photographers overlook the full implications of this. Only material you can do without for an indefinite period of time should be deposited with a photo agency. Also, since the agency probably assumes extremely limited responsibility for the safety of your photographs, you will not want to submit your most precious, irreplaceable images. Agencies will often accept duplicate slides. Some photographers who work regularly with an agency take care that a good shooting yields a full complement of similar images. But note that you cannot submit similar (or even dissimilar) images to another agency during the contract term unless the sales territory for each is explicitly defined.

Incidentally, it isn't necessary to behave as though a contract is made in heaven, never to be tampered with; lawyers don't. A clause that is inconvenient to you may often be eliminated at your request without undue hassle if the change will not interfere with the basic conduct of the agency's business. You may, for example, ask for a one-year or two-year trial period, so you won't have to wait five years to withdraw unsold work. Contracts are always designed for the benefit of the party which is in a position to give them out, so be alert and make an independent decision about the benefits and liabilities involved.

In considering an agency, do not overlook intangible aspects either, such as the agency's general "personality," its attitude toward your work, its

reputation among fellow photographers and the care it seems to exhibit toward images. Even a stock agency should represent you in the fullest sense. Many a photographer does poorly with one agency and very well with a subsequent one, due to a great many factors.

Agency representation can work out extremely well for some photographers and be disappointing for others, but often not even the agency pros can tell which will be the case in advance. Few photographers are catapulted to fame and fortune by an agency, but many derive tidy supplements to their incomes over a long period of time. You may not hear from your agency for months on end, but every quarter or so, when accounts are done, a check for cumulative sales may arrive.

It can be most exciting to see where your work is published, too. A friend of mine was amazed when, after placing work with an agency, tear sheets began arriving from strange publications in the remotest parts of the world. But there was a catch: Payment rates in many of these places were extraordinarily low; a dozen uses of a small photo-story could net only seventy-five dollars altogether. Still, he agreed, that was seventy-five dollars he would not otherwise have had.

A personal representative

I have known many photographers who believed the route to success lay in acquiring a photography agent, or personal representative. Although being able to concentrate entirely on photography, leaving sales to another, is an attractive idea, it is often unrealistic. First, you would be depriving yourself of the first-hand marketing experience that can be crucial to your photographic development, as stressed at the beginning. Second, until you have extensive experience, a superb portfolio and a good income coming in from photography, you are unlikely to find an agent to take you. It is the old problem of getting help only when you do not need it any more.

An agent cannot make a photographer, though a good one can certainly advance a career and direct a talent toward fruitful directions. The agent has to believe that not only can the photographer earn his own way, but that the agent will earn his living on a percentage of the income. The usual arrangements call for commission of twenty-five to forty percent, and the agent expects this to apply to all new sales, even if made by the photographer.

Personal agents handle the most commercial work, geared to the most lucra-

tive markets—advertising, industry and such. Although some agents handle a group of photographers of varying specialties, many feel that two or three is the optimum number. Still others find the one-to-one relationship the only practical approach. Almost everyone agrees that selling photography on a personal basis is not an easy way to make a living. A good personal rep is worth the high-sounding commission rate because, besides relieving a photographer of the marketplace trudge, he can negotiate better arrangements with clients, maneuver access to some markets which cannot be approached directly, and obtain assignments. In addition to professional sales skills a rep can draw upon market information available only to his peers.

If you believe your skills are sufficiently proven to interest an agent, a list of professionals is in *Photography Market Place.* Nearly all are located in New York City, because that is where most buyers are. If you deal with local, rather than national, ad agencies and industries, you may be able to track down a local rep. You might even cultivate your own agent. If, for example, you have an out-of-work friend who loves your photography, a wife or husband with some time to invest, or an acquaintance related to the photographic industry and willing to try something new, you can develop an interesting collaboration. Every photographer and agent team starts off selling by trial and error, although you will not want too many errors made in your name. Some photographers get good results by sending their models around with the portfolio.

Whether you find an experienced rep or a beginning one to take your work, observe a few cautions. Be sure that all financial arrangements and other matters are clearly agreed upon in writing; be sure that you are agreed on whether clients already established are part of the future terms. And just as important, remember that your agent should be "in tune" with you and your work. A unified image and personality are essential, since you will have to get along with any client solicited by your agent. You do not want a super hard-sell sales pitch when your own style—personally and photographically—tends to the understated. Soft-spoken selling can be every bit as effective, more so when called for by the product.

There is an organization called the Society of Photographers' & Artists' Representatives (Box 845, FDR Station, New York, NY 10022) that can provide information on agents. Detailed guidelines on the photographer-agent relationship are contained in the *ASMP Professional Business Practices in Photography* guidebook.

Picture syndicates

In the Manhattan Yellow Pages under "News Service" is a full column of organizations that collect and disseminate information in the U.S. and elsewhere. They represent a market of major proportions vastly underestimated by photographers. The two American giants are Associated Press (AP) and United Press International (UPI). Since they are accessible in cities around the country as well as through their New York headquarters, understanding their interests will be useful to you. Many of the principles discussed can also apply to the foreign services listed, which channel news and pictures back to their home countries and inform American outlets of overseas events.

Both AP and UPI are awesome organizations with complex distribution networks around the U.S. and the world. Their news and picture services are the mainstays of many newspapers in the nation, and are also drawn upon by many magazines. In addition to spot news, they supply television newsfilm, feature material and columns. Because even the largest possible staff could not possibly provide the huge input constantly demanded, the wire services depend upon outsiders to supplement staff material. Amplifying this natural opportunity is the intense competitiveness of the two goliaths to get the best and get it first. Insofar as modern technology can implement this aim, every innovation is employed to get material in and out faster and better. But the input must always come from writers and photographers. How does this relate to the freelancer?

Officials at the wire services all say, "We don't care where a picture comes from; if it's good we'll use it." The wire services have top-flight staffs working out of offices around the globe and on special assignment as events arise. In addition, they can use the pictures of photographers employed by the newspapers they service by contract. But even these facilities cannot guarantee sufficient coverage. An interesting or important event can occur at any time, anywhere, and an amateur or freelancer on the scene with a camera may possess the only pictorial record available. Even when a major event is well covered, the wire service executives gladly admit, it is not surprising to see a nonstaffer emerge with a better photograph.

Partly for this reason, wire service offices are expected to review material from hopeful contributors as an important, continuing duty. Track down the office nearest your home base. A staff member willing to review a portfolio and advise you on his organization's needs and standards should be available. If this system does not work out for any reason, contact the New York headquarters, where this function is taken very seriously.

If you have pictures the service can use, an arrangement may be made on the spot. Prices paid range from five dollars to thousands according to the interest value of your picture, its relative uniqueness and the extent of distribution anticipated. A picture may be circulated on a local, state, regional, national or worldwide level. Often price is negotiated, and naturally the wire service representative will try to make the best deal he can. If you have reason to believe you've got something important, don't hesitate to bargain. There have been sad stories about pictures-of-a-lifetime getting sold for relatively nothing (for example, a picture of a large airplane diving into its crash landing).

The wire services are interested in several kinds of photographs. Spot news pictures must be brought in immediately if not sooner if they are to have value. It is not out of the ordinary for an AP or UPI office to process your film for you when you have captured a major happening, and they may even negotiate a price before seeing the results.

Additionally, and more importantly, the services have an unremitting demand for feature photographs. Note, in the newspapers you read, the number of pictures not related to important news events; classify them by type, and you will have a good idea of the market the syndicates try to fulfill. An AP photo editor said, "We need pictures that make people feel good about the world."

News events and the corresponding pictures tend toward the depressing, so newspapers try to give their readers reason for cheer as well. The result is a shortage of some picture varieties that by now may sound familiar: cute pictures of animals; babies and children; humorous pictures; dramatic pictures; seasonals and scenics; pretty girls; happy pictures; photographically unusual images; and human interest shots, such as appealing emotional expressions and people helping people. From this perspective, more than one photographer has discovered a goldmine buried in his files, since such pictures are not dated unless outmoded dress or hairstyle gives them away.

Since the wire services' need for general material provides you with a chance to show your portfolio at least, give it a try—you may well learn something about photography and what to bring next time if at first you don't succeed. A good starting point might be a basic portfolio with attention to the kinds of pictures listed above and candid pictures of people in action. A continuing arrangement can evolve if you have photographs or abilities the wire service can use. Stringers are often given assignments.

Pictures used by wire services can also find their way into a picture-library operation at the New York headquarters, which sells photographs in much the way commercial stock agencies do. Be sure you know what rights are being purchased for the price when negotiating.

A somewhat different marketing potential is offered by news-feature syndicates—some are listed under the same "News Service" category in the Manhattan Yellow Pages, and *Writer's Market* carries a listing with an explanation of their interests. Like photo agencies they work on commission (forty to sixty percent) upon placement of material in a newspaper, magazine or other medium. These are the organizations that distribute syndicated columns—regular material that may appear in numerous outlets. The syndicates also handle single features when they look salable. Many purchase illustrated articles of great range, and others are especially open to photographic stories. Good editorial feature material is supplied to users around the world and a good human-interest photo story can get surprising play. Note when checking your research guides that agencies like Globe, known as a stock photo house agency, are also listed as syndicates; the functions of agencies, picture syndicates and editorial syndicates tend to blur together where photography is concerned.

And finally, don't forget that it can be worthwhile to investigate any special needs of the foreign news services (such as Reuters, Tass and Kyodo), which have offices in New York and sometimes elsewhere in the U.S.

Stringing

The publishing industry is almost entirely centered in a few urban areas, most notably New York City and to a lesser degree Los Angeles, Boston, Washington, D.C. and Chicago. Major newsstand publications often have outposts in one or more distant areas, usually to sell advertising but sometimes to represent editorial interests outside home base. Only the few very wealthiest publications can afford to support a full-time editorial staff in any second location. As a result, editors depend on stringers, that is, local contributors who regularly or frequently supply material, either on request or by their own initiative.

A stringer may be a photographer who is ready to cover an event within a certain radius of his base; the same person may string for a number of non-competing publications. A stringer may have a more official designation, perhaps appearing on the masthead as West Coast Correspondent or such. In the latter case, he is often expected to represent the editorial interests of the publication in some manner, which usually ends up being in proportion to his personal abilities.

A certain number of photographers understand the idea of stringing only to a limited degree, since they will mail out a promotional letter and perhaps

picture samples to a list of publications, saying something like, "I am an experienced versatile photographer who will be delighted to cover events in my area for you upon notification." There is nothing precisely wrong with the approach, but it ignores the publication's real needs, and thus your best opportunities. The editor's problem is less that of locating someone to cover an event, and more that of finding out that there is an event to be covered. An editorial staff's vision is largely limited to its immediate surroundings. Even something that constitutes big news in Oshkosh may not reach New York ears at all, especially when an angle relevant to publication can only be observed on the scene. What we are suggesting is an active concept of stringing, one of scouting ideas that you can follow through upon when appropriate. This approach can open surprising doors for you.

This is really the logical result of the practice advocated earlier as cultivating your personal market, taking advantage of geographic factors. It is much better to have one or more consistent markets for your material than to search out new ones every time a subject comes up. Actually, having a destination market will help you see more subjects around you than if you try to work without limitation of viewpoint.

The best way to establish a continuing stringer relationship with a great variety of publications is to supply them with good ideas well executed. Even one such experience can interest an editor in exploring more ideas with you; or you can supply a second good idea. Except in rare cases where the editorial inbaskets are too full already, every editor needs good reliable input and welcomes new sources. Stringers are ideals from the editor's viewpoint because they do not cost him anything additional to what would normally be spent filling up his issue. Most stringer arrangements call for paying at regular rates for material published. When listed on the masthead as Midwest Representative, or something similar, a stringer may be paid a retainer fee as well, but it is usually small.

Most photographers to whom the stringing idea is suggested respond, "But nothing much happens in my area—you have to live in a big important place to succeed this way." This is inaccurate. The power to observe events and interpret them in an interesting light is determined not by location but by individual thought. I once heard the director of a major publication point out that while he hadn't heard from his stringers in Chicago or Boston for years (although they were glad to accept assignments), an eager young photographer from a small midwestern town was sending in so many strong stories that his home was starting to look like the pivot of the universe. Since so many successful stories are those with the most personal, human appeal, it is obvious why a

small community can be a wonderful breeding ground for ideas. And you may encounter far less competition in marketing yourself as a stringer from a less crowded area than you would from an urban capital.

A certain number of publications may be able to use you as a photographer stringer, but even just-adequate writing capability expands this market potential enormously. If you choose not to write, you are limited to situations where no words are needed or a writer can be separately supplied.

Consider the following kinds of outlets.

Newspapers

Your local newspapers are probably always short-handed; most newspapers are. Make yourself known to the editors as someone who will be available when they need you, or as a contributor who will cover events on your own initiative and offer the results for use. More significant than any payment is the local publicity and the experience you will gain. Moreover, it is often the local newspaper which is called upon for advice when an outside buyer needs a photographer in the area. Such moonlighting jobs often go to staff photographers or reliable stringers with special talent.

Photographers who live in places such as New York City may hesitate to approach the *New York Times* or *Daily News* this way, but note that about forty-five weekly community newspapers are currently operating there, a trend apparent in many cities. Many of these neighborhood publications use offset printing and modern layout, making them good showcases for photography. Their low (or nonexistent) payment rate eliminates the bulk of your competition. Local newspapers are usually receptive to reportage photography and feature material, especially of neighborhood scenes and people.

Wire services

The wire services are always in need of pictures and suppliers, as already discussed; making your work known to the local office is a good way to promote your availability. If you can produce useful ideas, all the better.

Photographic agencies

Photographic agencies are also accessible to stringers because stringers are able to cover happenings in their own parts of the world. The more

progressive assignment agencies are placing more emphasis on selling to prominent markets stories originated by the agency or photographer. Stringers who can initiate and develop editorial ideas are encouraged.

Trade magazines

Trade magazines offer outstanding opportunties for stringers. Many cannot afford regular coverage outside their base area, but they serve national audiences and are glad to expand their coverage by using stringers. Down-to-earth material will suit them admirably—portraits of local business in the publication's field, coverage of professional conferences, and examples of problems and solutions relevant to the industry. Look critically at any professional publications you receive to see if you can spot any subject coverage you'd like as a reader; visualize a way to handle it and you may have a salable idea. Taking the initiative with trade magazines can especially pay dividends because their editors have the least time, facilities and money to spend digging up contributions.

A good many writer-photographers earn healthy livings by representing a group of trade books. You might think about potential audiences with interests related to one you know well and track down its publications through one of the research guides. A knowledge of one scientific field, for example, is often sufficient for understanding many others. Don't forget to ask any editors you're already working with whether his company publishes other magazines and, if so, if you can ask its staff about their interest in your services. Most publishing houses diversify by developing publications for new audiences related to existing ones. The existing staff develops the new idea, and established advertising accounts are solicited for ads in the new medium. You are automatically qualified to contribute to the new magazine, too.

In practice, after you have had some experience contributing to trade magazines, you will become less modest about your ability to cover any subject. Writer-photographers who think of themselves as communicators contribute to a very diverse list of publications. And you are apt to eventually conclude that most fields are reasonably easy to deal with when you have mastered the techniques of analyzing audience interests and dealing with people.

Consumer magazines

Consumer magazines of both general and special-interest orientations use

stringers, often in profusion, to cover as much ground as possible. Again the best approach is to offer a good idea and your services to execute it. Few magazines are too big to snub a prospective contributor.

Someone I know as a fine photojournalist served for a while as features editor for a large family-health publication. Wishing to encourage good photography and young photographers, he had an open-door policy and reviewed portfolios endlessly.

"Many showed considerable talent, but I rarely had assignments lying around handy to offer them. So I always said, 'I reserve space in every issue for one good photo-essay type story. Present me with an idea for anything related to family life, health, medicine or psychology, and the pages are yours.' Well," he told me, "after a full year I reviewed the result and found that only two photographers had followed through with a suggestion—both of them already internationally famous photographers."

Leaf through *Writer's Market* and you'll find hundreds of editors encouraging submission of ideas from people in every geographic location. The person responsible for photography at *People* magazine was quoted not long ago to the effect that photographers wanting to publish in that magazine should locate interesting personalities in their own areas—not famous people but everyday ones with interesting hobbies, backgrounds or achievements. A considerable number of big magazines share *People*'s enthusiasm for human-interest stories, even though such material forms only part of their content. All the idea-generating suggestions in Chapter 9 are relevant. Especially productive to watch for are people-helping-people situations, subjects of hot regional concern, and local controversies that microcosmically represent national feelings and problems. Pay attention to the local media and do not assume they are seen by the world at large.

Foreign magazines

Most American photographers exhibit a peculiar provincialism in thinking of American publications as the only ones worth their effort. They overlook the fact that most major foreign magazines maintain at least one editorial office in the United States and, in addition to keeping their staffs of full-time photographers frantically busy, are eager buyers of freelance material. In fact, many foreign magazines are aggressively competitive about obtaining the best material, especially when several publications from the same country are vying for superior coverage of America. For example, there are three highly influential German magazines with New York offices—*Stern, Quick* and *Bunte*

Illustrierte. They watch each other like hawks; moreover, they are watched closely by other foreign publications, which frequently wish to purchase strong material run in one of the German magazines for their own audiences.

Many of the foreign publications pay handsomely for photographs, publish them with excellent reproduction quality, and provide prestigious credits. Some outstanding photojournalists have built their careers by covering assignments, often self-initiated, for European publications. After all, these magazines have a huge beat to cover—America at large—and have all the problems any magazine has of maintaining enough eyes and ears, usually amplified by smaller staffs.

While the better foreign publications are good markets for assignment-seekers—especially the experienced photojournalists—a newcomer can best approach them with already existing material. Most of these publications are interested in photo-feature stories, and many are enthusiastic buyers of strong story-telling single shots, often not caring where else your picture was used before or how long it has been sitting in your files, as long as it is interesting and non-datable.

What should you submit? Good bets may include features on American citizens native to the magazine's own country (for example, prominent German Americans). Many foreign publications are interested in pictures reflecting strong controversies or important news events in the U.S. They also like feature and human-interest stories that appeal to people anywhere in the magazine's home country, or stories that their readers can identify with in some way. The unusual, bizzare or amusing may also sell.

Each publication's needs naturally vary and should be individually investigated. How can you do that? The same way you examine domestic markets: by studying back issues of the publication.

Many cities have foreign-magazine stores which stock a great variety of overseas publications. If you can't find such a shop, try local clubs (an Italian American club, for example) to see what's on hand for members, or search out any other avenue your ingenuity suggests. The market potential is worth it.

Large companies

Large companies that are headquartered elsewhere but have a branch in your locale can be lucrative markets for the alert stringer. Even those with large photographic staffs are usually unable to send a photographer to their branches more than a few times a year. Try to bring yourself to the attention of the local branch if possible—via the public relations, communications or per-

sonnel department. Find out what publications are issued by the parent firm, examine them and think out story ideas based on the branch office activities or personnel. You might deal directly with the magazine staff at headquarters, but cooperation from local people is essential, so do not bypass them. This suggests another on-the-road approach—scouting branch offices you are traveling near—but this is apt to work best if you establish a prior relationship with a company magazine so possibilities can be discussed in advance.

The stringing idea can be applied in accordance with your location and orientations. You need not live in a small Midwest town and offer to cover neighboring states for a New York-based magazine; you can live in New York and offer to cover the action for magazines and newspapers in California, Chicago or Florida. And you can check out possibilities for covering your locale for foreign publications, such as the German *Stern* and the French *Paris-Match*, as suggested earlier.

To amplify something said earlier: Magazines and newspapers do not expect exclusivity from stringers, or they would not be stringers. They usually do not wish stringers to contribute to rival publications, however. It is entirely conceivable to develop arrangements with a whole set of noncompeting publications at once. If you were to provide each of several publications with a certain amount of material per year, you could do fairly nicely even though most such publications do not pay generously.

The great value of stringing is the regularity it can provide for the sale of your work. If you contribute every other month to, say, three small publications, you are probably at least covering your rent and can work upward from there.

14

Freelancing to Business and Industry

Say "commercial photography," and most people think about the glamorous world of the movie, *Blow-up*. Say "industrial photography," on the other hand, and people think of smoking steel mills. Neither impression is accurate, and the photographer who fails to look beyond the catchwords of his profession remains ignorant of some of its best opportunities.

Inventive thinking can pay off in these spheres to a remarkable degree. But so can the less glamorous-sounding technical capabilities. The first step toward finding markets suitable to your skills is to understand how business and industry use visual material and what trends are developing.

One of the difficulties in talking about industrial photography is that it encompasses such diverse users as:

- Businesses: from architects to insurance companies, record manufacturers, distributors, advertising and public relations agencies, and retailers.
- Industry: manufacturers of every conceivable product.
- Government agencies on the federal, state, city, country and local levels.
- Schools, universities and all types of educational institutions.
- Hospitals, medical centers and research institutes.
- Scientific study centers from astronomical to zoological.
- Law enforcement agencies.
- The military.

That's just to begin with. All the organizations within these categories may use photography for the following:

- Advertising and public relations.
- Documentation of processes and products.

- Employee communications.
- Basic research.
- Safety monitoring and efficiency studies.
- Quality control.
- Surveillance.
- Publications of every type.
- Displays and exhibits.
- Training and recruitment.
- Decoration.
- Investment.

And that's only a few of the ways photographs may be used. The business, industrial, governmental and scientific complex consumes photography in traditional forms, such as portraiture, journalism and documentation, and it is also in the forefront of applying related technologies, such as X-ray, electron microscopy, acoustical and thermal imaging, infrared, high-speed, time-lapse, aerial and underwater photography. The industrial outlook on visual materials is not in the least limited to still photography. Motion picture, video and audio-visual media are part of the effort. The current approach is not to separate still photography from the other visual media at all, including the electronic modes. For this most pragmatic of all photography users, the name of the game is most truly communications. The field can be lucrative; clients such as General Motors and the U.S. Army have quite a bit of buying power behind them.

The diversity of the field makes generalizations difficult, even for those directly involved in it. The traditional industrial photographers are men and women employed on the staff of any kind of business. ("Captive photographers" is another common label, distinguishing these nine-to-fivers from the theoretically free-as-a-bird freelancers.)

If you read any of the publications issued for this audience—*Industrial Photography, Photomethods* and *Technical Photography*—you will find that these professionals are quite preoccupied with trying to define their jobs and their roles to themselves and their employers. This is for good reason, because income and authority within their organizations are relative to such definitions.

Companies vary enormously in their understanding of photography's possible contributions to their causes. The talents of the photographers they hire and their range of responsibilities differ accordingly. Many of their staff photographers are not paid well or given much recognition. This discourages many talented among them from remaining captive. Those who persist for the

sake of security are forced to concentrate their efforts on the routine, day-to-day, dull work, which does not in the least help their ability to become imaginative if they are eventually called upon to do so.

Nonetheless, many in-house photographers perform incredible feats for their employers, with scant fanfare as reward. I am assuming that some readers *are* such captive photographers, who are seeking routes to satisfaction and recognition both inside and outside their companies. The principles of freelancing described in this book offer, I believe, their best approaches.

But if you are a noncaptive photographer, a freelancer, it will help you to understand the in-house man's position. For one thing, he is often the person responsible for hiring freelancers and directing and evaluating their results. Furthermore, it is the employed staff's capabilities and limitations which determine your opportunities. Freelancers are most frequently hired to perform:

1. The glamor jobs that the staffer is incapable of—or rather, is *thought* incapable of, by a management that tends to think anyone it can boss around every day can't be creative.

2. Specialized photography that is outside the staff's capability, usually because it is not needed often enough to justify keeping someone on the payroll to do it.

3. Support work when a special project is underway or the staff is temporarily overloaded.

Some organizations hire freelancers for *everything*.

The glamor stuff

A photographic department's bread-and-butter work varies according to the kind of organization it serves. A hospital needs medical photography done daily: photographs of patients and documentation in the laboratory. A manufacturer needs constant documentation for quality control, technical investigations and so forth. A law enforcement agency needs photography for evidence. A school system needs audio-visual aids. These organizations can require an astonishingly high volume of copying, slide- and print-making and chart-making. People who perform these functions well are often thought ill equipped to handle the photography for the glamor jobs, such as annual reports, publications, advertising, public relations, images for exhibition purposes and portraits of executives. These jobs involve the company's presentation of itself to customers and public.

Many large companies and organizations farm out a good part of this work to advertising and P.R. agencies. The agencies hire the photographers or buy

stock pictures. That is why so many photographers devote so much effort to pitching the agencies.

If you're trying for assignments in this league the first thing you'll have to do is find out who to talk to. Every client-agency relationship is different. If you want to do the photography for an annual report, you may have to sell yourself to the agency, to the company directly (which may handle this chore all by itself) or quite possibly to both.

When you've picked out a company the route is simple enough: Call the company office and ask where that work is accomplished and to whom you can apply. Usually there is someone available to review portfolios. At an agency this may be the art director in charge of the account, the account executive, the creative director or even the president if it's a small operation. Or you can find out which agencies are handling which accounts by looking it up in a book called the *4A Directory* (by the Association of American Advertising Agencies) available in some libraries.

Various aspects of dealing with agencies have already been discussed. With their often complex chains of command and decision-making, it can be a highly frustrating business, and only the size of the paycheck keeps many photographers trying. Others enjoy the competitiveness, constant challenge and insecurity of working for national accounts.

The proper portfolio to bring an ad agency will depend on how closely you've analyzed your potential contribution—what you want from it, in other words. If you are specifically seeking an annual report assignment, take the trouble to study several recent examples done for that company, and look for others that are considered exceptionally well done. Both the agencies and their client corporations are delighted to supply annual reports, and many cities have special-collection libraries that stock them. You may find that some balance between product and product-application pictures, executive portraits and photojournalistic treatments of company events and work scenes is appropriate. Come the closest you can to demonstrating your skill with these subjects. Good candid reportage of people involved in activities can be sufficient, whether the scenes are set in factories or not. Don't hesitate to include pictures that show imagination; for example, you might show a dramatic way with color, regardless of subject; a technique for double-exposing a product and what it does or accomplishes; or a filter technique that transforms a dull scene into something atmospheric.

An advertising agency, unless it is restricted to hiring only big-name photographers, is usually *looking for someone who can produce the non-routine dramatic image and suggest ideas*. The agency wants photography that will carry the

annual report or advertising campaign to new heights of esthetic splendor and marketing success. Esthetic and sales qualities are not always sought equally, because many of the most successful ads, television commercials, for example, are boring or ugly. The agency world constantly debates the value of its own awards, which honor the beautiful or interesting; but beautiful or interesting images often do not serve the client's goal of selling merchandise, and all too many clients are beginning to understand that. Thus, the overall quality trend over the years would be downward, and some think it has been.

It should not be inferred, however, that wonderful, innovative photography is not being daily produced for advertising and other promotional purposes. To gauge the highest industry standards and keep current, or just for general inspiration, search out a copy of *American Showcase* (or buy it from its distributors at 39 West 71 Street, New York, New York). Look also at *CA—Communications Arts,* which is heavily read by art directors all over the country (order it from P.O. Box 10300, 410 Sherman Avenue, Palo Alto, California); the end-of-the-year annual of this magazine is especially worth perusing. These showcases present the best current work as used in advertising and other commercial purposes.

In order to be hired by an agency, you must often show many times the skill and imagination you will probably be permitted to execute in the campaign itself. If a company's previous advertising and annual reports look uninspired to you, don't think you'll get the job by showing equivalent mediocre work. Your portfolio must stand out.

Pitching an agency is the time for your splashiest, zippiest presentation: big sharp color prints, if you have them, or a well-planned slide show. Highlight dramatic closeups of product parts or small objects, strong visuals that suggest abstract concepts, or images that show a flair for making dull scenes and subjects attention-getting. Remember the problems that may typify the client involved: Perhaps there is a need to show dull factory buildings, or people doing dull things, in a vivid way; or a need to present visually a concept such as the application of electronic data processing.

Take into account the job function of the person you're seeking. An art director, for example, will know much more about photography than an account executive, meaning the latter is more readily impressed with dramatic effects but may also want to be reassured of your solidity, your ability to produce good standard shots when required.

Exciting things have been happening in annual-report photography in recent years, making some reports showcases for top professionals of journalistic and artistic talents as well as commercial. Progress is generally hampered by

some very real considerations of audience, however. Annual reports are issued for stockholders, for the company's clients and for influential sectors of the economic community—hardly the off-Broadway of the visual world.

When you're specifically after advertising work, you ought to consider the potential client's product or service when preparing your portfolio. You don't have to construct photographs around that specific product—some agencies, in fact, prefer not to review portfolios that provide full campaign themes because of legal problems that can arise if something similar evolves independently. But your selection should be idea-oriented, demonstrating imaginative use of backgrounds or models, for example, or the kind of qualities recommended earlier for annual-report presentations. Suggesting campaign concepts can work if you're dealing with a smaller agency or client and are prepared to risk their appropriating the idea.

Dealing directly with companies

Even organizations that prefer having their advertising and annual reports handled by outside agencies may use freelance services frequently. Depending on the organization, the hiring of freelancers may fall to the photographic, audio-visual, graphic-services, visual communications, communications, public relations or advertising department. It rather depends on the history of applied photography at that company or institution. At some very large companies, for example, the camera was initially employed by the personnel department for training or identification purposes, and its services have remained under that department's auspices ever since.

The only way to find out who's in charge of what you want to sell is to ask. Be as specific as you can. If you ask for an appointment to discuss a feature for a company publication, the person you will be referred to will be different from the one to review a portfolio for an annual report assignment, an audio-visual job or photomicrography. You may want to investigate possibilities with several department heads. In really big companies and institutions there is such a huge amount of visual support activity that you may never find one person who knows about all of it. The decentralization of these functions may be accidental or it may be a deliberate policy; either way, it often results in internal confusion and in duplication of services and facilities. This doesn't even hint at the situation in governmental circles.

This means you might have to make a number of tries at selling your free-lance services. And if you are hired to perform a special job that someone else on staff, a few offices down, is eminently qualified to fulfill, it won't be the first time.

As with agencies, who you're seeing and what you're trying to sell will help determine what to show. Find out what you can about the company and its products. Think in terms of applied photography, which is photography used for purposes determined by the needs of the organization. This arena is not for the art-only crowd, though the most current techniques and esthetic trends may well be used for this work.

Big companies are monolithic beasts who may move with the times, but slowly. Because photography has been so undeniably useful, practically since its invention, for such purposes as documentation, recording and teaching, it has been routinely used for those purposes while some of its larger possibilities are escaping the notice of the companies' management.

Today's business-industry-government complex has precisely the problem of largeness. Big organizations have trouble with their communications systems—trouble accomplishing simple things like getting information disseminated, shared among specialists and translated for different audiences. They have trouble transmitting company policy from top to bottom and re-laying problems, gripes and suggestions from bottom to top; finding out what's being done at branch offices or headquarters; training recruits in efficient, standard, but individualized methods; keeping executives up to date in their own fields and related ones.

In addition to these examples of information-overload crisis, the big organi-zations have another set of problems which sound a bit less tangible but are no less crucial. These relate to the question of how employees feel about the company and their jobs. Motivated people work harder and stay away from the job less; inspired salesmen produce more orders; employees who feel appre-ciated for positive contributions perform more of them.

The problems of both information and team spirit rely heavily on photography and related visual systems for solutions. Some approaches are obvious. Still photography, audio-visual programs, film and video all offer excellent alternatives for indoctrinating employees. In numerous industries, workers are apt to learn their jobs largely via illustrated manuals and video-cassette programs; top management stays up to date with daily in-house tele-vision broadcasts; films, filmstrips, slides and unlimited quantities of photo-graphic prints are produced for learning resources in the endless chain.

But there are less obvious potentials for applying photography, in the broadest sense, to common problems. Here are a few samples of things with which some organizations have been experimenting.

• A regular photo feature in a company publication on an outstandingly productive employee.

• Exhibitions of photographs showing the work of specific departments,

the people and facilities of a branch office or headquarters, or what happens in an inaccessible part of the operation (for example, in a computer or furnace room).

• Training programs on film or videotape written and produced by the people who do the job, with some technical backup. One firm started by asking a group of secretaries to plan and produce a presentation on standard procedures for all new secretaries, with such success that the method was introduced to other job areas.

• A videotape session each week for employees to record suggestions or complaints for television viewing by top management.

Insofar as you can adopt the goal orientation of big business (which is often manifested as an urge to solve problems at minimum cost) you can begin to develop useful—salable—ideas for ways in which visual media can help identify and contribute toward solutions. Besides the team-spirit and information crises, for example, a big organization also has trouble projecting an image of being a positive part of the community. Photographs documenting the company's participation in charity work, conservation efforts and so forth are among the concrete possibilities that this problem suggests.

All of this is not as far afield as you may at first think. The right frame of mind, as we keep stressing, is essential to really intelligent self-marketing.

A few more points concerning management's attitude can usually be taken into account in some marketing situations. One has to do with minimizing costs. Big business and big government have more money to spend on communications material than any other segments of the market, and they are the only ones that routinely proceed on a cost-is-no-object basis. Nevertheless, the executives to whom you are trying to sell are very sensitive about spending their budget money. This does not mean you should offer to work cheap—you should never undervalue the worth of your services to this buyer—but rather that some thinking about multiple uses of your product can be time well spent. The over-shooting required for a good annual report job might, for example, lend itself to an in-house photo exhibit; a big project to document a company activity might provide grist for an advertisement; images taken for training manuals might be incorporated readily into filmstrips; a promotional series might suggest some dramatic audio-visual presentation for a stockholders' or sales reps' meeting. Any one of these ideas probably means more money for you; economy is relative.

A clever photographer I know produced on assignment a series of images of company structures. Management was willing to use some large prints to spark up a corridor. Rather than choosing half a dozen or so different images, suggested the photographer, why not select two complementary ones, make

five prints of each, and alternate them along the corridor as a single long unit. This would create a nice designer effect and save a lot of money: a single print from a negative would cost $100, but more prints from the same negative were only $50 each. So the company would accomplish its purpose for just $600 while getting a lot more for its money. The photographer was hired again.

Your presentation needn't be built around such concepts but certainly they can be mentioned. This will demonstrate your ability to think in businesslike terms, making you less of an alien object in the executive's eye—more a reliable, right-thinking sort. It shows you are thinking of "the big picture" and may well be useful. And such suggestions give your reviewer something to work with in dealing with his superior in the chain of command. This is not to be taken lightly. The thinking of big organizations tends to eschew real caring about jobs well done in favor of jobs looking like they are well done. An executive wants always to avoid the appearance of mistakes. He wants as much backup as he can get for his decisions, so that if something goes wrong he cannot be faulted for his reasoning. So give him what you can—not only sound business suggestions but your best credentials in the way of former clients and accomplishments.

Some executives, at both businesses and agencies, want something more than a qualified visual communicator. There are instances where, with a lot of money involved, the executive wants a little personal return on his investment of company funds in you, or he wants a little share of the free-living lifestyle you freelancers are so well known for, or he wants to personally select the model used for the sexy ads and help direct the shooting sessions. In such cases you're on your own.

A selling technique of which you should be aware is that of bypassing the command channels completely and seeking out the top of the pyramid in its own habitat. A photographer who belongs to the Harvard Club or Yale Club may well haunt their lounges. Others join country clubs, Chambers of Commerce, athletic clubs, museum boards, hospital boards, business clubs, party circuits or whatever else they can think of as top-executive haunts, especially leisure-hour haunts. I've met more than one photographer who carries a mini-portfolio in a pocket to be pulled out when occasion allows. Others use a more soft-sell approach.

Other things business buys

As stated earlier, business, industry and science are purchasers of excellent technical skills. Marketing here must start with your own individual speciali-

zations. A good photomicrographer is quite probably of use, whether regularly or intermittently, to all kinds of scientific and medical facilities, manufacturing plants, police labs and engineers. So would be a photographer skilled in macro work. Accumulate a catalog of personal possibilities and make yourself known to the appropriate places. As in all selling, but with photography more than most products, you are apt to find excellent sales leads by referral once you begin the process. Specialists in any given field know many others; they attend meetings, conventions and less formal affairs together and exchange information. They often have locally distributed newsletters or other publications, too, and if you can offer a really solid competence in a field you might even advertise.

At the other end of the spectrum, large companies and their agencies can be good markets for stock photography. Pet and baby food manufacturers, for example, buy pictures for their files. So do airlines, travel bureaus, convention centers, government agencies and municipal offices. Such files are drawn upon for a range of needs so broad that each organization cannot anticipate them.

The audio-visual market

"Audio-visuals" is another industry catchword. Huge sums of money are spent on that market in ways that many photographers fail to apply to their own abilities. The possibilities merit some specific discussion.

The market potential for a-v (let's shorten "audio-visual" to that) is virtually as broad as that of photography, because every kind of organization that needs to train personnel, make dramatic presentations or keep records of anything resorts to some form of a-v. In practical terms we can define a-v as any medium combining visuals and sound technology.

Motion picture and video are usually lumped into the a-v category as well, but we are limiting ourselves to still photomedia.

A-v can be a filmstrip, a multi-media presentation or a slide show. It can range from a single-projector and tape recording to special effects involving many projectors and tapes, live presentations and computer coordination.

There is a relatively small number of professional photographers with studios specifically oriented to producing this kind of material. Some have the capacity for systems design, others just know how to work with professional designers (and sometimes architects) when needed. Such studios compete for major projects sponsored by, for example, Pepsi-Cola or the U.S. Information Agency. There are full-scale production houses that employ all the professional specialists necessary to turn out filmstrips and other a-v media on order. First-rate a-v technology is quite complex today.

The a-v market for photography is enormously broader than many photographers assume. They underestimate it because, first of all, most of them never get to see the slide shows and filmstrips that are turned out. These photographers aren't going to school, being trained by a large company or being recruited by a government agency today (yesterday was different). Second, they overlook the fact that a-v media consumes still photography in huge amounts. A professional production house may obtain photographs from stock sources, or may assign staff photographers to cover a project. It also hires freelancers for jobs, and may be in the market for stock pictures bought directly from the photographer.

This is also true of a-v presentations and filmstrips produced by the users—companies, government agencies, charities; by educational institutions—school systems, universities, religious organizations; and by firms that produce various materials for the education market, such as book publishers and suppliers of teaching aids.

The field is so diverse and the needs so individual that research in the area must be up to you. The basic procedures can be followed: Start perhaps with the filmstrip and a-v production houses listed in guides such as *Photographer's Market*. Analyze all the possibilities you can think of, especially locally, after completing this chapter. Write some letters and make some phone calls. When you are invited to submit a portfolio, this is the time, generally speaking, for color, and it is best presented in a carefully assembled slide show. Show sequences.

Well-done slide shows and filmstrips try to simulate the effects of motion pictures in continuity of action, in the range of close, middle and long views, and in pace. In order to demonstrate your ability to supply the right kind of material for others to work with, take their ultimate objectives into account. Much of the a-v market is geared to horizontal rather than vertical formats, as opposed to the magazine market, so take that into account, too. Images should, of course, come across clear, sharp, colorful, uncluttered and graphically arresting when possible. That's in general, of course. Many purposes will suggest something different, so find out as much as you can beforehand about what stock material might be in demand or what kind of assignments in the offing.

The federal government

Despite the huge number of photographers, a-v specialists, and communications personnel the government employs, it is a mammoth buyer of photographic services.

Documentary and technical photography constitute a substantial part of this business. Training and audio-visual materials are purchased continually. Many government agencies collect images for their archives (which are heavily drawn upon by picture researchers in need of illustration; the government usually provides such pictures free or for a nominal fee). Many agencies and government branches commission photography of every kind. And the U.S. government is recognized as the largest publisher in the country—maybe in the world. It issues books, magazines, pamphlets, manuals and educational and informational material in nearly inconceivable quantity. Visit a Government Printing Office shop to glimpse the tip of the iceberg.

Finding out what opportunities are available for selling photographs to the government can be difficult. You can check with your nearest U.S. Federal Building personnel office about any short- or long-term projects for which hiring, at least in part, will be done locally. If you want to try for some military work, of which there is plenty, write to the commanding officer of a military installation and ask if you can be included on the eligible bidders' list so you can bid on upcoming contracts. It is a good idea to personally investigate particular government agencies that might be relevant to the kind of work you do—for example, recreation, parks, agriculture, wildlife. Tracking down possibilities can be time-consuming, as it can take a chain of letters before you find the right people to query; but working with a government group does not necessarily involve as much red tape and complex rules as you may fear. I have been told by photographers who often sell to the federal government that specifications for work performed are often very, very precise, but once the language in which the forms are worded is mastered, little problem is presented. At other times, working for a government agency or publication will be just as individualized as any other situation.

There is also a centralized source of information that reports everything the government is buying, is planning, is inviting bids on, and has awarded contracts on. It's called the *Commerce Business Daily* and is looked to by everyone interested in doing business with Uncle Sam. Check photography and related category listings in this publication and you will find projects ranging from the military to the Office of Economic Opportunity, the U.S.I.A. and the Peace Corps.

Many professionals scour these listings regularly looking not only for jobs they are equipped to handle themselves, but for announcements of contract awards to big businesses, who may subcontract a portion of the work. Especially if a local business is the prime contractor, a photographer may then directly contact that business, offering his services for that part of the work for which he has sufficient ability, equipment and facilities.

Many government contracts are awarded on a bidding system, and often a minimum number of bids are required by regulation, so responsible-sounding inquiries regarding bid listings may be taken quite seriously.

The *Commerce Business Daily* is issued by the Department of Commerce and is available in the business section of a good library. Or you can order your own. (A trial subscription starts at forty-five dollars for six months, mailed second class; write Superintendent of Documents, Government Printing Office, Washington, D.C. 20402.)

Be aware, especially if you are competing for work from any one of the armed forces, that security clearance can be an issue—not just your own, but the security of any facilities you might use, such as a processing plant.

The music market

Many young photographers have a natural affinity for the contemporary music scene and for the kind of inventive, highly experimental imagery that is inherent to much of its frenetic marketing strategy. If you are such a photographer, you'll be glad to hear that there are most certainly opportunities for the freelancer to sell appropriate work.

The record industry is the focus for these energies. As of several years ago record sales were generating more than $50 million—per week. Dramatic visuals are given substantial credit for making many an album a best-seller and making stars of certain performers. The effort to attract attention from hundreds of competitors in the racks and windows of drugstores, bookstores, music and variety stores impels the industry toward the limits of the visually extreme.

Most record company headquarters are in New York or Los Angeles—the latter has been attracting an increasing share. If by virtue of your presence at rock concerts you've gotten what you think are exceptionally strong, exciting shots of a group, you might start with that group's record company. The art director or A & R (artists and repertoire) man who works with the group might be your contact. In-person presentation is best, but the mails can be used, too. You can also suggest your most original or bizarre cover concept to the company. Bear in mind that large record producers have one or more staff photographers ready to execute concepts with all the equipment and technical backup conceivable. They undoubtedly also have a crew of stringers on tap. Even so, ideas are so critical to their operation that a new photographer who can produce one may get the work.

Concert tours provide the enthusiastic photographer with as much opportunity as he should need to get great pictures of the group in action, something

which, happily, 35-mm cameras are beautifully suited to accomplish. Color is the stock-in-trade of cover visuals, but black-and-white actually has a much larger market. The record company needs black-and-whites for publicity material, trade and consumer advertising, posters and promotions of all kinds.

Newspapers and magazines also prefer black-and-white. Don't forget the marketing possibilities among local media and rock and fan magazines. As with all photography marketing, you can try to sell what you've got on film as "stock"—to the record companies, publications and the star himself or his manager. Big recording companies purchase pictures for their files of virtually every talent on contract.

If you want to sell yourself as an assignment photographer, prepare the best possible portfolio. You shouldn't be surprised to hear that this is a competitive business. Go for mood, drama and excitement, especially in color samples. Include informal, spontaneous coverage of the group offstage, between numbers and rehearsing. A strong close-up of an individual performer has a good chance of finding a use.

As with advertising photography, you will have to work hard over a period of time (at your own expense) to collect good work and to cultivate the acquaintance of record company personnel, magazine editors and music industry types.

The music business is more than rock, which is merely its flashiest component. There's plenty of money in classical, mood and folk music; jazz, country-Western and children's records; teaching records, such as those that instruct in a language; and special material, such as show and movie music, historical subjects, comedy, seasonal material and religious music. These categories suggest possibilities beyond shooting pictures of performers and selling the pictures to the record company or group itself. This overall market uses scenics, romantic shots of couples, beautiful women, travel pictures, even arty abstractions. Check out a record store and see. Then check out the record companies (via the New York and Los Angeles phone books, music magazines or *Photographer's Market*) for interest in reviewing appropriate portfolios.

More markets

Also included in industrial and commercial photography are the following possibilities. Judge them according to your abilities and preferences.

Architects

Architects' offices (and sometimes builders' and contractors') frequently

purchase photographs of their creations. Pictures that are both graphically interesting and faithful to the buildings' structure and detail are considered fairly hard to come by. Although nice things are being done in this field with 35-mm equipment, most architects want larger format and more "professional" paraphernalia used when they're paying, since 35-mm snapshots can be taken by "anybody," including the architect. Taking the pictures and showing them is a better beginning than asking for assignments. Interior photography is part of this game too; doing it well takes experience and practice.

Real estate offices

A lot of selling in the property market is aided by visuals; some really enterprising salespeople use videocassette programs. Mostly mediocre stills are used, however, for catalogs and advertising. If you want to do such work try contacting real estate agencies directly. Most, to judge by the level of pictures they use, prefer doing it themselves and saving the dollars. But maybe you can show them the difference.

Restaurants, hotels and motels

These use photographs for advertising, brochures, postcards, maybe even stationery if they're smart (or if you are). Also, restaurants, hotels and motels are likely to have occasion for coverage of events: meetings, conventions and maybe even weddings, parties and other celebrations. Many restaurants or places of lodging are often asked to recommend a photographer, so if you approach a manager with pictures of his place and he likes them, remember to explain your availability. Sometimes photographing a hotel at night automatically provides something new and different and, thus, the entrée you want.

Stores and shopping centers

Stores use photography for window and interior displays, for advertising and promotion, for catalogs and, particularly, for seasonal selling. They also may be in the market for photography of special events: Shopping centers, especially, often sponsor exhibits and entertainment. A shopping center may even be interested in an exhibit of your photographs, or an exhibit derived from your taking portraits on the spot in some trafficked area.

Insurance companies

Insurance companies may need documentation services—photographic records of objects, buildings and works of art—or be asked to recommend someone for that work. They may also use freelancers for accident documentation and investigative work.

Lawyers

Lawyers may need photographs of accident scenes, accident victims and evidence. They may need courtroom presentations prepared.

Graphic art studios and designers

Graphic-art studios—usually small enterprises that provide freelance art services—often hire photographers for specific jobs. Many small businesses depend on these studios for their creative needs, and even large advertising and P.R. firms often farm out work to them. You can show your portfolio to art directors at these studios and, because few of them are deluged with photography, they are apt to remember you when an assignement or stock need seems up your alley.

Companies that produce textiles, linens, placemats, china and a host of other decorative items are beginning to turn to photography for patterns and inspiration.

State and local governments

Look into state and local governments in the same way as you would the federal government. Do not forget historical societies, libraries and museums that collect both historical and contemporary material. They may want you to donate work, but then you become part of an eminent collection.

Law enforcement agencies

Your police department may have an in-house photo staff and still hire freelancers; or it may hire outside for everything. What the police need done depends on how up-to-date the department is, but the usual categories are photographs of crime scenes, evidence, fingerprints and comparisons of several specimens, for example. If police are really sharp they may use

infrared, ultraviolet and other special techniques. Photography for police work may end up in court, maybe even requiring you to testify. If you are asked to do such work, use some sense and know what needs to be shown—this will determine whether you use color or black-and-white equipment, how large or small the subject must be and whether an indication of time or size should be incorporated. Good police photography is one of the least-used tools available to law enforcement.

Entertainment industry

Theater groups, opera and ballet companies, acting schools, music schools, concert groups, singers and other performers always need pictures for promotion and publicity. If you like doing this kind of work take note of the entertainment activities in your area; you might be surprised by their range. This work can be a fine way to develop your abilities at both action and staged portraiture, and also to get first-class free models—all to the good of your experience and portfolio. Even if you donate your time and materials in exchange for the opportunity, remember that individual participants in a repertory company or dance group can provide an eager market for prints.

Don't forget to check out press agents representing groups or individuals who might be able to use your pictures or abilities.

Museums and art centers

Museums and art centers often need to document facilites and events, catalog objects and, often, to produce slides, postcards and other items for sale to the public. Work done for these purposes may find its way into publications ranging from museum bulletins to art books. Museums are always understaffed. Even an established New York museum turned to its receptionist for slides and book projects. A museum may appreciate knowing of your availability if you have some expertise in its specialty and your price is right.

Travel bureaus, agencies and airlines

These may buy good pictures of specific locations for all sorts of purposes and can be good places to try stock travel work. Travel clubs and associations may also be interested.

Resorts and camps

Resorts and camps use photography for publicity, promotion and advertising.

Model agencies

Professional and aspiring models constantly need excellent photography for their portfolios, just as you do. They may not want to buy photographs from you, but arrangements for an exchange of services may be made through an agency or school—you get a good subject for your test shots, the models get free prints from you. Many fashion photographers routinely do this. (If you don't have a studio to work in, you might suggest shooting outdoors.)

Fraternal organizations and clubs

These may need photographic coverage of events, especially of the community-involvement type, or documentation of facilities or people.

Churches, missionary organizations and religious groups

These groups often need photography of places, people or events. Many issue fine publications, including a great many directed to teenagers, or informal information sheets. Many operate old-age centers, orphanages, research facilities, hospitals and schools, each of which can require photography.

Hospitals, medical centers and scientific institutions

Medical and scientific institutions often have good in-house photographic staffs and facilities because they require photography routinely, but tight funding can mean inadequate staffs. If you have real technical expertise to offer this market, make yourself known. Some needs are of the public-relations and news variety, so those skills may also be applicable.

Athletic organizations and clubs

Possibilities for some photographers exist with little leagues, bowling teams, and professional and amateur athletic enthusiasts of all sorts. Some photog-

raphers stalk athletes in their habitat—bowling alleys, parks, ski lodges, airports, marinas, gymnasiums. The roving camera is not to everyone's taste, of course.

Are there any more markets out there?

Yes, of course there are. Hundreds. Thousands. You can probably name some of them offhand yourself. As I said when we started, there is no such thing as a complete list of the photographic market. Some markets die while new ones are born daily. And the balance is most definitely on the side of the new ones.

As a civilization we are increasingly dependent on photography and its visual cousins—film, a-v and video—to inform, inspire, stimulate, challenge, enlighten and entertain us. A scant century and a half after the invention of photography, it is impossible to envision a world without it. The thrust of our culture has been to add more images daily, more ways to use photography, more ways in which we will rely upon it.

Some think photography's visual language is becoming a substitute for our written one and in some ways our verbal one. But of course we need all of them.

Communication, the biggest catch word of all, is perhaps *the* issue of our times. Understanding between individuals, groups, regions and countries seems more difficult today than ever. Is it progress to know how far apart we are? Maybe, but there's little question that our communications technology is going to have to catch up with all the other kinds of technology we have so unheedingly created.

This effort needs thinking men and women. People who not only produce a paragraph or a photograph upon command, but are conscious of the larger dimensions of their role.

Photography is a major resource in our need to explain ourselves to ourselves and to each other. If you are a photographer, or want to be one, consider the big picture as often as you can instead of getting bogged down in the endless small struggles of selling a particular photograph or winning a special assignment. *Think* when you take pictures. *Think* about ways photography can make something easier, or better, or faster, and the future is yours.

15

Promotion: Building Your Name and Personal Image

PHOTOGRAPHY is an image business in more ways than one. The degree of professionalism you project can be as critical to success—whatever success means to you—as your skills with camera and enlarger.

Ironically, the importance of your professional image is due substantially to the very absence of any definition for photographic professionalism. There is no question that a doctor, lawyer or accountant is "professional" because he is officially certified to be that. But other than being someone who makes a living with a camera, what is a professional photographer? In the U.S., anyone can set up a photographic business without having to prove himself qualified to either a government or a peer group (this is not the case in a number of other countries). The "degrees" awarded by a few national photographers' societies are thinly veiled mutual-admiration compliments that have no meaning to nonmembers. Unlike a plumber or truck driver, a photographer needs neither a license nor a union membership to practice.

This lack of requirements for training, knowledgeability and accountability, added to the fact that no universal standard for "good photography" exists, results in a situation that is uncommon among the trades and professions. Many fine photographers are overwhelmed by less talented competitors who are more skilled at self-promotion. "If you've got it, flaunt it," is an outlook intrinsic to the modern business scene. In fact, many people would say, "Even if you haven't got it, flaunt it anyway—nobody will know the difference." You owe it to yourself to consider some of the possibilites. You may not want to put your name on billboards, drop promotional leaflets from helicopters or advertise on television (although some very successful photographers do all three). But even a soft-sell champion can benefit from some down-to-earth approaches.

Keep in mind that because no uniform standards, working methods or business techniques have been established, your horizons are nearly infinite. There are remarkably few occasions that really demand the use of photography; people do not need it the way they need food, doctors and plumbers. As the cosmetician sells glamor, a photographer is selling something that makes life more beautiful, expands knowledge, expedites communication, inspires buying, decorates the home or a hundred other things.

To an extraordinary degree, the market for a photographer's work is created in proportion to his imaginative effort. Consider the example provided by portraiture. Logic might lead you to assume that the most successful studios are located in affluent neighborhoods whose residents are conditioned to buying luxuries. Not necessarily true. Many studios in rich urban areas are marginal operations, while some of the most profitable are located in tiny rural hamlets and low-income neighborhoods. As some clever photographers have learned, the latter groups offer a better potential market in some ways because of their greater reliance on traditional values, family ties and, thus, desire for portraits. But not only must the successful photographer know his audience, he must reach them, and perhaps more than in any other enterprise, success tends to be a function of how you see your own value and project it to others.

Professional demeanor

Photographers are often hired, or rejected, on grounds more relevant to personality than to skill with a camera. The buyer is not wrong to consider your bearing, conversation, attitude and thought process when you solicit an assignment or a job. After all, most photography is performed not in a vacuum but in close contact with many people under potentially stressful circumstances. If an editor finds you offensive he assumes that so will the models, writers, art directors or others involved in the project. To the picture editor, agency executive and company manager, a "professional" photographer is by definition adaptable, cooperative, punctual, reliable, honest, resourceful and even-tempered. Unprofessional is the photographer who is sloppy in his work habits, inconsiderate of others, careless about meeting times and deadlines, insistent on his own viewpoint and subject to temper tantrums when inconvenienced or denied his own way.

Your buyer does not generally demand that you be charming but does expect you to be pleasant. He assumes you understand that when you are on assignment for him, you are in every sense his representative upon whom he has staked his own reputation. He does not necessarily expect you to dress the way

he does, but he will probably react negatively to a sloppy or dirty appearance. He does not expect you to lick boots, but does hope you will show basic courtesy to those you are photographing as well as your coworkers.

Self-assurance is a professional quality. It derives from confidence in your ability to handle the project you have solicited, efficiently and effectively. It does not imply a need to impose your will on everyone else or aggressively state your personal qualifications. Action can be directed without riding slipshod over others. Many of the most-used photographers exercise a real feeling for other people, which not only makes everyone's job smoother, but elicits the most communicative poses and expressions from their subjects.

It is undeniable that in choosing to be a photographer, you are opening the door to many personal rejections. That is an unavoidable part of the game. You can do yourself a great service, however, by remembering that every situation is new and promising. The editor you are seeing this time is not responsible for the ego blow dealt you by the art director somewhere else. And the editor who takes personal satisfaction from turning a photographer down is very rare. In almost every case, remind yourself, he or she will be almost as happy as you are should your mutual needs prove complementary.

So whether you are showing a portfolio or performing an assignment, put yourself on the other side of the desk: Would you hire an applicant who expressed hostility, suggested your ideas were stupid and ignorant, or needed to prove his creative nature by temperamental piques?

If you think the foregoing is out of place addressed to an intelligent audience, you are right—or should be right. It is a basic editorial experience to encounter many photographers who feel that the free creative spirit is expressed by contradicting normal human standards. In any other field, this would be a funny way to sell; it doesn't really work in this one either.

The professional image

A good salesman is future-minded. He has an eye not just for immediate results but long-range cultivation of contacts and markets. He seeks to build up his selling message and personal memorability to the prospective buyer gradually. The photographer, who is selling a very personal service, has a special concern with building his name and getting remembered. Although these goals are not accomplished through gimmickry, something as simple as attractive business stationery is so effective in creating a good impression that to avoid spending the money for it is foolish.

Business cards, letterhead, mailing labels and envelopes can be surprisingly

important in setting the stage even when you are addressing a simple query letter. Possession of such trifles serves to identify you as a "professional," not only to sophisticated buyers at magazines and ad agencies but to members of your own community, who may be among your best potential markets. Further, if you take some care with the appearance of these trappings, you are making an instant statement about your graphic taste even before showing a single photograph. This can cut both ways: A poorly prepared or ugly self-presentation is also taken into account by your evaluator.

Before making up even a business card you should think through the possibilities, because you are about to launch your initial promotion program. The words and design you choose should be those you can live with for a long time; they should identify to you and to others your standing as a photographer. Your business cards and all your stationery should carry the same look. If possible have them all printed at the same time; doing so will ensure that ink and paper match, and it will save you money, too, since the printer can do the work consecutively with the same materials. A local printer who does "short runs"—that is, items such as wedding invitations and personal stationery—is an excellent source of information about prices and style choices. You may find it helpful to shop around a bit, because prices and services can vary considerably.

There is no reason to spend a great deal of money you do not have, because good taste can be expressed in simple, inexpensive ways. A choice among the standard styles offered by your printer combined with a selection among paper styles and colors, or perhaps some simple decorative borders, can give you an attractive and distinctive look. If you want something more elaborate, such as your own logo, it may be advisable to consult a friendly art director or someone whose taste you trust. Being a good photographer does not automatically make you a good designer—the functions are usually quite separate. All too many photographers trust their layout abilities more than they should and end up with old-fashioned, amateur-looking materials.

At the outset you will probably want a business card, business stationery (8½-by-11-inch size) and business envelopes. Aside from any special design, these typically give your name, address, telephone number and a statement of your business or services. This latter item deserves some reflection. With the right word or two, you are really providing a capsule statement of your professional identity. You could simply say "Photographer"—many of your colleagues do. Or you could define your services more specifically: for example, "Photojournalist," "Documentary Photographer" or "Advertising and Commercial Photography." You could also add an adjective making your

skills more specific or appealing: "Interpretive Photojournalism," "Outdoor Portraiture" or "Creative Reportage." The idea is try for a relatively distinctive self-label without getting cute or so specific that you cut yourself out of work you would like to do. If you have a genuine specialty, state it—for example, "Aerial Photographer," or "Commercial Photography—specializing in aerial imagery." Some photographers have several business cards made up to distribute according to the occasion.

Business cards

The photographer who can altogether dispense with business cards is rare. Besides being handy for business contacts, both scheduled and unplanned, business cards are filed by many picture buyers in a desk-top box. For friends and neighbors, cards can suggest a genuine professional status that only you know may be not yet warranted.

Cards can be printed in a great variety of type styles, paper stock and color, sizes, shapes and designs. They can include logos, symbols and photographs. Photographers catering to advertising markets sometimes get particularly tricky; I have seen beautiful cards, printed with four-color reproduction, that fold out in complex ways or take the form of wall posters. Are such expensive approaches worthwhile? Well, if your business card goes up on the wall, or is saved by the editor or art director as he moves from office to office (and job to job), then the investment may indeed pay off. You might use a photograph that shows off your special talents in an eye-catching way. An especially attractive technique is to simply make up a small batch of black-and-white prints on fairly sturdy paper, and write your name and phone number in the margin or on the back. This need not be expensive provided you do not mass-distribute them. You might use them only occasionally, giving out a simple printed card at other times.

Letterhead

Your official business stationery is also a highly productive investment. The price can be quite low if you choose a standard paper and type style. The variables described for business cards apply here as well. You should probably avoid eccentric-looking extremes and odd colors, but some photographers go to great length to make stationery distinctive. Their aim is instant identification of their missives on receipt, or in a batch of mail, and they may have all

their mailing materials, receipts, bills and business forms produced with the same styling toward this end. This idea can be implemented in any number of simple and not necessarily expensive ways: a stripe of a particular color along one edge, a tinted paper stock or, of course, your personal logo or symbol. There is no getting around the fact that visual effects are important to the business you are in, so you should take advantage of the opportunities implied. Just remember that when you do it yourself, keep it simple.

I have seen materials that make excellent use of such a simple device as a border in the pattern of film sprockets, or even just a large scrawled signature at the top of an otherwise blank page (address and phone can run along the bottom edge), as if the photographer were signing a fine print.

Incidentally, a business letterhead or business card is your instant qualification for various professional benefits such as certain press privileges, subscriptions to industry publications, professional discounts and special admission prices for a number of events. Besides, such small matters can make considerable difference in your feeling of professionalism, and will prove a good investment provided you do not go overboard.

Promotion pieces

Promotion pieces can take many shapes and forms, with the best usually being those most carefully thought out in terms of the photographer's personal aims and style.

Photographic posters can achieve prominent wall space for you but can begin to run into real money. Great care must be given to design or you will waste your investment. The people whose attention you wish to attract are very sensitive to graphic nuances, and a poorly executed display piece is worse than none at all. Again, a good possibility is to produce a small batch of prints on your enlarger, perhaps writing in the information on a margin. These can be distributed selectively. I have seen photographers called because an art director had kept a poster on his wall for years. In other cases, visitors have made careful note of a name appearing on a promotion piece in someone else's office. There are many less direct instances of relationships resulting from a display piece.

For similar reasons, many professional photographers make a point of producing attractive Christmas cards every year, and editors look forward to seeing each year's batch. Naturally you will want to include a picture, and this can be done any number of ways: Ready-made mounts is one way. Small

prints with a message and name, hand inscribed, can be perfectly sufficient. Seasonal greetings offer a nice opportunity to personalize a business relationship. One clever young photographer I met was remembered for a continuing approach: He would photograph picture buyers while showing his work and send a print through the mail as a postcard. At other times, photographic postcards of some random, usually amusing scene were sent, and his recipients enjoyed collecting them and showing them around. This self-promotion technique was successful to a certain extent (major assignments somehow did not materialize) because it suited the photographer's personality and shooting technique—friendly, casual, the candid-observer approach. Just as a portfolio is tailored to your audience, self-promotion is most ideally tailored to your individuality.

Full-scale mailing pieces, such as printed leaflets, can be productive in certain situations. They can work most notably for photographers who want to establish a mail-order stock operation or solicit major commercial assignments. A mail-order business requires a really solid file of specialized material, resulting from years of conscious file-building efforts, to justify such promotion. Many photographers would not think of developing a stock business with less than 100,000 negatives and transparencies, all meticulously indexed and cross-referenced. For commercial assignments, you must have the expertise and facilities to ensure fulfillment of anything resulting.

If money is no consideration, you may want to plan a leaflet or brochure describing your talents and the services you can provide, with suitable illustrations in color or black-and-white. This will require the services of a printer, preferably an art director also, and possibly a writer oriented to promotional material. When money is an object—which it should be—you can use a simpler alternative when you feel the mail can bring you business.

Tearsheets

If you have been published in a presentable medium, examples of your published work, well used, are irreplaceable for promotion purposes. Smart photographers take scrupulous care to obtain copies of such examples. Most magazines will provide a contributor with a certain number of copies—either the entire publication or "tear sheets," unbound pages left over from the print run. When you are dealing with a magazine whose circulation is small (say under 100,000) be sure to talk to the editor before the magazine is printed so arrangement can be made for the copies you want. It may be necessary to plan an "over-run," which may involve expense. Most magazines try to be helpful

on these matters and may offer to absorb the expense as part (or all) of your payment or supply issues at a discount rate (like half or a quarter of the cover price). You should request 100 or more copies of your work in any attractive or impressive (to a particular audience) medium, not for mass mailing but for careful, gradual distribution. A fine mailing promotion can consist of a short letter (on your letterhead) introducing yourself and your services, with several handsome printed samples enclosed.

If you are unable to obtain enough copies of the publication carrying your work, the purpose may often be served by photographing the pages and printing up as many copies as you need. A custom lab will do this work for you if you prefer, at not too exorbitant a price. You can also get surprisingly good results quite often with color photocopying machines. (Technically, reproducing a magazine page is a violation of copyright, but it is extremely unlikely that you will be sued in such a situation.) Some professionals find it very useful to make a composite by photographing batches of published work rather than single pages. The samples can be laid out attractively on a wall or table, or carefully arranged on illustration board and pasted down. This is an effective way to show the range of your work and credits. Since the arrangements of the samples on the board will cause some to overlap others and focus attention on only a few of them, you can include some of your mediocre-looking samples to swell the crowd without reflecting badly on your photography. A composite print can make a good portfolio backup piece, too, if you're dealing with a client who needs to be impressed with your credits.

Resumés

A resumé, the formal statement of your credentials, can be a useful addition to your portfolio, promotions and applications. It need follow no standard format, so start by defining your best qualifications in light of your intended audience, and then develop the format that makes best use of your selling points while minimizing your weak areas.

If, for example, you wish to present yourself as a fine-art photographer, your resumé could include the following categories in simple, straightforward order:

Education (including any college and, possibly, *significant* workshops).
Professional experience (for example, freelancing or staff work).
Recognitions and awards.
Lectures or teaching.
Works published or reviewed.
Work in public collections (museums, colleges, institutions).

Exhibitions your work has appeared in, starting with the most recent and
working back. Indicate one-person or group shows.

If you have nothing to list in a category, omit the category and add others as
appropriate. The emphasized categories of a photojournalist's resumé would
probably be staff experience and selected publication credits; a commercial
photographer would include a brief list of major clients. Professional member-
ships may be relevant.

With resumés, less is better than more. You want to give the impression that
you are abstracting a few highlights from your photographic career or experi-
ence, not citing every small accomplishment. Including too much buries your
main points.

Your resumé should be at most two typed pages, single-spaced with at least
double-spacing between categories. If you can manage with one page, good.

Small print shops can type and print hundreds of resumés at minimal cost;
you can ask them to use your letterhead or provide a special design, too.

Individualized promotion

A good promotion piece capitalizes in some way on what you have done, and
can do. One or more examples of your published work can be excellent. A de-
tailed verbal breakdown of your stock file categories can be good. A list of
distinguished clients you have served helps in certain conditions.

Like many commercial photographers stalking big assignments or trying to
sell stock work, you can provide duplicate slides for an art director to keep.
(These are most effectively presented as a small, carefully chosen group dis-
played on a single mount—the black cardboard kind with cut-outs the shape of
the transparencies.)

The key to choosing, planning and executing a productive promotion
approach in most cases is to start at the end, with a careful analysis of your
audience: Who are they? What do they need? The most expensive brochure
and samples are wasted sent to the wrong recipient, while a well-thought-out
mailer to a small, selected audience can work beautifully on a relative
shoestring.

So analyze what you are selling, who your potential buyers may be, and
what they are probably looking for. Consider special selling strengths deriving
from your background, experience or accomplishments. Think of picture sam-
ples that can be included and that relate to the expertise you are emphasizing.
Fortunately, the hallmark of modern design is simplicity, so if you decide to
do it yourself, simplicity of appearance, message and objective can be your
guidelines. And if your common sense tells you that your market objective will

probably not be furthered by a promotional investment, by all means, do not bother. Most magazines, for example, are better approached on a periodic, personal basis with a strong portfolio.

Even when you are willing to spend a little money, try not to underestimate the time involved in planning, executing and mailing anything at all. Time should always be regarded as your most precious commodity.

Do-it-yourself P.R.

Public relations is a catch-all term for your efforts to look professional, make helpful contacts, and get work shown in effective showcases. The professional public relations agency's repertoire of techniques gives you some easy ways to capitalize on your own assets.

Mailing list

It is important to keep your mailing list up to date. This may consist mostly of your market data cards, recommended earlier. Even if you see no immediate need for a promotional mailing, your market and mailing list will prove useful. An astonishing number of photographers neglect to keep past buyers informed of their whereabouts. Since photographers are peculiarly nomadic in their habits, the number of pictures that go unpurchased because their makers could not be located are legion. In fact, I have frequently seen whole portfolios filed as nonreturnable because the photographers changed address and phone number after leaving the portfolios somewhere. Moving from one address to another means that a mailing to your entire list is in order; this presents a fine chance for a letter, or other promotion, to remind buyers of your existence. At other times you will want to contact a portion of your mailing list.

How do you start a list from scratch? Nearly everyone to whom you have supplied photography in the past should be included first. Professional free-lancers watch mastheads like hawks and keep their ears open for indication of personnel turnover, because staff changes mean it is time to make themselves remembered. When a business acquaintance assumes new responsibilities or moves to another organization, he may usefully be reminded of a past service or relationship. Magazine and advertising people tend to take their suppliers with them in their job travels; when they are called upon to fill new needs, finding appropriate suppliers is a priority concern. Bring yourself to the attention of the person assuming the vacated job, too—with a letter, business card, promotion piece, or request for an appointment.

Your mailing list might also include those for whom you would like to do work. These would include the most prestigious publications in your field, buyers who might develop needs in your geographic area, media related to your photographic specialties, and publications that might be interested in any stock material you have accumulated. Obviously the tools and techniques of market research described earlier are relevant here.

The list can also include nonpublication clients you wish to solicit directly. Although this book is not directed to photographers already engaged in large commercial enterprises, the operational methods of certain established entre- preneurs may be of interest. Portrait-studio photographers often depend heavily on local announcements of births, engagements and family events. Brochures, invitations to visit the studio, or even phone calls to prospective clients may bring results immediately. Most extreme is the offer of a free, or practically free, portrait of the newborn baby, because the future-minded studio operator in a stable community hopes to serve the same buyers for life. He who photographs the new baby can remind the family of his service when the baby has a birthday, when the next baby is born, when occasions call for family gift-giving, when the baby gets engaged, married, has a baby, and so on, according to the old cycle. Astute photographers not only want to get in on the life cycle as early as possible, but see their future business growing from the desire which their services create for more portraits. Thus, promotions may go out to a customer every year or two, before Christmas, birthdays, Valentine's Day, and anniversaries. Other photographers concentrate their promotion efforts at slow seasons to even out studio patronage, perhaps offering special rates. Some clever ones offer portrait packages, such as ten sittings over a five- year period at times chosen by the customer at a fixed, discount price.

Commercial studio operators may perform similarly. Their information sources include carefully culled trade magazines, newspapers, and company publications. Hot news may be the announcement of a new company branch, an office relocation, acquistion of a new client by an ad or P.R. agency, or the naming of a new regional manager, advertising manager or company presi- dent. Many successful commercial pros routinely send a congratulatory letter on such occasions, with an offer of photographic services plus any relevant brochures or samples. The new person then becomes part of the mailing list for future promotion efforts.

These commercial techniques may seem inappropriate or too high- pressured for your taste, but your own version of a mailing list will be used for various occasions. For those events when you're sending out press releases, press kits or invitations a mailing might go to local and nearby metropolitan newspapers; local television and radio stations; editors and art directors who

have used your work (even if they are thousands of miles away) and others with whom you would like to work; photography magazines; local and regional publications; and publications related to your specialties, such as science magazines if you are a photomicrographer. It is frequently helpful to send more than one press kit or invitation to each place, because such material often is not circulated among the staff. As always, address your material to particular persons. It is well to start with top management and include when relevant anyone personally known to you: the art critic, camera columnist, news desk, and person in charge of coming-events calendars.

If you're using your mailing list to send out invitations remember that it should include more than media representatives. Prominent local citizens, politicians, business acquaintances, and your suppliers should be included, as well as friends and relatives. Since only a fraction of the people invited will attend, your list should err far on the side of excess.

Press releases

The idea of sending news releases about yourself to the media belongs in the repertoire of most photographers but is often dimly grasped. A great variety of occasions provides you with the chance for invaluable publicity once the simple principle is accepted. Consider the following possibilities:

• The opening of your exhibit, no matter how humble the setting.

• The receipt of any award, honor, professional recognition or competition prize.

• The acceptance of a picture by a museum, gallery, private collection, university or charity auction.

• An honor bestowed upon you by your community, church, civic association or Boy Scout troop.

• Publication of anything at all in a prestigious-sounding medium.

• Your speech to a local group, camera club or school class.

• Your donation of artistic photographs for sale at a fund-raising event or to decorate a hospital ward or boys' club.

• Your "official" opening of a new studio, headquarters or expanded facilities.

• Donation of your time as a photographer to a good cause: advising a high school newspaper, teaching photography to prison inmates, documenting some major civic accomplishment or renovation project, or doing documentary work for the conservation club.

• Your establishment of a new photographic business, or your offer of a unique new service of some sort.

To be realistic about it, many photographers (like many other businessmen and politicians) see such events more as occasions for good publicity than as significant in themselves. But they are right to feel that an achievement or contribution merits attention. All the events listed may deserve coverage from local media, always hungry for such news. It is your special advantage that you can provide the interesting illustrative material so often sought by newspapers and other media. Some of the events can earn space in regional or trade publications.

How can you go about the self-publicizing business in practical terms?

If any event of any kind is involved, it is well to take P.R. into account at the outset.

Advance publicity

If you want to ensure attendance at an event—such as your exhibit opening—advance publicity is not just highly desirable, it is mandatory. Both the invitation list and material for the media deserve your personal attention even when a gallery or other organization assumes basic responsibility for the event.

Although the cost of any mailing can mount up, issuing invitations and a "press kit" need not be too expensive if you can spend some time on the process. Your investment of time and money in proportion can be very rewarding. Media coverage can extend your audience far beyond the number of people who actually visit your show.

Remember that if you want a calendar listing or advance news item in a newspaper, your material must be received several weeks ahead of time. Magazines generally require several months' lead time even for a calendar entry.

A completely acceptable invitation can take whatever form fancy and budget allow. Handsome printed mailing pieces, perhaps with an illustration, are very nice. A hand-written note or personal letter can work as well; so can a phone call. Media people should also receive a press kit; the requirements for it are more formal.

Press kit

The press kit's purpose is to provide accurate and, we hope, stimulating information about an event for both those who attend and those who do not. The attenders are encouraged to participate in the occasion—often during their personal, nonoffice hours, don't forget—and to approach it knowledgeably be-

cause they have received your material in advance. You will have provided an item for filler in their publications when space pops up, which happens more often than you might think. It is most specially to your advantage to include the visual material which is intrinsic to your event as it is to few others. This can easily earn you space in a publication even if no one shows up at the celebration.

Thus, the two parts of your press material are a press release, or information sheet, and pictures. Include one to three carefully selected photographs suitable for publication. Exhibit prints ought not to be provided; relatively inexpensive 8-by-10-inch glossies are good. Choose simple images with large forms rather than highly detailed, fussy pictures; prints for publication should show strong lighting and minimal tonal subtlety. That's in general—if you're aiming for a magazine or a newspaper that uses good offset reproduction and perhaps a higher-grade paper, then something with more detail can be welcome.

Your written material, the press release, should be simple and straightforward. One or two 8½-by-11-inch sheets should be sufficient; typing should be double-spaced. The top of the first page should contain a date of release ("For immediate release," unless you want the information held until some later date), usually on the right-hand side. At top left, write the name of the person the newspaper should contact for additional information—you or another person—giving name, address and phone number.

The release itself should have a headline (centered below the foregoing items) which simply summarizes the subject of your communication ("John Jones's Photographs of Rice Paddies On View at the Marbury"). The rest should follow in news-information style: Check your Five W's and include anything particularly interesting or provocative. You're trying to create interest, but don't get carried away with dramatics. Your information should be presented in the third person (not "I," but "he" or "she"). You may wish to end with a line like, "Mr. Jones will be available for interview at the opening, or for a personal appointment on request." An event with some worthwhile civic aspect or especially interesting story angle can suggest a newspaper feature, Sunday supplement story, or even a local television interview.

Your press release can take a variety of forms provided it is neat and readily understandable. Some quite venerable institutions have used mimeographed sheets of paper for decades and still do. If only a few releases are needed, they may be individually typed, or a good copying machine can do the job perfectly well. You might prepare your material on letterhead stationery or use letterhead for the copy paper instead of blank paper. This approach is also

suitable for photo-offset reproduction, which you may select if you need many copies. The small printing shops which do resumés are well-equipped for this and usually will supply you with several hundred copies for less than ten dollars, with expert typing provided at perhaps a small additional cost.

When your press kit contains photographs, you will of course have to mail it in a suitably sized envelope and protect your prints with one or two pieces of cardboard. Avoid staples and paper clips on or near the prints; but do identify each photograph thoroughly, preferably with full caption material taped to the back.

Coverage of your event

One important point often overlooked by photographers is the need to cover your own event while it is happening, especially if you cannot trust this function to someone else. If the occasion is an exhibit, you should make a complete set of photographs of the installation, no matter how modest. Quite possibly record the installation process; certainly get some good shots of your opening or party. These pictures will prove invaluable, both for immediate purposes and for years to come. If you've just installed your first exhibit, you were probably surprised at how difficult it was to hang the pictures effectively, and will want a record to follow if you plan on doing it again. More important in our present context, you will have the material you need for obtaining more publicity after the event.

Follow-up publicity can get you useful attention even when you've done everything possible to promote the event beforehand. In many events, follow-up may be the only publicity possible. The receipt of an award or honor can be reasonably big news to a local publication, especially if the award was given by a national organization. You can prepare a press kit similar to that described for advance publicity, except that you would shift the tense to past where appropriate. This kind of release might be headlined, "John Jones Cited for Outstanding Portrait Photography by the Professional Photographers of the World." Your illustrations might include that old standby, the awards presentation shot (make it your business to see that there is one); a black-and-white print of the winning photograph, or a good typical one; and a shot of yourself in your studio or work area or in front of a wall beautifully decorated with examples of your work.

Doing a good job on press material can be very productive because in a sense you are doing the work of the people to whom you're sending the material. Giving them interesting visuals and information almost ready to use saves

them the trouble of developing material themselves. Lots of publications, alas, are composed almost entirely of press releases.

Once you've tried it, you may find that producing publicity and other kinds of promotional material is interesting and enjoyable. You will be performing for yourself the same services that professional P.R. agencies do for their clients, at great cost. Many top photographers prefer creating their own promotional materials throughout their careers, because they can do it best. One caution: Do not get carried away with the idea to the point of sending a constant flow of material to the same recipients. They will eventually ignore it altogether. If a local newspaper does come through with a small article or a feature, the next time around you may find a space salesman calling upon you! Nobody will give you continuing free publicity; paid publicity is advertising, a publication's bread-and-butter. So, can advertising do anything for you worth its cost?

Advertising

In deciding where and when, if ever, it pays for you to advertise, take the following factors into account.

A local or community newspaper tends to do what it can to help the local ad-paying businessman. Your help in supporting the newspaper by placing an occasional ad may be rewarded with news articles, prominent use of your work when appropriate, or recommendation of your skills to anyone inquiring. A local publication can often be a clearing house for both local and out-of-town callers seeking a service.

Moreover, even a small ad in a respected commercial medium can give you a quite disproportionate amount of prestige on a local level. People tend to think someone who advertises is not only a legitimate professional but a successful one. They assume that all publications charge advertisers the kind of rates that big, nationally circulated magazines charge.

The cost of advertising is in direct proportion to the size of the audience reached. Publications base their ad rates on circulation figures. Generally, too, the broader the audience the more you will pay. A readership that is limited in some way, whether by geography or a special qualification for subscribers, will usually mean a lower price for ad space. This means that an advertising dollar goes further the more you narrow and define your audience. If you can isolate a skill or service salable to a trade or professional group, trade magazines offer the relatively small, preselected audience you're after. For most photographers, whose goal is to build local business, the local media are

the natural choices: newspapers, Sunday supplements, magazines and "shoppers."

Whether an advertising budget is $50 or $50,000, the person directing it is expected to shop around before buying media. For this purpose, many publications and radio and television stations have "media files" to send you. Besides pitching you on how terrific each is as a sales generator, these include specific facts about rates, audience size and makeup, format requirements, and any competitive factors that can be dredged up. The rate structure is often quite complex, taking account of ad size, colors (one to four), any special positions, whether you are placing a single ad or contracting for three, six or other multiple times. You will probably find it interesting to peruse some media files and educational in regard to your own selling efforts. Naturally, you should also study sample issues of each medium for relative merit regarding your special needs.

Do not overlook the costs of producing an ad to the given technical specifications. A print ad can require professional typesetting, graphics and production of the form needed by the publications. Most media will willingly provide substantial help to a new account, hoping for the best in long-range terms, and may perform the whole physical production process at small, or negligible, cost. Such matters can be negotiated with an advertising salesman, the ad manager or the publisher. It is not unlikely that someone would call on you, as even a tiny ad merits the sales department's attention.

Can you write and design your own ads? Basically it is just as simple as doing your own promotional material, as previously described, and follows similar principles. Take advantage of your visual skill by using a photograph that will reproduce reasonably well given the approximate size of your ad. Use the least number of words to make the point you want. Keep the graphics extremely simple for the clean, modern look you want. Gear the ad as closely as you can to the audience you are after and the response you want. Fine results can be achieved by carefully thinking out a single good ad, perhaps with professional writing or design assistance, and thereafter changing only the picture. A West Coast studio chain built business dramatically with a simple ad format running one-sixth of a page and containing three elements: a single copyline (like, "Creativity makes the difference"); the studio logo, address and phone number; and a well chosen sample portrait. The copy was superimposed over one corner of the image and each time the ad ran, only the portrait, and if necessary the position of the copy, was changed.

Many photographers make the mistake of trying to appeal to too many buyers simultaneously. It is tempting to list every possible kind of photog-

raphy remotely related to your experience, but effective advertising tries to sell one thing at a time. An ad that reads: "John Jones, for portraits, weddings, parties, passports, industrial, commercial, advertising and aerial photography," is both unprofessional (though professionals do it all the time) and unconvincing. It is better to try: "John Jones, for the living portrait of your child as individual as he is." Or, "Your own family in your own home... that's where the finest family portraits are made. Ask about our unique we-do-the-travelling plan." Or, "John Jones Commercial Photography, when you really want to reach an audience." The point is that it's better to sell *something* rather than randomly trying to sell everything. Some photographers include impressive-sounding affiliations, possibly helpful for certain audiences.

When to advertise also depends on what and who you are after. Some photographers only invest in advertising when business is doing badly; others advertise prior to important seasonal events which inspire gift-giving. Some prefer mid-season times when volume is ordinarily low, or promote a special incentive, like a small discount; others periodically place an ad just to keep their names familiar.

The classified advertising section of a newspaper or magazine can offer a good, inexpensive alternative to page-rate ads. Certain publications run closely read classified sections—your own experience may tell you which they are.

School publications, such as newspapers and yearbooks, can be effective and inexpensive advertising media for some kinds of businesses and a good way to get known in a stable community. Such an investment may come under the heading of good will rather than hard-sell marketing, but good will is indeed a valuable commodity.

Do not overlook any special media possibilities that might serve you very well in your own community, such as transit advertising—on buses, for example—at relatively reasonable rates with a variety of approaches.

Some very specific aids for establishing advertising and promotional programs, designed solely for professional photographers, are available from the Eastman Kodak Co.'s Rochester, New York, headquarters. Because the pro is a significant consumer of its products (although an infinitesmal market segment compared to the amateur) that giant company has for years been concerned by the failure of so many photographic businesses to survive and grow. Thus it has spent a lot of money developing business management information and promotional material oriented mostly to portrait studios, and available for the asking from the Great Yellow Father, as some call it. How do you prove that you're an eligible professional? Why, by writing on your professional letterhead or enclosing a busines card, of course.

A few last words on advertising: None need be considered prerequisite to

successful photography, except perhaps for one type often overlooked—via your telephone company. Inclusion under "Photographers" in your local Yellow Pages is helpful, and quite possibly under sublistings as well; for example, Commercial, Portrait, Stock. You may wish to be included in the Yellow Pages of the nearest large city or two, also. You can of course also buy advertising (display) space in the phone book just as in any other publication; there are thriving photographers who claim to have built big businesses this way.

Local business guides and directories put out by private firms, sometimes called "Green Books" or something like that, can also pay their way. Large cities may also be served by special directories listing creative services for various buyers, and you should find out about any in your area and arrange to be listed. An important one used nationally by art directors, TV producers and businessmen is *The Creative Black Book* (80 Irving Place, New York, New York 10003). This includes categories such as art supplies and equipment, audio-visual services, retouching, paper, printers—and photography (original and stock). Listings are free to qualified suppliers (meaning anyone with a professional letterhead!), and photographers are listed by geographic location (Northeast, Midwest, etc.). Advertising display space is sold and whether or not this investment looks appropriate for you, the advertising provides a nice compact overview of how the classiest commercial photographers are presenting themselves. And some of the suppliers listed may be of use to you as well. *The Creative Black Book* costs about fifteen dollars.

Even though you may feel advertising expenses should be deferred until later in your career, or only after the multitude of promotional and publicity tactics are exhausted, it is important to ensure that you can be located. I have frequently looked under "Photographers" in telephone directories of areas foreign to me, and found none listed at all. A local citizen can have equal difficulty finding the photographer next door, to say nothing of the troubles an out-of-town buyer may experience. And what you lose this way, some other photographer will gain.

16

Building Business in
Your Own Community

IT IS often difficult to see what is closest to us. Scores of impatient photographers emigrate to urban capitals only to find intense competition, high costs, and considerable trouble getting a foot in any door at all. If you are now living in a small town there are innumerable avenues of potential business to explore. It is for good reason that many perceptive photographers, from photojournalists to portrait specialists, prefer to develop their careers in rural or small-town atmospheres. Many big-city natives eventually transplant themselves despite being well-established where they are.

As described in the foregoing chapters, one's involvement with a community can produce story ideas sought by many types of publications. Opportunities to work with a newspaper or other local publication are far more available than in the big city. Young journalists have long been told to get their start in the small town no matter how high their ultimate aspirations, and the advice holds for many photographers today.

Living elsewhere than New York or Los Angeles certainly does not preclude your contributing to national media. Occasional visits to publishing centers can be sufficient to establish, or maintain, relations with buyers while the mail does the rest. Many contributors submit material to publications without ever meeting the editors. This principle may not hold for specialties such as high fashion, underwater, or movie production stills; they limit you to appropriate locations. But if you are prepared to explore the special opportunities native to your own location, or be a "general practitioner," your best chances might be right on your doorstep.

How general should a local photo business be? That depends on your interests and capabilities, the particular locale and an imaginative analysis of its

potential. There are photographers in tiny hamlets who make excellent livings solely with bridal portraits. Others offer all services from weddings to industrial photography. Set limits to avoid soliciting everything and handling nothing very well.

In building local business, you can capitalize upon a number of natural advantages. You already know and understand the people, and they probably know you. Certain selling approaches, both hard and soft sell, can be attempted that are near-impossible in more impersonal environments.

A relatively self-contained, stable society helps intensify the effects of any positive accomplishment. Gaining recognition can be a steady upward progress, with any recommendation or piece of publicity getting a lot of mileage. On the other hand, major mistakes get around equally. Luckily, most consumers do not recognize bad work in photography—although you can teach them to appreciate good work.

Perhaps a more genuine problem is the tendency of people to think that the unknown outsider, the visiting fireman, is professionally superior. To combat this idea, you may wish to give particular attention to the professional trappings discussed in the last chapter: your business card and stationery, a polished portfolio or other presentation, and an assured professional appearance. National publication credits should be fully publicized, as should any honor received.

It may be worthwhile to join one or more professional groups. The American Society of Magazine Photographers (ASMP), Professional Photographers of America, National Press Photographers Association, and other national, state and local associations are always interested in new members, and the affiliation can easily be worth the price of dues. Many photographers include such memberships on their stationery and business cards. They may little value the degrees awarded by groups like the PPA, but know they can spell qualification to many laymen. So does readiness to assume professional authority in neighborhood situations, as we'll see later. And don't overlook chances to capitalize on your economic advantage of being able to offer services without expensive travel and, probably, overhead costs.

One small but pivotal matter demands mention: getting your availability known. Many a photographer who should know better sits around waiting for the phone to ring, when he has developed no channels through which he can be found. If you work from home, even without a formal studio, a sign may be in order, and there's no law against it. (Some locales will want a business-license fee, however, and there may be zoning questions.) The Yellow Pages and local business directories should certainly list you and perhaps carry your advertising. You should be known to a local newspaper office and, preferably,

contribute to it in some way. The dealer from whom you buy your equipment should know what kind of services you offer. So should the processing lab you use and the printer you work with. Just as a magazine editor can have trouble finding the photographer he needs, so can any customer. It is up to you to make yourself easy to find. It is not a bad idea to put up a card or promotion piece at a few judiciously chosen locations around town.

If you wish to undertake work such as weddings, bar mitzvahs and anniversary parties, you might talk with the local caterer and florist, who often supply or at least recommend photographers to their patrons. However, be aware that financial arrangements (known as kickbacks) for this service are not in the least unusual. If you want to get in on the profits of mass-photographing school graduates, things are even more complicated. Schools nearly always permit only a single "official" photographer to function, and a lengthy contract can provide for such matters as: the photographer's personal financial contribution to the school, a specific number of days he will spend on campus, gratis assistance to the school's yearbook staff or photography club, free photography of school activities, athletic events and the staff, and so forth. Also, large school-specialist chains are competing for this lucrative business. Graduating seniors can nonetheless be attracted to a "nonofficial" photographer if you offer a superior photographic product, geared to appeal to them, and advertise its availability. But you need a reasonably impressive studio for this, unless you want to go on location to their homes.

According to the service you want to sell, you can cultivate a local reputation by inexpensive local advertising, carefully distributed promotion pieces and the associated paraphernalia. But if you're a newly arrived photographer embarking on unfamiliar territory, take care. Think before you make any memorable statement; get to know the people a bit. A photographer recently arrived in a small West Coast city, who perhaps had moved there in search of better opportunity in line with the ideas suggested here, built a whole advertising campaign around the theme, "New York Professionalism Comes to Eureka." As he should have known, that was the last thing his neighbors wanted to hear, and I doubt very much that he succeeded.

Mark Twain memorializes regional differences in one of his lesser novels, *Pudd'nhead Wilson.* The protagonist has just hit town, somewhere in the South, and encounters a howling dog. He treats his audience to his native New England humor, saying that he "wishes he owned half that dog—because he would shoot his half." The Southerners find this so unfunny that they instantly conclude the newcomer to be a total "pudd'nhead"; and he is obliged permanently to make a living outside his profession as a lawyer.

The country has grown more homogenous since then, but local attitudes do

differ. If you're the home-grown photographer, you can hope the immigrant makes mistakes of this type.

Selling photographic prints

The "average man" may be a lot readier to spend money on photographs for home decoration than many photographers realize. If your output is "artistic," a little effort can pay off nicely.

You will want to make the most of any showcase you already have—a storefront, studio space, office space and your own home. Your prints should be matted, framed and signed, not only to make them look their best but to place them in the context of fine graphics. There is nothing wrong with selling prints to friends or neighbors; what is given free is seldom valued. Act like a professional and have prices ready to quote.

Many of the locations for exhibits recommended in Chapter 12 can be employed to extend your showcase. Consider placing some prints on a consignment in a local art gallery, gift shop, greeting card store, furniture store or home decoration center. In the latter two cases, photographs can be used to create the interesting homelike arrangements that are desirable in such stores without, you might point out, costing the store anything. An agreed-upon price that includes a sales commission for the store can be assigned each image, perhaps affixed to each on a label.

The decorative potential of photography can be similarly exploited by hotels, ski lodges, lobbies, cafeterias, restaurants. One fine approach I have seen was employed in a restaurant with an excellent lunchtime trade of business executives. A photographer's black-and-white prints were placed around the restaurant on pretty wooden easels, integrated with the decor and enhancing it. Near the entrance where patrons waited to be seated was a rack containing more prints, conveniently placed for viewing; each print was protected by a cellophane wrap and labelled with a price (forty to forty-five dollars). On each table was a small reproduction of one of the pictures and a brief biography of the photographer; these were printed on a long card, attractively designed, that folded into a freestanding triangular shape. I do not know how many pictures were sold, but patrons were obviously enjoying them, and the publicity could only benefit the photographer. It takes a clever restaurant manager to mount such an exhibit, or it takes a clever photographer to explain the merits to the manager. The latter was the case in this instance. If the restaurant is moved to use different artists' work like this at other times, you've done a good deed for everybody.

Hotels also ought to be hospitable to suggestions of this kind. What better way is there to add warmth and individuality to lobbies, hallways, and perhaps even guests' rooms? Local scenes and landmarks might serve especially well for them. Rather than providing free decoration, however, you might want to try selling pictures to hotels and motels for permanent display. Some smart hoteliers use huge mural-size prints to create attractive environments, at minimal cost. Such prints can be produced by commercial labs or by one of the new processes that create enormous murals by "painting" the image onto fabric. Scenic photography, especially of local origin, works well for such purposes.

Local businesses can also be approached with varieties of the foregoing ideas. In recent years, big corporations have hung photographs in their head-quarter buildings and offices, either in addition to other art or as the sole choice. Photography's ability to make barren modern structures more human and intimate has barely been explored. It may be worthwhile to assemble your thoughts on the subject, glean some arguments from this book and other sources, and prepare a sales pitch on the subject.

The principle is in line with many selling situations: Think out some of the problems a prospective client may have and present your unique solution to them. Modern corporations, for example, need to give employees a sense of identification with what seems a very impersonal entity, a sense of partici-pating in a team effort, a feeling that their contributions are important and that they are individually recognized. Photography can help humanize stark modern spaces and personalize offices that tend to look endlessly similar. Or rather than sell stock pictures, talk company management into long-range as-signments to document company activities, branches and faces.

You may find businessmen far more receptive than you expect to photo-graphs as investments. With recent inflationary trends, valuable objects make attractive investments; some convincing advice on buying photographic prints purely for investment has begun to appear in business journals. The idea that an Ansel Adams photograph could fetch $4,500 today when a few hundred would have bought it a few years ago is a good business argument. Not every photographer's work can merit that kind of increase, but investors are starting to venture into the purchase of more current (and affordable) work. Many show a predilection for acquiring good local photography.

A slightly different buying audience is constituted by art collectors. People accustomed to spending goodly sums on paintings, graphics and sculpture may already be adding photography to their collections or, like the business-man, be ready for a well-delivered presentation. You should know who the col-

lectors in your community are. Galleries and museums are good sources of information on this. For more reasons than that, it may certainly pay you to participate in some way with your local art museum; many have advisory committees or support organizations in the various art media. Does your museum lack a photography division? Maybe you should help assemble one.

Do not overlook doctors and dentists as possible buyers. They not only have the money to spend but are usually looking for new investment ideas. Here's one: While the objects are getting more valuable, they are decorating the office. Why do medical offices look so barren and sterile? Tradition, apparently, and lack of imagination, since it's hard to think of any milieus more in need of warmth and comfort.

Markets such as the foregoing, which to greater or lesser degree require the photographer to participate in their creation, demand not only a little verbalizing about the value of photography and its contributions, but your most physically polished presentation. Approach a corporate executive or doctor as you would a gallery, with meticulous, beautifully-crafted prints that are mounted or matted. Subjects with wide appeal are suggested—scenics, still lifes and such.

In selling prints, don't overlook the obvious outlets either, such as local art sales, street fairs and craft fairs.

Portrait photography

Portraiture is often eliminated from many a photographer's repertory on the assumption that an impressive studio, large-format cameras, special lighting equipment and esoteric skills are called for. Although certain styles of portraiture do require such equipage, there are nonetheless genuine opportunities for those with nothing more than a small-format outfit, some general photographic experience and an interest in taking people-pictures.

This is because probably more than any other branch of professional photography, portraiture overall has failed to keep pace with modern taste. The carefully-lit, formal portrait seems irrelevant to many members of the younger generations, who constitute a major portion of the market. Even older people exposed to good photography in publications and advertising have found traditional portraits old-fashioned looking. The taste for more real-life portrayals has been substantially nourished by television's informal visuals.

In recent years, the most aggressive portraitists have found they could successfully promote the following approaches to portraiture:

- Outdoor portraits with available light and natural backgrounds.
- Photographs of children in motion or involved in activity, rather than stiffly posed.
- Portrayals of children with natural expressions, not necessarily smiling directly into the camera.
- Dual portraits—mother and baby, husband and wife, sister and brother.
- Family-group protraits, often in the client's own home rather than against a blank wall or studio backdrop.
- "Environmental" executive portraits of men and women in their working worlds, rather than "head and shoulders" shots.
- Portrayals of teenagers as they want to look: in jeans, for example, with their own skis or guitars.
- Mini-album presentations of children or entire families in various activities and relationships, rather than the single formal portrait.

In short, the more responsive portrait-makers began rather belatedly to apply contemporary photojournalism's techniques to their work. In doing so—never fear—they scarcely lowered their high prices. In fact, they offered such services as The Ultimate in custom, up-to-date, Capital-A-Artistic photography.

But the number of studio operators who absorbed the lesson remain in the minority. The "mom and pop" studios have been marginal businesses, with a level of business acumen generally so low that the failure rate is extraordinary. At the other extreme are the highly successful operations (often chains or department store franchises) that push either high volume at cut-rate prices or expensive custom "artistry." The latter are usually the very visible, glossy, expensive-looking studios. They often advertise and promote heavily.

An intelligent scouting of your area should show what kind of portrait operations practice nearby. When they have any storefront at all, each takes pains to represent their style of work in window displays. Looking at their products may increase your confidence in your own.

If you decide to open a studio, or are already operating one, however simple, business advice is available from government small business agencies, Eastman Kodak Co., and a number of books. For most readers interested in portraiture as a supplement to other income, the obvious route is to market services that are not performed, or are performed poorly, by existing competition. Without a fairly glamorous-looking studio you may choose to capitalize on your mobility. Your willingness to go on location is a marketable asset.

All of the portrait styles listed at the beginning of this section can be done in

the client's home, office, backyard or in a park, weather and season permitting. The idea, once suggested, appeals to many families. Those who purchase expensive portraits usually take pride in house and furniture, and their living rooms offer good potential for props and backgrounds. Wardrobe adjustments can be made on the spot. Posing is limited only by your imagination; your subjects are comfortable in familiar surroundings and may be directed toward expressive group arrangements. Children can be encouraged to pursue an activity interesting both to themselves and to the camera. Using a small-format camera, you can take advantage of the journalist's creed that film is the cheapest part of the process, allowing you to shoot a great deal, to experiment, and to catch spontaneous expressions and action.

If you work indoors you'll find today's fast films invaluable, but you should be prepared to control lighting in a variety of situations. It is best not to have to depend totally on available illumination. You are the best judge of your ability to fulfill reasonable expectations. Some photographers restrict themselves to outdoor portraiture because of personal predilections and skills. If you are able to offer a flexible schedule to allow for weather, even winter provides charming portrait possibilities. If you live in a warm-all-year climate, all the better.

How can you solicit this kind of business? Word of mouth will be your best salesman and pleased customers will display your work. The best beginning is probably to make people you already know aware that you are offering a custom, *professional*, unique portrait service. An attractive business card should emphasize the special qualities of your approach. A small promotional folder or brochure can show several representative images of the type you want to take. Pictures of your own family and friends can serve excellently for promotion pieces; someone I know launched a career by using non-datable pictures of her children taken a dozen years earlier. You may select distribution points for folders around town or try mailing them to some likely candidates.

An elegantly presented small portfolio may also help. This can be used to display finished samples as well as the quality of your work, so both you and the customer know more or less what the final order will consist of. Don't sell outside your technical limitations; for example, if your client wants a 40-by-60-inch color image and you're using only a 35-mm camera, you are not apt to satisfy. Emphasize in any discussion the positive side of what you will actually deliver, rather than agreeing to fulfill vague expectations based on traditional-type portraiture. It should not be hard to build enthusiasm for the unique at-home pictures you will produce.

It is important to *feel* professional when you're marketing along these lines.

You do not want to feel like a door-to-door salesman and in fact should never try to sell that way. You are a creative artist—otherwise, why should the family not take their own portraits? You may want to respond to inquiries by making an advance appointment in the prospective client's home, so while explaining your services, you are not only scouting the location but communicating the great possibilities to the customer. Suggestions on clothing and makeup can be made at this time and of course your price structure explained. You will probably want to establish a fixed sitting fee plus a minimum size for the order, according to an established price list. Pricing is covered later, but for the moment prepare yourself to charge high fees and to explain briefly why fine artistic work by an experienced professional is so expensive. Studio photographers do this all the time.

One of the more productive techniques employed by studios that may be adaptable to your needs is to have someone other than the Great Photographer discuss the sordid business side of the deal. This takes a trained receptionist or efficient friend; he or she can handle preliminary negotiations, scout locales, work up the order, and set the stage for your appearance. The fact is, the less your prospective customer understands about good photography, the more eager he is to be impressed with the trappings of professionalism. Collect a few issues of magazines directed to the portrait photographer (*Studio Photography, Rangefinder, The Professional Photographer*) and you will find that the pros are quite preoccupied with the psychology of selling on a luxury level.

You will also find by examining the advertising that many specialized supplies and services are available to the portrait specialist, such as custom printing, retouching and special effects, and that the traditional studio is heavily into the profitable sideline of selling frames, albums and so forth. If you want to handle even a small amount of such items you can take advantage of your professional status (grace of letterhead) in dealing with suppliers.

A final word on portraiture—pay attention to current cultural trends and see if they can be incorporated into your photography in any way; this can both please customers and give you something attractive to promote. Some of the sharpest professionals have, for example, taken care to analyze what appeals to the teenagers they want to reach in areas like movies, television, greeting cards and music as well as photography. A strong trend in recent years, somewhat contradictory to the trend toward realism already noted, is toward the romantic and sentimental. Dreamy-looking portraits of sixteen-year-old girls in soft focus, complete with a flower, feminine clothing and a big wicker chair, sell remarkably well in many locales. So do double-exposure images with the subject looking pensive in two views, frontally and in profile.

At the other extreme is a newly developing taste among culturally aware

people under forty for honest documentary coverage of themselves and their families. These portraits are journalistic records of family life, not merely flattering pictures. A particularly alert studio owner I know has received several requests to give a day or more of his time in a family's home shooting black-and-white photographs of everything they did. The best results would be presented in an album. The photographer found this exciting and potentially very profitable, and he now plans to market the concept to more buyers.

Appealing rather to the impulse buyer and the nostalgia craze are the numerous operations offering "old-time" portraits, usually in heavy-traffic tourist locations. Especially popular in the West, these places have on hand a small assortment of old clothing and props representing the Old West, the Gay Nineties, the Roaring Twenties, from which patrons can choose. Many use a Polaroid process and produce sepia-toned prints on the spot (shooting perhaps four poses and offering several for ten to fifteen dollars). Others are full-scale studios charging high prices for sittings. Most people pose as couples or even in large groups, and they are easily pleased with the results, because they are usually fun. Many of the Polaroid cubbyhole operations are run by entrepreneurs who know nothing whatever about photography in general.

Weddings

Like portraiture, modern wedding photography can and is being done with small-format equipment and journalistic techniques. Wedding work is not to everyone's taste or capability. But again, if you want to venture in this direction, scouting the competition is awfully simple. Besides looking in studio windows, go through the wedding albums of friends—you may be surprised at what often passes for professional "candid" photography.

If you do *not* want to produce endless stiffly posed family groupings, clichéd shots of the wedding cake being cut, or the sugary variety of work with names like "Misties" (cousin to the sentimental portraits some teenagers like), remember that a great many people getting married today do not want such old-style coverage either. Some modern brides dispense with photography altogether, or ask a friend for some snapshots, because they know of no alternative. Should you offer to tell the wedding story in a natural, nonintrusive fashion—as it really happens, rather than as one more example of the standard "ideal" event—you may discover a more receptive audience than you think.

Candid coverage does not mean the photographer snaps away at random. A wedding, bar mitzvah, golden anniversary party or other celebration must be

photographed with the same care given to any other kind of assignment. You will need to inform yourself of facts such as who is involved, the exact nature of the locations and the ceremonies; any limits about photographing during a religious event with or without flash; any special desires of participants; and the precise nature of the final photographic order, whether large portraits, albums, or thank-you note prints. Such matters should be researched as for any other kind of story, so that you can plan your equipment and coverage. Make a list of the important people and events that require coverage and plan your vantage point if possible. There may be at least several occasions during the event when you must step out of your unobtrusive role and arrange a "controlled candid" to ensure desirable imagery and at least a few outstanding pictures.

Prices for wedding photography are often very complex and you will need to work out a personal system. As for a magazine story, you might want to charge a standard day rate that includes a certain minimal number of prints. Additional prints and copies can be charged for individually or by the batch. Remember you want to cover your time, costs for materials, use of equipment, final prints and accessories, *and* make a profit. Check around your area for pricing and types of services; you may be able to obtain schedules from the studios themselves. Of course you do not need to follow their charge system, services, or their usual hard-sell methods of upgrading orders; simplicity and soft-sell can be part of your unique service. It is, however, essential that you and your customers thoroughly agree upon the types of pictures, their general style and the pricing before the event. A substantial advance payment to reserve your time and prevent change-of-heart (at least concerning the photographer) is the traditional approach and well based.

It can be most profitable to develop some imaginative ideas at the early stages of your discussion with wedding clients. Many families would like movie coverage of the great event, which may be outside of your capability and their budgets. But how about a slide show, supplied by you in a Carousel reel and perhaps complete with a soundtrack? Or, if you do get a client who is indifferent to cost, has a really huge family or a need (perhaps political or corporate) to publicize the wedding, try this unique idea: an illustrated, nicely designed, printed brochure recording the wedding and providing the text of the ceremony. This requires art direction and is of course expensive, but also amazingly effective.

An excellent source of advice on all phases of 35-mm wedding photography, from planning to pricing, is the Suzanne Szasz book *Modern Wedding Photography*.

One more note: if you're interested in obtaining wedding assignments and can demonstrate your qualifications, established local portrait studios can be a good source of business. Weddings form an important but uneven segment of their trade and many portrait studios hire freelancers at times of high volume. Some always employ freelancers for this work rather than use their own weekend time or that of staff members. Make your availability known to such studios.

A studio might also consider giving you assignments for at-home portrait sessions if customers should request them; you might even persuade a studio to promote such a service and, we hope, hire you to do the work.

Roving camera

A possible extension of your mobile portrait business is to track down special-interest groups in your area and photograph them, for money, of course. Actually this is one of the oldest traditions of professional practice. Many early photographers earned their living this way, photographing, for example, the crews of ships and the ships themselves for sale to the proud seamen; or the lumbering crews which felled huge redwood and cedar forests with their primitive equipment. The pioneer photographers undertook such tasks with at least forty pounds of their own primitive equipment, considerably more of a challenge than faces you today. But their approach is well suited to contemporary hobbyists.

One photographer I heard of developed a healthy adjunct to his weekday business by frequenting an airport used by small-plane owners on weekends. It never occurred to these people to take pictures themselves, let alone hire a photographer, but a photographer on the scene offering to record each with his beautiful airplane was virtually irresistible.

Variations on this theme might include boating enthusiasts, motorcyclists, horse show participants and skiers. Check bazaars, pet shows, clubs and service organizations. Look especially for anything particular to your area.

Similarly, be aware of any local attractions or special events that occur near where you live and may interest a wider audience. Major magazine space goes to things such as a frog-jumping contest, an annual snake hunt, a chili cook-off, or a build-a-car contest. The familiar can be hard to see, so examine your environment as if it were a foreign country.

Many a clever photographer is able to build a substantial amount of business on a local theme of some sort. For example, a photojournalist who lives in Newport News, Virginia, earns most of his living by supplying the media with

information about the city's giant naval-industrial complex. If you're associated in some way with a very large company, or have an inside track via a friend or relative, a myriad of story possibilities exist at any moment. If your town is Las Vegas or Niagara Falls or Pasadena at Tournament of Roses time, a lot is going on that others may want to know about.

Commercial photography

From a photographic viewpoint there are two kinds of businesses in any community: those that employ photography in some way and those that do not. Larger companies are more likely to have realized the benefits of good photography, but not necessarily. Ways to sell your services can be cultivated with a little thought.

Medium- to large-sized companies are apt to have a great many photographic needs that may or may not be fulfilled by an in-house staff. Firms headquartered elsewhere may be served only sporadically by a visiting staff photographer. Others maintain the staff and facilities to handle their routine work and hire freelancers for the occasional or special need. This is most often the situation. The "glamorous" side of photography—publications and advertising—may be handled through advertising and public relations companies. It can be well worth the time to check out the situation at companies within reach. You might usefully request a portfolio appointment with the Director of Public Relations, Director of Communications, Personnel Director, Chief of Photographic Department, or other management officials suggested to you in a telephone query. If you can get a company personnel directory, you should be able to figure out the likeliest executives to talk to.

In planning a portfolio presentation or sales pitch consider the possibilities covered in Chapter 14, plus any other you can think of in relation to the firm in question, so you can anticipate needs and relate your skills to them. Don't approach a company blind any more than you would a magazine. Explore any ideas that might involve the company's relation to your community as well as standard possibilities such as annual reports, documentation imagery and so forth. Community P.R. is of special concern to many large companies, and it represents your advantage over visiting firemen.

If you want to compete for photography business that a firm is currently awarding elsewhere, you might collect all the samples you can and evaluate them with an eye toward finding your competitor's weaknesses. Many an aggressive photographer with an all's-fair philosophy has built his income this way. Chances for a pitch like the following one are far more available outside

the urban centers: "I have been studying your material and think I can do a fantastic job for you. Here is a portfolio showing the high level of my accomplishment to date, and I'd like to tell you about some special ideas I worked out just for your needs." Many a highly confident photographer would go so far as to offer to provide one sample assignment or ad, on speculation or minimal charge, on condition that acceptance include a contract for the future work.

If you see occasion to attempt this kind of approach, do not emphasize the shortcomings you have observed in the photographer previously used. This only insults your buyer's judgment. As in all your selling stress the positive—the unique contribution you can make to the need you have so intelligently recognized.

Some of your most exciting potential is in selling clients on uses of photography they have not considered before. Besides the examples cited in this volume you should accumulate your own list of interesting applications run across in your readings and travels. You could have a particularly stimulating time working with the smaller businesses that have never considered photography to be within their range. A photographer living within one of the numerous communities that make up the Los Angeles Basin decided to explore local potential by emphasizing the "patronize local business" approach. He produced an inexpensive flyer, stating simply that he was "available to talk about what creative photography by a professional right next door could do for you." He mailed or hand-delivered these to shops and small industries around the neighborhood. More than half the recipients actually called for the appointment, a really unusual return.

Another enterprising photographer, a photojournalist in an Eastern suburban area, prepared some equally simple material to publicize his services to small manufacturing and commercial concerns. He discovered an instant response among several new businesses run by young people who were more than ready to recognize the value of good visuals, and glad to find a way to afford them. Some of these businesses grew and he found himself providing related services—design and copywriting—at first by hiring freelance help, and eventually by developing a staff. He had begun building a business of his own by catering to a common need: the small business's desire for effective promotional materials without the need for internal staffs, or advertising agencies, beyond their means.

Retail businesses are also open to photographic services. Large department stores often have staff photographers for the continuing flow of advertising, catalog and promotional work. Others do not, or may hire outside photographers for part of the job on a seasonal basis—pre-Christmas or pre-sale. A

phone call can determine a store's policy and indicate how you can compete for existing business. But why not think several steps beyond your competition, and be ready to suggest some innovative ideas—like using mural-size photo backgrounds for display windows, or collage arrangements to set a theme. Some examples are snow scenes for skiing clothes or Christmas-shopping time; children for back-to-school; lovers for Valentine's Day; and animals for Easter. Settings for special displays in the store can use photography in similar ways. Suggest a photo exhibit of local attractions or a store-sponsored photo exhibit.

In thinking about photography for a business purpose, look past the obvious to applications that are somewhat behind-the-scene. Consider catalogs, mailers, equipment and procedural records, insurance documentation, trade advertising and publicity, trade displays, annual reports, and training materials.

And don't forget to investigate the special needs, as relevant to your capacities, of architects' offices, real estate agencies, insurance companies, hotels, motels and restaurants of every type, and hospitals. Governmental "businesses" make a list themselves: police bureaus, firefighting departments, schools and educational centers, military installations, and city hall.

"Non-profit" photography

Especially if you plan to cultivate a photographic career within a community, active participation in that community's life can be extremely beneficial over a period of time. Your skills offer a distinct benefit to civic endeavors that rarely use good photography because the organizers are unaware of what it can accomplish or are unable to pay the going rate.

Photography is a superb tool for nearly every kind of civic, social-service and charitable organization. Among the groups that welcome help in publicizing needs and achievements are churches, youth projects, service clubs, schools, animal shelters, hospitals, charities, orphanages, senior citizens' homes, conservation groups, Y's, orchestra and theater groups, and citizen-action committees of all types.

Photography is able to show reality convincingly and to attract interest in that reality; to recruit members and influence decision-makers; to inform the public of services; to document the "before" and "after" of a project; and to present convincing proof of a need, such as for a traffic light or park cleanup.

Many organizations can make good use of photography as visual testimony for a contribution of time or money. Some have learned that slide-show

presentations work better than dull written reports, whether to the public, members, or government agencies. Few groups can fail to be excited at the possibilities of using photography for more effective fund-raising.

Good photographs can work wonders in posters, newsletters, brochures, mailing pieces, reports to members and donors. Added to press releases, a good photograph greatly increases a charity's chance of gaining prominent newspaper space and will better attract readers' attention. When the group can budget for advertising, an interesting picture will function for it just as well as it does for multimillion dollar campaigns.

If you really want to take the initiative, suggest a photographically-based story on some aspect of the organization or project and develop it for submission to an appropriate medium. Newspapers, Sunday supplements, and local or regional magazines are very receptive to efforts like this. Or, you might even organize a photography exhibit centering on the group's work and display your own pictures and those of others. Follow up by finding exhibit space, holding a reception, and so forth, as with any show.

The natural focus for this kind of photography is of course people; as has been said many times here, natural-looking pictures of people involved in some activity are in wide general demand. Often a cause provides photographic possibilities with wide appeal—animals, children, teenagers. At other times you will have to be more imaginative in developing subjects and accept the challenge of photographing meetings, award presentations and other unexciting events in an interesting manner and finding the appealing aspects of charitable causes.

You may also wish to follow up your own enthusiasms with local special interest groups. Conservation clubs and ecology organizations present particularly rewarding potentials for photography. Your leadership in demonstrating how photography can document existing conditions, record an improvement process, attract public attention and dramatize goals and accomplishments can prove rewarding for everyone concerned.

In recent years the photographic resources of the past have begun to attract great interest. The great treasure troves of early photography are being unearthed from attics and archives and demand intelligent, informed treatment if they are to be preserved. The task falls variously to historical societies, museums, libraries and informal groups of citizens. It is unfortunate that virtually none of these groups is equipped to deal with photography. This means opportunity for you.

Help is desperately needed in sorting through files to discover what is in them, cataloging collections, and restoring old prints and negatives or at least

handling them in a manner not to cause further damage. Heartbreaking stories abound on the subject. One historical society was lucky enough to possess thousands of daguerreotypes which, by virtue of special funding and volunteer help, they carefully washed with an acid that erased every image. More than one irreplaceable collection of old glass negatives has been used to build a greenhouse.

Exciting possibilities for using these old materials are limitless—exhibits documenting local history, publications of every type, books, various illustrative purposes. Some interesting books combining old images with new ones have appeared. Television and film presentations have been based on historical photographs, making excellent use of camera scanning and zoom to create the illusion of motion.

Photographers I know who have looked into the local picture archives in a sense have never emerged—working with the material proves fascinating, and incidentally, quite enlightening about early techniques that now look new. The historical society or museum needs modern documentation too, recording structures, people or accomplishments and they need publicity efforts to educate more people about the value of that dusty old material that all too many of them still throw into the garbage during spring cleaning. Do not undervalue your potential contribution to this important effort even if you have never been especially interested in old pictures. You already know far more about basic photo materials and processes, and possess a more developed visual judgment, than the historians now responsible for the archives. And you can easily learn more as the spirit moves you. Some excellent books are available (most notably, *Collection, Use, and Care of Historical Photographs* by Robert A. Weinstein and Larry Booth).

If your taste is toward showmanship, you may discover organizations delighted to screen slide shows, related or not to their direct interests. Travel shows are in demand among church groups, fraternal orders, community centers and clubs. Some might be pleased to have the idea suggested to them, especially those which need to entertain people—old age homes, hospitals, schools, nursery schools, convalescent homes and so on. Usual presentation is a slide show with running commentary; take care that the commentary is prepared in advance or you may be embarrassed. The same show can be presented to many different audiences. For something different and really involving, skip the running commentary and prepare a coordinated sound track instead, drawing music from records or radio. (This may be in violation of copyright if you use copyrighted material, but you are unlikely to be sued unless you are doing something that is making a lot of money and/or attracting

wide attention. Records are available with music expressly cleared for such use if you are concerned about this.) You can handle the projection manually, or investigate a simple synchronization system at your camera dealer or a-v supplier.

Many universities operate speakers' bureaus that serve as clearinghouses for groups and speakers in search of each other. Ask if you can register.

Politics offers another arena to your talents. Media's determining influence on elections is news to few office-seekers, but local candidates often do not know how to apply the principle. I know of one photographer who donated some time to a campaign for someone he personally supported. When alert staff members saw some of the results—candid style reportage of the candidate meeting his public—they grasped the chance for better advertising and public relations material. Huge posters were made up for prominent display around town and prints sent out with the barrage of press releases. Provision of good visual material helped get the candidate more than his share of media space. Rather to his own surprise, the photographer found himself with new clients—they included other candidates hoping to buy his services.

Helping others with causes you believe in can give you excellent showcases for publicizing your own capability. Community participation also offers you interesting subjects for pictures that can be used for other purposes. Remember, it is precisely the closely focused, human interest stories that are in universal demand. If even more reason is needed, note that endeavors like charities, historical societies, conservation efforts and political campaigns usually involve citizens with the greatest affluence and influence. Photography is a service business, and contact means more than a picture proof.

Depending on the nature of each situation you may choose to donate your services as a contribution, ask that expenses be reimbursed, or charge a fee. Whenever possible the people you work with should agree that a credit line is in order when your images are used in any form. If you succeed in marketing the results in the form of a story sale to a magazine or other outlet, the proceeds are naturally yours but the placement should preferably be approved by the organization. You do not want to unfairly exploit the special access you have been given to people and events.

Teaching photography

If you have any penchant at all for teaching, students abound. Camera clubs, arts and crafts schools, universities, prisons, adult enrichment programs, senior citizens' centers, Y's, camps and scout troops find photography courses

to be in great demand and may welcome your inquiry. Such programs usually pay the instructor. Although the sums are not often large, many a freelancer finds the income from a few regular courses a nice steady resource. Basic how-to courses are wanted in most places; if the organizations you contact already have such classes, suggest something more specialized. According to your skills, consider, for example: Available Light Photography, Creative Darkroom Work, Portraiture, Photojournalism, Landscape Photography; or even Close-up Photography, Available Light Portraiture, Photographing Children, Commercial Photography, Wedding Photography, or The Photo-Essay.

Many photographers elect to offer courses not through an established channel (which usually will retain part of the income) but from their own studios or homes. A small amount of advertising in a local newspaper, notices on bulletin boards or a few fliers in relevant locations can bring the pupils to you, if there is an interest. Depending on local circumstance and the nature of a class, typical fees for a course eight to ten weeks long, two to three hours per week, can range from $35 to $100 plus, per student. Do not forget to cover the cost of any supplies or equipment included.

To teach, of course, you must know your subject. But if you venture into it, you will find that photography is surely among the easiest subjects to teach. Most of your students will be enthusiastic and eager for any information you can offer. In addition, their provision of their own picture-making efforts gives you a convenient, inherently fascinating takeoff point for discussion.

Even if you do not want to commit yourself to a continuing class, or you are not sure you will like teaching, you might experiment with giving some one-shot lectures. A photography club in the community or a school might appreciate your discussion of a specialized topic geared to their members. A club or school publication staff might like your expert advice and opinion.

Or you might participate in a program that uses photography as a self-help tool. Some notable successes have been scored by programs which put cameras in the hands of prison inmates, the underprivileged or culturally deprived, or emotionally disturbed children and adults. If such programs do not now exist where you live, you might suggest them to appropriate adminstrators with an offer of your services.

Teaching can stimulate your own photographic thinking better than almost anything else. Confronting a dubious student helps you clarify your own ideas, values and perceptions. Moreover, it automatically places you in a position of authority—you become *the* photographer, and that can not be bad for business.

The key to success on the local scene lies in your image of your own role. If

you announce that you are ready to produce pictures, you may wait a long, lonely time for takers, whether you are charging for your services or trying to give them away free. Perceive a need, think through ways in which your talents can meet it, and prepare a presentation accordingly. Talk to people about photography meeting needs, not merely about pictures. Apply your imagination not only to observe ways in which photography is now being used in your environment, but to conceive more ways it might be used.

In your world you should be a pioneer, exploring new directions and leading others toward a better appreciation of photography's value. You are the resident expert on visual communications—or can be, if you see yourself that way; keep your eyes and mind open and think about what is in front of you.

17

Pricing Your Photographs

IF IT has seemed to you that in some areas of evaluating and selling photographs few definite answers exist, you may be ready to appreciate that even fewer are available when it comes to financial questions. To charge what you can get away with is the basic applicable principle. Each photographer has to juggle the factors of his professional reputation, the degree of competition, his long-range and short-range goals, what the buyer can afford and how he will use a picture, the amount of time necessary to produce a picture or perform a special assignment, and his evaluation of the best balance between volume and price.

The problem with establishing pricing systems is that they require concerted effort on the part of the group concerned. Unions, of course, do precisely this for their members. But what could be more non-unionizable than photography, especially freelance photography? Do not mourn this lack, since the existence of a real professional photographers' union would probably prohibit you from selling any pictures at all. Many newspapers are unionized, and in some places the contracts they negotiate virtually eliminate the buying of non-staff material.

However, there is one national organization very much involved with legal and monetary matters relating to freelance photography. This is ASMP—American Society of Magazine Photographers. Based in New York, with nine additional chapters around the country, ASMP is an organization of dues-paying professional photographers in several membership categories. Full membership requires three years' active experience, as demonstrated by tearsheets or other proof, and sponsorship by two full members.

ASMP works to set legal precedents favorable to photographers and to pro-

tect their rights, acts as a clearinghouse of industry information, issues a bulletin and a membership directory, and sponsors educational activities.

Most significant in our present context, it publishes information on pricing and business practices. Until a few years ago the prices outlined in the ASMP business-practice book were referred to as guidelines. ASMP put a lot of effort into trying to enforce these guidelines as suggested *minimum* rates. This was a difficult undertaking, since even members often made deals for sub-minimal rates on assignments they wanted, making it hard to really pressure the buyers. In any case, the organization no longer sets minimum rates. Establishing standard charges can be construed as price fixing, which the government considers a very bad thing.

So ASMP's 1979 *Professional Business Practices in Photography* is most carefully subtitled A Compilation. "ASMP DOES NOT SET RATES," reads the introduction (capitals theirs). The rates described, as well as the business practices, "are based on extensive surveys of photographers, their representatives, and others."

Nonetheless, these prices are what people are usually talking about when they refer to standard rates, or established rates. Obviously you will want to be aware of ASMP's survey results as a general framework and useful reference point, but as a newcomer to money-making photography you would be foolish in many situations to insist on getting these rates.

ASMP is basically geared to the big-time worlds of advertising, corporate and editorial photography, with scarcely a glance toward some areas that will be of interest to many freelancers. Let's start with those.

Pricing art prints

As mentioned elsewhere, I do not recommend that any image you are categorizing as fine art be given away. Try to avoid even making such a donation to charitable auctions, since people are confused about valuing such an item and the low bidding could damage future sales (for this reason artists often attend auctions themselves or have a friend do so, prepared to purchase the item lest a low selling price permanently reduce the marketability of their work).

All images you want to sell as art should be mounted, matted, or even framed; you won't do very well with a print that curls at the edges. Naturally, it should be a first-rate print suitable for hanging.

My personal recommendation is that such a print not be offered for less than thirty dollars. Higher is better, but how high will depend on your buying

public, local taste, and a lot of other factors, including how badly you want to make such sales.

If you decide it is only worth selling prints if you make a profit at it, you'll want to take account of all material costs and your time. What is your time worth? One way to calculate that is to figure out what you could have earned spending the time some other way.

Selling any form of art naturally requires an appreciative buyer. Anyone who thinks a Matisse drawing or Arp sculpture is inferior to something their four-year old could have done is not likely to pay $100,000 for either one. And they are probably not oriented to spending thirty dollars for a photograph. On the other hand, a person who would consider adding a Matisse or Arp to his collection might have some strong reservations about purchasing a photograph. Until recently this was partly because photography was not presented to this audience in the fine-art context these buyers were accustomed to, and, paradoxically, prices weren't high enough to suggest good investment values. Both these problems have been substantially solved but a more basic one remains: the non-uniqueness of a photographic print. There is only one original Matisse drawing, but a negative can be reproduced as many times as the photographer wishes to or has a buyer.

For this reason some photographers limit the edition for a given image as graphic artists have traditionally done. They may print several hundred (which are appropriately numbered, "25/150," for example) and then destroy the negative. Or they may simply announce that only a given number of prints will be made over the coming years. Such an announcement, if you are Ansel Adams, can cause the selling price of a particular print to double overnight. Chances are very good that you are not Ansel Adams, however, so the limited edition technique may not be presently relevant to you. It is probable that it will be an important aspect of the fine-art photography market of the near future.

For now, note that any initiative you can take toward educating others in the appreciation and valuation of good photography will build the market for good prints and prices can be raised to correspond.

Pricing portraits

In the earlier discussion of portraiture, we emphasized the possibility of making at-home pictures of subjects rather than formal, posed studio ones. Most readers don't have real studios and can best compete by capitalizing on their mobility. This kind of work is relatively uncodified (though home

portraiture has been popular periodically over the years) and there is very little to go by in establishing a price schedule. One approach is to set a fixed rate for the sitting, as most studio photographers do, plus additional costs for each specific item ordered. A well-established studio photographer I queried offers outdoor and home portraits and charges thirty-five dollars for the sitting fee. His studio price is ten dollars for one person, fifteen dollars for more. Here are some sample prices from his schedule for color prints:

Individual prints:	3 x 5	5 x 7	8 x 10	11 x 14	16 x 20
First print	$15	$20	$27	$60	$90
Each additional print	7	10	18	50	60

Wallet-size prints, set of three:	
First set	$ 8
Each additional set	5
With $15 order	5

Combinations:	
One 8x10, two 5x7, and three wallet-size	$ 55
One 11x14, two 8x10, and three permanent proofs	95
One 11x14, six 5x7, and three wallet-size	120

Additional prints are offered at substantial reductions. A separate schedule also offers considerably lower prices to graduating high school seniors, who constitute a highly desirable clientele.

Such a rate structure is far from fixed. As of this writing, it represents a deliberately middle-of-the-road pricing system by one photographer in a large West Coast city. His personal marketing choice is to stay in the middle ground; at the end of each year, he examines his profit ratio and the volume of the business handled. There can definitely be too much business in relation to existing facilities in which case prices will probably be raised. Or he could choose to hire more personnel and enlarge space. Seasonal factors are also relevant; fall tends toward low volume, so this would be the time for special offers and promotions.

The basic idea is to determine how you want to operate and try to be consistent within that framework. You can choose to do a high-volume, low-profit business; the chain-store photo studio does this. You can opt for medium volume and medium prices or low volume and high prices. There are portrait photographers who quite happily charge $500 for a portrait, do a couple a week and spend the rest of their time at the beach. Nice work if you

can get it—and there's no telling how large a part salesmanship plays in getting such fees.

Remember that you create expectations with a price structure. Charge $100 for a portrait and a loving parent expects something different than he would get from Sears. On the other hand, a glance at the work of many quite expensive studio photographers offers some hints at how far you can go by creating the atmosphere of expensiveness. An unimaginative, routine portrait—executed with barely adequate technical competence—enlarged to 20-by-24, printed on arty-textured canvas and ornately framed—what is that worth? Not only several hundred dollars to the presumably happy customer, but quite possibly a blue ribbon from the state or national professional association. Such is the state of much contemporary portrait photography. Why hesitate to compete in a market like that?

Setting prices that attract customers, or at least do not scare them away, while simultaneously supporting your costs and time, will take some trial and error. But do not neglect to carefully record all elements of outlay and income and analyze precisely what you're doing, and where it's not working, so you can make changes. Keep doing that and you'll avoid one of the biggest reasons for new-business failures. Another one is under-capitalization, which is why I've discouraged you from launching into full-time photography with expensive overhead.

Wedding photography

Photographing weddings, and to a lesser extent anniversaries, bar mitzvahs and parties, consumes quantities of materials and time that will surprise you. Many photographers fail to calculate their costs in accepting the first job or two and end up losing money. Fortunately, most customers are aware that good wedding coverage is expensive. But if for no other reason than to help you hold firm on a quotation if customers try to bargain, do total up your anticipated costs beforehand.

Remember that you will need a fair amount of film to cover as many aspects of the affair as possible, to make sure you get important shots, and to emerge with pictures that are flattering to those involved as well. Suzanne Szasz in her *Modern Wedding Photography* estimates that all-color 35-mm coverage of a wedding requires six rolls of 36-exposure film. With processing and jumbo-printing by Eastman Kodak, the cost of lighting equipment (flashbulbs or batteries), and provision of twenty 5-by-7-inch prints, her cost of materials is $150. Materials for black-and-white coverage is under $94. She adds $200 to

the costs for her time and suggests that additional prints be provided at double their cost.

Most studio photographers who shoot weddings offer package prices. Here is our middle-of-the-road photographer again with four package offers:

1. Sixteen 8-by-10 color prints in an album for the bride and groom; thirty-six color proofs in an album. Based on four hours of photography time and a selection of eighty proofs, price is $250.

2. Sixteen 8-by-10 color prints in an album for the bride and groom; sixteen 5-by-7 color prints in an album for the parents; forty color proofs in an album; one 8-by-10 anniversary portrait certificate. Based on four hours of photography time and a selection of 100 proofs, price is $355.

3. Thirty-two 8-by-10 color prints in an album for the bride and groom; sixteen 5-by-7 color prints in an album for the parents; forty color proofs in an album; a five-year family certificate for ten portraits. Based on five hours of photography time and a selection of 100 proofs, price is $460.

4. Thirty-two 8-by-10 color prints in an album for the bride and groom; thirty-two 5-by-7 color prints in two albums for the parents; forty color proofs in an album; a five-year family certificate for ten portraits; one 16-by-20 color portrait mounted on canvas. Based on five hours of photography time and a selection of 100 proofs, price is $685.

If you are thinking about wedding photography on a serious level, scout your area and collect sample price lists.

Note that most photographers require payment of fifty percent of the total order when it is placed. Many require an advance deposit of perhaps fifty dollars to reserve the photographer's time.

Publication work

ASMP has a complex structure of typical reported rates which is based on the publication's circulation and type, whether the image is black-and-white or color, size of reproduction, rights purchased and so forth. In practice most magazines and newspapers have established policies on payment rates that they apply to all photo suppliers except in special cases.

Rates, then, are rarely the subject of bargaining between a photographer (or writer) and a publication. If you are selling stock pictures, an editor may tell you outright what his publication will pay for them; or he may tell you that the price depends on where the pictures will be used and how large, and that the price will be calculated at the standard rate after layout or publication. This rate can easily range from five dollars per picture, even in this day and age, to hundreds.

Assignment situations are usually just as nonnegotiable. If you are hired to do a magazine feature you may be paid at a space rate or at a time rate, which may or may not be at the ASMP survey level. Sometimes you have a choice, or the arrangement can be for whichever price is higher after the finished work is calculated. Inquire about such matters beforehand.

Clarify whether expenses are covered, item by item: costs of travel time, transportation, models, assistants, special equipment rentals, props, costumes, film, processing, printing, and anything else relevant.

Determine precisely what rights are purchased at the prices specified, whether for one-time use, multiple use, use in any other media or for any other purpose, or outright ownership of the negatives. Determine whether the arrangement covers all images taken during the shooting or only a selection, and whether the buyer has first North American rights, first world rights or all rights.

The typical assignment situation is for purchase of first rights. Sometimes the photographer can sell all or some of the pictures elsewhere only after a specified period, say three months after first publication in the assigning medium. For stock pictures, one-time use in a specific medium is the most normal situation, with the buyer reserving the right to employ the image for promotions involving that medium.

What about editorial features that include both words and pictures? If you've only done the photographic portion of the package, the foregoing principles apply according to whether it is existing work or done on assignment. This may net you anywhere from nothing at all to thousands. If you are the writer as well as the photographer, a new element has been added.

Many newspapers and magazines have a separate standard rate for illustrated features, or, frequently, several rates for different story categories. The price depends on how difficult it is for them to obtain each kind of material or how valuable it is to the publication. It is risky to quote "standard" figures, but in practice newspapers pay $15 to $50 for concise features; while well-established trade magazines and small-to-medium-sized consumer magazines pay $150 to $500 for reasonably solid feature packages. (This is often computed as a page rate, running from $25 to $75 per printed page.) Many consumer magazines will pay $500 or more just for the writing, and pay substantially for the photographs on a separate scale, but the smaller publications rarely differentiate. If and when they do, the balance will probably fall something like eighty-five percent for the writing and fifteen percent for the photography. Good pictures are still a luxury to such magazines, who see tight budgets best spent on written material. That, of course, is why I have been advocating that photographers practice their writing skills. There is decent

money to be made from small publications hungry for material and willing to work closely with new contributors, a fine situation for beginning freelancers.

I've been talking about situations where payment is a take-it-or-leave-it matter: "This is what we pay for that kind of material," the editor or art director says, and you accept his terms or not. When should you be prepared to negotiate?

Whenever you have something special that more than one buyer may want. When you are hired for a job because of a unique qualification of any kind. When a great deal of time is involved. When there is any element of danger. When the crucial deadline is extremely tight. Whenever your buyer is purchasing anything beyond one-time rights. Exclusive rights, complete transfer of ownership, or a contractual prohibition against your selling any results of the shooting elsewhere, or the buyer's assumption of the right to have you produce quantities of prints from your negative upon need, or to use your work in media or forms other than the one for which the work is bought, are all above-and-beyond situations. You ought not to give such rights away at "standard" prices. The amounts paid should take account of the fact that you will not be able to produce further income from a shooting or sell existing images again. So definitely, negotiate.

Assignment and stock photography: ASMP survey rates

Anyone seriously interested in freelance photography as a career ought to obtain a copy of *ASMP—Professional Business Practices in Photography* ($14 including postage from ASMP, 205 Lexington Avenue, New York, NY 10016). In addition to the rate surveys already mentioned, the book discusses the photographer/agency relationship, copyright, insurance, book-publishing contracts, settlement of disputes, and trade definitions. It also gives some data on the ad rates charged by major magazines (presumably to prove that the publications can afford to pay photographers better). And it contains some form agreements: model releases, delivery memos, an assignment confirmation and a few others.

Reading through this compact book is not only the fastest way I know to get the flavor of freelance photography as practiced in the big league, but to gauge its many potential pitfalls. Reflecting its members' pioneer struggles to earn good money and fair treatment in their relatively new profession, ASMP tends to be problem-oriented, and the book is full of little warnings to the unwary. Its forms are so comprehensively written that they are sometimes intimidating—to models as well as to clients.

True, from a photographer's point of view, it cannot be denied that it is highly desirable for a client to commit himself, on paper, before an assignment, to binding arbitration under American Arbitration Association rules for any dispute involving more than $1,000, with the client paying *all* costs including attorney's fees. And it would be nice if he would sign an agreement beforehand stating that, should your credit line not run adjacent to your editorial photography, the invoice will automatically be doubled. And, with stock photos, it would be best for you to have a signed guarantee that your client will pay a minimal charge of $1,500 for any lost or damaged transparency, or holding fees of $5 per transparency per week after fourteen days.

Why shouldn't every photographer demand such detailed contracts in every case? Unfortunately, more than one photographer has found that it can be precisely the existence of such requirements, or lack thereof, that determines where an assignment goes. One recently noted to me that a series of attractive assignments had materialized "because they thought I was super-nice to work with, just because I didn't ask them to sign a lot of detailed stuff in advance like my competitors did. And it wasn't that they were planning to behave dishonorably or cut costs—the client was an oil company—and I was paid and treated very well."

The business forms and practices described by ASMP are based on the organization's experience and its surveys. It is not specifically stated who was included in the surveys, but I assume the membership was actively involved. Like the price information, the business approaches are clearly based on the outlook of established professionals who are in a position to substantially set both their own prices and working methods. Realistically, it must be admitted that if a client is asked to pay an unknown photographer what he would have to offer a Pete Turner, and to provide all the contractual stipulations that a Pete Turner requires, he might decide to hire Pete Turner.

Where does that leave you?

As far as the business forms are concerned, you might at least absorb the principles ASMP sets forth, which are based on a lot of hard experience. One form, for example, gives you an excellent checklist for estimating assignment expenses, which are very important for a major project and should be accepted at the outset by the client, who often furnishes a substantial advance.

In establishing your own business procedures you may want to design modified versions of ASMP's forms on a level that both you and potential clients can live with. Note, though, that even a slavish imitation of the materials prepared by ASMP does not protect you from possible problems and lawsuits. The introduction notes, "We render no legal opinion concerning their appli-

cation. Individual modifications are indicated and encouraged."

Once again, you have to draw your own lines. And, getting back to figures, ASMP price surveys must also be interpreted individually. Note, for example, that the absolute rock-bottom price recorded for selling "decorative fine prints" is $100 to $150, the "average" price is $250, and the "upper" range is $1,000 plus. That's for "personal use"; "office/commercial/public display " is higher, and reproduction costs are additional.

Note too that the lowest-circulation magazines for which picture rates are recorded are lumped together as having circulations "below 250,000"—in a footnote indicating that "there are *some* trade, and other highly specialized magazines, as well as newspapers, with circulations that are so low that they may not be involved in the economics of *this* marketplace generally" (italics theirs).

In other words, if a magazine has a piddling circulation below a quarter of a million, the way many, many magazines do, it probably cannot be charged ASMP-type rates. Reasonable enough.

Here are a few sample prices from the book's schedules, just to give you a feel for the rate structure. As the authors note, it should be kept in mind that in many cases necessary overhead is quite considerable and photographers' fees have not risen as much as most of their costs.

Assignment photography

Editorial journalism (with all expenses billed to the client, proper credit line used, and one-time-only use in the designated publication) *day rate* (as guarantee against space rate, which is specified at stock photography rates):

News photojournalism—lower range, $250; average, $300; upper, $400 to $600 plus.

("Under 2 hours; magazines under 200,000 circulation; or Newspapers," $150 to $225 plus).

Advertising day rates (not including travel time, expenses, prep time, and for use only as originally specified, with further use requiring additional payment):

National consumer magazine, national newspaper campaign, or national billboard campaign—lower range, $1,000 to $1,250; average, $1,500 to $2,000; upper, $2,500 plus.

Rates for regional, local and trade magazines run roughly half of the foregoing.

Corporate/industrial day rates: annual reports start at $500; most other projects start at about $300.

Catalog and brochure assignments: a per-image price is cited, the very lowest figure being $75. Rates vary according to the nature of the images—whether still life or figure, degree of complexity, etc.

Stock photographs

Rates for stock photographs are based on the licensing of one-time U.S. publication rates in the English language only; additional rights are more, and all rights would cost six times as much.

MAGAZINES: magazines with circulations of less than 250,000—black-and-white cover, $200; inside page, $120; color cover, $250 to $400; inside color page, $250. These rates move upward according to the size of the magazine circulation.

Magazines with circulations above three million—$1,000 minimum for a cover and $600 to $800 for an inside color page; $250 to $300 for an inside black-and-white page.

ADVERTISING: national consumer magazine, color—$1,000 to $2,500 plus; black-and-white, $750 to $1,500. Local and trade magazine rates run about half.

CORPORATE/INDUSTRIAL: annual reports, color cover—$500 to $2,000; inside color, half page or more, $350 to $750 plus; under half a page, $250 to $500. Black-and-white runs somewhat less. House-organ color covers run roughly similar to inside annual-report color.

BROCHURES: according to print run. Smallest is 20,000 and under—black-and-white inside page or fraction, $150 to 1250. These rates rise to a run of one million—black-and-white, inside page or fraction, $350 to $750. Color is more.

The price-survey charts cover a great many other photographic categories that you will want to know about. The book also cites useful information for situations like sale of extra rights, postponements, cancellations and reshoots.

All in all, knowing what the top pros command should add some more fuel to your ambitions as a freelance photographer, should you need any. Just remember that no one starts at the top.

18

Photography and the Law

ON SUCH legal questions as copyright, rights and obligations and contracts, you might think that precise guidelines surely exist. Right? Wrong. Few areas of law are so contradictory and confusing as that concerning artists' rights and recourse. Similar cases may have entirely different outcomes depending on the states in which they are tried. When questions involve copyright, which is federal law, the interpretation of that law is altogether lacking in coherence or consistency. And in fact, were the letter of the law to be strictly adhered to, many common practices in the publishing industry would have to be discontinued.

I am not suggesting that you ignore the law. But you have to know that there are limits to how well you can protect yourself and your pictures from abuse. You will find yourself having to decide, perhaps frequently, whether to take a risk.

The best single piece of advice I can offer you is: Try to solve problems with common sense before taking them to a lawyer. First of all, few lawyers have much expertise in the area of artists' rights. Those who give you fast, precise answers to most questions you bring them may not understand the situation. Lawyers who are relatively knowledgeable, on the other hand, are reluctant to provide straight answers because there rarely are any.

Second, resorting to the courts is not only extremely expensive, but often far from your best recourse. An artist who feels ripped off in some sense may think too quickly about consulting a lawyer to bring suit. Many become discouraged when offered a realistic picture of probable costs and benefits (which a good lawyer will provide). Others may forge right ahead, common sense forgotten. Both may overlook the fact that a more or less amicable settlement

might have been made with the ripper-off had some calm, analytical judgment been applied.

Always consider precisely what it is that you want. If a publication has lost a favorite slide, do you want to force them via a lawsuit to make restitution—which will probably be based on the last price you were paid for a similar slide—at the cost of finding yourself permanently unwelcome at that publication and twenty others issued by the same company?

Most established publications value their reputations among photographers and will attempt some reasonably fair arrangement if you talk to them in a fairly reasonable way. If the staff absolutely refuses to admit any responsibility whatever even though you feel they should, consider that collecting $100 may cost far more than that in time and legal costs. As you practice photography you are likely to find some situations where you'll just have to chalk up some kind of loss and go on.

The following is intended to give you a useful framework on matters such as copyright, model releases, contracts, recourse if a picture or idea is stolen, and invasion of privacy. The questions are those most frequently asked by photographers. The answers are based upon considerable effort in pinning down some knowledgeable lawyers, research into the source material, and experience with common practice.

Note that none of the material in this book should be considered legal advice. Complex laws can only be touched upon briefly, and a great many aspects of law are not covered at all. Further, the law not only varies in important respects from state to state, but is constantly subject to new interpretation. Individual problems and questions will require consultation with a lawyer. However, I hope the legal questions brought up here will alert you to the possibilities of better protecting your legal rights as a photographer.

Copyright

What is copyright and why does a photographer need it?

Copyright denotes a complex system of federal law designed to protect artists, including photographers, from unauthorized use of their work. This means that if ownership of a copyright is infringed upon—for example, a photographer's picture is published in a magazine without his permission and without compensation—he has recourse to legal remedies.

According to current copyright law, which became effective January 1,

1978, for works published after this date the length of copyright ownership is the artist's lifetime plus fifty years. (Prior law provided a twenty-eight year period which could be renewed for an additional twenty-eight years. Work copyrighted before January 1, 1978 and currently in its first twenty-eight year term must be renewed when that term expires; but rather than giving another twenty-eight year extension, the new law allows for an extended period of forty-seven years, for a new total of seventy-five years from the date of first publication.)

There are a few exceptions to the new rule of life-plus-fifty years, including work copyrighted in a corporate name, under a pseudonym, or other situation where there is no way to determine "life." Then copyright lasts usually for seventy-five years from the date of first publication, or one hundred years from the date of its creation, whichever expires first.

The new law also provides for a "termination of transfer" by an author or certain heirs during a five-year period beginning at the end of thirty-five years from the date of publication or transfer of copyright, to protect the creators of work from permanently losing their rights because they sold something without knowing its eventual worth. Some allowance is also made for works copyrighted before January 1, 1978. You will probably need a lawyer's help if you want to file for a termination.

How do I obtain copyright for a photograph?

You obtain copyright protection as soon as you have created the photograph. The problem is how to keep your copyright "alive" through the many possible pitfalls lying in wait.

The means which our law provides for protecting new work is the copyright notice. Proper notice must be affixed to all "published" copies of your photograph and may take one of several forms:

©year, name (as in ©1980, John Doe). This
is the preferred form because it is the one
required for purposes of claiming Universal
Copyright Convention Protection.

Copyright, year, name (as in Copyright, 1980, John Doe).

Copr., year, name (as in Copr., 1980, John Doe).

"Publication" is considered to include any distribution via public sale, transfer of ownership by lease or rental or loan, and placement in any public display with concurrent public offer of sale; meaning that hanging a work in a gallery where it can be purchased constitutes publication, but not at a museum, as long as the museum has rules against copying exhibited work (most do)—unless, like the gallery, the museum offers the prints for sale.

To fully protect your work each photograph should display the copyright notice prominently, either on the face of slide mounts, or the margin of prints; notices placed on the backs of photographs may be perfectly proper if clearly visible. The basic rule is that the copyright notice must be affixed so that it can easily be seen.

The next step is to register a photograph with the Register of Copyrights, which is a simple matter of obtaining the appropriate form for visual arts (the VA form), completing it, and sending two copies of the photograph to the Register of Copyrights with a check for ten dollars. (You can write for the form, and also for a free Copyright Information Kit, to the Register of Copyrights, Copyright Office, Library of Congress, Washington, D.C. 20559.)

To save on costs, some photographers send a contact sheet, composite print or transparency with a number of photographs shown therein, assuming all are thus properly registered. The 1978 Copyright Law does in fact allow for a single registration of related works, including a group of photographs by one photographer.

In this country, failure to observe the formalities exactly as specified by law can result either in loss of copyright or loss of certain remedies. No judicial action to enforce a copyright can be pursued unless prior to the action the work has been registered and deposited with the Copyright Office. Moreover, if you haven't registered it before the infringement was made, certain remedies are unavailable to you even if you've later registered it.

What happens if copyright is lost?

The work enters the public domain, meaning anyone can make use of it for any purpose without consulting or paying you.

How can copyright be maintained?

By making sure that the correct copyright notice appears each time the work is published or publicly displayed or offered for sale.

How come magazines don't usually print the photographer's copyright notice with every photograph they run?

Because it's too much trouble and it doesn't look nice graphically. However, the entire magazine is in most cases copyrighted, by inclusion of the notice within the first few pages. This usually covers all material within the issue, thus keeping your photograph out of the public domain. Of course, this means that the magazine owns the copyright, not the photographer. Following publication the photographer can request the magazine to provide a letter stating that copyright is hereby assigned to the photographer and most will comply.

Who owns a photograph taken on assignment?

You do, according to the copyright law that took effect January 1, 1978. This matter was far less clear under the earlier law and thus is almost certain to produce a good deal of misunderstanding between photographers and clients, not to mention litigation. The basic change in orientation involves a redefinition of "work made for hire." Work for hire is now considered to include: preparation by an employee within the scope of his employment (unfortunately not fully defined); and certain works specially ordered or commissioned. Special order or commission encompasses a contribution to a collective work, a part of a motion picture or other audio-visual work, or a supplementary work, specifically said to include "pictorial illustrations."

Fortunately, in view of how confusing this already sounds, the new law adds that an agreement between the parties must specify that the work in question is "made for hire." In the absence of such written agreement, the creator is the owner. This is important for a number of reasons—not only does it give you basic control of what you produce on assignment (unless you deliberately or carelessly sign an agreement with your client saying you are doing work for hire) but it allows you later to take advantage of the thirty-five-year termination option, which you can not do with work made for hire.

The shift in law can be seen using portraiture as an example. Prior to January 1, 1978, the copyright on a portrait commissioned by a subject would belong to the subject. With portraits taken from that date on, copyright belongs to the photographer. Is the new law retroactive so that portraits taken earlier now belong to the photographer? Alas, the law has nothing at all to say on the point. So you can begin to see why copyright law is so complex. The entire Copyright Act is stated in a mere sixty-odd pages, but the interpretation and commentary may be infinite—somewhat like the Bible.

Note that owning the copyright does not necessarily give you the right to *use* a photograph—publishing a portrait where you choose can, for example, produce an action for invasion of privacy, infringement of the right of publicity, or other legal problems.

Why don't photographers go crazy worrying about copyright problems?

Obviously copyright questions only arise when there is a question of infringement or misuse. Since law in this country is substantially established by the courts—the test case system—interpretation of the written law is what really counts. This is why some situations are unclear (perhaps untested) and others confusing and contradictory.

So we end up back at the common-sense level. If someone has stolen your photograph, talk to him about it. Perhaps it isn't possible to negotiate, because someone who would steal a picture can't be talked to—right? Not always.

The perpetrator may easily have acted in ignorance. It is surprising how many people, even in publishing, don't think a photograph is worth anything. Or he may have hoped you wouldn't find out about his unauthorized use. Most promising of all, the photo-thief with any intelligence is as reluctant to resort to lawyers and the courts as you should be, so evincing a quiet determination to seek recompense may do the trick. If you can quote some legal rights all the better.

Clearly your course of action and possibilities of obtaining "justice" depend on the organization involved. If the *Podunk City Boy Scout News* stole a picture for a monthly column, a lawsuit is probably not called for. But if someone builds a national advertising campaign around your picture and paid you nothing, or paid you ten dollars for a news photo, you might actually want to see a lawyer.

It should be noted that proper registration of a work with the U.S. Copyright Office allows you to collect attorney's fees, certain statutory fees, and also obtain injunctive relief in cases of proved copyright infringement. In addition, a clear case of copyright infringement may result in federal prosecution.

A serious question of copyright infringement may well require a qualified lawyer's advice. Changes in this area are occurring quite rapidly and certain portions of this material, and any other you read, may be inaccurate or obsolete by the time it reaches publication. This is especially true because court interpretation of the recently passed law may redefine important points or require modification of some of the advice given here.

If you want to try doing your own legal research, the standard law book in the field is the most current edition of *Nimmer on Copyright*, by Melville B. Nimmer.

Model releases

When do you need a model release?

Strictly speaking, every picture that includes a recognizable person requires a signed model release from that person if the picture is used in a public medium, including magazines and exhibitions. The traditional exceptions to this rule are news pictures used for reportage purposes in recognized news media—there are arguments about whether even a weekly news magazine falls into this category—and pictures used for purely educational purposes. When a subject is a minor (anyone under twenty-one, in some states) you need a release from his guardian, though in some states this does not apply to minors earning their living as professional models.

Why do you need model releases?

To protect you as far as possible from being sued on such grounds as invasion of privacy, defamation and libel. And at least as important, many publications and most commercial users will flat-out refuse to use a photograph not fully covered by model releases. Why? Because *they* don't want to be sued.

A publication's policy concerning model releases is apt to be based on its particular experience with lawsuits in the area. Generally, the larger the circulation the wider and richer-looking target it presents and the more possibilities there are for lawsuits being brought. This is pretty logical, because people won't usually resort to the courts, especially after consulting a lawyer, unless there's a good chance of making a profit on the undertaking. A magazine once bitten—especially by a suit for millions of dollars or even one for far less that cost thousands in legal fees to defend—will probably never again neglect to ask for a model release before using a picture.

On the other hand, galleries and other exhibitors rarely worry about releases.

Ad agencies, as already noted, are fanatic on the subject because almost anyone whose face has been "stolen" for an ad imagines a great deal of money may be at stake, and not wrongly.

Why are there so many forms and varieties of model releases?

One complicating factor is that model releases are not governed by federal law, as copyright is; rather they are matters governed by state law. While contract law is fairly uniform among the various states, you will need to be sure that your own particular state does not have specific regulations that would be inconsistent with general releases (for example, in defining and dealing with minors).

Of course, a national publication of your work could produce a lawsuit not in your state but the one in which the model lives, or the magazine is produced, or any in which it is distributed. Which law will then govern? Who can say?

Model release is a complex question for other reasons as well, forming, quite literally, a subject for trial and error. Court interpretation can be crucial. If a model agrees that her photo can be used for "all existing purposes," what about one that was invented after she signed the release? Enough loopholes have been found in model releases over the years to result in quite a lot of money being handed over—not least to the lawyers, who, unlike the parties they represent, never lose, unless they've invested their time on a contingency-fee basis. Accordingly, most books dealing with the subject now suggest a several-page legal document listing every current and imaginable purpose as being included in the authorization.

Is a long involved model release the best?

Personally I think the best approach is to keep your release as simple as possible. If you don't understand it, and the model doesn't, neither will the lawyers and judges, and it will become open to interpretation. Moreover, a model may not sign a two-page form couched in legalese and apparently giving her life away.

In practice, most publications accept anything in writing as indication that everyone is acting in good faith. If you doubt this, ask several magazines if they have a sample model release form acceptable to them and you may be surprised at its simplicity.

With commercially-used pictures, an arrangement with the model may well be in order if the purpose arose subsequent to your taking the picture. This is only common sense. If you photographed the girl next door "for fun," and she casually signs a model release, whether simple or complex in form, and then you sell her picture for use in a national ad, does she have a right to complain? You bet. Usually a situation won't get to this point because the ad agency will

be avid in getting a release signed that will hopefully fully protect it from suit.

Never think that a signed model release protects you from everything or gives you blanket permission to do anything unfair or contradictory of common sense. Consider the following possibilities:

1. A release was signed, but the magazine caption misidentifies the sitter as a construction worker rather than an aspiring poet.

2. A release is signed, but the model is horrified to find her portrait included in a picture magazine in which nude women are shown.

3. A release is signed, but the model's face is taken from the image where she is shown chastely clothed and is superimposed on a sexily posed body, thinly veiled by a sheet; this result is hugely displayed in a national advertising campaign.

4. A release is signed, and a shot of a semi-nude model is actually on press as the cover of a major national magazine, when the model's boyfriend calls to say he'll personally strangle the editor if it runs.

All these situations happened. The first three people sued. The last was completely resolved without recourse to the courts or a single lawyer, because no one wanted to be strangled. (A replacement cover was made at great expense.) So again, we're dealing not so much with the law as with people.

One more note: when you do have even a scrap of paper serving as a model release, never mail or give it to anyone using your picture; give them a copy of it. People and big institutions can lose things. If you didn't get a release when you took a picture and someone wants one, certainly a release signed anytime subsequent to the picture's use is applicable; and hopefully you know where to find your model.

Besides badgering local bar groups for help on model releases, the best source of information may be ASMP. Their business procedures guide offers sample forms. You might write to inquire if they can tell you of any special requirement in the state where you live.

Libel and invasion of privacy

How do invasion of privacy and libel concern the photographer?

The first three of the four situations we just cited with respect to model releases also raise the complicated issues of libel and invasion of privacy, as do many lawsuits involving photographers. The "right to privacy" is an

emerging area of law in this country but is currently particularly vague; only a handful of states now have applicable laws. You can be sued on this ground nonetheless if a picture for which you have no model release is used. You can also be sued even if you do have a release but the subject claims to have been damaged in some way by the picture's use—perhaps direct financial loss, impaired ability to make a living or lessened reputation. The exact wording of your model release would have a direct effect on the outcome of such a case.

Libel is a more firmly rooted concept under English and American law and refers to publication (in its broad legal sense) of defamatory material. Laws originally applied to printed words are also applied to photographic material. Suit can be brought not only to collect alleged financial loss, but to compensate for the victim's pain, suffering, psychological damage, loss of reputation, and so forth. A central question, usually, is that of malice: Did the photographer deliberately produce a picture that he knew was misrepresentative of facts or exposed the person to ridicule?

The best defense against libel is to prove the truth of what was published.

If you photographed someone setting a fire that destroyed a building, and he did commit the crime and you can prove it, expect to win if he sues you for libel. If he didn't commit the crime but you can convince the court you had reasonable grounds to believe he did, you'd probably win. But if you staged or faked the shot to make it look like the person set a fire which he didn't, expect to lose.

Obviously, most cases aren't so simple, because the questions arise from context, or juxtapositions with words such as headlines and captions. Most of the situations we cited earlier hinged on these matters. How far can the photographer be held responsible for matters that are out of his control?

If you can show that you were honest, accurate in the information you provided (or had good reason to think it was accurate), and well motivated, you are unlikely to be held responsible. But you can never be sure what a judge or jury will decide. This is another reason, incidentally, that smart photographers take care to provide accurate and detailed information with pictures they supply.

Are celebrities fair game for the photographer, or are there laws restricting access to them and use of their pictures?

Generally, for news pictures, it has been impossible for celebrities to prevent photographers from taking their pictures. Among those who have tried, Jacqueline Onassis has been notable. However, photographers are certainly

restricted from taking pictures of celebrities for commercial purposes. Lawyers are beginning to refer to this as a "right to publicity," and it is a fast-emerging area of law. It means you cannot use a picture of someone to endorse a product, or seemingly endorse it, without making arrangements with them. A picture of Robert Redford or Henry Kissinger cannot be used to sell light bulbs; nor can you shoot a picture of model Cheryl Tiegs on the street and use it to sell bubble gum—unless you want to help ensure the prosperity of future generations of lawyers.

Contracts

The idea of simpler-is-better applies here as it does to model releases. Especially if you are signing a contract, be absolutely sure you understand everything it says without exception. Most contracts usually end with a statement that the written contract has precedence over any verbal agreement, so accept no glib explanations that something doesn't really mean what it says or won't be enforced. If in doubt, try crossing it out. Contracts aren't handed down off the mountain, they are made by people who have the other party's best interests at heart, not yours. It is customary for lawyers or business executives to look at you patronizingly or with pity when you push for truly clear explanations; ignore this standard tactic and pursue the point every time.

When do you need a contract?

I usually find this question comes up whenever the photographer has an uncertain or difficult situation on his hands. Usually in such cases it is unlikely that a written contract will help you out of it. The better idea is to develop standard procedures for getting work, handling jobs, and getting paid.

There is an important qualification to this approach. A contract, like a model release, can be of value because if people think they are committed they will usually honor the commitment. For this reason some photographers like to use elaborate, lengthy forms to be filled out on each occasion, specifying the rights and responsibilities of the concerned parties. If you find it useful to imitate such a form, do keep in mind that its objective is to keep potential problems out of court, not to guarantee you a foolproof argument in your own favor. Contract disputes often involve not a clearcut charge of nonfulfillment but conflicting interpretations of what was meant.

Other photographers who prefer to have something in writing will ask for a

purchase order (which as a document has no specific legal standing) or a letter. Or they will write a letter setting forth the arrangements and stating that this agreement will be considered accurate if the other party does not respond or seek to clarify anything.

Certainly there may be situations where a large commitment of time or even money on your part suggests an effort toward very explicit understanding. Whether you choose to put it on paper or not, don't forget such potential sore points as: who will cover each anticipated expense, exactly what rights are being purchased and what uses made of resulting photographs, how much you will be paid and when, how many photographs you will deliver and when, and your credit line.

Some photographers also present quite detailed invoices to buyers, which may deal with such matters as the date material will be returned, holding fees for delay after that time, responsibility for loss or damage, liability under any lawsuit, arbitration arrangements for any disputes arising, and so forth. If you can get your buyer to sign it, good for you.

For more information on such approaches, try the current ASMP Business Guide or law books for photographers, such as *Photography: What's the Law?* by Robert M. Cavallo and Stuart Kahan.

In referring to books, remember that material on copyright written before the 1978 revision took effect may be substantially out of date.

Problems, problems, problems

Obviously there is no way to provide a guide for the handling of all business problems, which are governed by many sets of laws which can be in conflict with each other. If you are still in doubt about this, find an opportunity to query several lawyers for advice on the same question. If their opinions vary substantially, try another lawyer in another city, let alone another state, and you'll get more opinions still.

A previous statement bears repeating: Think less about the letter of the law and its formal system of recourse and more about handling basic problems in their human context. Talk first to the people involved; if that fails utterly, consider a lawyer, but only if there's a definite amount of money at issue and a source from which to collect it. Otherwise you may have to chalk up your loss, and perhaps it is better to do that sooner than later.

Here are some tips on subjects many photographers worry about.

What happens if a customer is dissatisfied with work performed on assignment?

It depends on the circumstances. If it is important that he be satisfied, ego aside, be thankful if you have another chance to do so. If you're sure you've produced your best work—or great work by any standards—try explaining nicely why you think it's so good. This sometimes actually works.

Sometimes the client is clearly responsible for the problem and will pay you an additional fee to reshoot.

Sometimes a sharing of the additional expenses involved can be worked out.

Sometimes you'll just have to eat the loss, unless you want to try to force the client to pay through legal proceedings. A written contract may not do you much good in such cases because the disagreement usually involves something intangible—like whether the work delivered was "satisfactory." Did you misunderstand what was wanted? Did they fail to inform you clearly enough of what they wanted? Know at least to be more careful next time.

Many professionals routinely expect that a certain percentage of reshootings will be necessary, often at their own expense.

What can I do if a buyer or potential buyer loses my work while it is in his possession for review?

There have been some landmark court cases on this issue that photographers have won. However, unless you can prove that the work would be impossible or expensive to replace, you will probably have to be a well-established photographer in order to demonstrate significant monetary loss in such a situation. If you've never sold a picture before, it will be hard to prove that your work was worth anything beyond the materials. Usually redress will have to come from talking to the people. Cautious photographers sometimes make it a policy to get a receipt of some sort when leaving important work—perhaps a slip of paper signed by a receptionist or picture editor who accepts the work—and a return receipt for material submitted by mail. This may not bestow legal responsibility on the recipient—note the disclaimer about mailed-in work in many publications, especially regarding unsolicited work—but it does certainly make an individual feel a lot more personally responsible and will virtually guarantee you a whole-hearted search of the premises. If another tactic is needed to bring home the seriousness of such a loss, you can point out that the courts have held that a single transparency may be valued at $1,500. It's true.

What if a user damages my work?

If they've used your work and damaged an expensive print or irreplaceable transparency so it can not be used again, a magazine may: a) tell you better luck next time, b) agree to cover the cost of replacement if it's replaceable or c) pay you more for the transparency—but reluctantly. Use as much tact as you can muster in dealing with these situations. Remember that you may wish to deal with the people involved again. But the occasion may call for a firm stand. If you're altogether easy-going about a serious loss, editors are only too glad to forget the whole matter.

Use common sense about where you leave your work and how much of it you leave, and keep similar shots or duplicates when possible. Professionals do this especially so that smiling at important contacts who have damaged or lost their photographs won't be quite as hard.

What can I do if an idea is stolen?

If you think someone who's reviewed your portfolio imitates some feature of it in a publication or advertising venture, you'll have to think calmly about the possibilities. Ideas cannot be copyrighted. So a *similar* picture is usually not grounds for collecting damages. However, it has been held that a duplicate image, which for example poses a very similar model against an identical background, does constitute a copyright infringement. You may wish to bring suit if the offender has the money. He may, in such cases, be responsible for punitive as well as actual damages.

Remember that the burden of proof is yours in such cases. That is, it will be up to you (or your lawyer) to prove to a judge or jury that your work was virtually appropriated.

Do I need permissions and permits to photograph in many situations and places?

Yes, strictly speaking. Many communities do require you to obtain official permission to shoot for commercial purposes in such places as public parks, zoos, buses, ferries, subways and public buildings. Many photographers take pictures in such locales of course, and you are not likely to be questioned unless you look professional—like using a tripod and lots of paraphernalia and ten assistants. Regulations are very strict on photographing in courtrooms, jails, museums, military installations and similar places. Check local regulations as necessary.

What if my work is used in such a way that it looks bad and damages my reputation as a photographer?

It happens all the time, to even the best photographers. Next time they don't submit work there, unless they need the money or for some other good reason. It is possible to bring suit on such grounds but the case will probably be hard to win.

If a lawsuit is called for, can the photographer bring suit without a lawyer?

Yes. Many counties have small claims courts; a good number of them actually forbid lawyers from speaking for the parties. Procedures vary from court to court and full information on what to do is available. Amounts collectable can range up to $1,000 in some places for each contested claim (meaning you could, if you wanted, sue individually for a number of violations). There is a catch: It is sometimes difficult to enforce judgments obtained in small claims court.

It is feasible to skip small claims court and go to your local lower court. You will have to learn a little law to do this but the infringing party will take you much more seriously and any judgment obtained is far more easily enforceable.

Another alternative for settling disputes is to arbitrate them under the rules of the American Arbitration Association. Some photographers incorporate a clause calling for this in their agreements and invoices. This process is, however, rather expensive, as you must pay for the arbitrators, while judges are free. Besides, it may take a court order to force a recalcitrant client to arbitration in the first place.

When I do need a lawyer, how can I find one who is knowledgeable in the appropriate areas?

You might ask a few of the best-established commercial photographers where you live, since they have probably had some problems and may have found a good lawyer. You can query a local law school, or a state or local professional photographers' association. ASMP can be a good source of advice, either via New York headquarters or one of the chapter offices in various cities around the country.

About half the states now have volunteer lawyers for the arts groups,

specifically operated to help with the kind of questions you may have. Your state bar association can tell you if there is one where you live. Or track down the group nearest you by contacting one of the following established organizations: Bay Area Lawyers for the Arts, 25 Taylor St., San Francisco, CA 94102, Tel. (415) 775-7200; Lawyers for the Creative Arts, 111 N. Wabash Ave., Chicago, IL 60602, Tel. (312) 263-6989; or Volunteer Lawyers for the Arts, 36 W. 44th St., New York, NY 10036, Tel. (212) 575-1150.

Index